PHOTOGRAPHING NATURE

A photo workshop from Brooks Institute's
top nature photography instructor

RALPH A. CLEVENGER

Photographing Nature
A photo workshop from Brooks Institute's top nature photography instructor

Ralph A. Clevenger

New Riders
1249 Eighth Street
Berkeley, CA 94710
510/524-2178
510/524-2221 (fax)
Find us on the Web at www.newriders.com
To report errors, please send a note to errata@peachpit.com

New Riders is an imprint of Peachpit, a division of Pearson Education.

Project Editor: Nikki Echler McDonald
Development and Copy Editor: Robin Drake
Production Editor: Hilal Sala
Proofreader: Nikki Echler McDonald
Indexer: James Minkin
Interior design and composition: Kim Scott, Bumpy Design
Cover design: Charlene Charles-Will
Cover image: Ralph Clevenger

ISBN 13 978-0-321-63754-3
ISBN 10 0-321-63754-2

9 8 7 6 5 4 3 2

Printed and bound in the United States of America

For MJ

Acknowledgments

To the people who shaped my life: my dad, Chuck Farwell, Ernie Brooks II, George Lepp, and Craig Aurness.

To my mom, for obvious reasons.

To my peers, who helped me to make this book a reality: Chris Orwig, Mike Verbois, Christy Schuler, Kelly Kirlin, and Michael Lussier.

To my editors: Nikki McDonald, who had the vision for this book; and Robin Drake, who helped pull all the pieces together. To Kim Scott, Hilal Sala, Charlene Charles-Will, and the rest of the production team at Peachpit Press.

Thank you.

About the author

Ralph Clevenger grew up on the coast of North Africa and began diving in the waters of the Mediterranean Sea at the age of seven with his father. He eventually went on to study zoology and worked as a diver/biologist for the Scripps Institution of Oceanography in La Jolla, California before attending Brooks Institute of Photography in Santa Barbara, California. Ralph went on to work as an associate photographer with renowned nature photographer George Lepp and, in 1983, was offered a teaching position at Brooks Institute. He teaches courses in nature photography, stock photography, video production, and undersea photography.

Ralph has traveled throughout the world on assignment, including Australia, South America, Antarctica, and Africa. His clients include Monterey Bay Aquarium, MacGillivray Freeman Films, Fox Sports Net, The Nature Conservancy, Denali National Park & Preserve Wilderness Access Center, the U.S. National Park Service, and the NOAA National Marine Sanctuaries. His publication credits include Audubon, AQUA Magazine, Islands, Oceans, Outside, Orion Nature Quarterly, National Geographic, National Geographic Traveler, Popular Photography & Imaging, Nature's Best Photography, National Geographic Books, Smithsonian Books, Sierra Club Books, and many other national and international publications. Ralph's stock images are represented worldwide by Corbis.

Contents

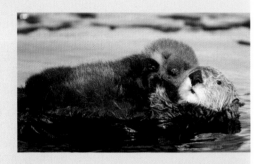

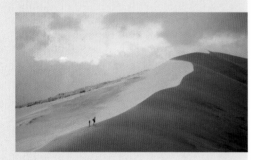

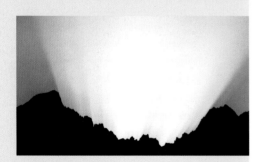

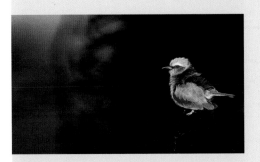
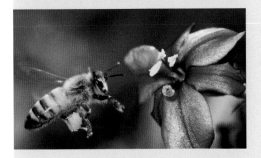
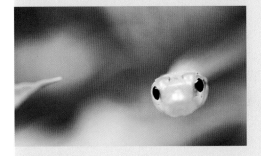

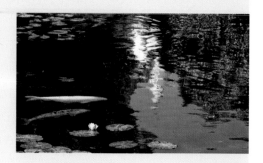

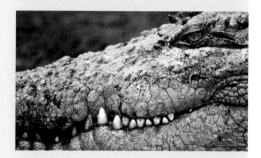

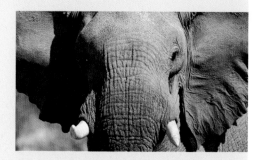

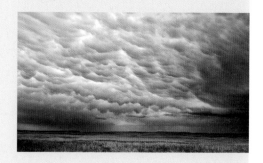

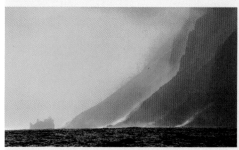

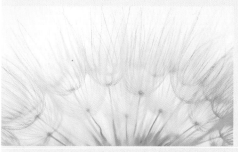

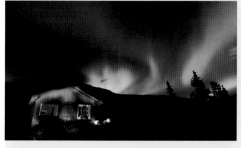

Foreword

By George Lepp

Some folks are born teachers, and some born photographers, but the accomplished photographer who can also teach is a rare gift indeed. Such a man is Ralph Clevenger, who has been working on the cutting edge of this field for thirty years but never tires of sharing his insights and skills with students of the art and craft of nature photography.

I've known Ralph as a colleague and friend since his graduation from Brooks Institute. Shortly after graduation he worked with me on a photographic project for Cal Poly University, San Luis Obispo to produce images for educational filmstrips. He brought with him not only strong technical ability, but also a great background in zoology. We photographed everything from "flower arranging" to "grading eggs for quality." Even then we were both into teaching!

Since those early days, Ralph has traveled the world, generated a significant body of work in the field of outdoor photography, and become a highly successful stock and assignment photographer. He brings this experience to the classroom and helps his students make the leap from the controlled educational setting to the real world of professional digital and video photography. His former students tell me that Ralph is an exceptionally effective teacher who motivates them to master the skills and perfect the techniques that will lead them to achieve their own creative visions.

Ralph brings this same combination of expertise and inspiration to *Photographing Nature*. The illustrations in this book provide the proof that Ralph is a world-class photographer. The teaching format, including questions and assignments (a.k.a. homework!), draws on Ralph's many years

as an instructor at one of the country's premier photography schools. But Ralph doesn't want you to stop with this book. He also provides a selected bibliography of resources that will let you expand your pursuit of nature photography.

Most people will never have the chance to take Ralph's nature photography course at Brooks Institute, but with *Photographing Nature*, everyone's invited to the classroom. So dig in, be informed and inspired, and let Ralph lead you to greater enjoyment and satisfaction in your own photographic endeavors. For me, and for Ralph, that's what great teaching is all about.

Introduction

I never dreamed of being a photographer or a teacher. I wanted to be a marine biologist. And I became one, working at one of the world's most prestigious marine science institutions. But much of science is mundane and tedious, spending time in labs analyzing data collected in the field, and my passion was being in the field—being out in nature. An important part of being a scientist is recording what you see, and I soon realized that photography and filmmaking were my tickets to spending as much time as possible in nature. So I became a photographer.

Making a living from photography has never been simple. When I graduated from Brooks Institute, I realized that I needed to embrace not just nature photography, but many aspects of commercial photography, in order to generate enough income to survive. But I promised myself it would all be "outdoors." This broad experience in photography led to an offer to teach for my alma mater. I'm not a teacher. I'm a photographer who teaches. For me, this is an important distinction.

The students I teach at Brooks are unique in that they've decided to make a career in the visual communications field. By the time they join my nature photography class, they've taken more than a year of intensive photography or filmmaking classes. Very few of them actually want to be professional nature photographers. So my course offers much more than the "nuts and bolts" of how to take pictures in nature. My biggest challenge is teaching my students to take what they already know about lighting and photography and apply it to flowers, bugs, birds, and landscapes. To get them to see beyond their preconceptions of what a subject is *supposed* to look like and think about what it *might* look like.

In a broad sense, this book reflects my nature photography course at Brooks. Of course, many readers of this book don't have the same background as my students, so I've included information and resources that will help anyone become a better photographer, regardless of their level of photographic experience.

I hope that reading this book will help you to grow as a nature photographer, and that it will do for you what some of my favorite nature photography books did for me when I started learning photography. Their images and words helped to simplify the seemingly chaotic world in front of my camera, motivating me to go out and make photographs, rather than just take pictures.

I could write thousands of words explaining how a particular picture was taken and why I think it's a good photograph, but it's better to let the photos in this book tell their own stories. As Michael Freeman said in his book *Light*, "Fortunately, photography is not so exact that all of it can be put into words."

The best way to learn how to take better photographs is to understand what makes a good photograph. Really, no one needs to tell you what a good photograph is; you already know. It's instinctive. You turn the pages of a magazine or view a website, looking at the photos, and then pause at one you like. That's a good photograph. It's good because it made you stop and look at it.

Another thing. I've read a lot of books and articles on photography written by lots of different photographers, and they all seem to say pretty much the same thing that I've been saying to myself, and my students, for

decades: Making good photographs takes a basic menu; the ingredients are the same, but the presentations are unique. We're all saying the same thing. This is good. It means that each seminar, book, video, or website that shows you how to make better photographs is consistent with all the others. Most of us need repetition to learn something well, and hearing the same things from different sources reinforces the idea that maybe we should actually try that technique or spend more time researching. If it works for the photographers you admire, it will work for you, right?

This isn't a book about Photoshop or how to operate your DSLR, although the chapters that follow explain a lot about cameras and lenses and what they're capable of doing. This is a book about how to create images of nature that you'll be proud of and want to share. It's about learning how to see things differently than you do now. Of course, I've also provided plenty of cool tips and tricks that I've learned from my own experiences and from other photographers, naturalists, and friends who have joined me on my adventures.

Finally, this book talks about your responsibilities when you're in the natural world. To become a better nature photographer, you have to become a better naturalist. You have to develop the patience to sit and watch animals, learn to understand why flowers look so beautiful, believe in the reality that all living things are connected. You're part of nature, so learn as much about it as you can. Learning about what I photograph completes the process for me, makes the experience of capturing an image more satisfying, and helps to minimize my impact on my "studio"—the natural world.

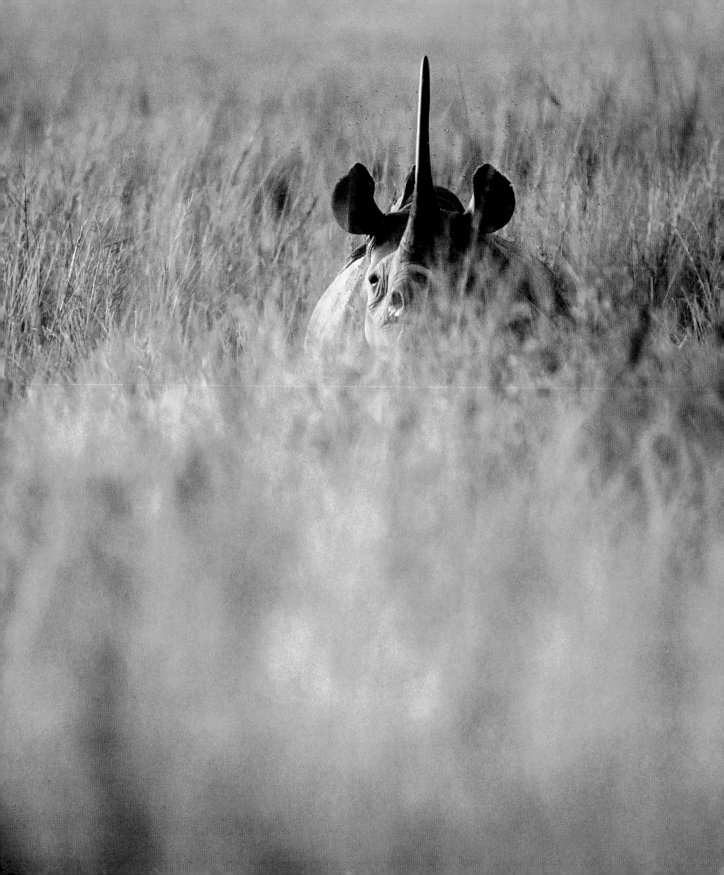

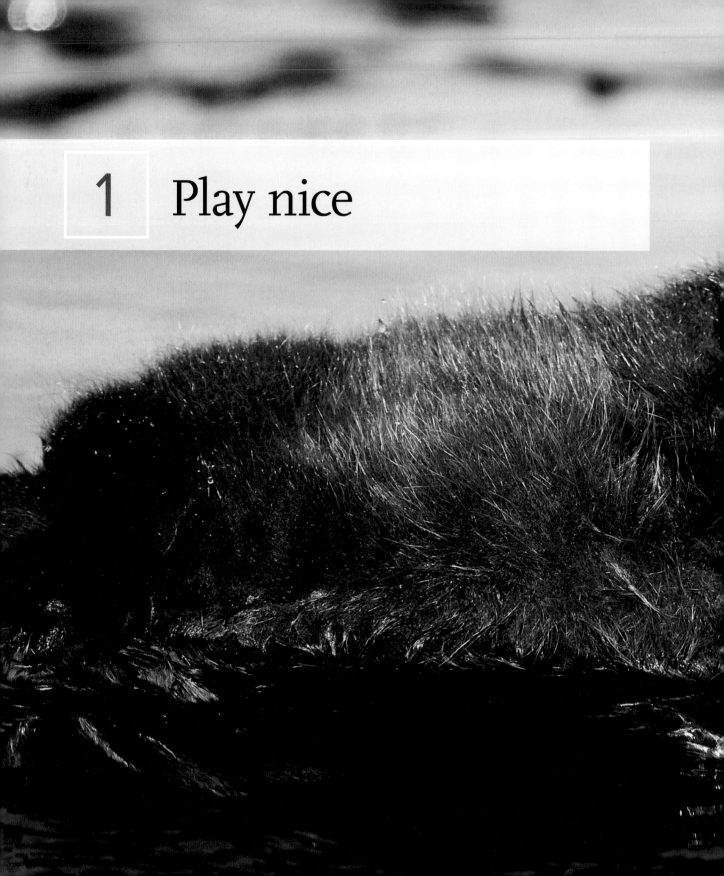

1 Play nice

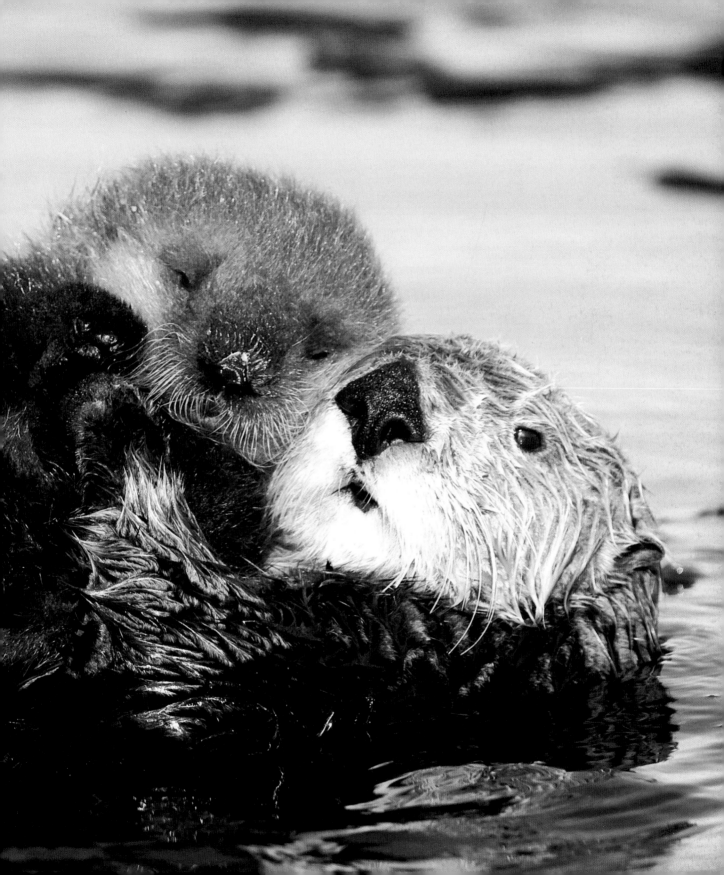

Treat animals, plants, and the land with care. Tread lightly and learn about the places and creatures you photograph.

Most of us—maybe even all of us—became nature photographers after we fell in love with nature. Maybe we grew up with nature around us, or maybe we learned about it on summer trips away from the city. Maybe it was the birds or the flowers, hikes in the mountains, or just watching snails. For me, it was the ocean. I've lived near the ocean most of my life, and many of my assignments allow me to spend time photographing animals like the sea otters on the preceding pages. These otters live near a harbor, but still maintain their distance from people. All wild animals require a certain amount of space to feel safe, and when we intrude on that space they feel threatened and will either flee or attack. It took several hours of quiet waiting to get this photograph of a very comfortable mother and baby. I enjoyed every minute of the wait.

This passion about nature is the most critical aspect of making great nature photographs (**FIG. 1.1**).

FIG. 1.1 The guides at this reserve know the animals so well that they can usually predict where the animals will be at any time of the day. It was close to sunset when we found this beautiful leopard resting before the night's hunt. Since they aren't afraid of the vehicles, we could get fairly close. But I still had to use my long lens to get this portrait. Mala Mala, South Africa. (Nikon F4, ISO 32, 400 mm lens, steady bag, Fuji Velvia 50 film, exposure unrecorded.)

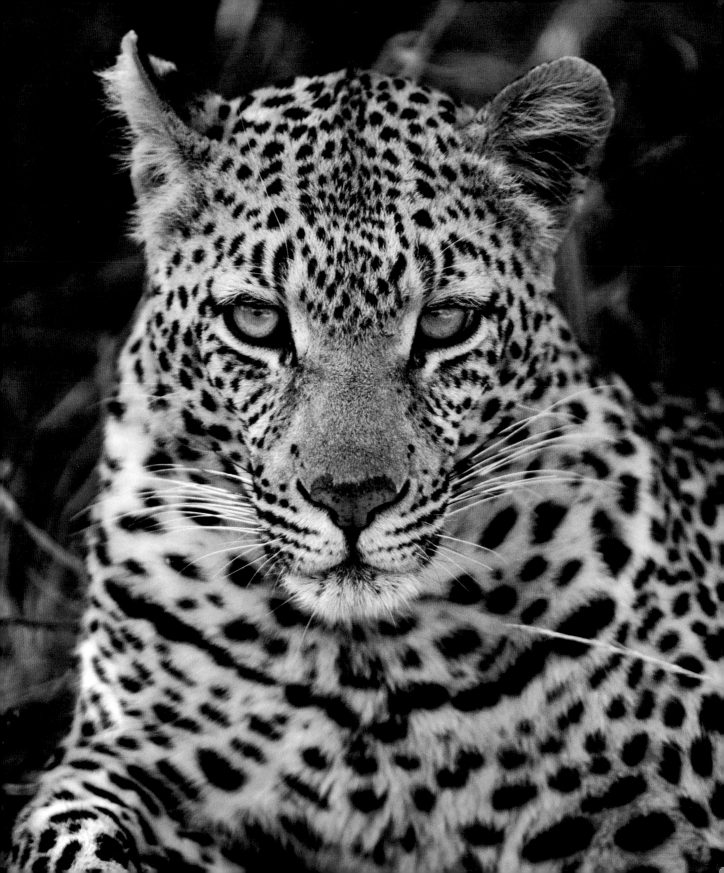

Ethics

As nature photographers, we need to set an example for others. Photographers aren't special; we have no more right to watch animals, or get close to them, or hike off trails than anyone else has. We actually have *less* right, because we should know better.

When you set up a tripod and camera, maybe with a big lens, lots of people will stop to see what you're doing. As photographers, we may even have a greater impact on the natural world than non-photographers. It's our responsibility to protect our subjects and their habitats in every way we can. Part of that responsibility includes educating others about how to act responsibly—and we can do this through our deeds, our words, and our photographs.

Parks and reserves throughout the world have rules and guidelines specifically designed to protect the habitat and wildlife within their boundaries. Outside of these areas, there are few rules and less protection.

If there were only a few people in the world, we wouldn't need rules. Nature would make the rules, and we would have to follow them. But there are more than just a few of us. U.S. national parks have over 275 million visits in a single year. That's a lot of impact on nature (**FIG. 1.2** to **1.4**).

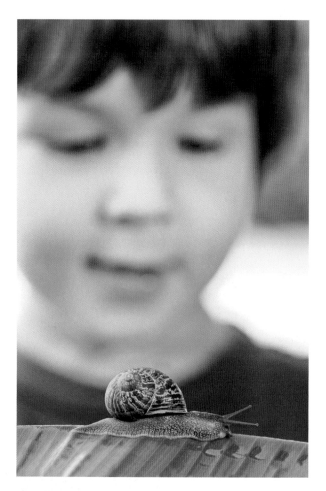

FIG. 1.2 Kids are always curious. Encouraging them to explore, touch, and learn about the natural world will help them to respect and care for all of nature. Balancing my camera exposure for the background, I lit the boy's face and the snail with a diffused flash on the right. California. (Nikon D2X, ISO 200, 105 mm macro lens, tripod, off-camera TTL flash, 1/125 sec. @ f/3.2.)

▶ **FIG. 1.3** The desert tortoise is a threatened species because of human activity. Many are killed crossing roads, so I stop whenever I see a tortoise on or near a road. Just standing by the tortoise will cause most motorists to slow down, but if it's a busy highway I gently move the animal out of danger. Mojave Desert, California. (Nikon D100, ISO 200, 70–200 mm lens, handheld, 1/200 sec. @ f/6.3.)

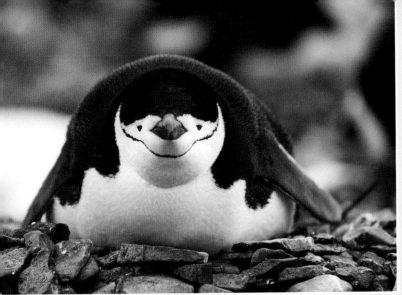

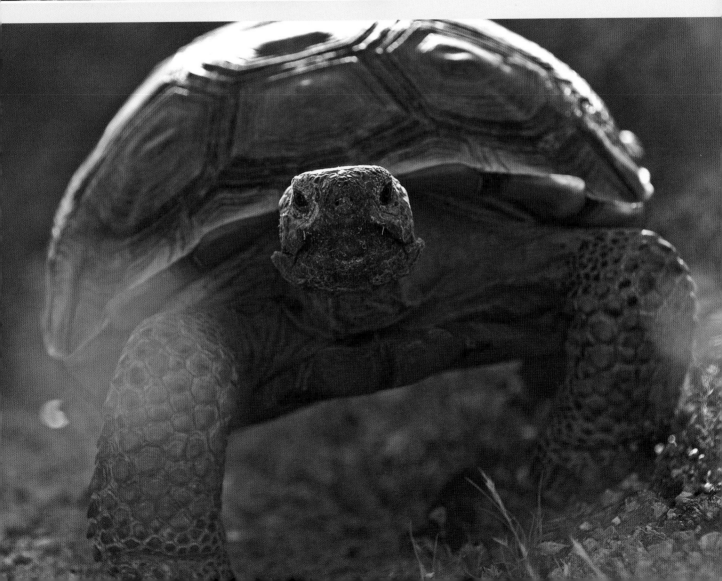

◀ **FIG. 1.4** Chinstrap penguins nest on rocky areas free of snow. The parents take turns sitting on the egg and guarding the chick once it's hatched. These penguins are unafraid of humans, and as long as you stay on the edges of the rookery they seem quite undisturbed. Antarctic Peninsula. (Nikon F4, ISO 80, 400 mm lens, tripod, Kodak Ektachrome Lumiere 100X film, exposure unrecorded.)

FIG. 1.5 Alpine meadows are very fragile. They provide a home for nesting birds and mice, and contain dozens of species of plants and wildflowers. They're also popular places for people to visit and camp. Follow posted signs and good backcountry etiquette to ensure that meadows stay vibrant and healthy.

As photographers, we sometimes forget that a personal encounter with an animal along a trail is only one encounter for us, but may be the 20th encounter for the animal that day. Other people who use the trail may see the same animal. The cumulative effect of all these interactions may lessen the animal's ability to survive. It may live near the trail because it has been pushed out of quieter areas by other animals, and constant interruptions by well-meaning, curious people make the animal's life stressful. Being aware of this problem can help to define your behavior when photographing. Maybe you'll be willing to walk farther from the parking lot, or you'll encourage other people to sit quietly and just watch.

Signs are posted for a reason. We need to observe messages from "No Trespassing" to "Beware of Poison Oak." Highway signs telling us to slow down, especially in parks, are intended to help save animals. Vehicles are the single biggest killer of wildlife in North America, and the least we can do is slow down when we're in areas where animals are protected (**FIG. 1.5 to 1.7**).

The North American Nature Photography Association (NANPA) publishes "Principles of Ethical Field Practices" that list actions all nature photographers should follow. I've included these principles at the end of this book and the appendix lists the NANPA website, where you can download the principles and learn more about NANPA. The true test of our commitment is whether we will practice ethical photographic principles even when no one is watching us.

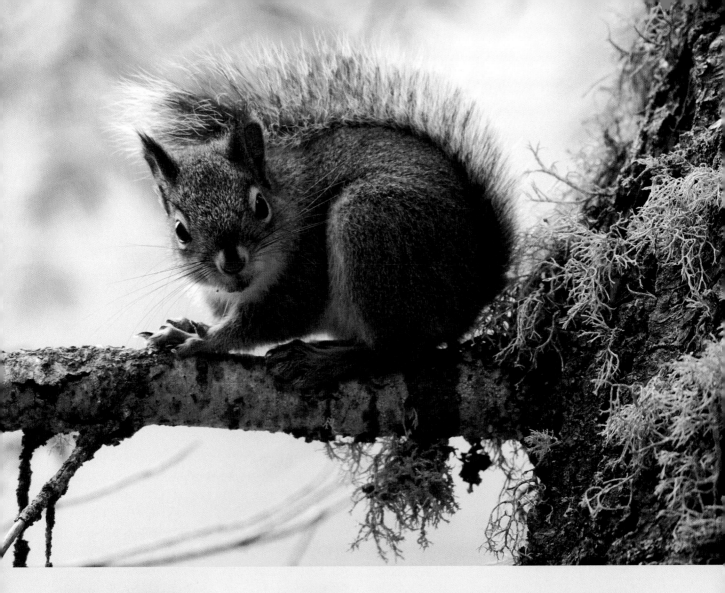

FIG. 1.6 and **FIG. 1.7** The Douglas squirrel, sometimes called a "chickaree" after the sound of its call, is fascinating to watch. They're active by day and chatter noisily at people walking by. I found several squirrels running around what appeared to be a nest. Sitting down about 20 feet away, I set up my long lens and waited. Several young squirrels soon popped out and started chasing each other around, totally disregarding me as long as I stayed still. Unfortunately, squirrels sometimes disregard cars, too. Driving the speed limit and keeping an eye out for wildlife can prevent animal deaths. Kings Canyon National Park, California. (Nikon D300, ISO 800, 500 mm lens, tripod, 1/320 sec. @ f/4.)

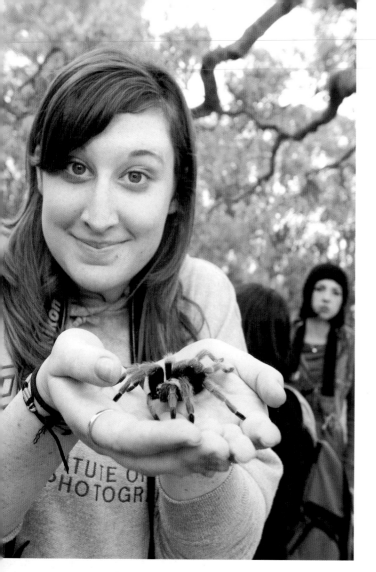

Knowledge and creativity

Some of the students in my nature photography classes are experienced outdoors people, but many are there because they want to try something new, breaking out of their bubble of comfort. I always have a few who have never camped, at least as an adult, and many who are afraid of spiders, snakes, or even the "wilderness" in general. What they all have in common is a passion for photography.

There's a progression in my class to deal with these differences in outdoor skills and phobias. The first new experience for many of my students is my "critter demo." A good friend of mine, Dennis Sheridan, an experienced animal wrangler, photographer, and educator, brings a menagerie of insects, reptiles, and amphibians to the class, and talks about the animals' natural habitats, their unique characteristics, and how to handle them. We spend a full day photographing pythons, frogs, tarantulas, and strange insects. The animals become real for the students through holding them, feeling their skin or scales, watching them move, and being responsible for their safety. The students work in teams with one animal at a time, and they have to return an animal before they can "borrow" another one. For many students, this is the experience of a lifetime (**FIG. 1.8**).

A strong connection to nature comes from knowledge. As Ethan G. Salwen wrote in his article "Rethinking Creativity" (NANPA *Expressions* 2009), "Everyone who makes truly stunning nature images will tell you they do a lot of research." I try to learn everything I can about the places I visit and the living things I photograph. I watch documentaries, read magazines and books, search the web, visit museums (**FIG. 1.9**).

FIG. 1.8 This student started the day deathly afraid of spiders. Look at her now! Providing opportunities like this to my students helps them to move beyond their comfort zone and encourages them to try new things. Both skills are helpful for making creative images. Red-kneed tarantula. Santa Barbara, California. (Nikon D300, ISO 400, 12–24 mm lens, handheld, off-camera TTL wireless flash, 1/80 sec. @ f/7.1, captive.)

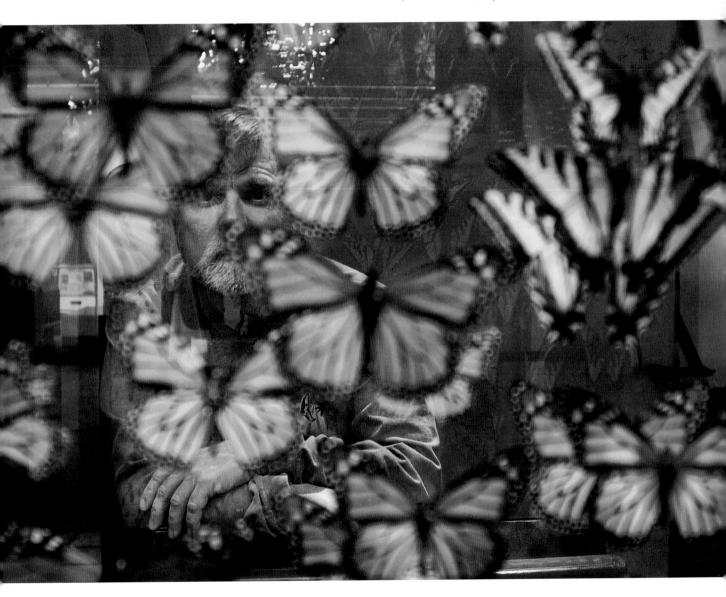

FIG. 1.9 Research may sound boring to some people, but I find it fascinating. What I learn gives me knowledge I can use to choose the most interesting subjects or to determine what's most important about a place. I love visiting natural history museums. This is a self-portrait in the insect hall at the Santa Barbara Museum of Natural History. California. (Nikon D100, ISO 200, 28–70 mm lens, tripod, 1/5 sec. @ f/4.5.)

FIG. 1.10 Our guide shows us what's found in elephant droppings, including large thorns from an acacia tree that the elephant has eaten. I wondered why our drivers always swerved around elephant dung in the road—now I know why: Those piles may contain thorns that pop tires. You learn something new every day. Botswana, Africa. (Nikon F4, ISO 80, 20 mm lens, handheld, Kodak Ektachrome 100 film, exposure unrecorded.)

I go back to the same places every year with my classes. Familiarity can breed boredom, but boredom motivates creativity. Having to look for a new way to see the same old thing pushes my photography. Familiarity also fosters a deeper appreciation of and caring for a place. You become more sensitive to changes, learn to recognize specific animals, and develop friendships with people who live and work in the area.

Talk to the people who know. Even if you visit the same places every year, as I do, things change, so communicate with people in the places you're photographing. Talk to ranchers and farmers, visit with volunteers, ask park rangers about where to see things you want to photograph. This on-site research has a lot to do with making more creative images. Much of what makes a great nature image is knowledge about the subject, where to go for the best view, what to expect from the animals, which meadows are in bloom, and so on (**FIG. 1.10**).

When we learn about something, we're more apt to care for it. There's a saying I tell my students: "We will protect only what we care about, and care about only what we know about" (**FIG. 1.11**).

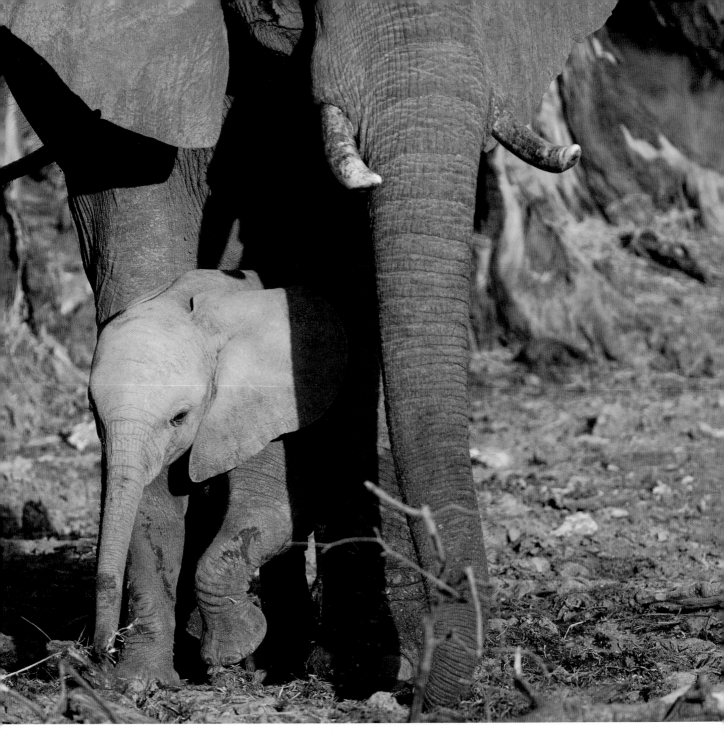

FIG. 1.11 We sat and watched a family of elephants for over an hour. With our vehicle a good distance away, the herd paid very little attention to us. It was just a matter of waiting for interactions between mother and baby, watching where the trunks were positioned, where the shadows fell. I love watching elephants and can do it for days. Zambia, Africa. (Nikon D2X, ISO 200, 200–400 mm lens, ballhead mounted on vehicle, 1/500 sec. @ f/4.)

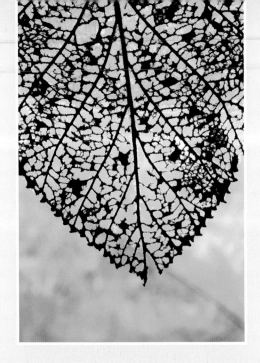

FIG. 1.12A It wasn't windy when I shot this skeletal leaf, but I wanted to compose the shot so you could see through the leaf. I used the Plamp to hold the leaf in front of the lens, keeping the background far away so it stayed out of focus. (Nikon D100, ISO 200, 105 mm macro lens, tripod, 1/160 sec. @ f/16.)

FIG. 1.12B A tiny cricket sits inside a California poppy. The wind was blowing this flower all over the place, so I clamped one end of the Plamp to my tripod leg and the other end held the stem of the flower in place. I'm amazed that the cricket stayed in the flower the whole time. Big Sur, California. (Nikon D200, ISO 100, 105 mm macro lens, tripod, 1/640 sec. @ f/4.)

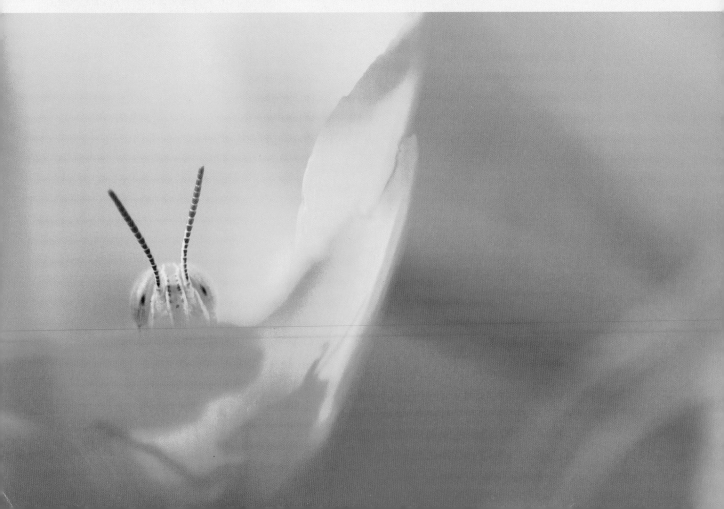

Equipment

Batteries

Part of reducing your impact on the environment is how you manage all the batteries your equipment requires. Photography is a battery-intensive activity, and I shudder to think how many batteries have been dumped in landfills because of our dependence on them. Rechargeable batteries are part of the solution. But you have to manage rechargeables to get the maximum life out of them. This means fully charging them when they're new, and periodically discharging and conditioning the batteries to keep them working as long as possible. And when they're done, proper disposal at a recycling center is important.

I use rechargeable nickel-metal hydride batteries from a company called *Maha*. The newer batteries of this type, called *hybrid Ni-MH*, can hold their charge for months, and work great in low-drain devices such as remote controls and flashlights. These hybrid batteries will work around your home as well as in your photo gear.

Never leave dead batteries in foreign countries; always bring them home with you for recycling. Most batteries left at hotels and resorts end up in the local landfills and create toxic pollution in pristine areas.

Plamps

In the "old days," most people would just break off a branch or stem to get it out of the way for a photo. It didn't matter if it was dead or alive. I remember seeing photographers use a clothespin glued to a stick, stuck in the ground to hold flowers steady in the breeze. But the clothespin crushed the flower stem, usually killing the flower. There had to be a better way (**FIG. 1.12A** and **1.12B**).

One of my favorite tools is the *Plamp*; it's a clamp for plants. Shaped like a clothespin attached to a clamp, it's used to hold a flower stem so that the flower doesn't blow around in the wind. The clothespin part has gaps so the plant stem doesn't get crushed, and the clamp end can attach to your tripod or any steady support. You can even use it to hold reflectors and diffusers to help light close-up photographs (**FIG. 1.13**).

FIG. 1.13 This is the official Plamp from Wimberley. Lots of people have made variations of these devices that work just as well. The most important part is the "clothespin" that holds the plant stem. To prevent crushing, the stem must fit into the slots at the end, with room to spare. I have a couple of Plamps and use them all the time for close-up photography.

FIG. 1.15 My good friend and fellow photographer Todd Walker is dressed appropriately for early spring in Big Sur. The trees in the distance are coastal redwoods that rely on the moisture from ocean air and wet fogs. Todd can tuck his camera into his jacket to protect it from a sudden rain shower. Santa Lucia Mountains, California. (Nikon D2X, ISO 200, 28–70 mm lens, handheld, 1/250 sec. @ f/5.)

Blinds

A *blind*, sometimes called a *hide*, is any enclosure designed to screen the human figure from animals. Photographic blinds can be permanent or mobile, and many are camouflaged to blend in with their surroundings. Slits or windows allow lenses to be pushed through for unobstructed photographs. Many natural areas have permanent blinds situated near a watering hole, nesting site, or feeding area. On private land, you can use portable blinds to photograph nesting birds and other animals, with minimal impact. Remember, the blind only hides your form, and animals can still hear and smell you. It takes a lot of patience to sit in a hot (or cold) blind for hours, waiting for something interesting to happen. But your patience will be rewarded with a more natural-looking and less stressed subject (**FIG. 1.14**).

Preparation

Being comfortable in the wilderness has a profound effect on your impact on nature. The more prepared and comfortable you are, the less impact you'll have on your surroundings.

In an article in NANPA's magazine *Currents*, Gary Hart talked about the three *P*'s of nature photography; preparation, persistence, and pain. I like what he said about pain. It's really not *pain*, like hurt or danger; it's about discomfort. If you're not willing to be uncomfortable, you're going to lose great opportunities to make images. Nature doesn't care about rain, wind, snow, heat, or cold. These conditions are what make being outdoors an adventure. Many animals and even plants revel in adverse weather. Wolves love the cold, salamanders and snails are easier to find when it's really wet, some plants need strong winds to disperse their seeds. Skies are boring without clouds, and clearing winter storms offer some of the most dramatic light you'll ever see. We need weather (**FIG. 1.15**).

Gary says, "[Any] weather that requires adding clothing for comfort is photographer's weather. It's the polar opposite of tourist's weather—blue skies and the general urge to shed clothes for comfort." Check out Gary's website, listed in the appendix, for some great examples of "photographer's weather."

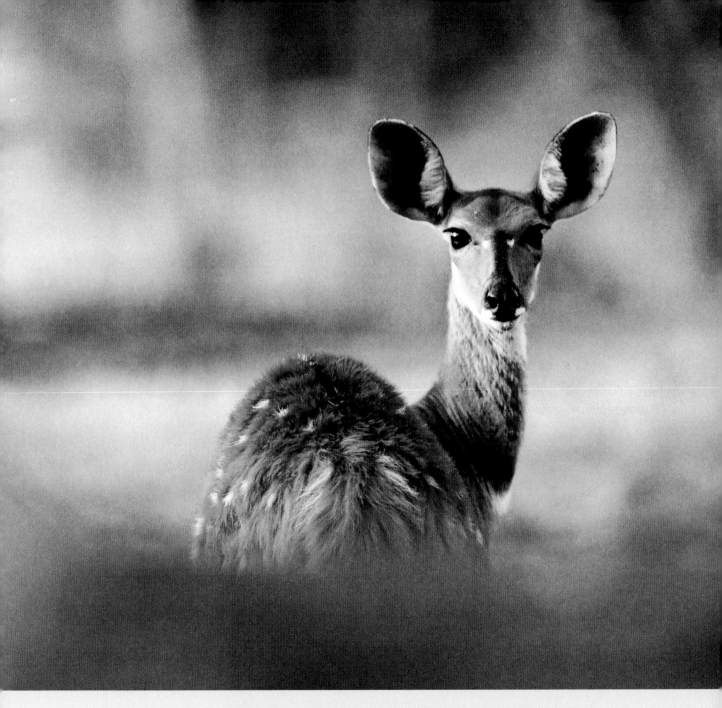

FIG. 1.14 The safari lodge had built an underground blind looking out onto a watering hole. We spent all day in it—hours of boredom intermixed with bursts of exciting activity. This bushbuck heard my motor drive and turned toward me. Click. The lighting was beautiful, his ears forward, one great shot in eight hours—well worth the time. Zimbabwe, Africa. (Nikon F3, ISO 200, 400 mm lens, tripod, Kodak Kodachrome 200 film, exposure unrecorded.)

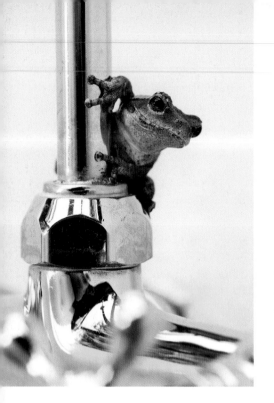

FIG. 1.16 Tree frogs eat a lot of insects, so finding these little amphibians hanging out in our shower was a bonus. Geckos are another voracious eater of biting insects common to rooms in tropical countries. They're so used to people that they make great subjects for nature photography. Zambia, Africa. (Nikon D200, ISO 200, 105 mm macro lens, handheld, 1/60 sec. @ f/8.)

Becoming part of the solution

When you travel, look for lodges and restaurants that support recycling, save water, and strive for an environmentally friendly footprint. Tell them you appreciate their efforts and will recommend them to others. I've included several sources related to "green" travel and camping in the appendix.

Practice recycling at your home, office, and when you travel. Your example is the best way to teach others. Avoid pesticides; look for organic ways to control insects in your home and garden. In many tropical destinations, you'll find creatures cohabiting with you. Don't kill the lizards and frogs you find in your room; they eat insects that may bite you (**FIG. 1.16**).

Don't feed wild animals, especially the cute ones begging for handouts around the picnic table. It's unhealthy for the animals and dangerous for people. Few people realize the long-term effect of leaving food on the picnic table or next to a stream. Mew gulls in Alaska have multiplied beyond their traditional numbers because of all the extra food available from hanging around near people. The mew gulls eat the eggs of migrating shorebirds. There's evidence that shorebirds are declining partly because of the increase in gull populations. As naturalist John Muir said, "When we try to pick out anything by itself, we find it hitched to everything else in the universe."

Is providing water or natural food or a nest box in your garden detrimental to wildlife? Urban wildlife may depend on our gardens for survival, and many of us may live on the edge of wilderness. We're part of nature. It's up to each of us to act responsibly, to act based on knowledge and understanding, to do our homework, to keep the wild as wild as possible (**FIG. 1.17**).

Providing photographs to local environmental efforts that don't have a budget to pay for photography is a great way to give back to nature. If the groups don't need photographs, volunteer to help in other ways. Working with people in these organizations can lead to wonderful opportunities for photography. You may get access to private areas full of great subjects, or meet a researcher working with interesting animals. By donating work to the local wildlife care network, I've been able to photograph baby animals that would have been difficult to photograph in the wild (**FIG. 1.18**).

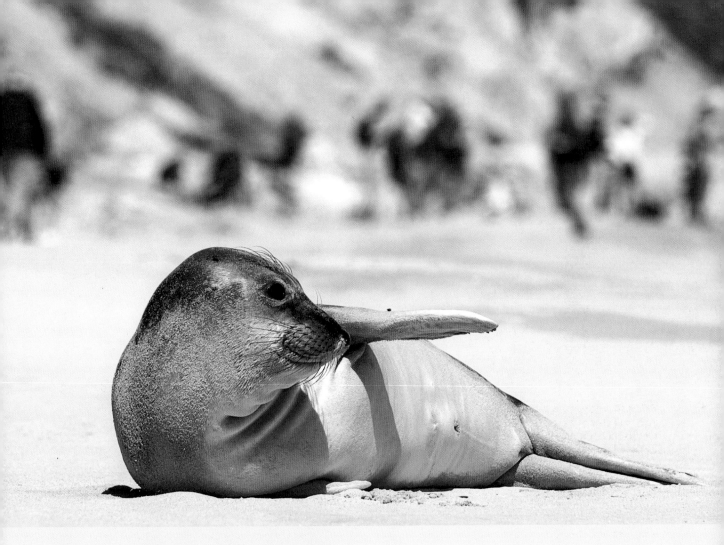

FIG. 1.17 A young southern elephant seal barely takes notice as a large group of visitors get ready for a hike. San Miguel Island is only accessible by boat, and seals seem very tolerant as long as they aren't approached too closely. I crawled around on the sand like a seal to appear less threatening and used a telephoto lens to get this image. Channel Islands National Park, California. (Nikon D100, ISO 200, 70-200 mm lens, handheld, 1/2000 sec. @ f/5.)

FIG. 1.18 On assignment in Denali National Park, I met these researchers, who were banding migratory songbirds. This volunteer is about to release a Wilson's warbler (I hope I got that right). I provided the researchers with photos to use in their educational programs in exchange for the opportunity to spend time photographing them. Alaska. (Nikon D2X, ISO 200, 12-24 mm lens, off-camera TTL flash, handheld, 1/60 sec. @ f/5.6.)

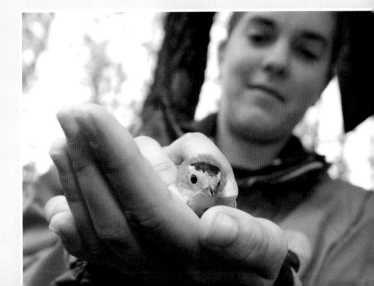

FIG. 1.19 Working with a local wildlife care group, I had the opportunity to photograph a very young bird still in the nest. The nest had fallen down and was rescued by volunteers. They hand-feed the birds and release them when they can fly. I placed the flash so that shadows from some sticks would fall on the bird's face, making the lighting as natural as possible. California. (Nikon D2X, ISO 200, 105 mm macro lens, handheld, off-camera TTL flash, 1/100 sec. @ f/16.)

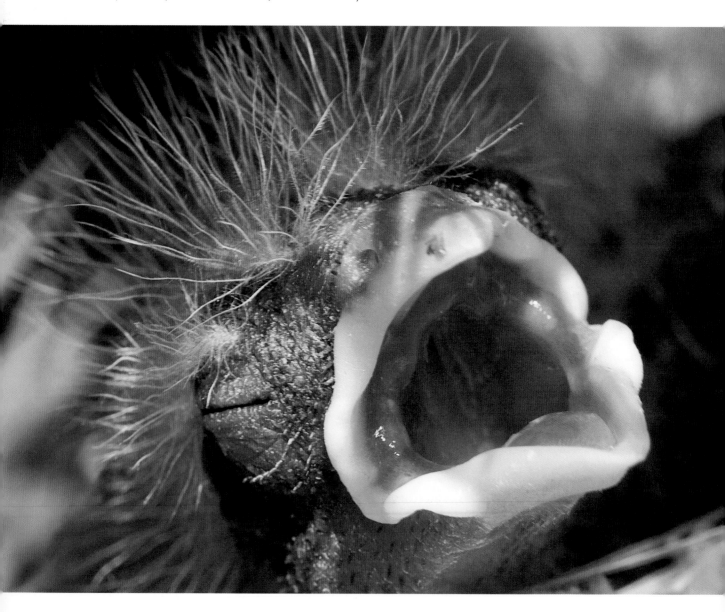

Questions & Answers

Q *How do you work with nesting birds without disturbing them?*

A Most nature photographers would jump at the chance to photograph an active bird nest. A nest is one of the few places where we can get reasonably close to birds without their flying away, and nesting behavior is always a great photographic subject. But nesting is one of the most critical times in the life of any bird, and if we're not careful our actions can have disastrous consequences. Always watch a nest from a good distance before trying to move closer to take photographs. Be aware of how long the parents are away, how often they leave and return to the nest, and where they perch. This way you'll know how they act normally and can gauge when you may have moved too close and changed their behavior. If they stay away too long, you're too close and need to move back. Many birds will vigorously defend their nests; if the birds appear agitated at all, back off (**FIG. 1.19**).

Here are a couple of other guidelines to follow: Never remove or change the position of branches, leaves, or sticks around a nest, for any reason. These things provide shade and hide the nest from predators both above and below the nest. Don't touch the eggs, nest, or young birds. If a young bird falls out of its nest, check with your local wildlife care organization about what to do.

If you feel you may be affecting the nesting activity at all, just stop. Pack up and let the birds get on with being parents. Do more research on the subject and wait for a better opportunity (**FIG. 1.20**).

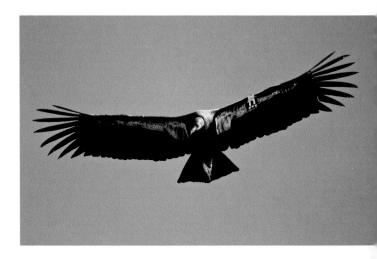

FIG. 1.20 The California condor is the most endangered large bird in the world. Only a few hundred remain, and all are tagged with radio transmitters. A group of volunteers patrol the Big Sur area, counting birds, educating people, and throwing roadkill off the highway. (The condors land on the road to feed on dead animals, where they risk getting hit by vehicles because their nine-foot wingspan makes them slow to react to oncoming traffic.) Big Sur, California. (Nikon D2X, ISO 200, 500 mm lens, tripod, 1/1250 sec. @ f/4.)

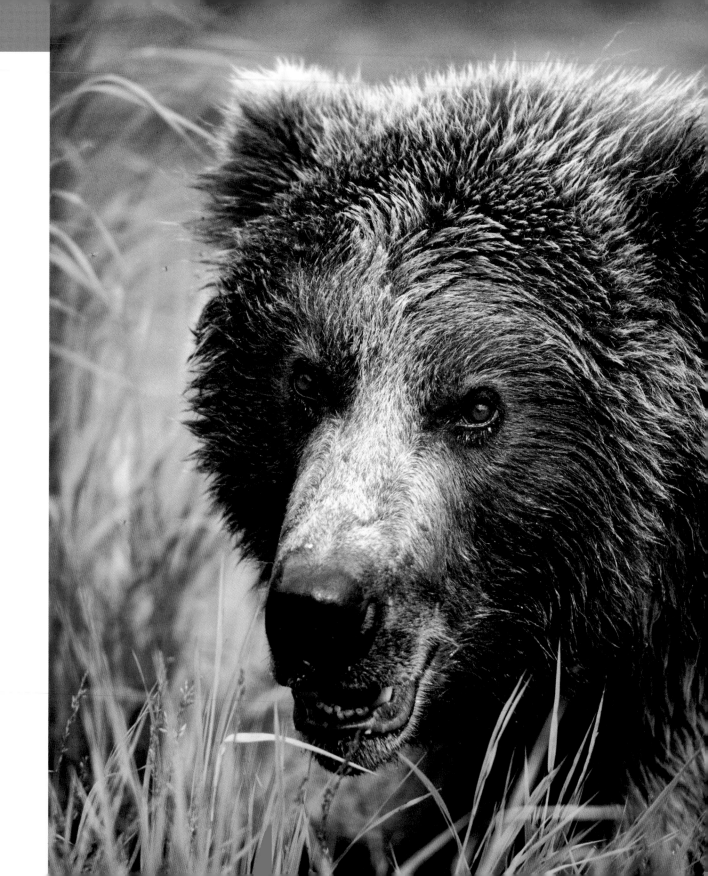

Q *Have you ever been hurt or attacked by an animal that you were photographing?*

A I was attacked by a bunch of wild turkeys once. Don't laugh too hard—they're scary birds. Fortunately, I escaped unharmed by fending them off with my tripod until I could run into a nearby house. I didn't even get any pictures of them.

I've sat in an open truck at night while lions walked by so close I could smell them. I've been bluff-charged by elephants and really charged by a rhino; both times I was in a vehicle. Walking by myself on a forest trail in Alaska, I came upon a grizzly bear about 100 feet in front of me. We looked at each other, and I started talking to him. He went back to sniffing around, and a few minutes later walked off. I whistled and talked all the way back to camp to avoid surprising any more bears (**FIG. 1.21**).

I've never been hurt by an animal. It usually takes a lot of effort on the part of a human to get hurt by an animal. Sometimes people do things that might be considered stupid. Sometimes they get hurt or even killed. Unfortunately, the animal usually gets killed, too, especially if it's a predator like a lion or bear (**FIG. 1.22**).

But what I find so exciting about spending time outdoors, about nature photography, is that I have to be aware of life around me. It can be dangerous, there are animals that can hurt you, and you can get lost or stranded. But I'm far more afraid in most cities than I ever am in the wilderness.

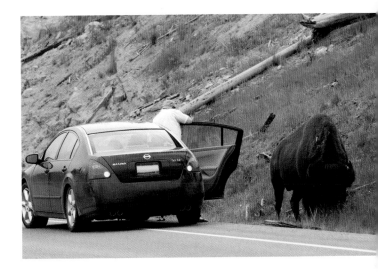

FIG. 1.22 Wouldn't rolling down the window have made more sense? Bison are the most dangerous animals in Yellowstone National Park. During a 20-year study, bison injured far more visitors than any other animal did, including the grizzly bear. I'm parked in a pullout inside my vehicle, shooting out the window. Wyoming. (Nikon D2X, ISO 200, 70-200 mm lens, handheld, 1/500 sec. @ f/4.5.)

◀ **FIG. 1.21** Brooks River, in Alaska, offers exciting brown bear photography. Bears congregate here to feed on the salmon migrating upriver to spawn. Most close-ups of bears like this are taken from one of the viewing platforms near Brooks Falls. I'm sitting on the platform photographing this bear about 25 feet away, feeding on a salmon. Katmai National Park. (Nikon F3, ISO 64, 400 mm lens, tripod, Kodak Kodachrome 64 film, exposure unrecorded.)

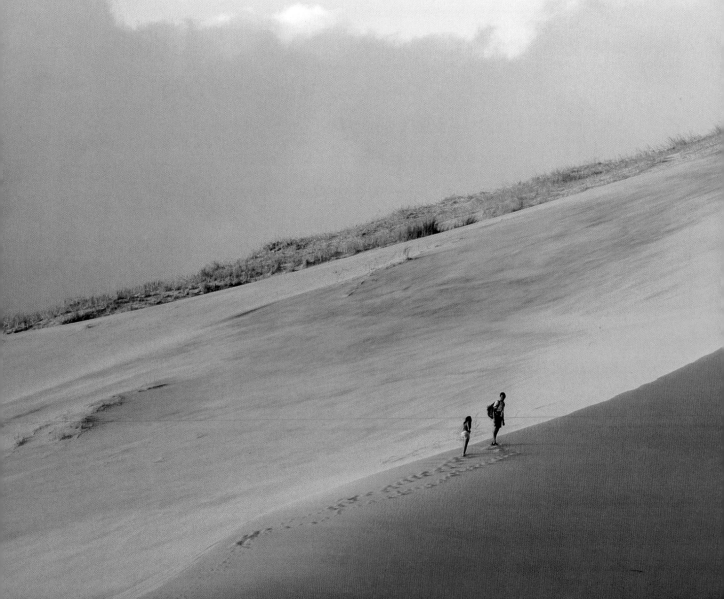

2 You need more stuff?

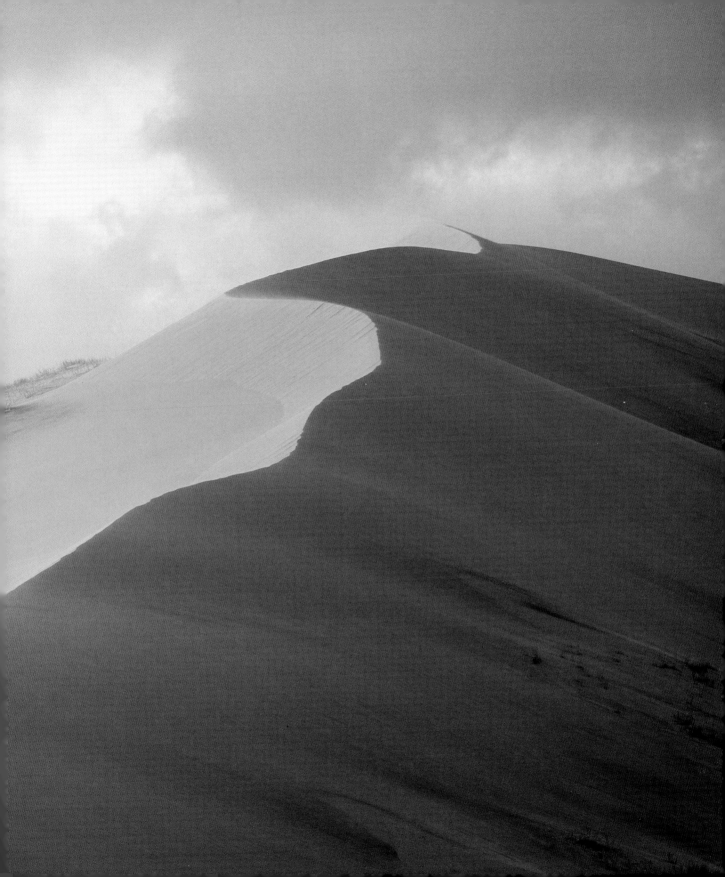

You're only as good as your tools, so get the right stuff, learn how to use it, and practice, practice, practice.

Stuff

Dewitt Jones, an amazing photographer and one of the best speakers on photography I've ever heard, tells a story about a little kid who asked him a very pertinent question. Dewitt had set up his tripod and camera, and then decided he needed another lens, which was back in his room. The kid looked down at Dewitt's big camera bag full of stuff, looked back up at Dewitt, and asked, "You need *more* stuff?" You can hear the whole story and get inspired by watching his DVD *Clear Vision!*

There's a popular saying: "Whoever dies with the most toys, wins." Nature photographers have a lot of toys...um, I mean *tools*. Because nature photography encompasses everything from landscapes to wildlife to close-ups, the lenses, support equipment, lighting, and cases needed is probably more varied than in any other type of photography. And we often have to carry it all on our backs through inhospitable terrain and inclement weather. The opening photograph for this chapter shows a father and daughter climbing the 600-foot-high Kelso Dunes in California's Mojave National Preserve. It can take a couple of hours to walk from the little camping area to the top of the dune, and carrying a tripod and backpack full of camera gear through soft sand and strong winds isn't what I call fun. But is it worth it? I'm sure every nature photographer would say *yes*.

The first few images in this chapter required very specific types of equipment. Having a tripod and flash was critical in capturing the hummingbird in flight in **FIG. 2.1**. Without the flash, it wouldn't have happened—the bird would have been a fuzzy blur. I went through a couple of batteries to capture this image; always be sure to have fully charged spares on hand.

FIG. 2.1 Several hummingbirds were coming into a feeding area, and trying to photograph them as they flew by wasn't easy. Using a slower shutter speed resulted in a sense of motion, while the flash partially froze the bird in midair. Monteverde Cloud Forest Reserve, Costa Rica. (Nikon D2X, ISO 200, 70–200 mm lens, tripod, flash on camera, 1/80 sec. @ f/4.)

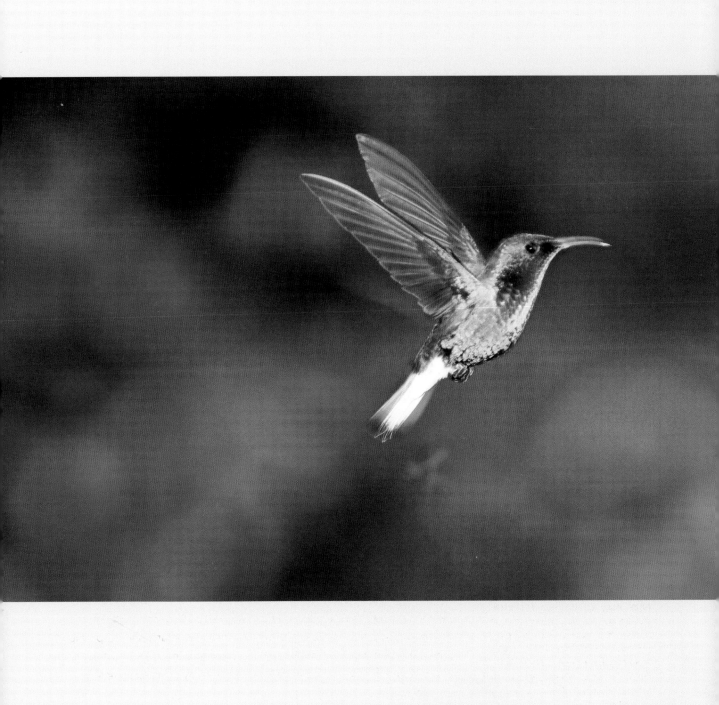

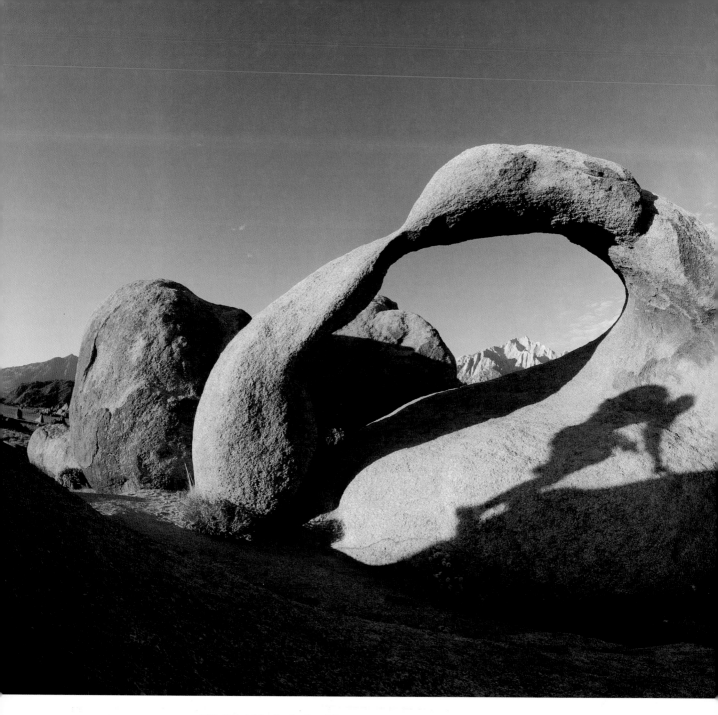

FIG. 2.2 A hiker's shadow falls across a granite arch framing Mt. Whitney at sunrise. This area of rugged boulders, called the "Alabama Hills," is a popular location for TV and movie productions. Composing this landscape and shooting at a slow shutter speed are big reasons why I used my tripod for this image. Eastern Sierra Nevada Mountains, California. (Nikon D2X, ISO 100, 10.5 mm lens, tripod, 1/60 sec. @ f/8.)

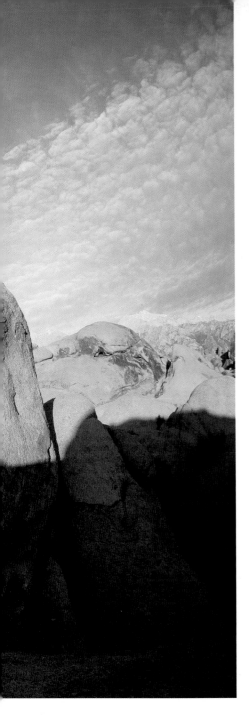

The arch in **FIG. 2.2** is hard to find. It's a lot smaller than it looks, and it's far from any roads—so you have to pack *everything* you'll need. A lot of photographers leave their tripods behind because they're heavy and a hassle to carry. That's a big mistake. If I'm lazy and leave something in the car, it will probably be the one thing I really need to make the image I've hiked all this way to get.

Practice

Without good photographic technique, you'll be left with only a memory when your picture doesn't turn out because it's not exposed correctly, it's not sharp, or you used the wrong lens. If you don't know how to use your tools and what they're capable of doing, you're going to be disappointed in your photographs. Learning about digital photography isn't simple. The manual for my latest Nikon camera is 421 pages long. Even after shooting with my camera for a year, plus viewing dozens of blogs, websites, and forums offering advice on how to use photo gear, I'm still discovering things.

When I buy a new piece of equipment, I do three things. First, I sit down for a couple of hours and play—push buttons, turn dials, and take pictures. Second, if I don't understand something or can't get it to work, I look it up in the manual. If I'm still confused, I go to the Internet, looking for other people who have the same questions I have. Third, I call my insurance company to add it to my equipment policy. If any of my gear is lost, stolen, or drops in the ocean, I need to be able to replace it quickly and get back to taking photographs.

We all secretly hope that buying the latest camera will make our pictures better, but the greatest impact on image quality comes from the lens, not the camera. Putting sharp, high-quality lenses on a less expensive camera will yield technically better images than you'd get from a cheap lens on even the most expensive camera body. Lenses also are useful for 5–10 years, maybe more, whereas digital bodies are obsolete in three. Put your money into the best lenses you can find, and remember that you get what you pay for. With any new piece of equipment, go out and practice. Shoot in all types of situations so that you see the advantages and limitations of your equipment. The better you know your equipment, the better the chance of nailing that once-in-a-lifetime image (**FIG. 2.3**).

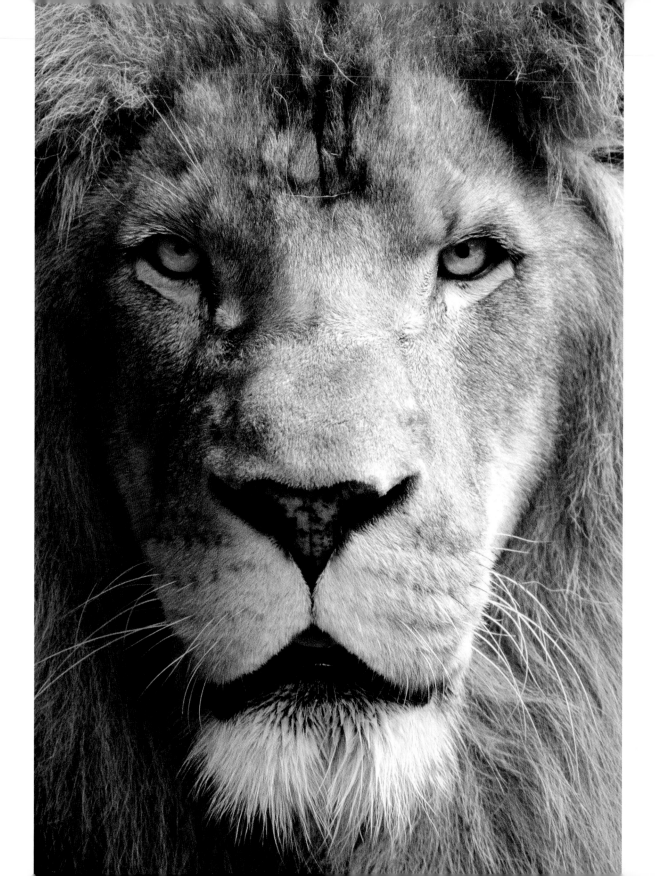

Equipment

Throughout this book, I'll refer to a digital camera that has interchangeable lenses as a *digital single-lens reflex* (DSLR). These types of cameras are the standard in serious nature photography. A smaller camera that can't change lenses, sometimes called a *point-and-shoot*, is nonetheless capable of capturing beautiful images, and many of the techniques described in this book can be applied to these types of cameras as well. Don't think of point-and-shoot cameras as any less capable of producing great nature images; after all, it's the pointing and shooting that counts, not the camera (**FIG. 2.4**).

I won't talk about what every little button on your camera does, or what all those little icons mean in your camera menu. Lots of other books and websites provide that sort of info, and more thoroughly than I can. Also, I'm expecting you to have your camera, lenses, and flashes handy when you flip through this book. If I talk about something that's equipment-related, go get your equipment and check it out. Some readers will know more about the technical aspects of photographic equipment than I do, and some will have no clue about any of this. That's why I've listed all sorts of great resources in the appendix at the end of the book, for everyone from beginners to ultra photogeeks. Geeks are cool now, right?

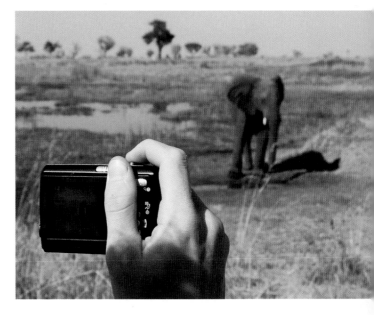

FIG. 2.4 Botswana, Africa. Good technique and proper exposure with any camera is important. Knowing everything about your camera, no matter what type it is, will let you capture the best picture possible.

◄ **FIG. 2.3** Practicing with new equipment at places like your local zoo can pay off when you go on a real safari. I'm shooting through wire mesh here, but I eliminated it by using a long telephoto lens and very wide aperture. Santa Barbara Zoo, California. (Nikon F4, ISO 80, 400 mm lens, tripod, Kodak Ektachrome film, exposure unrecorded, captive.)

My gear

In addition to the basics—cameras, lenses, flash, camera bag, and tripod—lots of other stuff can make photography fun and creative. Many of these accessories solve problems we encounter when we're taking pictures—how to hold two flashes; what to do if the light is too harsh; how to get a high enough view, shooting in the rain, and so on. These questions are the rationale I use for finding the right tool for the job. Over the years, I've accumulated a fair amount of gear that helps me to make the very best images I can. **FIG. 2.5** shows the equipment I usually pack for a road trip:

- Ladder (I'm short)
- Light stands
- Three tripods (one is taking the van picture—notice the shadow at left)
- Domke 3-foot diffusion panel
- Photoflex soft box XS for small flashes
- Wescott 42-inch 4-in-1 reflector kit
- Dry bag (waterproof soft bag)
- Apple laptop computer
- Walkie-talkies
- Trash compactor bag
- First aid kit
- Pelican hard cases
- Tenba bag filled with gadgets (my grip bag)
- Lowepro Mini Trekker AW backpack (my regular camera bag)
- Long lens bag with my 200–400 telephoto lens

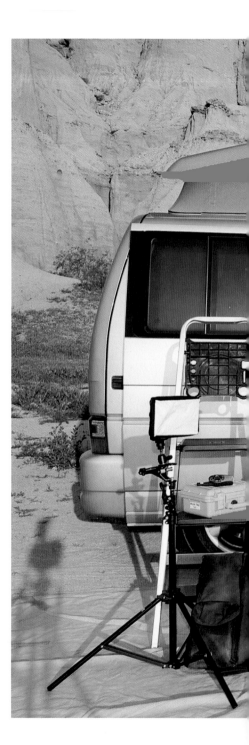

FIG. 2.5 Red Rock Canyon State Park, California. All this stuff, plus my camping gear (and me), fits into the van. I'll show the specific contents of some of the cases shortly, and many of the other items are discussed in later chapters. In case you're wondering, I definitely *don't* have everything I want.

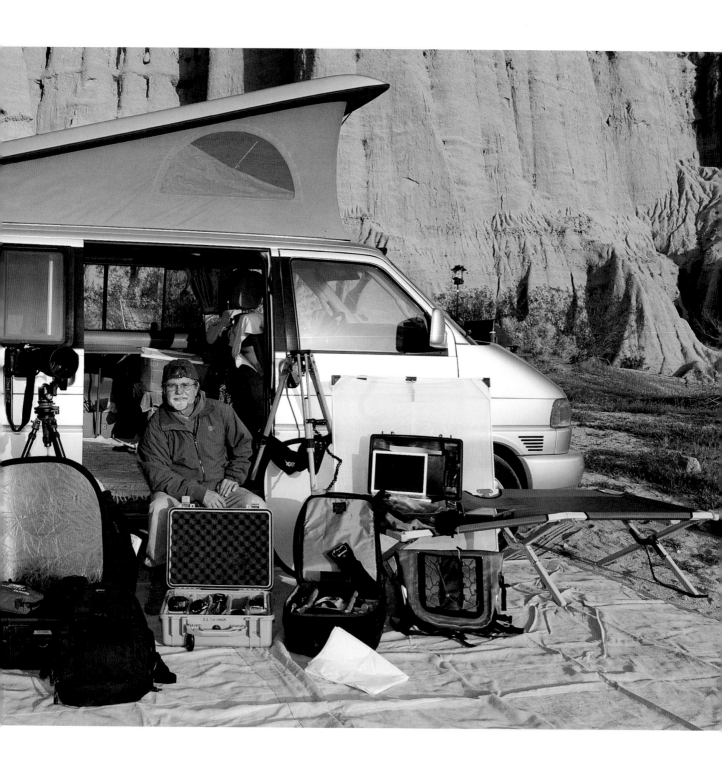

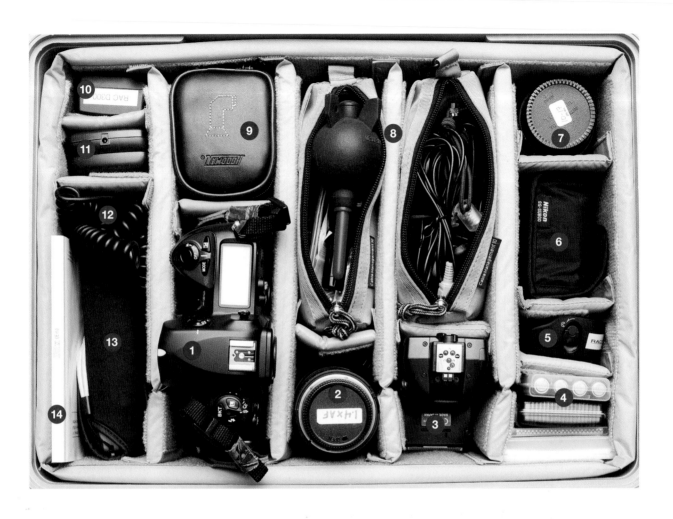

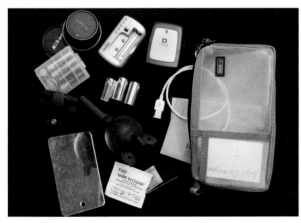 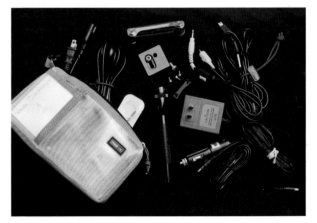

More stuff

What I pack in my hard and soft cases varies, based on the assignment and whether I'm traveling by air, boat, or car. I'll talk about packing for plane trips in Chapter 13, "On the road." **FIG. 2.6** shows what I pack in a Pelican hard case for a road trip in the van:

1. Second camera body
2. Teleconverter and extension tubes
3. Second flash
4. Lexar compact flash cards, spare AA rechargeable batteries
5. Spare camera battery (I always carry two batteries for each camera)
6. Wireless controller for flash
7. Extra lenses (this one is my 10–17mm fisheye)
8. Think Tank bags (discussed next)
9. Right-angle finder
10. Camera battery charger
11. AA battery charger
12. TTL flash cord
13. Epson portable hard drive/viewer (P4000)
14. Instruction manual for cameras

These hard cases are waterproof; since I work around water a lot, they've saved my equipment on several occasions. Once, on assignment for the Costa Rican National Park Service, I asked a boat driver to drop me off on a small uninhabited island. About 100 yards from the beach, the driver killed the engine and told me that this was as close as he could get, because the waves were too big. I had food, water, and a small backpack in a waterproof dry bag, and my hard case held all my camera gear. I put the dry bag on my back and tossed my hard case over the side of the boat. Resting on top of my hard case, I body-surfed through the waves to the beach. When I opened the case on the beach, everything was perfectly dry. Several hours later, I did the whole thing in reverse when the boat came back to pick me up.

Inside the hard case, I use these cool Think Tank "cable management" bags to store all the little loose stuff that usually ends up scattered around the camera bags (**FIG. 2.7** and **2.8**).

◀ **FIG. 2.6** This hard case can be locked and secured with a bicycle cable. I don't walk around with this case, so it's important that it be safely out of sight when left in my vehicle.

◀ **FIG. 2.7** and **FIG. 2.8** These two bags hold various tools, cleaners, special batteries, lens tissue, a blower for cleaning my camera sensor, AC power and camera cables, battery tester, spare lens and body caps, a compact flash card reader, eyeglass repair kit, flashlight, pieces of Velcro, spare plate for my tripod ballhead, and a mirror for reflecting light into holes (or for shaving).

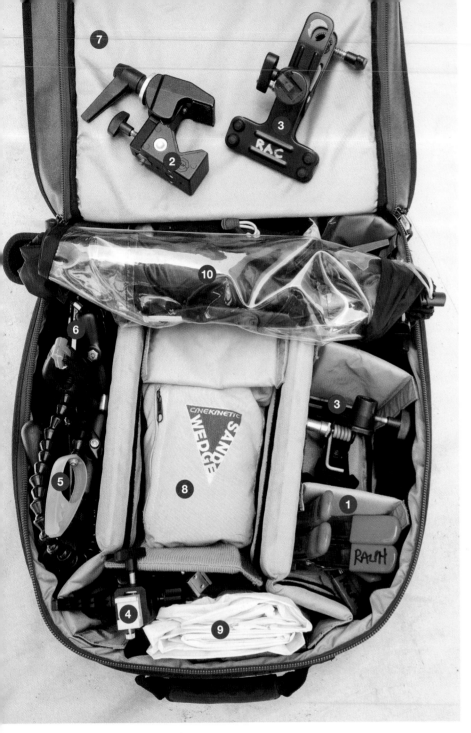

Another bag holds all my grip equipment—clamps, macro brackets, pop-up reflectors, and rain gear for my camera and lenses (**FIG. 2.9**):

1. A-clamps
2. Bogen super clamps
3. Justin clamps for small flashes (Manfrotto 175f)
4. Light stand adapters for small flashes
5. Plamp
6. Wimberley macro bracket for holding flashes
7. Reflector kit (in front pocket)
8. Weight bags for stabilizing light stands
9. Trash compactor bags
10. Rain cover for camera

If I'm flying, I pack most of this gear in my checked bag. None of it is delicate or expensive, so I just wrap clothes around everything. I don't take all of this stuff on every trip. I try to keep my bags under the weight limit, but I usually end up paying overweight charges. Since other photographers can have the same kind of equipment, I put my initials or name on all of my gear, including tripods, cameras, and lenses.

FIG. 2.9 Grip bag.

Finally, my camera backpack is pretty small, but as you can see I get a lot of stuff in it. It holds everything I need to complete most assignments, and it never leaves my side when I'm out shooting (**FIG. 2.10**). One of my most valuable items is a very old chamois cloth. Since it's never been wet, it's very soft (once they get wet, they get hard). It has lots of uses: protecting my camera from dust, keeping camera and lens shaded in the sun, cleaning the camera body and lens. When it gets dusty, I just shake it out. It's a must on safaris.

1. Camera body
2. Strobe (flash) with diffuser
3. 12–24 mm lens
4. 105 mm macro lens
5. 70–200 mm lens
6. 28–70 mm lens
7. Lexar compact flash cards, colored filters for flash
8. Plamp
9. Electronic cable release
10. Chamois
11. Spare camera battery
12. Inside pockets: Lens-cleaning supplies, rechargeable AA batteries, tripod parts, computer cable
13. Built-in rain cover for backpack

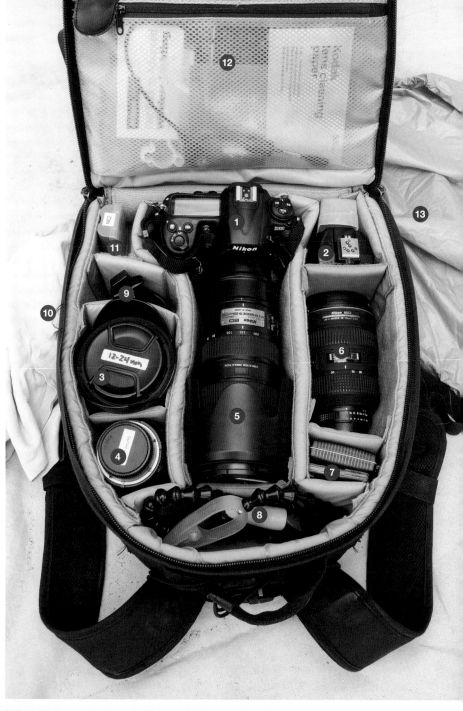

FIG. 2.10 Camera backpack. The outside front pocket (not visible) holds model releases, notebook, flashlight, rain cover/dark cloth, Photoflex mini disc reflector and diffuser (for close-ups), Westcott softbox for strobe, Honl snoot for strobe, and a Swiss Army knife.

Steady stuff

Nearly every photography book I've read lists the tripod as the most important tool for nature photographers. Using a good tripod keeps the camera and lens steady so your images are sharp, and it makes you slow down. Slowing down means that you'll take the time to compose the image, not just snap a picture and walk off.

I try to think of every situation as a chance to make an interesting photograph. For example, for this section I needed a shot showing someone using a tripod. When I spotted one of my students on the other side of a meadow, waiting for bears, I realized that it would make a great tripod image. I composed her off-center to make the image more dynamic—and then, luckily, the sun broke through some trees, backlighting her. The light keeps her from merging into the background (**FIG. 2.11**).

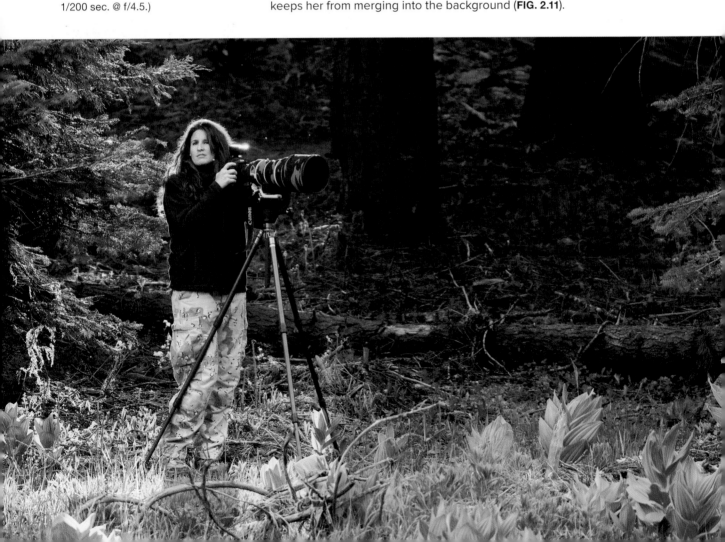

FIG. 2.11 One of my students, using a big Canon lens on a Gitzo tripod with a special gimbal head. (Later I'll talk about using these heads.) She has wrapped the lens with camouflage neoprene from LensCoat. Sequoia National Park, California. (Nikon D300, ISO 1250, 200–400 mm lens, tripod, 1/200 sec. @ f/4.5.)

There are two parts to a tripod: the legs and the head. Tripod heads come in *pan-tilt* and *ballhead* designs. Most ballheads work with individual mounting plates that attach to each camera and lens, making it easy to load and unload the tripod. Ballheads are more stable, can handle heavier loads, and are much easier to use than pan-tilt heads. Good ones are expensive, but I bought my first ballhead, an Arca-Swiss B1, 20 years ago, and I still use it.

I also use tabletop tripods, car window mounts, and steady bags to support my camera when I can't use a normal tripod rig. To hold reflectors, diffusers, and flashes, I use a variety of light stands, clamps, and grips. The Manfrotto super clamp is probably one of the most useful tools I own. You can mount just about anything to it, and it clamps onto anything that fits into its viselike jaws (**FIG. 2.12**).

Sensors and histograms

There are two important things to understand about your camera.

One is the size of the sensor. The sensor is important because it's what captures light. Sensor sizes are based on the original size of 35 mm film (24 mm × 36 mm), also called *full frame*. Some digital cameras have full-frame sensors, but most have what's called a *cropped* sensor, or *APS-C sized* sensor. A cropped sensor is smaller, usually around 16 mm × 25 mm. The amount of cropping varies with the manufacturer and is designated by a crop factor such as 1.3x, 1.5x, or 1.6x (**FIG. 2.13**). This crop factor changes the field of view of

▶ **FIG. 2.13** This image shows what a 1.5x cropped sensor will capture relative to a full-frame sensor. The cool creature is a fork-tailed bush katydid in my garden. Santa Barbara, California. (Nikon D300, ISO 400, 105 mm macro lens, handheld, 1/1250 sec. @ f/5.6.)

FIG. 2.12 My big video camera is mounted on the rail of this safari truck in Zambia. I used a Manfrotto super clamp with a video fluid head. You can do the same thing with a ballhead and a still camera. The white dust cover is made by CamRade. Be sure to take the camera off the mount when you're driving, or something will break when you hit the ruts. I promise you'll hit ruts.

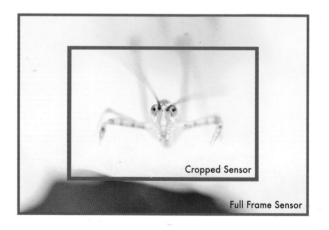

Cropped Sensor

Full Frame Sensor

▶ **FIG. 2.14** The Piedras Blancas elephant seal rookery is home to nearly 15,000 seals during certain times of the year. A long lens helps to isolate these two young males jousting on the beach at sunset. California. (Nikon D2X, ISO 200, 200–400 mm lens, tripod, 1/640 sec. @ f/4.)

any lens you put on the camera. It doesn't change the focal length of the lens. *Field of view* is what you see when you look through the camera, and what's captured on the sensor. For example, if you put a 200 mm lens on a camera with a 1.5x crop factor, the field of view will be the same as putting a 300 mm lens on a full-frame camera (200 \times 1.5 = 300). When shooting close-up subjects or things far away, this cropping may be an advantage, but it's a disadvantage when you want to use wide-angle lenses. A 20 mm lens on a 1.5x camera is like using a 30 mm lens on full-frame, and 30 mm doesn't have a very wide view.

The second important thing is *exposure* and how to read the histogram. The *histogram* is that graph on the back of the camera that shows up when you take a picture. It's also visible in Photoshop and other image-processing applications.

Proper exposure is critical if you want all the colors in a scene recorded on your camera's sensor. If your exposure is off, especially if it's underexposed, you don't have all the data necessary to make a good reproduction of what you saw. Most photographers underexpose their images. This is a big mistake because you could be missing about half the information your camera sensor needs to make a quality image. You can use your histogram to guide you in making good exposures. Try to get your histogram to move as far to the right side as possible without hitting the wall, but don't leave any gaps along that bottom line (**FIG. 2.14** and **2.15**). Be sure to turn on your "blinkies." (Your camera manual probably calls them "highlight alerts" or something boring like that.)

Shooting in RAW and correctly processing your photos in whatever photo software you're using helps to maintain the quality of the image, and will even let you recover some of that data that may have hit the right wall of the histogram. But if you shoot in JPEG, you'll lose detail in the areas of the photo that have spiked against either wall on the histogram. If you'd rather not spend time processing images at the computer, shoot JPEG, but be sure to expose correctly, because you don't have room for mistakes. If you want to capture as much information as possible, shoot in your camera's RAW format.

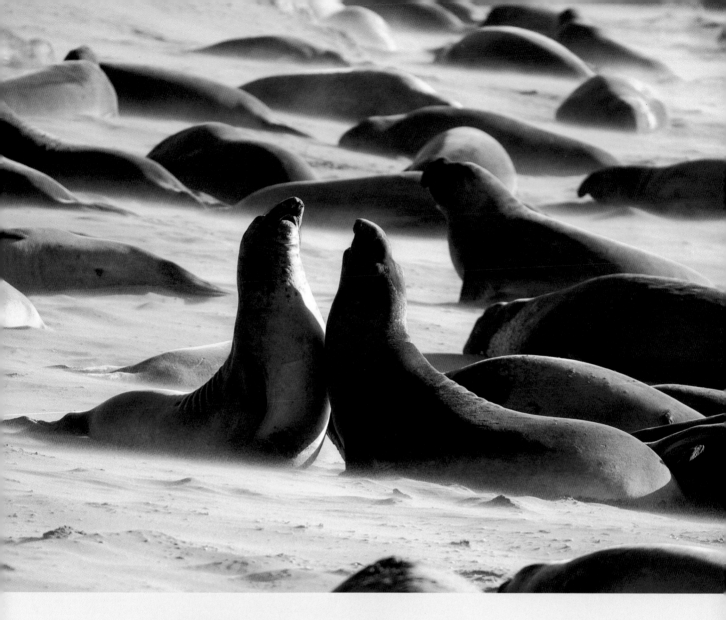

FIG. 2.15 The histogram for this image shows a proper exposure, with no gaps along the bottom and no large spikes hitting the wall on either side.

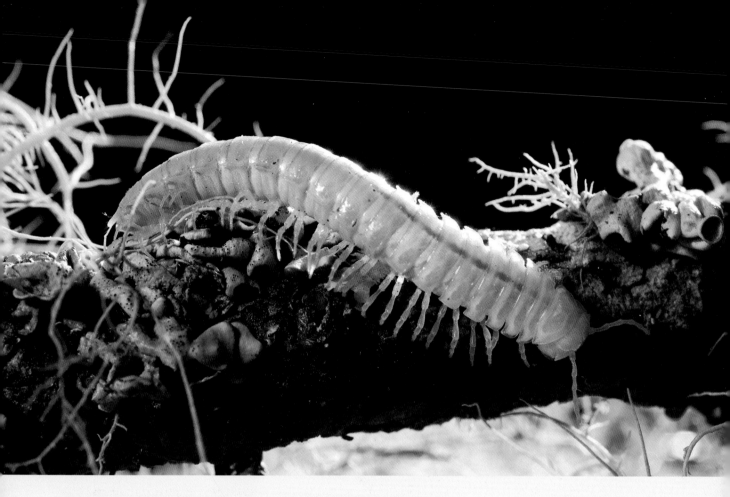

FIG. 2.16 This amazing creature is a Motyxia millipede. It has no eyes, comes out at night to feed on dead plants, and uses bioluminescence to warn off predators. It glows in the dark! I found it under the ground cloth of my tent when I was packing up, and I photographed it on my camp table. Butano State Park, California. (Nikon D300, ISO 200, 105 mm macro lens, three TTL flashes, handheld, 1/160 sec. @ f/16.)

FIG. 2.17 This lighting diagram shows how I set up my lights for the millipede shot.

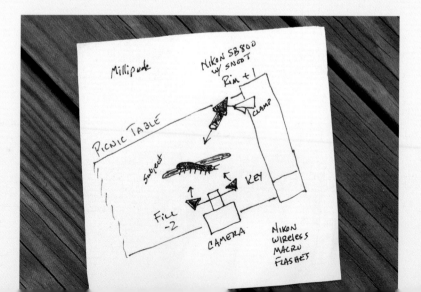

Lighting

Small, portable flashes made by Nikon, Canon, and others work great in nature photography. Getting your flash to work when it's off the camera is important in close-ups, lighting animals far away, and when you want to light your tent when camping. Both Nikon and Canon have wireless systems for their flashes that make lighting fun and creative.

I found the amazing Motyxia millipede in **FIG. 2.16** in the redwood forest. It's really dark in the forest, so I knew that I needed flash to light it. My idea was to photograph the millipede crawling over this really beautiful lichen-covered branch. I set the branch on my picnic table and clamped one flash to the table edge above and behind the branch. I used a snoot to narrow the beam of the flash so I wouldn't get any flare in my lens. Then I used a wireless macro flash system with two small flashes to light the front of the millipede (**FIG. 2.17**). All controlled wirelessly!

Diffusers and reflectors are also important lighting tools (**FIG. 2.18**). You can buy different-sized units or even make your own. Some diffusers work with the sun, and others go on your flash. I talk about how to use each of these light modifiers in Chapter 3.

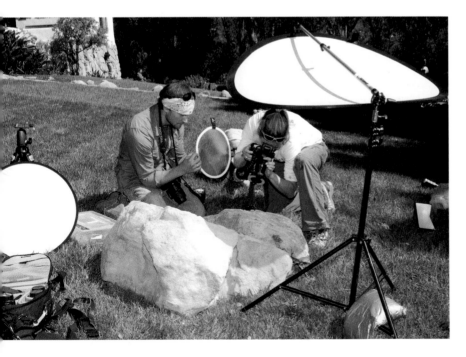

FIG. 2.18 A couple of my students are photographing a captive tarantula during my "critter demo" class. They're using a diffuser to create shade and then bouncing in some warm light with a small reflector. Santa Barbara, California.

Questions & Answers

Q **What lenses do you recommend?**

A I think most people understand what lenses are all about, but I get a lot of questions about what kind of lens to buy. Obviously, budget is an issue, but, as I said earlier, I'd rather spend more money on a good lens and less on a camera. Most people use zoom lenses, but there are still some important fixed focal-length or prime lenses you need, such as a good macro lens. Other prime lenses are the perspective-control (PC) lenses and large telephoto lenses (**FIG 2.19**).

FIG. 2.19 A telephoto zoom lens allowed me to frame this inquisitive giraffe between two trees. It always surprises me that big animals can blend this well into the background. From a distance, the giraffe just looked like another tree. Zambia, Africa. (Nikon D2X, ISO 200, 200–400 mm lens, steadybag, 1/640 sec. @ f/5.)

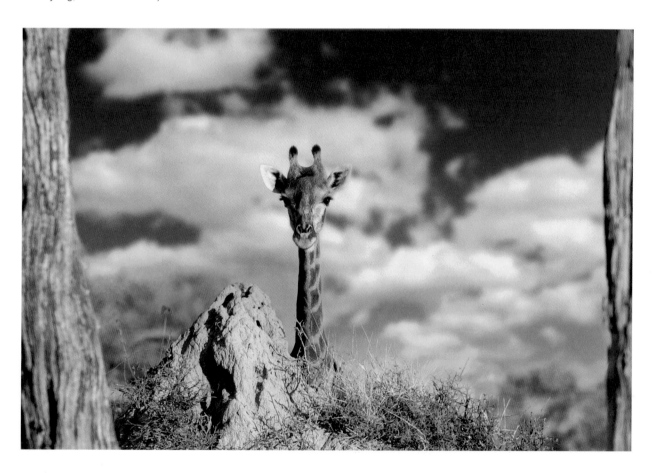

FIG. 2.20 George Lepp, a well-known nature photographer, lets my son look through his Canon 500 mm f/4 L IS lens with a 2x teleconverter—that makes it about a 1600 mm lens with the crop factor. The lens is on a Gitzo Explorer tripod with an Arca-Swiss ballhead. George's images are tack-sharp with this rig. Tanzania, Africa.

When choosing a zoom lens, I recommend getting one with a fixed-maximum f/stop, like f/2.8 or f/4. Avoid zoom lenses with a variable-maximum f/stop like f/3.5–5.6. Zoom lenses with really wide focal-length ranges are never going to be as good as ones with shorter ranges. I have a specific zoom lens within the wide-angle range (12–24 mm), the normal range (28–70 mm), and the telephoto range (70–200 mm and 200–400 mm). There's no way a zoom that can go from 18–200 mm or 35–300 mm can deliver quality images throughout its focal range.

 What features should I look for in a tripod?

A We'd all like one tripod that's inexpensive, lightweight, stable with big lenses, can set up tall and low to the ground, has a 90-degree leg spread, and folds down for easy packing. Nice wish list, but no tripod will give you everything.

Weight is important. You need a tripod that's heavy enough to give your camera stability, but light enough to carry. The bigger the camera and lens, the heavier the tripod should be (**FIG. 2.20**). But if you leave your tripod in the car because it's too heavy to carry, what good is it? I have a heavy aluminum tripod for big lenses that I use mainly on road trips where I work close to my van. If I'm flying or hiking long distances, I use my carbon-fiber tripod. It's lighter but still stable enough for my 200–400 mm telephoto. However, carbon fiber is expensive, and it's really not that much lighter than aluminum. My recommendation is to go with aluminum and spend the money you save on a good ballhead.

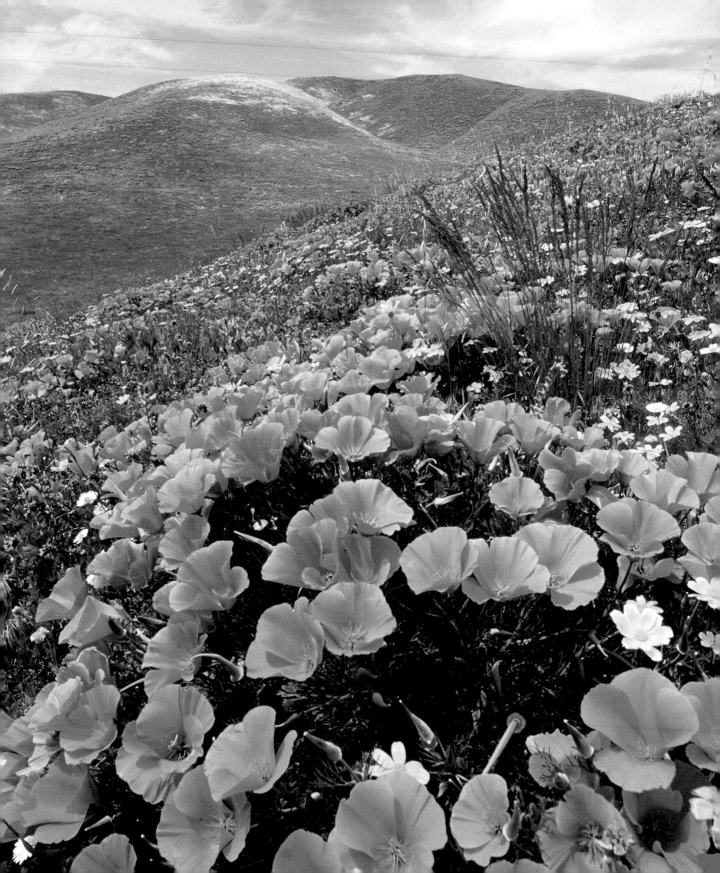

I like tripods that only have three leg sections. With four sections, the final one at the bottom is usually too flimsy to use. If you want a four-section tripod, you need to get one with bigger legs, so the last section is large enough to keep things stable. In nature photography, the ground is seldom level, so having a tripod with legs that angle all the way out is important. This design helps in getting low, too (**FIG. 2.21**). Speaking of low, be sure that the center column can be shortened or removed, or it will hit the ground before you're low enough for the shot. I rarely use a center column. It just turns my tripod into a less stable monopod.

Some pretty unique tripod designs are available, so play around with several at your local camera store before purchasing. One of my tripods can rotate the head off-center so I can angle it in all kinds of positions (**FIG. 2.22**).

◀ **FIG. 2.21** Landscapes take a lot of time to compose; using your tripod helps you to fine-tune all the elements in the scene. Here I've taken a high point of view and placed a large group of California poppies very close to the foreground. This composition leads the eye from the close flowers to the hills and clouds in the background. Only a wide-angle lens will let you get all these levels in one image. Gorman, California. (Nikon F4, ISO 32, 20 mm lens, Fuji Velvia 50 film, tripod, exposure unrecorded.)

FIG. 2.22 My Gitzo Explorer tripod, set up for a macro shot of those little white flowers next to the ferns. I like this tripod for macro shots because of its unique swiveling center column. The legs can spread all the way out flat, and I'm using one of my bags to hold another lens as a counterweight to the camera. A Plamp holds a reflector to add some light to the shot. Butano State Park, California.

▶ **FIG. 2.23** The coastal redwood forests in the spring are always wet. Even when it stops raining, the trees still drip water. Everything needs rain gear. I'm using a Harrison waterproof "dark cloth" to cover my camera and lens. And I live in my neoprene rubber boots during these trips. Butano State Park, California.

▼ **FIG. 2.24** One of my students doing some "sticker-belly photography." She's using her trash compactor bag to keep the little cactus spines and gravel away. Red Rock Canyon State Park, California.

Q *What's the most valuable piece of equipment for a nature photographer?*

A Good shoes. Seriously! With the right kind of shoes, you can go anywhere. And being in the right place is a big part of making great images. With good hiking shoes, you can walk safely across cactus-strewn deserts and climb rocky hills. With rubber boots, you can wade into tide pools and running streams in your quest for a better shot (**FIG. 2.23**). Without the rubber boots, you're stuck on the stream bank, getting the same shot as everyone else. And if you're wearing sandals in the desert, like one of my students, you'll be spending your time plucking jumping cholla spines out of your toes, rather than photographing that gorgeous sunset.

The other item I've found invaluable is a trash compactor bag. I read about it on the Really Right Stuff website years ago, and it's one of the most versatile tools I carry. You can lie on it to keep from getting wet, muddy, or poked; in a sudden rain, you can throw your camera bag in it. If you cut a hole in it and poke your lens through, you can use it as a camera cover in rainy or dusty situations. It can even act as a reflector (**FIG. 2.24**).

Shoes, trash compactor bags, and unending curiosity.

3 | It's all about the light

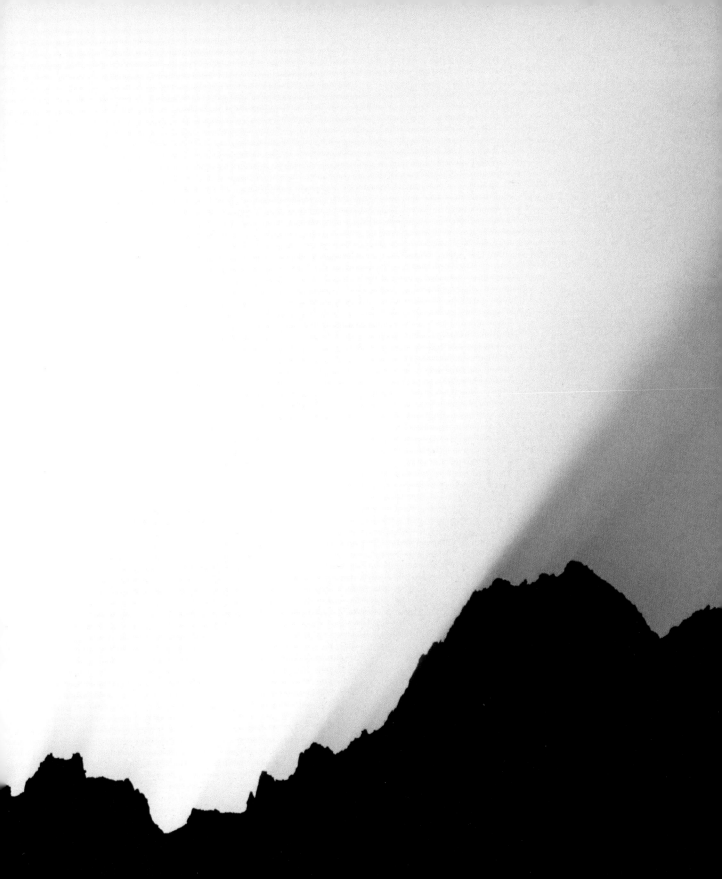

There's no such thing as good or bad light—just light or no light. Learn how to work with light of all types.

Qualities of light

Ansel Adams' book *Yosemite and the Range of Light* is filled with his photographs of the Sierra Nevada mountain range in California. Late one afternoon on a wintry day in those same mountains, I captured the crepuscular rays of light in the opening photograph of this chapter. The sun had dropped behind the ragged edge of the eastern slope of the Sierras, creating these strong, visible beams of light that many people call "God rays."

Successful photographs rely so heavily on light that a strong appreciation of light in all its forms is crucial to making great images. In nearly every visual medium (painting, architecture, movies, and so on), light gives things shape, color, texture, mood, and emotion.

In their first photography class at Brooks Institute, students are introduced to six "qualities" of light: brightness of light, lighting contrast, specular light, diffused light, direction of light, and color of light. You have to understand light if you're going to recognize and use it successfully in your photos.

Brightness is pretty easy to understand; it's the intensity of light. Midday sunlight at the beach or on a snowy mountain is bright because the light is direct and reflects everywhere. It even *feels* bright—that's why we wear sunglasses. But forests and jungles are dark even on a bright day. Only small shafts of sunlight filter through the leaves and branches; the rest is absorbed or reflected by the forest canopy back up into the sky. Think "darkest jungle" or "forbidden forest" (**FIG. 3.1** and **3.2**).

FIG. 3.1 Alaska's Denali National Park has only one road. It travels 90 miles from the park entrance to Kantishna and offers views of North America's highest mountain, Mt. McKinley. Clouds cover the mountain most of the time, so views like this can be brief. (Nikon D2X, ISO 100, 28–70 lens, handheld, 1/1000 sec. @ f/5.)

FIG. 3.2 After many visits to this coastal redwood forest, everything finally came together when thick, moisture-laden air and strong shafts of sunlight combined to create this amazing lighting. I used every lens I had, filling a couple of storage cards with images. Limekiln State Park, Big Sur, California. (Nikon D2X, ISO 200, 70–200 lens, tripod, 1/2 sec. @ f/16.)

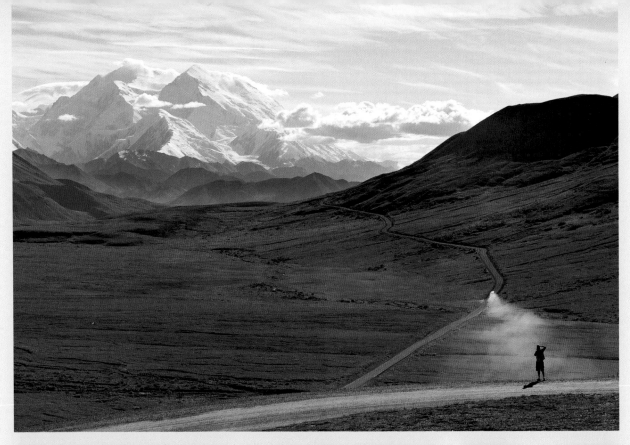
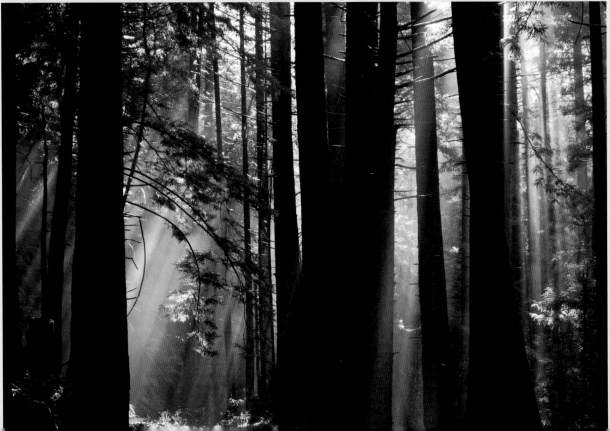

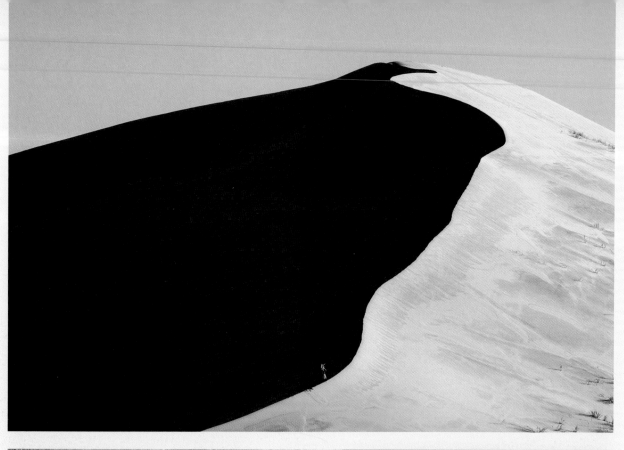

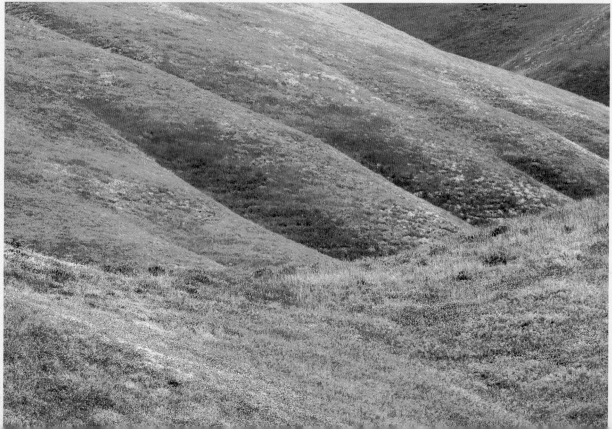

Contrast is the difference between highlights and shadows—the light and the darkness in a scene. It's also key to understanding the next two qualities of light.

Brooks uses the terms *specular* and *diffused* to describe how "hard" or "soft" the light appears to be. Think about a sunny day versus a cloudy day:

- On a clear day, all our light comes from a ball of fire 93 million miles away—the sun. When sunlight strikes a subject, such as a sand dune, it lights one side of the subject, creating harsh, dark shadows on the other side. This light is described as being "hard" or "specular" (**FIG. 3.3**).

- On an overcast day, the sun lights the clouds, making them the source of light. Compared to the sun, the cloud cover looks huge and much closer, creating light that wraps around the subject and reflects light into the shadows. This light is "soft" or "diffused" (**FIG. 3.4**).

The size of the light source relative to the subject determines whether the light is hard or soft. Since size is relative to distance, the farther away the light source, the harder the light; as the light source comes closer, the light becomes softer and more diffused. Hard light can come from any light source—spotlight, electronic flash, the sun (**FIG. 3.5**).

◀ **FIG. 3.3** The Kelso dunes in California's Mojave National Preserve rise over 600 feet above the desert floor. Their color comes from particles of golden rose quartz blown from the Mojave River sink. I took this picture just after sunrise, as hard light created strong shadows. (Nikon D100, ISO 200, 70–200 mm lens, tripod, 1/320 sec. @ f/9.)

◀ **FIG. 3.4** Spring wildflowers bloom in the hills of Gorman, California. For wildflowers, every year is different; this "normal" year still produced an amazing display of color. The subtle yellow colors show up better under the soft overcast light. (Nikon D100, ISO 200, 300 mm lens, tripod, 1/400 sec. @ f/6.3.)

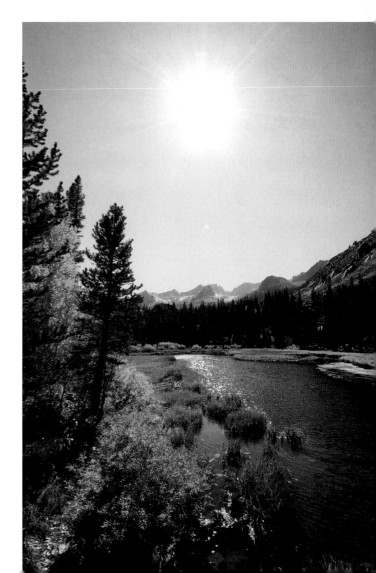

▶ **FIG. 3.5** The bright, hard light of midday can make taking photos difficult. Backlighting this scene helped a little, but I still try to avoid doing any shooting during the middle of a sunny day. Instead, I look for new locations, eat, take naps, work on my book…. High Sierras, California. (Nikon D300, ISO 200, 12–24 lens, handheld, 1/250 sec. @ f/11.)

FIG. 3.6 I was visiting a zoo when a wild great egret landed in a shaft of sunlight in one of the open exhibits. Backlighting the bird against the dark background added drama; then I just waited for the right moment. San Diego, California. (Nikon F3, ISO 64, 400 mm lens, tripod, Kodak Kodachrome 64 film, exposure unrecorded.)

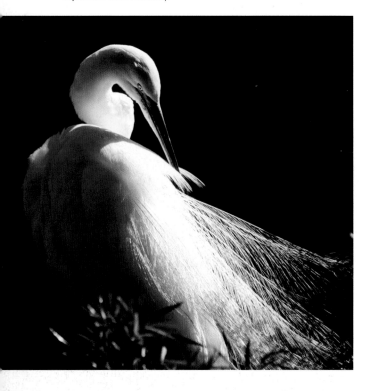

▶ **FIG. 3.7** Winter in Yellowstone National Park is pretty hard to beat for dramatic lighting, with steam from thermal pools and geysers, low hard light, and great subjects. Putting the sun directly behind the tree created strong shadows and accentuated the mist. Wyoming. (Nikon F4, ISO 100, 28–70 mm lens, tripod, Fuji Velvia 100, exposure unrecorded.)

You turn hard light into soft light by moving the light closer or by putting some type of diffusing material between the subject and the hard light. You can make your own diffusers with paper or fabric, or use natural diffusers such as clouds and fog to create soft light.

So how does contrast fit in? If the weather is clear, the sun creates the highlight and the sky fills the shadow. Not much light is bouncing around from a clear sky, so your shadows are dark, creating strong contrast. If the day is overcast, the cloudy sky reflects light everywhere, filling shadows and reducing contrast between highlights and shadows. The level of contrast in a scene has a huge effect on how people perceive images (**FIG. 3.6**).

TIP On driving trips with friends and family, I often stop to take photos, even if my passengers complain. It's easy just to keep moving, thinking, "I'll get that shot on the way back." But the view won't be the same then, because the light will change. It'll be a different color or come from a different angle, or maybe the day will be cloudy. Get out of the car now, and take the picture.

More than anything else, light establishes the mood of a photograph. The camera doesn't capture a subject; it captures light. Light is the essence of what we photograph. Sad, happy, bright, gloomy, bold, subtle— the moods of light are as varying as our emotions. If we want our images to create feelings in the viewer, we must understand light. Once we understand light, we'll look for it, see it, and capture it in our photographs—not just as an illuminator, but as a subject itself (**FIG. 3.7**).

There are two more qualities of light: *Direction* is discussed later in this chapter and *color* is discussed in Chapter 4, "Not everything's black-and-white."

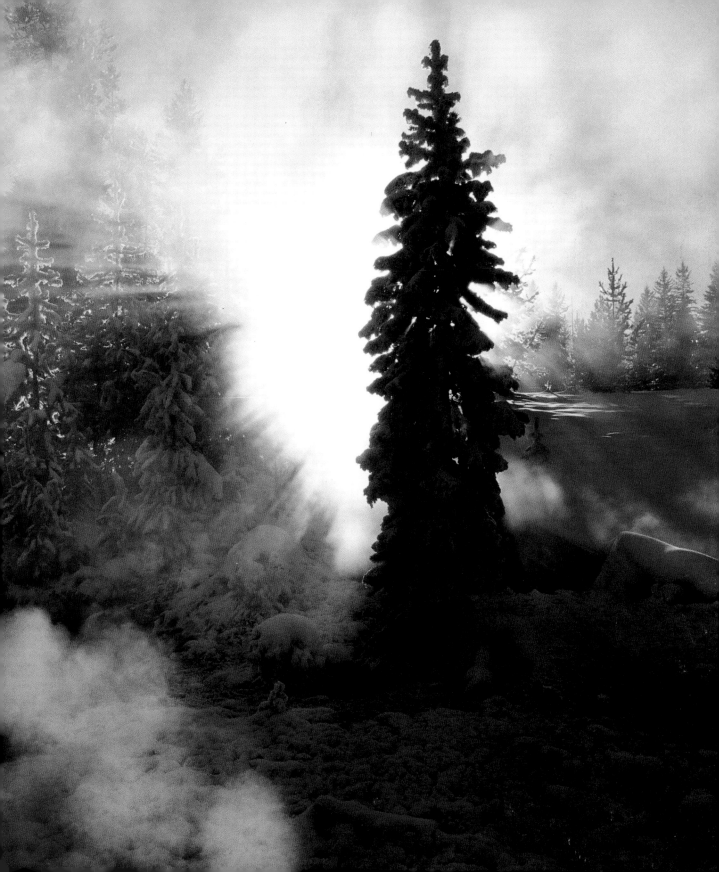

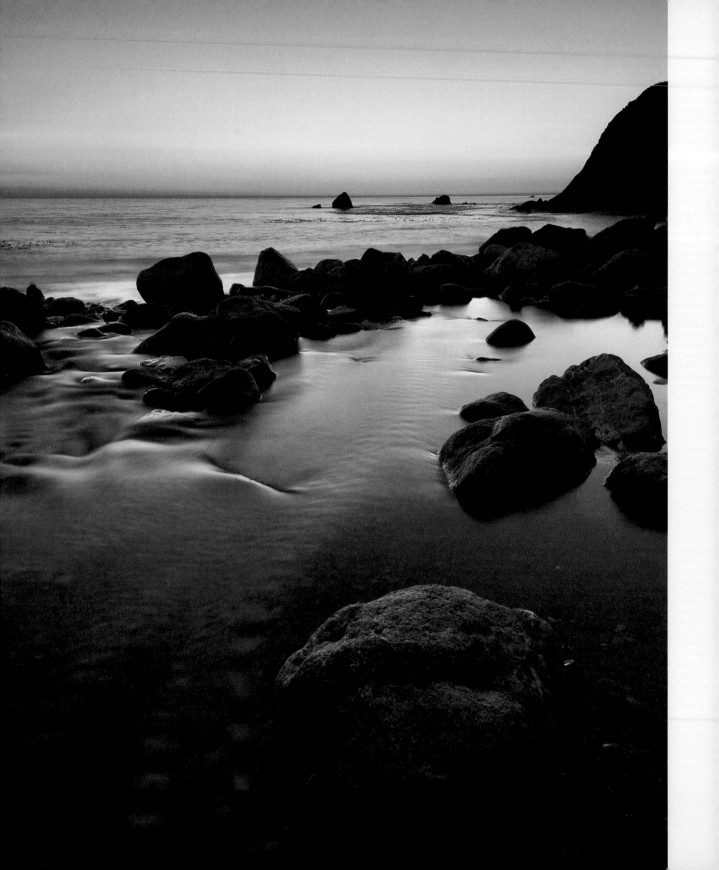

Equipment

Cameras

The range of light or contrast in a scene can (and often does) exceed the dynamic range that a camera is capable of recording. *Dynamic range* or *scene contrast* is the camera's ability to capture the various tones between highlights and shadows in a scene. Photographers use the f/stop as the unit for measuring this contrast range. If we compare the eye to the camera at a fixed f/stop, the eye sees a range of about 12 stops of light, whereas the digital camera only sees about half of that range. My point? When you take a photograph, what you see is *not* what you get.

To become a better photographer, you must understand the difference between what your eye sees and what your camera captures. Look at your photographs. Notice that they don't look the same as the actual scene looked to your eyes (**FIG. 3.8**).

Standing on the beach, watching the sun set, you see lots of details in the shadows, and subtle colors in the sky. You take a picture, exposing for the colorful sky—and the shadows in your photograph are black, with no detail. So you take another picture, exposing for the shadows. Now your sky is all washed out. You've just learned the limits of your camera; it can't capture the same range of light that you see (**FIG. 3.9** and **3.10**).

Of course, every scene differs in contrast, so sometimes your camera may be able to capture both the highlights and shadows, especially in diffused light. But in hard light it's impossible to get it all. Be sure to expose for the subject that's most important.

FIG. 3.9 Exposed for the bright part of the sky. (Nikon D2X, ISO 100, 12–24 mm lens, tripod, 1.3 sec. @ f/16.)

FIG. 3.10 Exposed for the shadows in the foreground. (Nikon D2X, ISO 100, 12–24 mm lens, tripod, 13 sec. @ f/16.)

◀ **FIG. 3.8** A creek flows down through Limekiln State Park on the Big Sur coast of California. This twilight scene is what I saw, but not what my camera recorded. I had to take the two images in Fig. 3.9 and 3.10 and blend them to get this result. The magic of Photoshop has overcome the limitations of the camera! (Nikon D2X, ISO 100, 12–24 mm lens, tripod, f/16, images blended with layers in Photoshop.

FIG. 3.11 This small, specular (shiny) gold reflector, held in place with a Plamp, is reflecting direct morning sunlight into a backlit evening primrose.

FIG. 3.12 This convergent ladybird beetle (ladybug) rests on a beautiful evening primrose, which will close during the hot part of the day and reopen as the temperature cools in the late afternoon. Backlighting the flower made it glow; bouncing light back into it illuminated the ladybug. Mojave Desert, California. (Nikon D300, ISO 200, 105 mm lens, handheld, reflector, 1/1000 sec. @ f/7.1.)

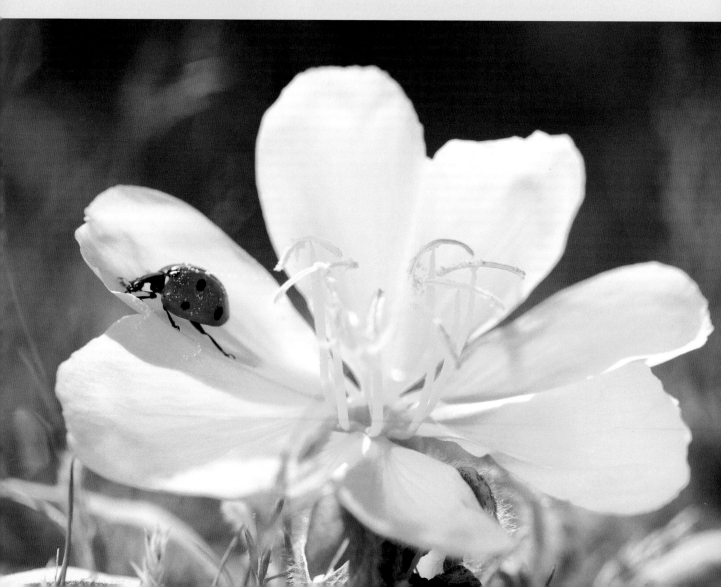

Lots of things can affect dynamic range. The type of camera, your camera settings, how you process your digital files, and other factors are at work. The appendix lists several good websites to check for more information on this complex subject.

Reflectors and diffusers

The *reflector* is probably the most common light-modification tool used by professional photographers. A reflector bounces light from a source onto the subject, filling shadows with light, helping to keep contrast within the range of the camera. The size of the reflector only matters relative to the size of your subject. A big subject needs a big reflector; small things, like this ladybug on a flower, only need a small reflector. You can buy reflectors in a variety of sizes, colors, and styles. Or you can make your own reflectors, using any material that's light in tone—but keep in mind that if your reflector is colored, the light it reflects will be colored (**FIG. 3.11** and **3.12**).

You can build a small reflector, great for close-ups, out of heavy-duty aluminum foil and cardboard. Wrinkle the foil, smooth it out, and tape it to the cardboard. Shiny side out will be more specular and dull side out more diffused.

Some natural objects make good reflectors. Sand and snow reflect a lot of light back into subjects. In a canyon, cliffs can reflect light back into the dark areas on the floor of the canyon. Walls can reflect light into gardens. Once you know where to look, you'll start seeing lots of opportunities to use reflected light.

Diffusers or *diffusion panels* are different from reflectors. You can create soft, diffused light on a sunny day by placing a piece of translucent diffusion material between the sun and the subject. Voilà! Instant soft light (**FIG. 3.13**).

TIP To get an idea of the compressed tonal range that your camera sees, try squinting when you look at a scene. Look at the shadow areas, squint, and then open your eyes. See how the shadows lose detail? Squinting lets you approximate what your camera sees.

FIG. 3.13 When a California poppy bud is ready to unfurl its petals, it first pushes off its surrounding sheath (the white conical shape shown here). On this sunny morning, I softened the hard light with a small diffuser. The background was in the sun, so it got lighter when I exposed for the flower under the diffuser. This helped to keep the bright feeling I wanted. Big Sur, California. (Nikon D100, ISO 200, 105 mm lens, diffuser, handheld, 1/500 sec. @ f/3.5.)

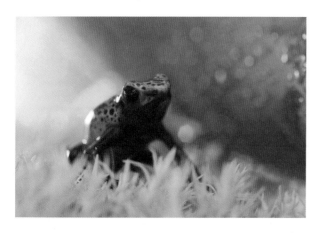

But watch out for any shadows created by the edge of the diffuser in your composition. They give away your secret to getting that beautiful soft light at noon on a sunny day. Diffusers can be made from anything white that light goes through, like thin cloth or plastic. Be sure it's white so the light stays a neutral color. Lots of diffusers are available commercially, and some light-modification kits have both reflectors and diffusers.

Lens shades

When light hits the front glass of a lens, it bounces around inside, reflecting off all the other pieces of glass and creating "flare," which kills color and contrast (**FIG. 3.14**).

Putting a shade on the lens prevents flare and helps to ensure good contrast and saturated colors in your images. Contrast makes images "pop" and appear sharp, and color needs contrast in order to look bright and saturated.

Most lenses come with a shade, and you can buy lens shades like the rubber ones that fold back to fit any lens. The larger the piece of glass in front of the lens, the larger the lens shade you need. Shades also help to protect the front element of the lens from bumps and scratches. If a lens takes a fall, the lens shade just might be the hero of the moment, taking the hit and saving the glass.

◄ FIG. 3.14 A great example of how flare can ruin a photo. Even small amounts of flare cut contrast and wash out the shadows. Azure poison arrow frog. (Nikon D300, ISO 200, 105 mm lens, handheld, 1/200 sec. @ f/7.1, captive.)

Lighting

The word *photography* actually means *light writing*. Learning how to "write with light" successfully depends a lot on your ability to appreciate the character of different lighting environments. You have to learn to "feel" the light. I don't want to get all deep and philosophical here, but light can be tangible, and it's certainly emotional. When people spend a lot of time in dreary, overcast weather or in the darkness of winter, they get depressed. That's why celebrations of springtime are so happy; the sun is back after a long, dark winter. People need light (**FIG. 3.15**).

FIG. 3.15 Desert dandelions open only in full sunlight and then track the sun as it moves across the sky. Mojave Desert, California. (Nikon D100, ISO 200, 14 mm lens, handheld, 1/4000 sec. @f/4.)

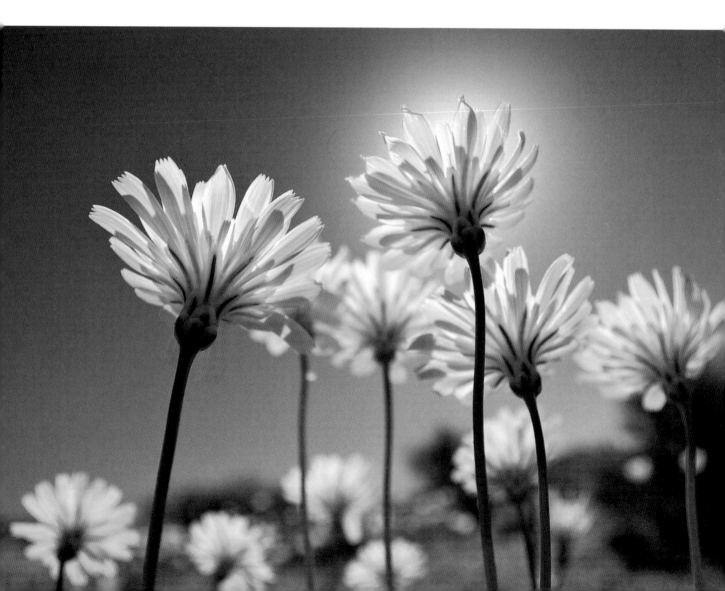

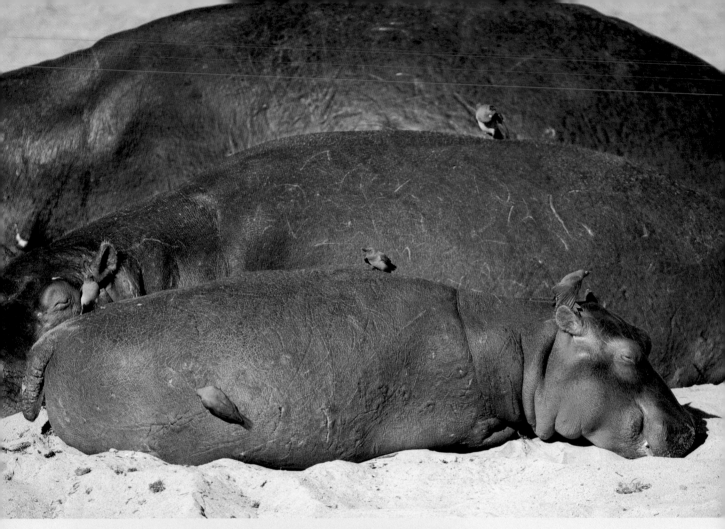

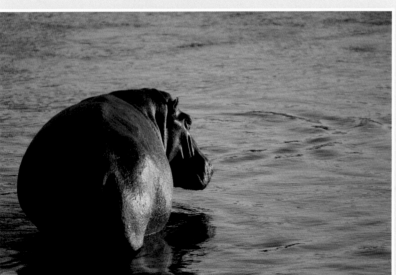

◀ **FIG. 3.17** A hippo makes his way toward the shore to begin his nightly feeding. The low sun provides sidelighting, creating shadows that show the hippo's roundness and the wrinkles in his neck. South Luangwa National Park, Zambia, Africa. (Nikon D2X, ISO 200, 70–200 mm lens, tripod, 1/500 sec. @ f/4.5.)

Perhaps the most important thing about the character of light is its *direction*. Since the sky is part of a sphere, direction is more than just high or low in the sky; it's also right or left, in front of or behind something. At the equator, the sun is pretty much straight overhead for 12 hours at a time in both summer and winter. But as you move north or south, you get a lot more variation in the direction of light during different seasons.

Creating depth in photographs relies on knowing the source of the light:

Front light comes from behind the camera and strikes the front of the subject or scene. The light source can be high or low, but either way there isn't much depth in the scene—everything looks two-dimensional. Subjects in the photograph appear to be on the same plane because no shadows separate them from each other or from the background. If you use front light, you need bold colors or strong color contrast to take advantage of the lack of shadows (**FIG. 3.16**).

Sidelight comes from the right or left side of the subject. The effects of sidelighting are only apparent when the light is low relative to the subject, such as in the late afternoon or early morning. Shadows are long, helping to define texture and shape. Sidelighting a scene gives it a three-dimensional look, separating the foreground from the background. It really shows off texture, as in the wrinkles on a hippopotamus (**FIG. 3.17**).

Backlight comes from behind the subject. High or low, backlighting can create depth and shape. If the subject has an interesting shape that light won't pass through, and you expose for the bright background, you'll have a silhouette. Backlighting works great on fuzzy and furry things; it creates a rim light that separates the subject from the background (**FIG. 3.18** and **3.19**).

If the subject is translucent, such as leaves and flowers, backlighting is a great way to get them to "glow" with light that seems to come from within. With landscapes, backlighting can separate foregrounds from distant objects, filling the space between them with different shades of light. This lighting is great for creating a sense of depth and distance (**FIG. 3.20**).

◀ **FIG. 3.16** Front-lighting these sleeping hippos makes them look like paper cutouts. With no shadow creating separation between them, they appear very two-dimensional. The little birds are oxpeckers; they eat ticks they find on the hippo's skin. Zambia, Africa. (Nikon D2x, ISO 200, 200-400 mm lens, sandbag, 1/800 sec. @ f/4.)

TIP In the northern hemisphere, the sun is always in the southern sky. It crosses in an arc, and its height in the sky depends on the season. It's low in the winter and high in the summer. Understanding where the sun and the moon are and where they're going is important for photographers. The appendix lists some great websites for tracking the sun and moon.

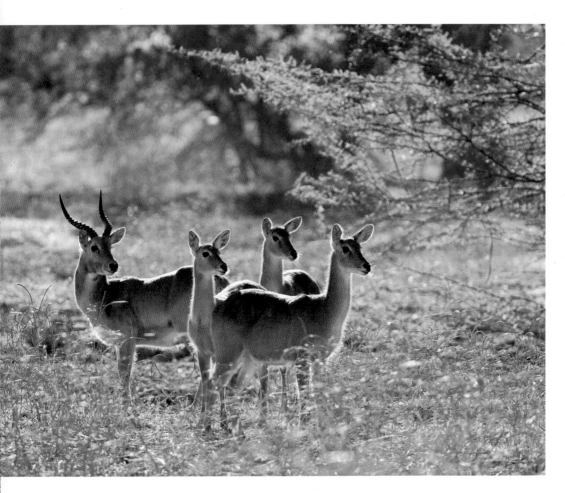

▶ **FIG. 3.18** An ibis wades through a river pool at sunset. The water reflects the colored sky. By exposing for the water, I made the bird into a silhouette. South Luangwa National Park, Zambia, Africa. (Nikon D2X, ISO 100, 200–400 mm lens, sandbag, 1/800 sec. @ f/4.)

▲ **FIG. 3.19** An impala with his harem. Backlight striking their fur outlines the shapes and helps to separate the animals from the similarly toned background. South Luangwa National Park, Zambia, Africa. (Nikon D2X, ISO 200, 200–400 lens, sandbag, 1/800 sec. @ f/4.5.)

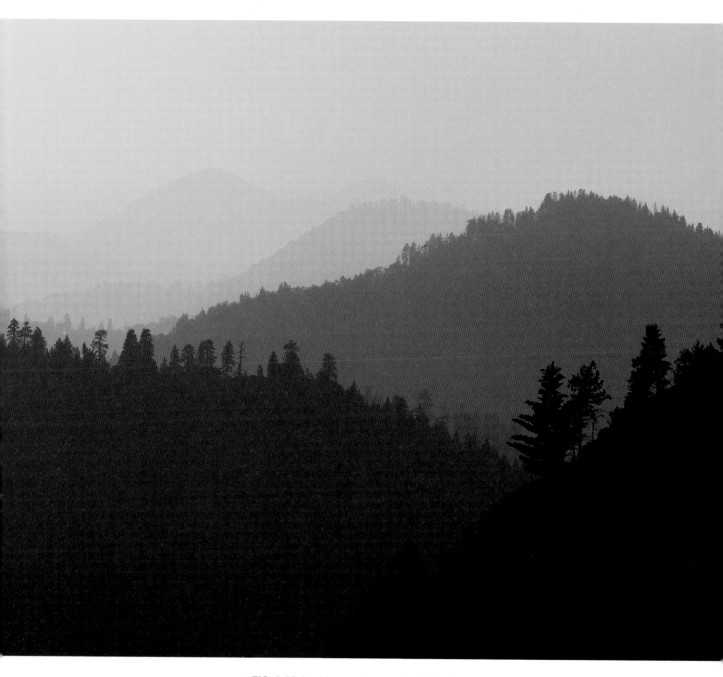

▲ **FIG. 3.20** Looking west across the thick air of the San Joaquin Valley from Sequoia National Park in California. The dust from agriculture creates these colors at sunset. (Nikon D2X, ISO 100, 70–200 mm lens, tripod, 1/250 sec. @ f/5.6.)

FIG. 3.21 I photographed this Blue Dick wildflower on a calm, misty day in the foothills of Santa Barbara, California. With both camera and myself garbed in rain gear, I had no problem taking advantage of the beautiful soft light. (Nikon D2X, ISO 100, 105 mm lens, tripod, reflector, 1/60 sec. @ f/5.6.)

► **FIG. 3.22** I shot this amazing scene in the Monteverde cloud forests of Costa Rica. Rain is plentiful along these mountain slopes, supporting a rich jungle in which everything seems alive. Busy scenes like this look better with diffused light. (Nikon D2X, ISO 400, 12–24 mm lens, tripod, 1/60 sec. @ f/5.6.)

Questions & Answers

Q *What things are good to photograph in soft light, versus hard light?*

A Shiny objects such as cars, glass, or the wet skin of a salamander look best under diffused light; objects such as fur or a peach can handle harder, more specular light. But which type of light you use has a lot to do with how you want a subject to be perceived. Soft light brings out the subtle hues of color and shows details in shadows. If the day is sunny, you can create soft light by using a diffuser, or just casting a shadow over the subject (**FIG. 3.21**).

The low contrast created by soft light is especially good at making a busy, complex subject easier to see. This is true whether it's a single flower or a jungle. I love using the diffused light created by fog or clouds in places like forests and jungles. If you try to shoot in a forest on a sunny day, the splotchy light is usually too contrasty, creating a confusing scene (**FIG. 3.22**).

Portrait photographers love soft light for hiding wrinkles and making faces glow. Animal portraits can also look great in soft light, but it really depends on how you want to portray the animal. If your point is how the animal blends into its environment, soft, diffused, non-directional light works great. Using hard light in this case would cause shadows that separate the animal from the background, giving it away (**FIG. 3.23**).

Few things in nature photography look good under hard light. Strong, directional light from the sun wipes out subtle colors, and only bold colors can withstand its intensity. Landscapes are rendered harsh, lacking depth or detail, especially if the light comes from the front or high overhead. But hard light is necessary if you want to create shadows and silhouettes, so finding subjects that have interesting shapes can pay off on a clear, sunny day (**FIG. 3.24**).

I don't normally shoot in the middle of a sunny day. Instead, I wait for the sun to be low on the horizon, and then I look for waves, leaves, petals—things that light can pass through or sidelight. The quality of the light has nothing to do with the direction of the light (**FIG. 3.25**).

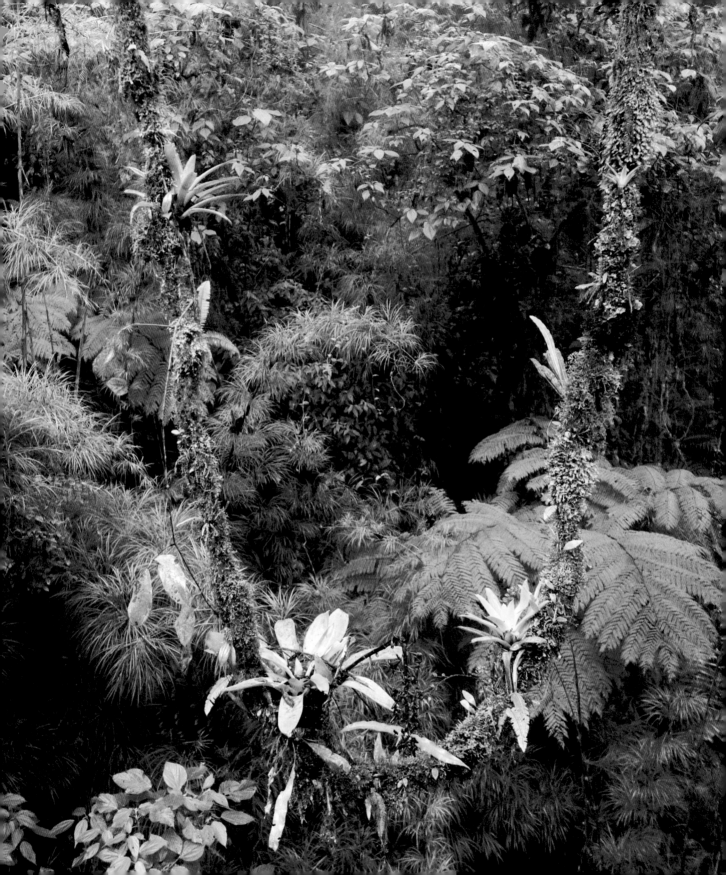

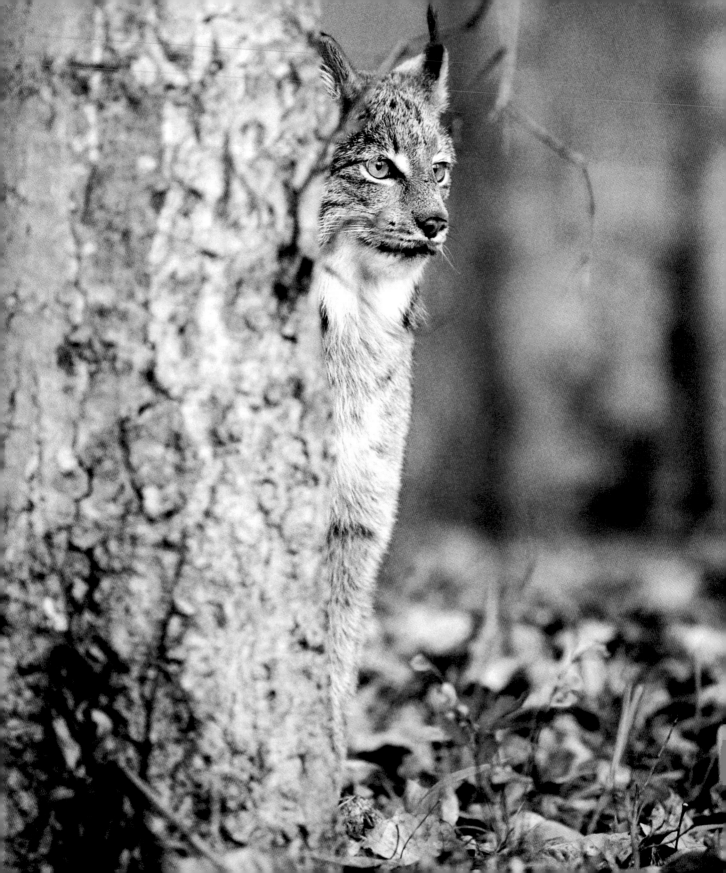

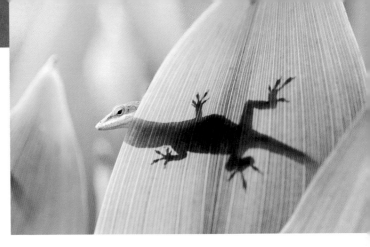

◀ **FIG. 3.23** The lynx has some of the most amazing camouflage I've ever seen. Diffused light softens the shadows here, accentuating the camouflage. I was fortunate to work with this animal model outside Glacier National Park in Montana. (Nikon F3, ISO 100, 400 mm lens, tripod, Kodak Ektachrome film, exposure unrecorded, captive.)

▲ **FIG. 3.24** On an early morning walk around a garden in southern Louisiana, I saw several of these anole lizards basking on large leaves. The strong, direct sun made for amazing shadows. This lizard let me approach, but kept peeking over the edge of the leaf to see if I was getting too close. (Nikon D100, ISO 200, 105 mm lens, tripod, 1/320 sec. @ f/4.5.)

▼ **FIG. 3.25** Offshore winds take the top off a wave near San Simeon, California. Only a half-hour after sunrise, and the light is already hard and direct—great for backlighting these breaking waves. (Nikon D2X, ISO 200, 70-200 mm lens, tripod, 1/800 sec. @ f/4.5.)

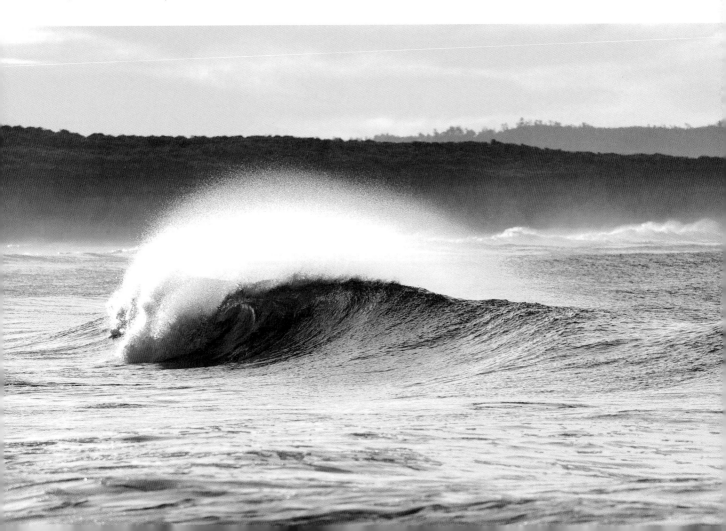

▶ **FIG. 3.26** The south fork of the Kings River flows through a steep gorge on its way out of the Sierra Nevadas. It was 10:30 at night when I made this image in the moonlight. If you tried to lighten the shadows, you'd see a lot of ugly noise. Sequoia National Forest, California. (Nikon D3, ISO 1600, 14–24 mm lens, tripod, 30 sec. @ f/5.6.)

Q *Does a full moon shed enough light to photograph at night?*

A Yes! Moonlight is just reflected sunlight, but the moon is so small that the light from a full moon is about 20 stops less bright than sunlight. Film might need hours to get a decent exposure under moonlight, but with today's digital cameras you can just crank up the ISO and start shooting. You're still going to need exposures of around 30–60 seconds at ISO 800, so use a tripod to keep your camera steady. Bracket your exposures for different looks. I love to photograph water under moonlight; it's always moving, creating ethereal scenes (**FIG. 3.26**).

Q *Someone said my images have "noise." What does that mean?*

A Sort of like grain in film, noise looks like speckles and is most noticeable in places such as skies and shadows. There are two kinds: *Color* noise is mainly pink and purple; *luminance* noise is kind of gray speckles. Every digital image contains some noise, but it increases with higher ISOs and longer exposures. Normally we don't want much noise, but sometimes it gives images "texture."

Many cameras have custom function settings that help to reduce noise. I leave those settings turned on. Photoshop and other programs also offer noise-reduction tools. The best way to reduce noise in most of your photographs is just to expose properly.

Assignments to try

Start by assembling three light-modification tools:
- Small translucent white diffuser.
- Specular (shiny) or diffused reflector.
- Black cardboard to create a shadow.

On a sunny day, photograph a large flower lit in several ways:
- Sunlit only (front-lit, then backlit).
- Using a reflector (backlit for best results).
- Shaded by cardboard.
- In diffused light (hold diffuser between sun and flower).

Examine the photos in detail onscreen. Compare the qualities of light on the same subject shot in four different ways.

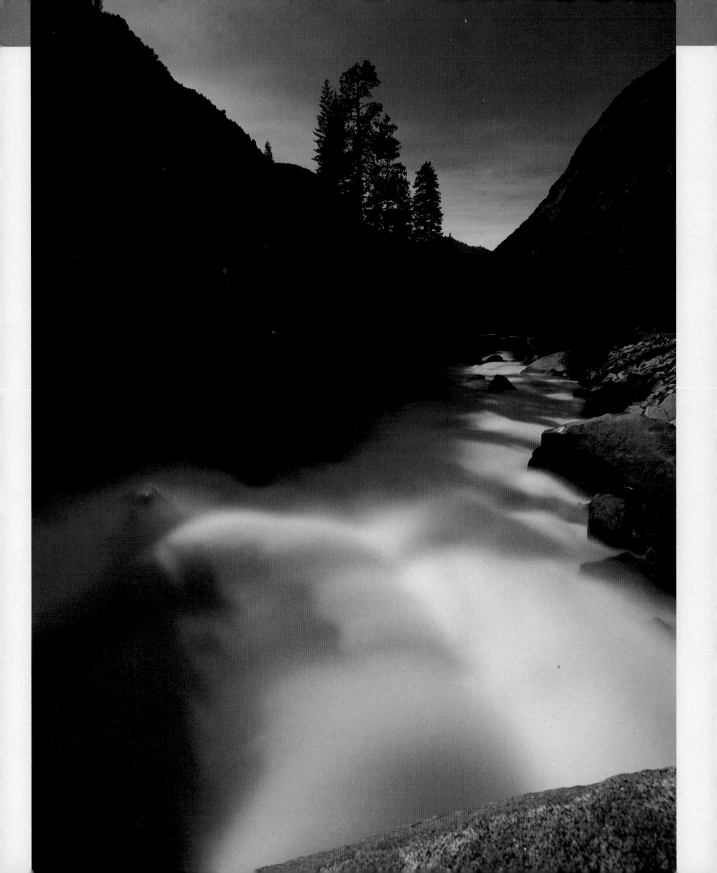

4 Not everything's black-and-white

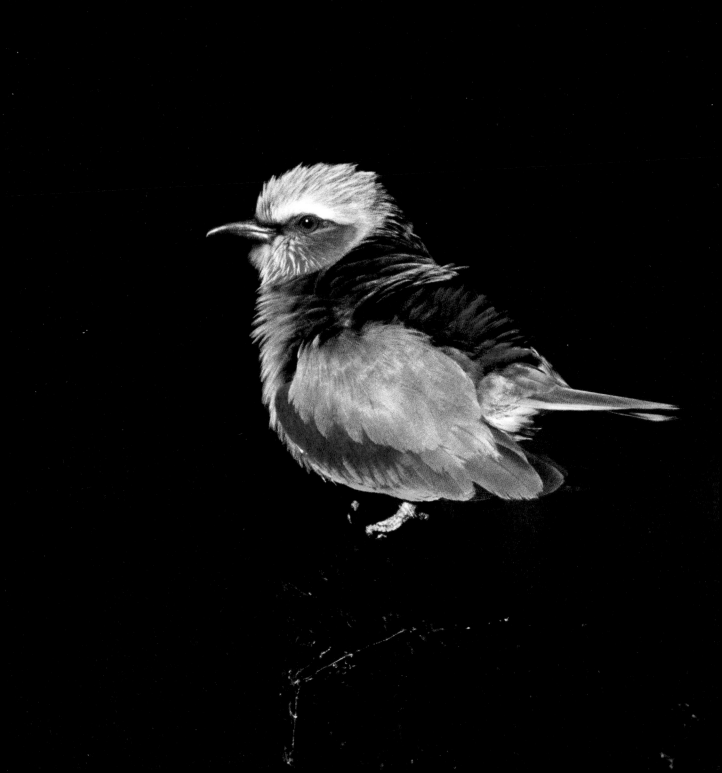

Color is a powerful creative tool, if you know how to use it.

The color of nature

Reds make our heart beat faster, greens have healing properties, blues calm us, yellows give us hope, browns and grays make us sad. Of all the visual elements, color is perhaps the strongest. Often a spot of color is the reason a photographer stops to take a picture. It catches the eye. Our reaction to color is instinctive; it's wired into the brain, part of how we interact with the world (**FIG. 4.1**).

Color seems to be wired into nature, too. Even though most other creatures don't see color like we do, the natural world has plenty of color. Flowers, plants, mushrooms, bugs, birds, lizards, sunsets, rainbows—even rocks have color. And sometimes it's unbelievable color, as in the lilac-breasted roller (LBR, as they say on safari), shown in the opening photo of this chapter. We were driving through a recently burned area in Tanzania when I spotted this bird hunting for insects. The dark burned wood provides a strong contrast with the LBR's incredible colors. This bird was pretty fearless, letting us get quite close. Then it ruffled its feathers...click.

Color of light

Color comes from light. The sun produces every wavelength that the human eye can see. So does a flashlight, but because its bulb has more red and yellow wavelengths than sunlight does, the flashlight's light looks warmer. Sunlight on an overcast day is filtered through clouds, which are made of water; therefore, the light appears bluer.

Colors of light are measured with a special temperature scale called *Kelvin*. Photography borrows this scale from physics, using it to measure

FIG. 4.1 These weren't the only aspen leaves floating in Rock Creek, but by choosing a long lens and framing tightly I eliminated everything but these few leaves, the rocks, and water. The contrasting colors really make you notice the leaves. Eastern Sierras, California. (Nikon D100, ISO 200, 70–200 mm lens, tripod, 2 sec. @ f/16.)

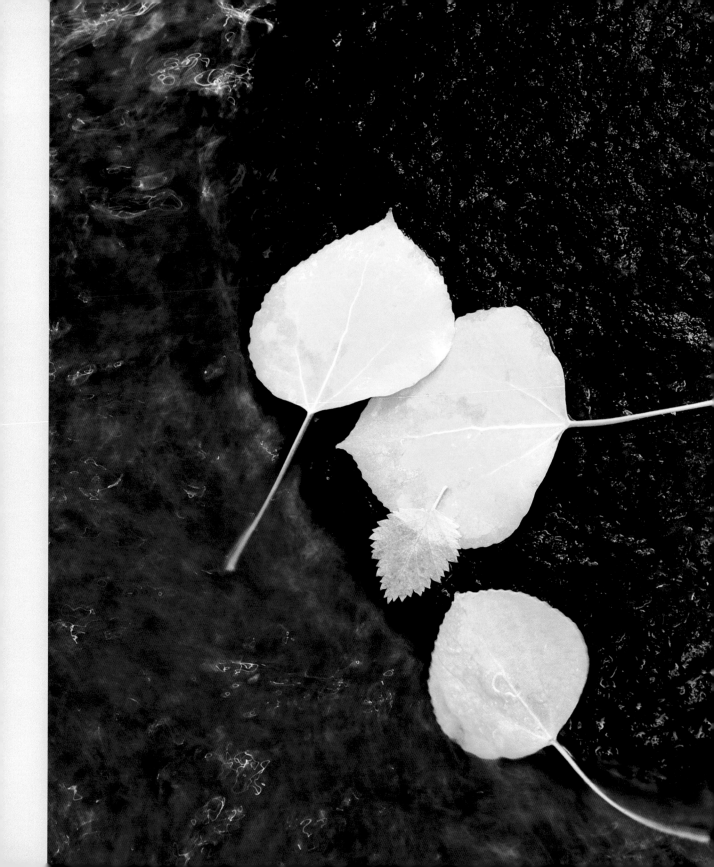

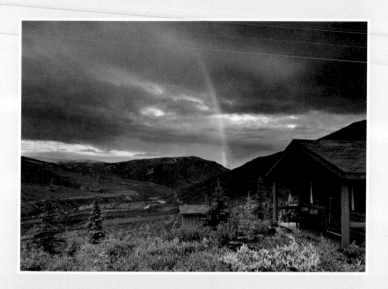

FIG. 4.2 The color of the evening light was beautiful. It was early fall, and the tundra was just starting to change around Camp Denali. Rain had passed through the area, and the last rays of light were hitting the distant hills. The light was almost palpable. Denali National Park, Alaska. (Nikon D2x, ISO 200, 12–24 mm lens, tripod, 1/30 sec. @ f/8.)

FIG. 4.3 One of the most incredible sunsets I've ever seen. The colors were just intense. I shot with every lens and tried every composition during the few minutes of peak color. You don't get a second chance with displays like this. Salton Sea, California (Nikon F4, ISO 32, 20 mm lens, tripod, Fujichrome Velvia 50, exposure unrecorded.)

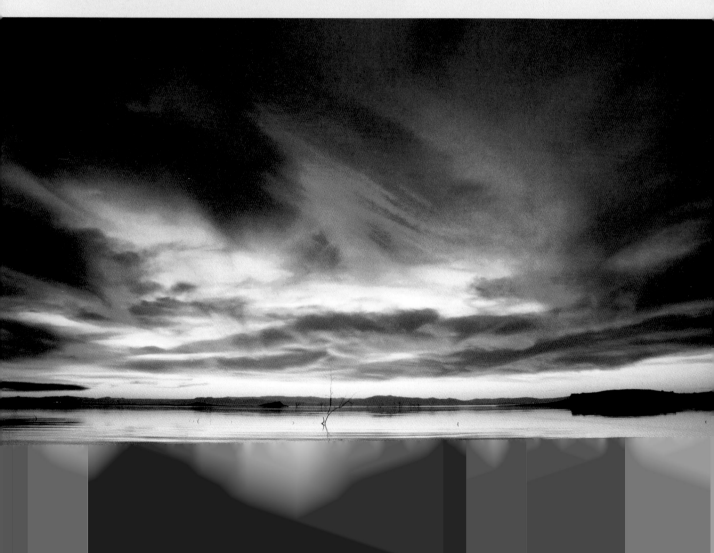

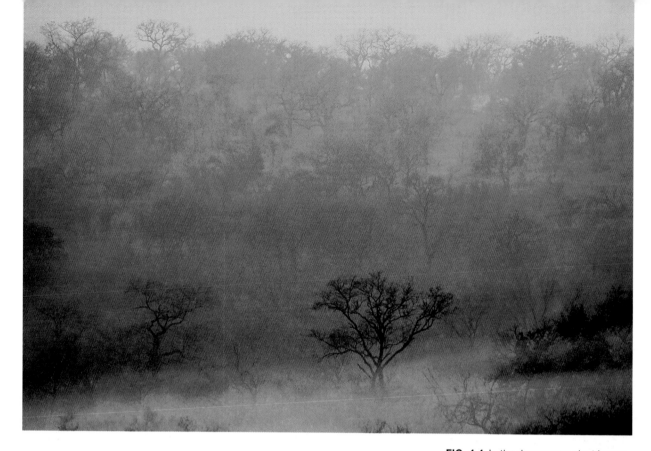

FIG. 4.4 In the dry season, dust hangs in the still air over the Mala Mala Game Reserve in South Africa. We were sitting on a rocky hill watching the sunset. As the sun descended, the air turned golden—everything turned golden. Choosing one tree as the subject helps to give the eye somewhere to go in all that color. (Nikon F4, ISO 100, 400 mm lens, tripod, Fujichrome 100, exposure unrecorded.)

the intensity of colors from red (warm) to blue (cool). The lower the Kelvin temperature, the warmer the light; the higher the temperature, the cooler the light. For instance, a candle flame is 1850° Kelvin, the light from a 100-watt incandescent lamp is about 2900° K, a sunset red sky is about 3500° K, sunlight at noon in the summer is maybe 5400° K, a light overcast sky is about 7000° K, and a shady spot can be 8500° K or even higher. You don't really need to know the Kelvin scale, but your camera does; since you're supposed to be in charge of your camera, you need to have an idea of how its temperature scale works, especially later in this chapter when we talk about camera white balance (**FIG. 4.2** and **4.3**).

Sometimes you can actually see colored light. If the time is close to sunset or sunrise and the air holds a lot of moisture or dust, you can get what I call "pink air." It's as if you can *feel* the air, it's so thick. The light turns the air pink. Everything's pink—the sky, your skin, the white T-shirt you're wearing, everything. It's like looking through pink glasses. Sometimes it's more yellow than pink, sometimes more orange. Maybe I should call it "colored air." Whatever. It's amazing light for photography (**FIG. 4.4**).

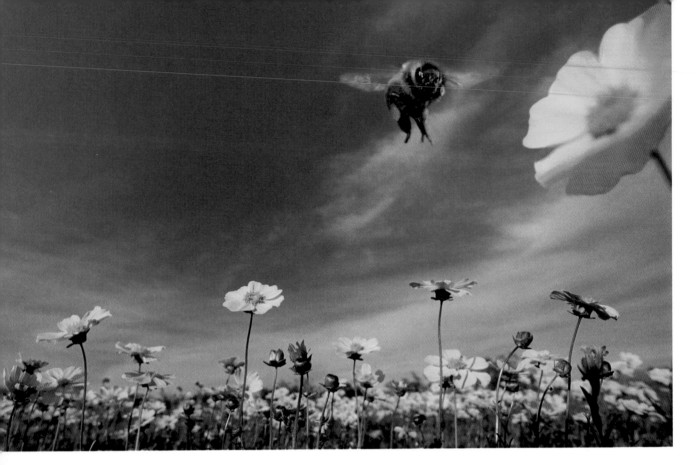

FIG. 4.5 I saw this image while lying on my belly photographing wildflowers in the Mojave Desert. I couldn't get the bee and flower in the same shot—with the wide-angle lens, the bee was just too small and never in the right position. Instead, I composited the flower shot with another bee shot that I had taken earlier, and created what I saw in the scene. This image was selected as Highly Honored in the 2007 *Nature's Best Photography* Annual Competition. (Digital composite.)

Color of subject

Just as light has color, things have color. When light strikes a subject, some of the wavelengths are absorbed and some are reflected. The reflected wavelengths bouncing off the subject produce the colors we see. What's unique about this quality of light is that it's subjective. Each of us, and each species of animal, sees color differently. Fortunately, most humans agree on the general hues of common colors. In photography, red, blue, and green are the primary colors; yellow, magenta, and cyan are the secondary colors. How you use these colors, how you mix them in your photographs, can mean the difference between a boring image and a contest winner (**FIG. 4.5**).

To understand how colors work together, designers use a *color wheel*, a diagram that relates colors to each other. The wheel shows which colors harmonize and which colors build tension, helping you to choose dramatic subjects and compositions. To create color harmony, find colors that are next to each other on the color wheel. Color harmony brings a sense of

balance to a photograph, helping to provide a connection between all the elements in the scene. Scenes that contain opposing colors jump out at us, make bold statements about the subject, and force the viewer to follow the colors in the composition (**FIG. 4.6**).

Nature finds color very useful. Flowers use color to attract insects and birds for pollination. Animals use color to attract mates, to camouflage themselves, to show their emotions, to warn predators that they're poisonous or can sting.

Birds, amphibians, and insects take the prize for color in land creatures. When you photograph animals like these, think carefully about the color of the animal relative to the color of the background. Is it harmonious, with the subject and background working together? Or is it complementary, the subject's color contrasting with the background, making it stand out (**FIG. 4.7** and **4.8**)?

FIG. 4.6 Analogous (similar) colors are next to each other on the color wheel; complementary colors are opposite each other.

TIP When you mix colored light with colored subjects, the complementary colors work against each other. The cool, bluish light in shade makes the colors of a red or yellow bug look less intense.

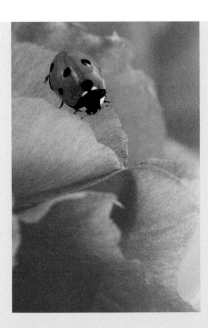

FIG. 4.7 Some people see the color of this beavertail cactus flower as pinkish purple. I think it's magenta and it harmonizes well with the red color of the ladybug. The black-and-white patterns on the ladybug stop the eye. Mojave Desert, California. (Nikon D100, ISO 200, 105 mm macro lens, handheld, 1/30 sec. @ f/16.)

FIG. 4.8 The brilliant magenta of this Taiwan flowering cherry tree contrasts strongly with the green foreground. Magenta is opposite green on the color wheel. Using complementary colors like these produces strong visual statements in your photographs. Santa Barbara, California. (Nikon D100, ISO 200, 28–70 mm lens, tripod, 1/30 sec. @ f/8.)

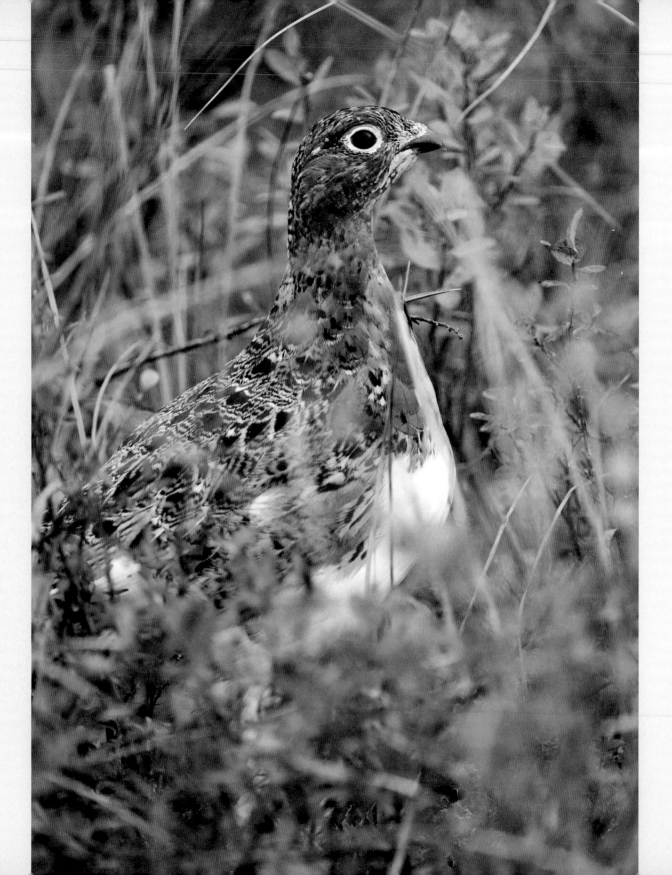

Equipment

Your camera comes equipped with a very useful and creative tool, the white balance button (WB for short). The white balance makes things that are supposed to be white really *look* white. Normally, if white things look white, all the other colors look right, too. Your eyes and brain make this adjustment automatically: White paper looks white under sunlight, shade, or a desk lamp. But you have to tell your camera to make the paper white under each different source of colored light (**FIG. 4.9**).

Pushing the white balance button presents plenty of choices: Automatic white balance is followed by a series of presets showing little icons of a tungsten lamp, a fluorescent lamp, a sun, a little lightning bolt (indicates flash), clouds, and the shady side of a house. Your camera may also offer a few manual settings. Consult your camera manual for the actual Kelvin temperatures of these presets (**FIG. 4.10A–F**).

◀ **FIG. 4.9** The feathers on this female willow ptarmigan are just starting to change to winter white. Only the white breast gives the bird away against the colors of the tundra. We were in thigh-high plants, and this adult popped out of hiding just a few feet from us. She posed for us for a few seconds and then disappeared into the bushes. Denali National Park, Alaska. (Nikon D2X, ISO 200, 200–400 mm lens, tripod, 1/400 sec. @ f/4.)

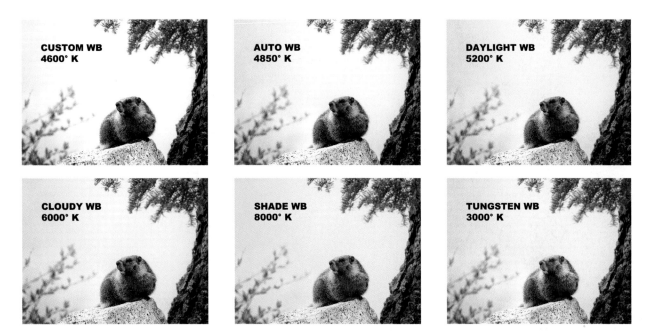

FIG. 4.10A–F This series shows a marmot shot with various white-balance settings. Since the marmot wouldn't sit still while I changed my white balance in-camera, I set the white balance during processing, using Adobe Camera Raw to match the color temperature that my D2X camera would apply for each white-balance setting. Some of the changes are subtle; it's all about getting the camera to see what you see. If you shoot RAW, you can make these changes in processing; if you're shooting JPEGs, you'll want to make the adjustments in the camera. Sequoia National Park, California. (Nikon D2X, ISO 320, 70–200 mm lens, tripod, 1/400 sec. @ f/3.2.)

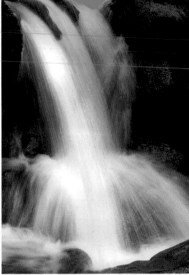

◀ **FIG. 4.11** I used the daylight preset white balance for this image. Little spots of direct sunlight hit the water, and the daylight preset kept the water pretty neutral. Accurate, but not very creative. Limekiln State Park, Big Sur, California. (Nikon D100, ISO 200, 28–70 mm lens, tripod, 1/5 sec. @ f/8.)

Couldn't you just use the automatic white balance all the time? You can do that, and it will probably work fine most of the time. But most cameras' auto WB only ranges from 3000–7000 degrees Kelvin, and light has a wider range of color than that. Auto WB works by measuring the reflected light from the subject—not by measuring the light itself. But reflected light can have lots of different colors, especially if it's coming from something very colorful. Auto WB looks at all these colors and tries to make white look white. Sometimes this system works, sometimes not. I'd rather set the white balance myself most of the time; after all, I want the photograph to look the way *I* see it, not the way the *camera* sees it.

Most DSLR cameras have a variety of ways to set white balance manually. You can dial in a specific Kelvin temperature, choose one of the presets, or use a custom white balance. A custom white balance is usually set using a white card, but anything white will work. Put whatever you're using to set the white balance in the same light as the subject you're shooting. If you're photographing a flower in the shade, your white card needs to be next to the flower in the same shade. If it's a sunny landscape, the card has to be lit by the sun. Fill the viewfinder with the card, push the custom white balance button, and your subject is properly white-balanced in that light. If the light changes, you have to perform the steps again. You don't need to buy anything—just use a piece of white paper. I use commercially available cards from WhiBal (PictureFlow LLC) or one of the plastic "warm cards" from Vortex Media (**FIG. 4.11** and **4.12**).

If you're shooting JPEGs and want the best possible quality, get your white balance right when you take the picture. Try a custom white balance, as I just discussed. Trying to fix the color in JPEGs after shooting isn't a good idea. Every time you make a computer adjustment to a JPEG image, you lose data, so it's important to get the image right while it's in the camera. If you shoot RAW, you can fix color-balance problems later, when you process the images. Of course, that's one more thing to fix at the computer.

▲ **FIG. 4.12** Without moving the camera or changing the exposure from Fig. 4.11, I switched the white balance to the tungsten preset. Wow, I like it! The water looks totally different—more like it felt when standing in that cold creek. Limekiln State Park, Big Sur, California. (Nikon D100, ISO 200, 28–70 mm lens, tripod, 1/5 sec. @ f/8.)

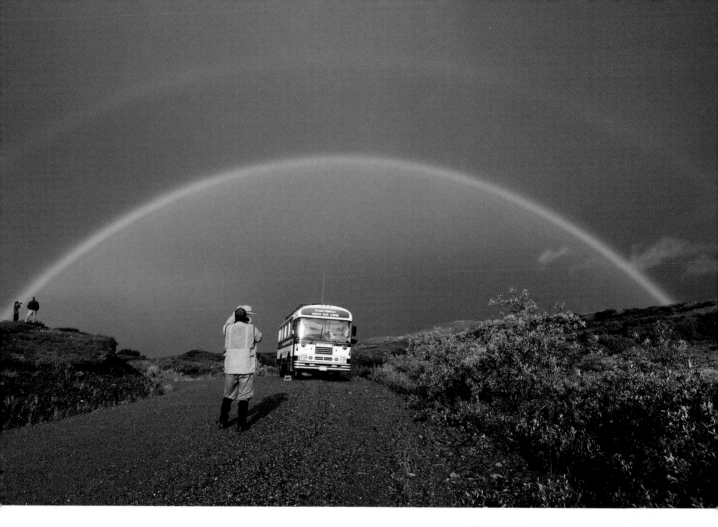

Lighting

Weather is probably the most influential factor in nature photography. It affects everything—the photographer, the equipment, the subject, the land, and especially the light. Weather changes the color of light by filtering it through dust, rain, and clouds. The more dramatic the weather, the more exciting the light, and if the weather is happening early or late in the day the colors can be truly breathtaking.

Beams of light break through fast-moving clouds, revealing patterns that sweep across the hills, and then a rainbow appears behind you. The clouds move, the light hits something new, you're waiting for light to strike the subject just right...there. Click. Click. You have to be ready (**FIG. 4.13**).

FIG. 4.13 Someone in the back of the bus was hollering, and the driver slammed on the brakes. "What's wrong?" he asked. "RAINBOWS!" Rain showers had been blowing over all morning; one minute a downpour, and the next bright sun. We piled out of the bus, and against the dark clouds saw a double rainbow. Be sure to expose for the light areas of the clouds and let the dark area stay dark. Denali National Park, Alaska. (Nikon D200, ISO 200, 12–24 mm lens, handheld, 1/500 sec. @ f/8.)

▶ **FIG. 4.14** I was with several students in Big Sur, hoping for a sunset on the ocean. The clouds were thick, and it looked like we were going to get skunked, so most of the students quit and went back to camp. A few of us waited. With a sudden break in the clouds, rays of sunlight streamed through, and my advice to the students— "Never give up on a sunset"—was vindicated. A few minutes later, it was all over. California. (Nikon D2X, ISO 100, 200–400 mm lens, tripod, 1/400 sec. @ f/5.6.)

Before I go on, I want to emphasize that if you don't have a good grasp of your equipment and techniques, or if you're not physically prepared for weather, you're going to miss these chances at capturing amazing light. This is one of the biggest lessons my students learn on field trips. When they're cold and miserable, they get impatient, they don't make good pictures, and they quit. When their cameras get wet in the rain and stop working, or their batteries die, they quit. If you and your stuff aren't prepared, you're not going to make images—you're going to quit. Nature seldom gives you a second chance.

One of my favorite times to take photographs is when the weather is clearing, the storm is moving off, and the clouds are beginning to break up. The mix of clouds, rain, wind, and sun create such diversity of lighting! A rainbow against black storm clouds, rain showers backlit by the sun, beams of light striking the ocean—it's exciting light. In California, these storms happen in the winter; in Alaska, the summer storms are more dramatic. In places closer to the tropics, the light and weather are different. Many people choose to travel during the dry season because they don't want to get wet—or because, in places such as Africa, the roads are passable only when they're dry. I like to go to East Africa at the fringes of these seasons, so I can get clearing storms with their rolling clouds and shafts of light. Granted, I'll have to help dig the truck out of the mud a few times, but it's worth the trouble (**FIG. 4.14** and **4.15**).

The light during these storms can be contrasty, with areas of brightness against darker areas. I use manual exposure mode, not auto exposure, and expose for the brighter areas, letting the darker areas go dark. It looks more realistic that way. Check your blinkies (your camera's highlight alerts)—you only want the very brightest spots to be blinking.

If you spend time looking at light and color, watching how they change depending on the time or season or weather, you'll develop an intuitive feeling for changes in light.

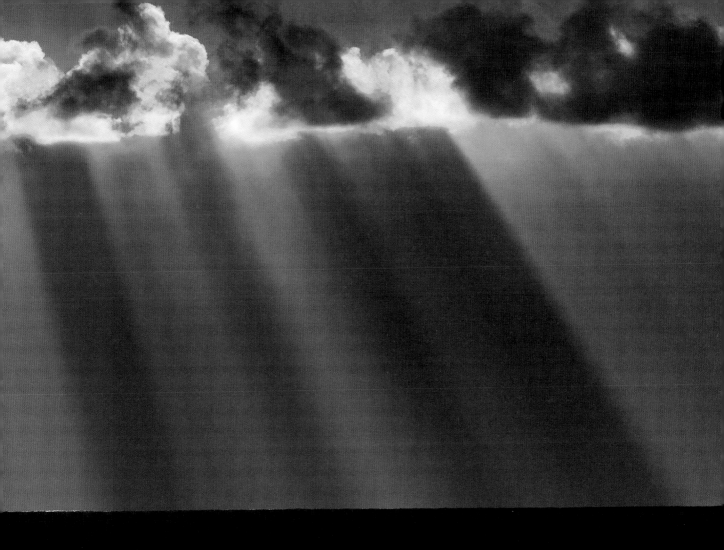

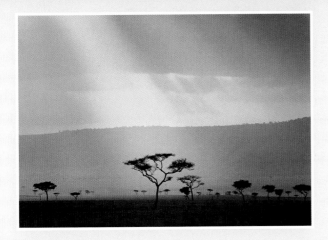

◄ **FIG. 4.15** Acacia trees are silhouetted by a beam of sunlight coming through clearing clouds over the Maasai Mara National Reserve in Kenya. I had my guide maneuver the van so none of the trees stacked up on each other, and then we just waited. The light was different every minute. Patience. (Nikon F4, ISO 32, 80–200 mm lens, sandbag, Fujichrome Velvia 50 film, exposure unrecorded.)

Questions & Answers

Q **What do photographers mean when they talk about "magic hour"?**

A Most people define "magic hour" as the hour after sunrise and the hour before sunset, when the color and quality of light make for especially beautiful photographs. I actually call it "magic *hours*." You have two hours in the morning and two or maybe three hours in the late afternoon to use this wonderful light. There's a big difference in the quality of light when the sun is up and directly lighting things, versus when the sun is below the horizon and everything is softly lit by the twilight sky. I try to shoot right through the transition (**FIG. 4.16**).

▼ **FIG. 4.16** Just after the sun went down, the eastern sky over this little fishing town in Costa Rica erupted in color. The clouds are catching the sun's light and reflecting it everywhere. You can feel this tangible "pink air." A high viewpoint can provide a better sense of the place you're photographing. (Nikon D2X, ISO 100, 12–24 mm lens, tripod, 1/25 sec. @ f/4.)

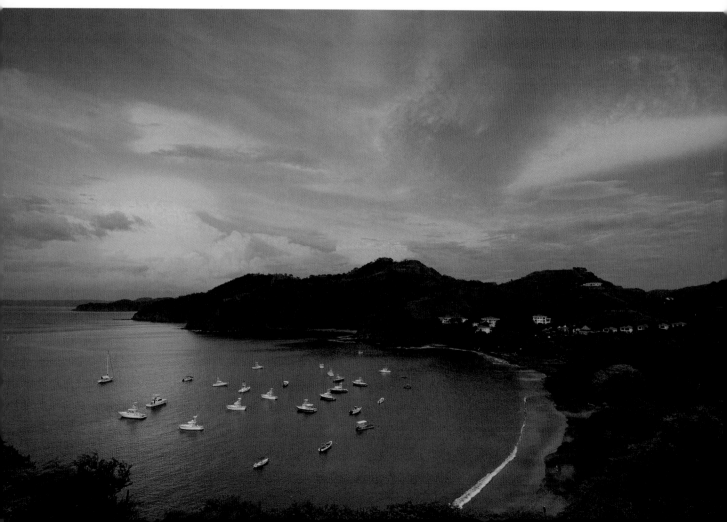

The colors you see during magic hours change, depending on what's happening in the sky. Let's take sunrise as an example of one type of magic hour. Before the sun gets above the horizon, all the light is being reflected from the sky. If the sky is clear, the light usually graduates from cool colors above to warmer tones on the horizon. But if the sky is filled with clouds, you have a chance for one of those amazing red sunrises. The clouds reflect the light from the sun, which is still below the horizon, spreading soft warm light everywhere and lightly filling the shadows. Once the sun crests the horizon, everything changes. The light is more directional, creating long shadows, and the colors fade to more neutral tones. This can happen very quickly at sunrise (**FIG. 4.17** and **4.18**).

Sunsets usually take longer to go through their cycle than sunrises. I don't know why; it's like the sun doesn't want to go to bed. In the hour before sunset, the color of the light begins to warm, shadows stretch across the ground and fill with hazy light. If you're looking toward the sun, textures and shapes stand out. This type of light is a favorite for landscape photographers. After the sun sets, the light loses direction, shadows fade away, and the color can either go cool or warm, depending on what's happening in the air. Smog, dust, volcanoes erupting a thousand miles away, high humidity—all affect the color and texture of magic hour light.

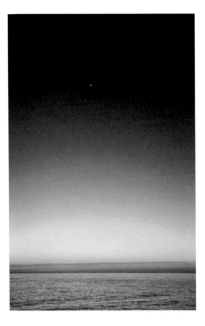

▲ **FIG. 4.17** Dawn, just before sunrise, from the deck of the Nautilus Explorer. I was on a trip to Guadalupe Island, off the coast of Mexico, to photograph great white sharks. The clear, clean skies over the ocean offer some of the most vivid colors you can find. Unless you just want a background, you need to include subjects in scenes like this. Although it's tiny, the moon is my subject here. (Nikon D2X, ISO 200, 12–24 mm lens, handheld, 1/25 sec. @ f/4.)

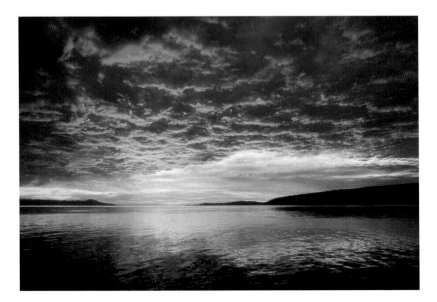

◄ **FIG. 4.18** There's an old saying, "Red sky at morning, sailors take warning." I arranged to have the boat captain put me on shore at Santa Rosa Island before sunrise, so I could get this shot using my tripod. The boat is too unstable to get sharp images in such low light. Channel Islands National Park, California. (Nikon D100, ISO 200, 14 mm lens, tripod, 1/20 sec. @ f/4.)

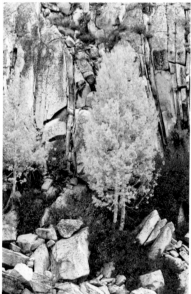

◀ **FIG. 4.19** The colors of these aspens and rocks changed dramatically during the couple of hours when I photographed them. In direct sunlight, the hard light creates strong shadows, warmer tones, and specular highlights on the leaves. Bishop, California. (Nikon D300, ISO 200, 28–70 mm lens, tripod, 1/1250 sec. @ f/6.3.)

Q *If the color of light in the shade is cooler than direct sunlight, why do they look the same to me?*

A Our brains can do a pretty good job of neutralizing light, making things look normal no matter what color of light we're in. You can prove it by looking at a piece of white paper outside and then looking at it again in a room lit only by lamps. The paper looks white in both cases, but you know that the light isn't the same color, because you just read about Kelvin temperatures. Cameras don't have brains to neutralize the light. To the camera, light in the shade of a cliff *is* cooler than light coming directly from the sun, because it's coming from the clear sky overhead (**FIG. 4.19** and **4.20**).

Overcast light is also cool because the light from the sun is filtered through the water that makes up the clouds. Even the light in a forest or jungle is cooler than sunlight, but it's more greenish than blue because of all the leaves.

Photographs taken in all these environments won't look very "natural," because the camera can't interpret the colors—it just records them. You'll have to manipulate your camera with the white balance tool to record the colors the way you see them.

Q *I set my white balance. Why does the color look wrong?*

A The camera probably won't record color exactly as you remember it, but it can get close. In many cameras, the white balance presets can be fine-tuned either warmer or cooler. Try altering the presets until you get something you like. Your camera manual (yes, you have to read it) probably lists how much warmer or cooler you can make each setting. Another option: Try white-balancing manually with a color other than pure white. If you white-balance on the faded blue jeans you're wearing, you'll get a look that's warmer than neutral.

▲ **FIG. 4.20** The difference between Fig. 4.19 and this shot is really amazing. The sun has dropped behind the mountains, and the canyon is in shade. Only the blue sky is providing light. I actually prefer this softer light for scenes like this. The blue of the rocks is complementary to the yellow of the trees. Shady, cool light really made this scene work. Worth the wait. Bishop, California. (Nikon D300, ISO 200, 28–70 mm lens, tripod, 1/40 sec. @ f/5.6.)

Another component to white balance is your computer monitor; it's the bridge between your camera and the print you display or the image you post on your website. If your monitor isn't properly adjusted for brightness and color, you'll make wrong decisions about color and exposure when processing your images, or working on them in Photoshop. Having a properly calibrated monitor is critical if you want to be sure that all your camera settings and processing work translate to what you originally saw when you took the photograph (**FIG. 4.21**).

The best way to calibrate your monitor is to use software and hardware tools specifically designed for color control. I use one called ColorMunki Photo. The appendix lists several other resources as well. These systems aren't cheap, so check with your local camera or computer club first; maybe someone who has a color calibration kit will come to your house and calibrate your monitor in exchange for a piece of lemon pie.

Assignments to try

This exercise may help you to solve the problem of colors that don't look quite right. Flowers are a good choice for this task, so we'll use those.

1. Put a mix of white, red, and yellow flowers with green leaves in a vase against a plain background, front-lighting them with the sun. If you like, put a diffuser between the sun and the flowers to make them look nice. Frame the flowers to fill most of the viewfinder.

2. Set your white balance to auto and take a photo. Then set it to daylight and take a photo. (Note: Sometimes it's easier to see the color differences if you put a white card in the shot or add a person's face next to the flowers to see how skin tones change.)

3. If your camera can fine-tune the daylight preset, take another photo at each of the adjustment values for daylight white balance. Try the open shade and cloudy white-balance settings. You can run through their fine-tune adjustments as well.

4. Bring up the results on your computer screen and note the settings that look the best to you. If your camera can save your favorite white-balance settings, save the ones you like so that you can dial them in whenever you want.

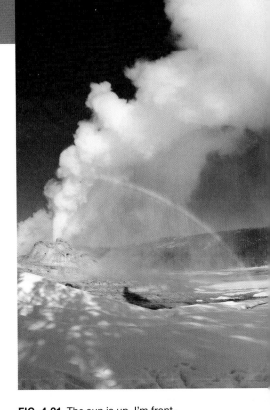

FIG. 4.21 The sun is up, I'm front-lighting the geyser, and I want the steam to be white—even a little bit cool white, because the steam looked white and I'm cold. I might have been able to use a custom white balance on the snow in the sun, but I didn't. I just fine-tuned my daylight preset to give me light that was a bit cooler. Yellowstone National Park, Wyoming. (Nikon D100, ISO 200, 16 mm lens, tripod, 1/320 sec. @ f/16.)

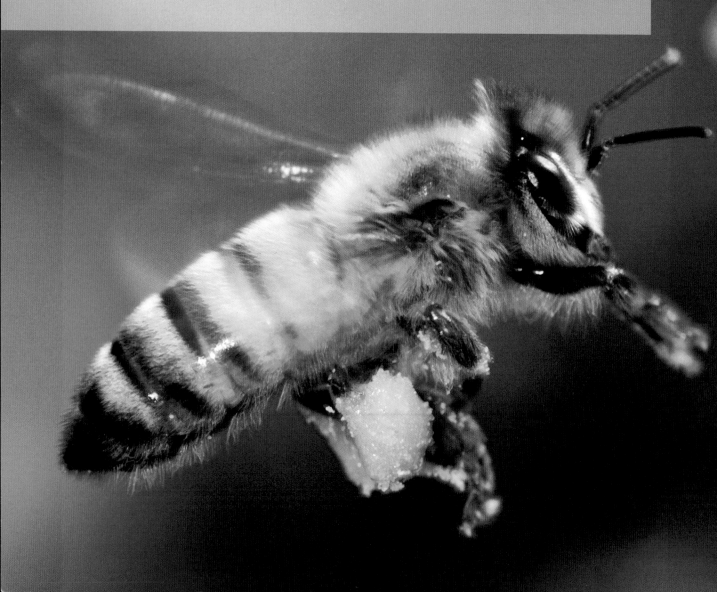

5 Flash! And you're in control

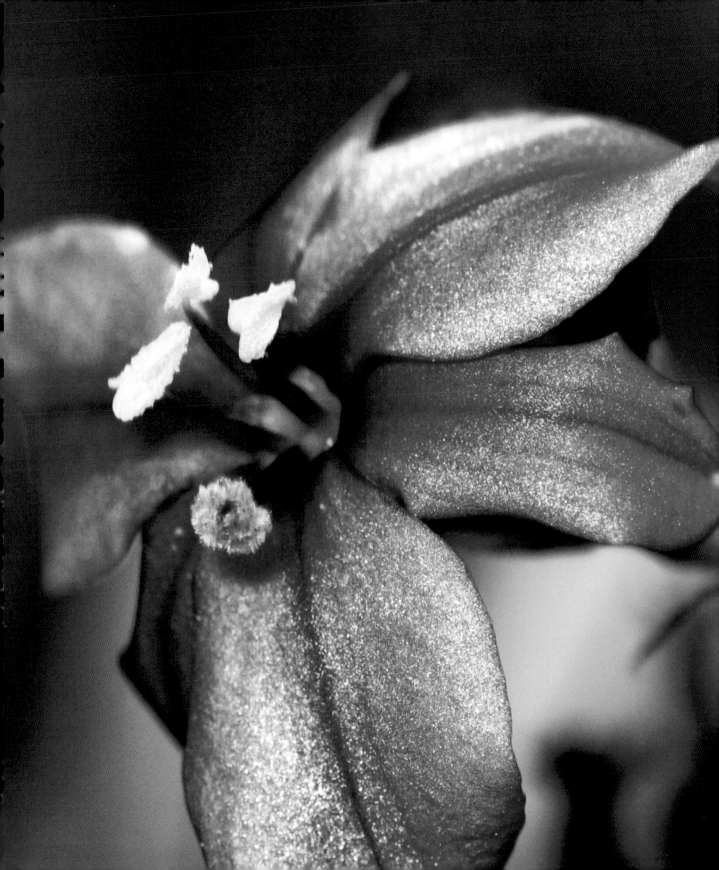

Use your flash to make images that reflect what you saw, not just what was there.

Light at 1/20,000 of a second

Photographers either love using flashes, or avoid them completely. I think the avoidance comes from not understanding how to use a flash. There's a lot to understand—more than I can fit into just one chapter. But once you understand the reasons for using a flash, actually learning to use them comes down to reading the manual, checking out some video tutorials, and practicing—a lot. The appendix lists some of my favorite websites related to flash technique. They're not specific to nature photography, but are great places to learn about using your flash.

Why use a flash? Three reasons: to control contrast, to freeze moving subjects, or because you don't have enough light to take a picture (**FIG. 5.1**).

Since your camera can't render contrast the way your eyes can, you need to add light to the shadows to get the resulting image to look natural. If you're close to your subject, the little pop-up flash on top of the camera will work fine. But to fill in the shadows on a subject more than a few feet away, you're going to need a separate *through-the-lens* (TTL) flash that's dedicated to your camera system. Using a flash mounted on the camera works fine in some fill-flash situations, but if you really want to make spectacular images you have to get that flash off the camera.

FIG. 5.1 The Oregon Zoo's Great Northwest exhibit puts visitors below ground, giving them unique views of magnificent gray wolves. It's winter, and a shaft of sun is backlighting this male. I added flash so you can see his face, and put a catchlight in his eyes. Portland, Oregon. (Nikon F4, ISO 200, 400 mm lens, on-camera flash, tripod, Kodak Ektachrome 200, exposure unrecorded, captive.)

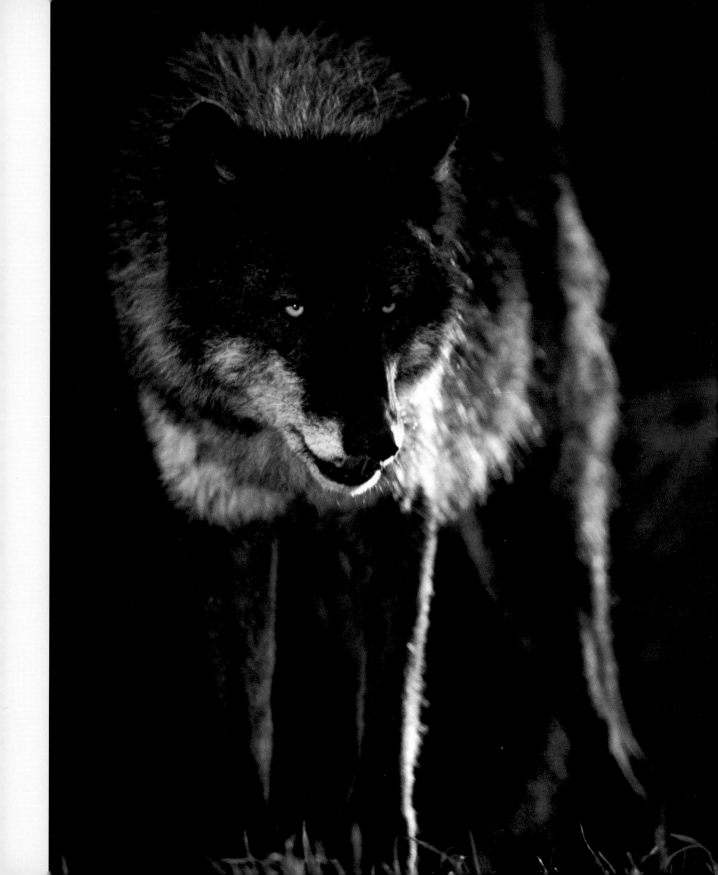

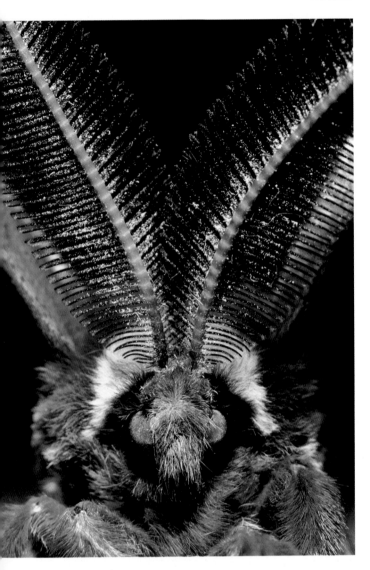

▶ **FIG. 5.3** The male Eclectus parrot is difficult to spot in the wild. This captive bird was high in the aviary; only with a flash could I get enough light to photograph him. I positioned the flash high on the right so the shadows from the leaves wouldn't cover the parrot's body. Adelaide, Australia. (Nikon F4, ISO 32, 400 mm lens, on-camera flash, tripod, Fujichrome Velvia 50, exposure unrecorded, captive.)

Your light plus nature's light

Unless you're in a cave, you always have two light sources when you work with flash: the flash and the *ambient* light (the natural or available light). Balancing these two light sources is the key to making your photograph reflect what you see, and go beyond just recording what the camera sees. You can use either light source for the main light or the fill light. If the sun is your main light, just use an on-camera flash for some fill light in the shadows. Power the flash down so your subject isn't over-lit. If you're under a canopy of trees, use the flash as the main light, and let the ambient light fill in the shadows and keep the scene looking natural (**FIG. 5.2** and **5.3**).

Two important things to remember when working with flashes and ambient light: First, ambient light is controlled by the shutter speed and f/stop, whereas flash is controlled by f/stop and distance. I don't worry about distance too much because I use the flash on TTL mode. If I want a darker ambient, I use the shutter speed control, because it doesn't affect the exposure for the flash.

Second, when you use a flash as the main light on the subject, think about the direction of the light. By backlighting or sidelighting with the flash, you can create a lot of drama and depth in the scene.

▲ **FIG. 5.2** I found this Ceanothus silk moth on the side of a building during the day. Using a stick, I carefully posed it facing me, and used a diffused flash overhead to capture the shot. The flash is very close, providing a nice soft light that fills all the shadows. When I was done, I returned the moth to the wall. Santa Barbara, California. (Nikon F4, ISO 32, 105 mm macro lens, diffused off-camera flash, tripod, Fujichrome Velvia 50, exposure unrecorded.)

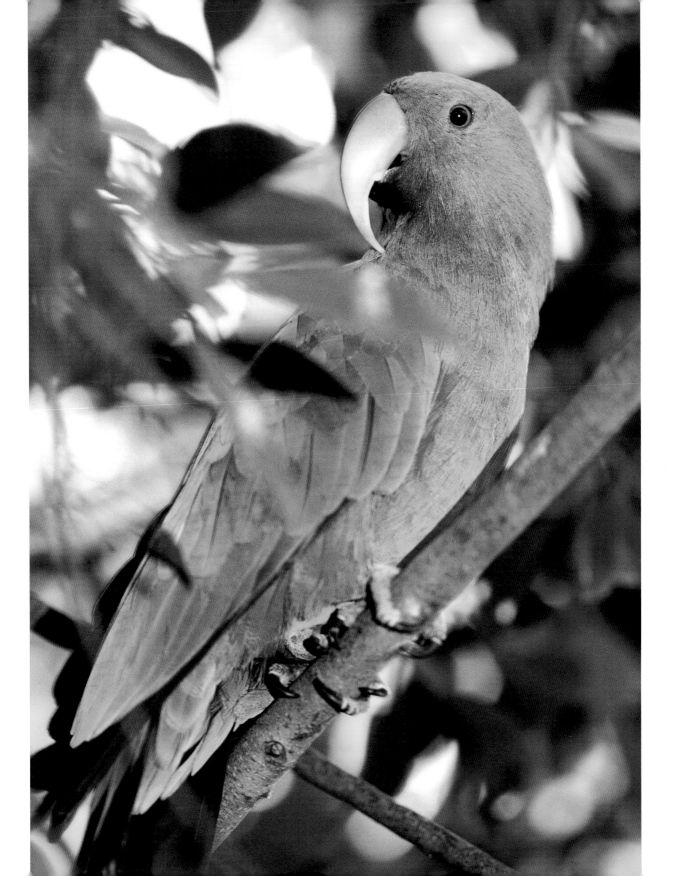

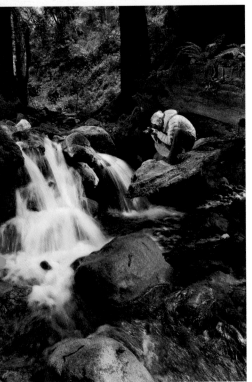

Here's the process I went through to make the photo of one of my students, Taylor Swift, by a stream:

1. I looked at the ambient light in the scene. I usually take a picture to see whether I want the scene to look normal, or darker. For this shot, I wanted the forest to feel dark, so I underexposed what the camera meter said by 1–2 stops. That exposure gave a darker, more mysterious look to the scene. A few shafts of sunlight were also filtering through, and I didn't want them to be overexposed (**FIG. 5.4** and **FIG. 5.5**).

2. To light the student, I placed a TTL wireless flash way over on the left, zoomed it to the narrowest beam, and pointed it at him. This directional light added depth to the scene by separating the student from the background.

3. Back at the camera, I pointed another TTL wireless flash on the right side at that big rock in the foreground. I set this flash to -2 TTL compensation so the rock wouldn't be too bright. Both of my flashes had warming gels to compensate for the cool light in the forest.

4. ISO 400 let me shoot at f/10, so I could get everything in focus. I took about 16 shots with four different poses and a little bracketing of the ambient light (with my shutter). The student stayed still, was wearing a jacket with a great color, and was doing something interesting. The top photo shows what I saw when I was there, but adding flash in combination with the ambient light was the key to getting the photograph I wanted.

◀ **FIG. 5.4** and **FIG. 5.5** Hare Creek runs through a beautiful coastal redwood grove. The trees are so thick that little light penetrates to the floor of the forest. The top photo is lit with ambient light only. The bottom is lit with two wireless off-camera gelled flashes. Limekiln State Park, Big Sur, California. (Nikon D300, ISO 400, 12–24 mm lens, tripod, 1/15 sec. @ f/10.)

Equipment

Flash basics

Batteries are critical to your flash system. Rechargeable batteries recycle fast, letting you take more pictures in a shorter time than you could with non-rechargeables, which can make the difference in getting the shot (**FIG. 5.6**).

Put your flash zoom control on manual so you can adjust it no matter what lens you're using. This technique will give you creative control over your lighting.

FIG. 5.6 Every winter, northern elephant seals come ashore to breed and give birth along the coast of central California. This young male looks like he's bellowing at me, but he's really just yawning. I underexposed the ambient sunlight so the background wasn't so distracting, and the flash filled in all the shadows, including that amazing red mouth. (Nikon F4, ISO 32, 400 mm lens, on-camera flash, tripod, Fujichrome Velvia 50, exposure unrecorded.)

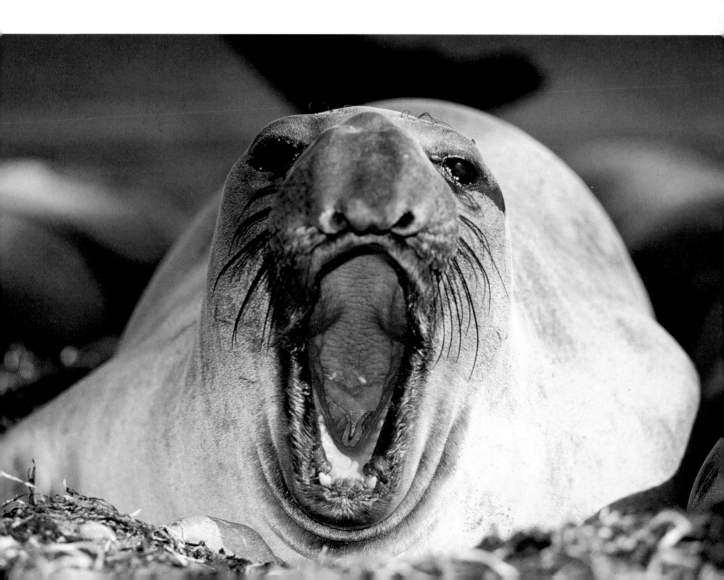

▲ **FIG. 5.7** A close-up of the "eye" on an owl butterfly's wing. When the wings are open, they look like the face of an owl with big eyes. High magnification is a perfect situation for the ring light. Monteverde Forest, Costa Rica. (D2X, ISO 200, 60 mm macro lens, 1.5x magnification, ring light flash, handheld, 1/160 sec. @ f/16, captive.)

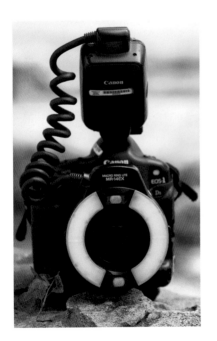

To light everything in a shot, the camera's shutter and flash must be synchronized. Think of the shutter as a curtain. At slower shutter speeds, the curtain has a wide gap; at higher shutter speeds, such as 1/500 or faster, it has a narrow gap. The flash needs to go off when the gap is wide, so the light from the flash hits everything in the photo. The fastest shutter speed at which this happens is called the *sync* speed, typically between 1/200 and 1/250 of a second. Your camera and flash will sync at any speed that's slower than the sync speed. Many cameras have a high-speed sync option so that you can shoot faster than the sync speed. This is great if you want to eliminate motion or darken bright ambient light. The best explanation I've found on how to use high-speed sync is on Syl Arena's website PixSylated (listed in the appendix).

Ring lights

Invented for doctors to use during surgery, ring lights eliminated flash arms, which would get in the way of the serious stuff. They're easy to use and produce such unique light that fashion and beauty photographers have adapted them for use in studios. The best use of ring lights in nature photography is for high-magnification images, especially when you're so close that you can't get your regular flashes between the lens and the subject (**FIG. 5.7** and **5.8**).

Wireless triggers (infrared vs. radio)

With wireless flash control, I can fire multiple TTL flashes, controlling the power of each light right from the camera—and all without those frustrating cords (**FIG. 5.9**).

Wireless flashes are triggered in two ways: *Infrared* triggers need line of sight and don't work in strong sunlight. Canon and Nikon flashes have wireless infrared built into the flash. *Radio* triggers work in bright sunlight, can see through walls, and aren't brand-specific. If you want to keep your TTL flash capability with radio slaves, be sure to use a system that's compatible. I've used Radio Poppers and Pocket Wizards, both very reliable.

◀ **FIG. 5.8** Ring lights surround the subject with light, eliminating all shadows. On many models, you can turn off one of the tubes to give a little direction to the light.

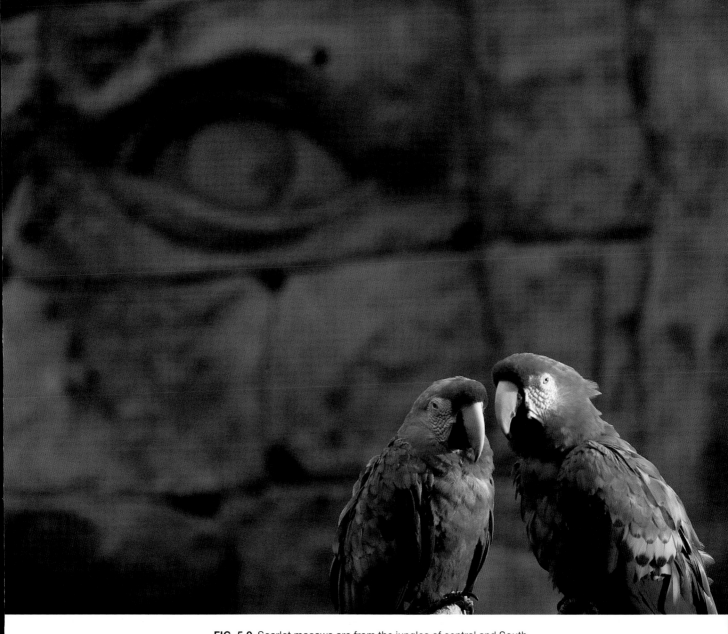

FIG. 5.9 Scarlet macaws are from the jungles of central and South America, so showing the Mayan temple face in the background adds interest to the image. But I needed some dramatic light. I set up some strong sidelight by clamping my wireless flash to the railing on a bridge about 30 feet away. Underexposing the ambient light kept the mood dark and showed off the light from the flash. Santa Barbara, California. (D200, ISO 100, 200–400 mm lens, off-camera flash, tripod, 1/250 sec. @ f/7.1, captive.)

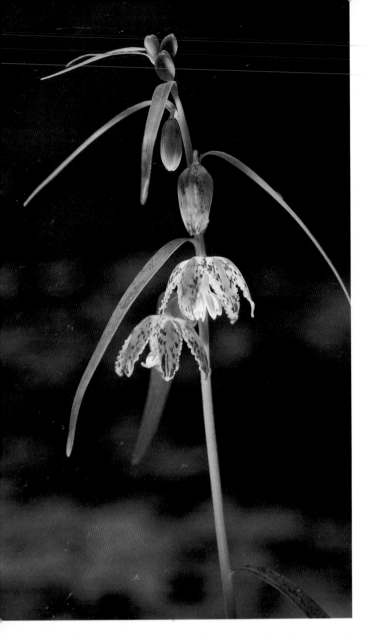

FIG. 5.10 Since the flowers of this checker lily point downward, I lit from below; I just laid my wireless flash on the ground, put a warming gel on it, and pointed it straight up. I underexposed the busy background to create a dark, forest feel. The weather was dark and rainy, so this mood seemed to fit. Butano State Park, California. (Nikon D300, ISO 200, 105 mm macro lens, off-camera flash with gel, tripod, 1/30 sec. @ f/8.)

Lighting

TTL flash metering makes using flash nearly foolproof. I use it all the time. It works with any camera exposure mode, including manual. Your camera, flash, and any cords or wireless systems all have to talk to each other for TTL flash to operate correctly. Here's how it works: You press the shutter button and the flash goes off. The light hits the subject and bounces back through the lens to a sensor in the camera; when the image is properly exposed, the camera tells the flash to quit firing. Your subject can even be moving closer or farther away, and the system will compensate for the changing distance by adjusting the flash power to make a perfectly exposed image (**FIG. 5.10**).

TIP TTL flash systems only prevent overexposure, not underexposure.

But the result isn't always perfect without help. First, you have to be within the flash's distance range. The more powerful the flash, the greater the range. Many flashes indicate the range on the back of the flash; for example, 2 ft—35 ft. This designation means that you can use your current camera settings, and the TTL flash will properly expose a subject between 2 feet away and 35 feet away. At 35 feet, the flash is going off at full power; at 2 feet, it's going off at something like 1/128 power. The maximum flash distance is based on f/stop and ISO. The wider the f/stop, the greater the distance (because a large aperture lets in more light), and the higher the ISO, the greater the distance (because the camera is more sensitive to light).

Many TTL flash systems can read the ambient light and automatically balance the flash with the natural light falling on the subject. Pretty cool. Nikon flashes call this *balanced fill flash*, or TTL+BL.

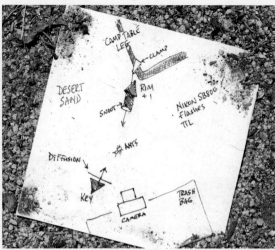

FIG. 5.11 and **FIG. 5.12** In the evening, when the desert cools down, ants move much slower, making it a lot easier to get photos without being bitten. Without any sunlight, this image was originally very boring. Shooting from a low angle, adding a couple of flashes with warming gels, and putting my camera white balance on cloudy created a realistic sunlit scene. The sketch shows how I set up my lights. Mojave Desert, California. (Nikon D300, ISO 200, 105 mm macro lens, two off-camera flashes with gels, handheld, 1/200 sec. @ f/16.)

The quality of light coming from a flash is pretty hard. The flash is small and usually far away, not a problem when all you're doing is adding some fill. But if you're using flash as the main light, you may want to soften the light with a diffuser. Diffused flash is used a lot with portraits of people and pets, but it's not very practical for wildlife or moving subjects—they're just too far away. If the subject is close, a few feet away or less, then it works well. I use diffused flash quite often in close-up photography.

In the ant photo, I decided to diffuse my main flash to give a more rounded look to the ant's shiny carapace. I used my second flash, mounted behind the ant, to simulate hard sunlight. The result looks pretty real, especially since it was taken after sunset (**FIG. 5.11** and **5.12**).

Usually the light from my flash is a bit cool for my taste, so I add a little warmth with colored gels. Adding color to a flash is another way to get your lighting to reflect how you see a scene. Nikon flashes come with a little filter kit, but Sticky Filters are my favorites—slap them on the flash and they stick.

Questions & Answers

Q **How did you freeze that bee?**

A A camera shutter can go off at pretty fast speeds, but not fast enough to freeze the action of many nature subjects. A flash emits a burst of light at very short durations, based on the power setting. At full power, the duration might be 1/800 second, which is pretty fast, but at 1/32 power it's closer to 1/20,000 second.

Here's how I froze the flying bee in the opening photo of this chapter: I found a patch of flowering blue-eyed grass that was swarming with bees. I sat down next to the flowers, set my exposure for the ambient light so the background wouldn't be black, and shot as bees flew in. Using a TTL flash mounted on a flash bracket allowed me to get the flash closer to the bee, causing the flash to fire at a lower power and for a shorter duration. I needed that shorter duration to try to freeze wings flapping at 200 beats per second. Every time a bee came in, I'd get 3–4 shots before my flash would have to recharge. Ten minutes later, I had about four good shots. All you need is one perfect shot.

Q **Your images don't look like you used a flash. Why not?**

A Depending on the scene, I balance my flash with ambient light to give a natural look. If the ambient is too dark, I use my flash to light the whole scene. The more flashes I have, the larger the scene I can light. But let's say that we only have one flash. Now it's about the direction and quality of the light. Getting the flash off camera and lighting into the subject's face, rather than from the back, helps to direct the viewer's eye to the subject. Using a diffuser or just getting the flash really close creates a softer light, filling in those shadows and making the scene look more natural. If you have the background close to the subject, the flash can light everything, and you won't get that black background that usually looks so unnatural. Use the plus and minus adjustments on your flash, control the ratio between ambient and flash, pay attention to shadows and the direction of light—all of these techniques can help to make your images look natural (**FIG. 5.13** and **5.14**).

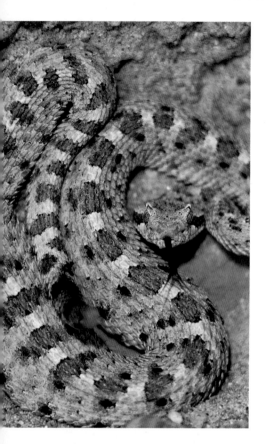

FIG. 5.13 We were camping in Red Rock Canyon State Park. In a small cave in the cliffs, one of my students found this little sidewinder rattlesnake. It was backed up against the wall and unhappy to have visitors. Using long lenses, we could stay a safe distance away, and my flash was able to light the whole scene. Mojave Desert, California. (Nikon D100, ISO 200, 80–200 mm lens, flash off-camera, tripod, 1/180 sec. @ f/11.)

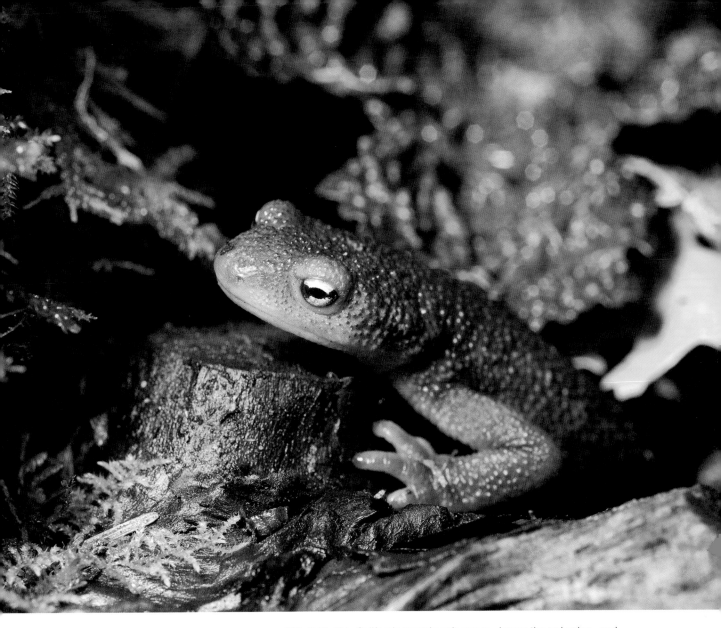

FIG. 5.14 This California newt is poisonous—hence the red color—and not afraid of people. Most of the time newts are buried in the leaf litter on the forest floor, but each spring they journey to streams to breed and lay eggs. I used a diffused flash high on the left as my main light, pointed at the newt's face. Butano State Park, California. (Nikon D300, ISO 800, 105 mm macro lens, off-camera diffused flash with gel, handheld, 1/125 sec. @ f/11.)

▼ FIG. 5.15 Named for its habit of hiding between the petals of flowers to wait for prey, this bug is called a *flower mantis*. I used diffusion on the flash to make the light soft, and made sure that the flash hit both the flower and the insect. That way, my background stayed nice and bright, just the way it looked. TTL flash tends to make light colors darker than I like, so I set my flash to compensate by +1 stop. Flower mantises are native to Asia and Africa. (Nikon D2X, ISO 200, 105 mm macro lens, diffused off-camera flash, tripod, 1/50 sec. @ f/16, captive.)

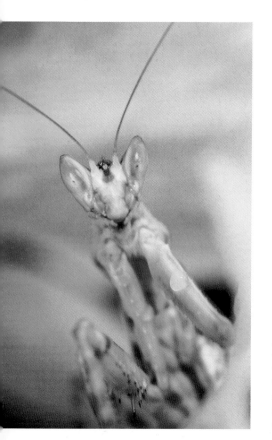

Q *When I use my TTL flash, why are black subjects too light and white subjects too dark?*

A Another thing that your system might not do quite right is make whites white and blacks black. The camera and flash make everything gray. Why? It's a long story. All you need to understand is that if the system sees a white subject and you want to keep it white, you have to tell the TTL flash to overexpose a bit. You do this on the flash, changing the compensation button to a plus setting. If the subject is black, use the minus setting. This setting fools the whole system and makes your colors and tones look the way they should. I use this option all the time; on pink or yellow things, I go to about +1 on the TTL flash (**FIG. 5.15**).

Q *When I use a slow shutter speed with flash, the blur is in front. How do I move the blur behind the subject?*

A When you use flash in combination with slower shutter speeds, you can get a real sense of motion in your photographs. The motion blur comes from the ambient exposure, and the flash freezes the subject. To make the motion blur look natural, you want the flash to fire at the end of the exposure, so the blur shows up behind the subject. The camera/flash system's "front-curtain sync" setting fires the flash at the beginning of the exposure; you need to set it for "rear-curtain sync" or "2nd-curtain sync" to blur behind the subject (**FIG. 5.16**).

▶ FIG. 5.16 I was camping on Anacapa Island and wanted to get the sunrise over the lighthouse. I knew that the western gulls might take off as the sun came up, because I saw them settle in around the lighthouse the previous evening. I set up my tripod, put on a wide-angle lens, turned my flash on full power (this was before TTL), made sure that rear-curtain sync was enabled, metered the sky to get my exposure, and waited. As the sky started to get some color, I took a shot every time the light from the lighthouse came around. On one shot a gull was perfectly positioned. It's amazing when everything comes together, but sometimes you have to make your luck happen. Channel Islands National Park, California. (Nikon F3, ISO 64, 200 mm lens, on-camera flash, tripod, Kodachrome 64, exposure unrecorded.)

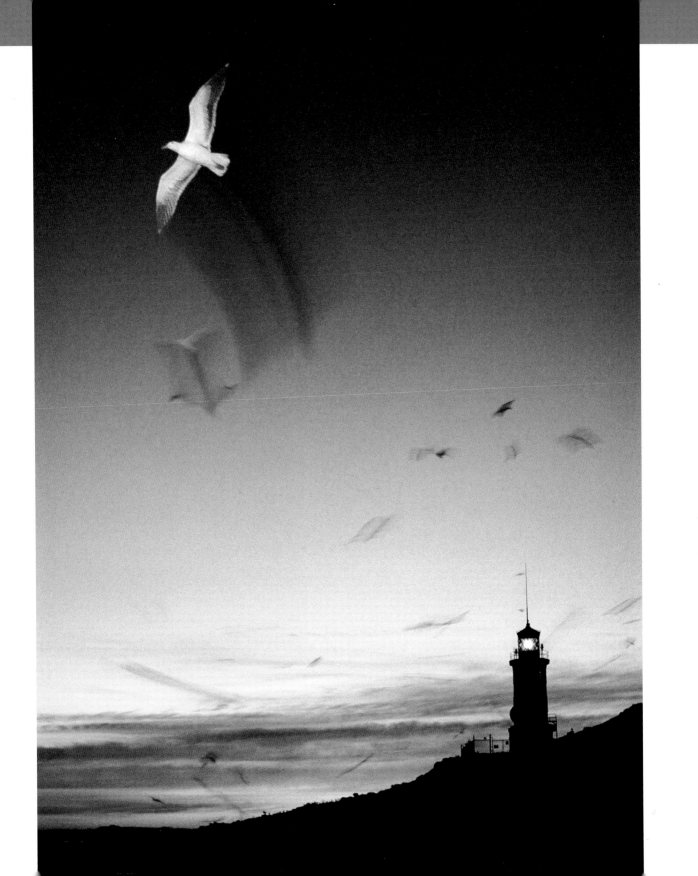

Assignments to try

- This assignment is easy. From now on, when you take pictures on a sunny day, turn on your flash and set it to the -1 or -2 TTL compensation, or one of the auto-balanced fill-flash settings. Try backlighting the subject with the sun and using the flash (my favorite setting). Throw a little diffuser on the flash to soften the light, if you want. Really, I'm serious. You'll immediately see an improvement in your images. This will only work if your subject is within about 25 feet. The distance depends on the ISO and the f/stop you're using.

- Find a subject to pose for you. If you have access to a couple of wireless flashes, set up a rim light and key/fill light arrangement. Control the contrast with your wireless system as I did with the ant shot discussed earlier. Maybe use a snoot on the rim flash and some diffusion on the other flash. Play around, have fun (**FIG. 5.17**).

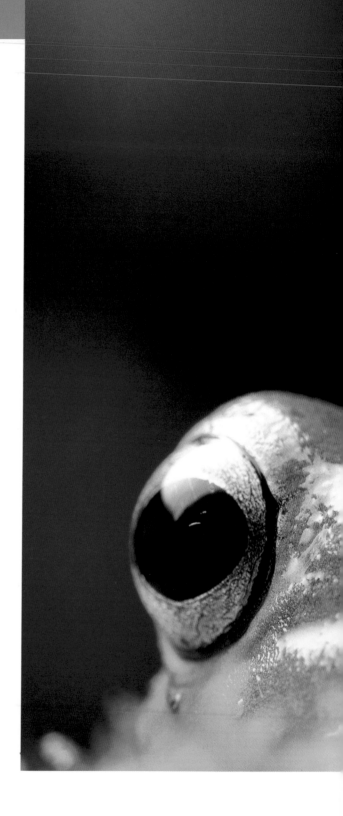

FIG. 5.17 White's tree frogs aren't very active; they seem to like to sit and watch life happen. Choosing a really low angle made for an interesting point of view and helped to clean up a busy background. Since the frog's skin is wet and shiny, I put a large diffuser on my flash and held it high on the left. Shiny subjects always look better with soft light. You can see the reflection of the square diffuser in the frog's eyes. (Nikon D2X, ISO 200, 105 mm macro lens, diffused off-camera flash, handheld, 1/250 sec. @ f/16, captive.)

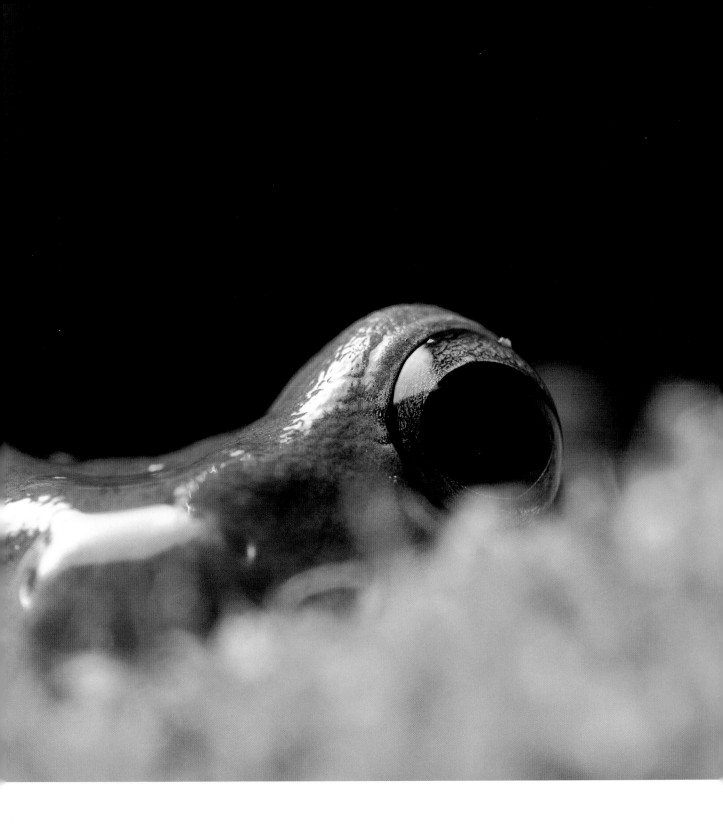

6 Wet-belly photography

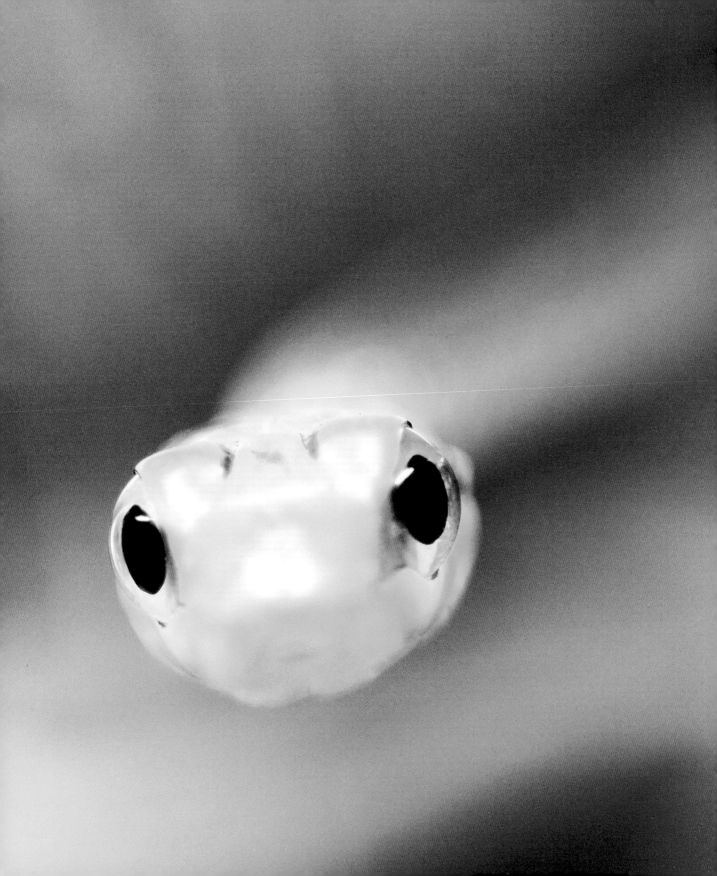

Most people step on what I like to photograph.
Explore the world beneath your feet, and you'll
find an environment rich in subject matter.

Finding flowers and chasing bugs

Most living things in the world are small. Actually, most are microscopic. In this chapter, we're going to stick with tiny things we can see: frogs, lizards, bugs, spiders, flowers, butterflies—pretty much anything smaller than your hand but still large enough to see.

You can find interesting plants anywhere. Try the vase on the dining room table, or a garden or vacant lot. Finding bugs? Where there are plants, there are bugs. That's what's so cool about plants and bugs—wherever you are, they are (**FIG. 6.1**).

You don't have to go far to find subjects for close-up (macro) photography, but you do need to crawl around at their level. Some people call this low-level approach to finding close-up subjects "wet-belly photography." When I'm doing this in the desert, I call it "sticker belly." It may be uncomfortable, but a lot of your subjects live on the ground, so get on your belly and start looking.

FIG. 6.1 Butterflies are among the most beautiful creatures in nature. Each summer, a living butterfly exhibit arrives at our local museum of natural history, and I spend hours there watching butterflies land on me. Santa Barbara, California. (Nikon D2X, ISO 100, 105 mm macro lens, 1/2x magnification, on-camera TTL flash, handheld, 1/50 sec. @ f/5.6, captive.)

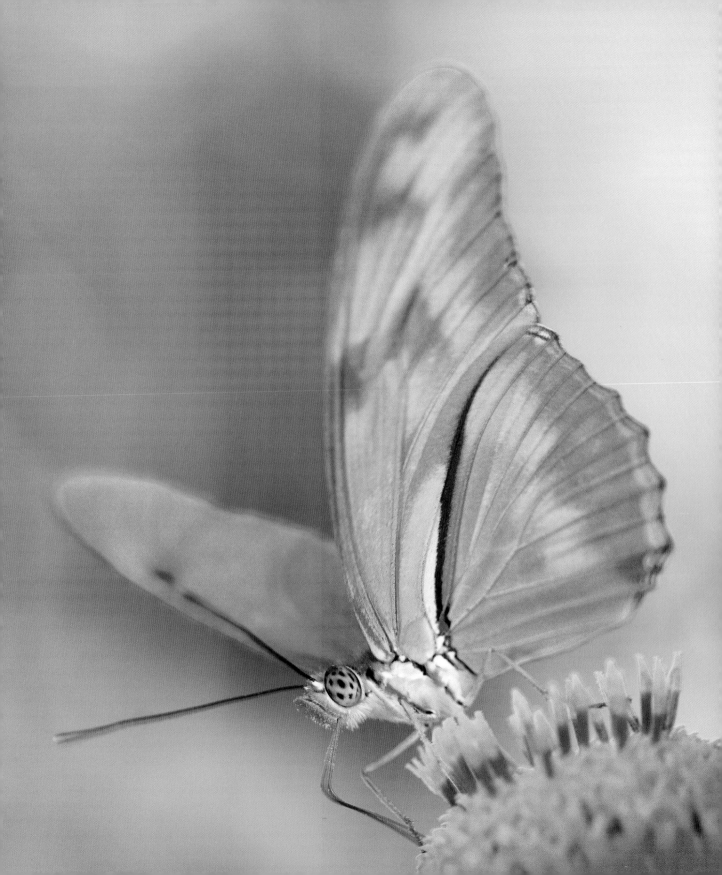

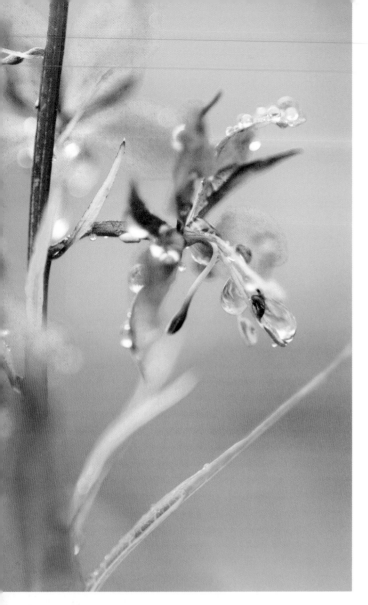

FIG. 6.2 It rains a lot during the summer on the Alaskan tundra where I found this fireweed flower. The soft light and green background make for perfect flower photography. Staying dry is a big concern here. Not you—you work fine whether wet or dry. It's the camera that has to stay dry, so I used a camera raincoat. Denali National Park, Alaska. (Nikon D200, ISO 200, 105 mm macro lens, 1/3x magnification, handheld, 1/250 sec. @ f/4.)

All-day shooting

Wild areas such as meadows, forests, swamps, streams, and mountains contain so many close-up subjects that the hardest part is choosing what to photograph. If you're curious and patient, you'll find the right subject. A great thing about close-up shots is that you can capture them at any time of the day, all day. Many flowers need a lot of sun to open fully, so you can work with them at midday, when the light is hard. Others will bloom in sunlight or shadow (**FIG. 6.2**).

A lot of close-up images can be shot with artificial light; for instance, the small green parrot snake in the chapter opener. On a trip with friends to Costa Rica, we spent a few days in the Monteverde cloud forest. We didn't have time to find all the amazing creatures in the wild, so instead we went to a nearby herpetarium (a zoo for reptiles and amphibians). The parrot snake was in a terrarium lit by fluorescent light. Using a high ISO and 105 macro lens, I focused on those dark eyes, creating a strong relationship between the snake and the viewer. All the subjects I needed were indoors, so I could shoot close-ups all day.

Even in seemingly lifeless places like the desert, you'll find amazing, tiny things. Some of the smallest flowers I've ever seen just appeared out of the sand after a brief rainfall in the desert. Plants have seasonal variations. Be sure to do your research on regional growing seasons, so you can take advantage of the opportunities each environment may provide—like one of those California spring wildflower seasons when the ground looks like someone splashed paint out of an airplane (**FIG. 6.3** and **6.4**).

TIP I don't like getting my belly wet or stickered, so I always carry a big white trash compactor bag to put on the ground under me.

▶ **FIG. 6.3** Harsh environments like mountains and deserts are hard on plants. This Wallace's woolly daisy grows only about an inch high—so low to the ground that people call them "belly flowers." Mojave Desert, California. (Nikon D100, ISO 200, 105 mm macro lens, 3/4x magnification, handheld on beanbag, 1/200 sec. @ f/11.)

▼ **FIG. 6.4** California poppies only open between 10 a.m. and 3 p.m.—very convenient if you don't like getting up early. This show of wildflowers is in the Antelope Valley Poppy Preserve, in the Mojave Desert north of Los Angeles, California. The poppy bloom is different each year and depends a lot on when the rains come. A great website called Desert USA (listed in the appendix) has wildflower reports. (Nikon D100, ISO 200, 14 mm lens, tripod, 1/250 sec. @ f/14.)

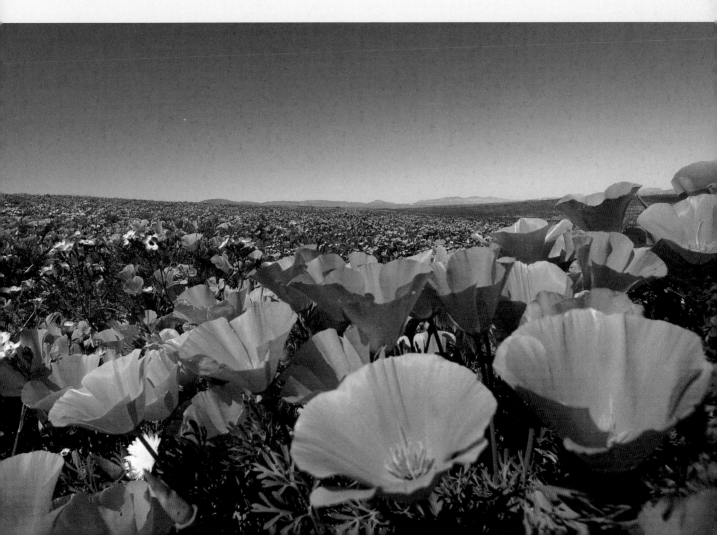

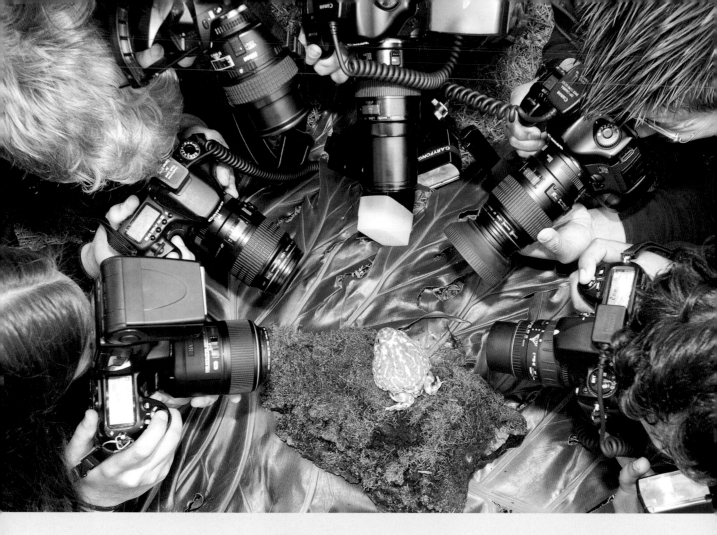

▲ **FIG. 6.5** A group of my students "macro-ing" away on a horned frog at the "critter demo" in our nature photography class. The most common macro lenses are the Canon 100 mm and Nikon 105 mm, but macro lenses come in a variety of different focal lengths, from 50 mm to 200 mm.

FIG. 6.6 This dime was shot at life size (1x).

FIG. 6.7 This image shows the scale difference between 1/2x and 1x—two of the dimes at half life-size fit on top of one of the life-size dimes.

Equipment

Close-up photography requires specialized tools such as macro lenses, extension tubes and flashes, plus all kinds of little focusing aids, grippers, and brackets. You may need a bigger bag for all this stuff (**FIG. 6.5**).

Lenses

To focus close to your subject and get it big in the frame, you'll need special lenses. Most standard lenses just can't focus close enough to get what you need. True macro lenses can focus very close and get life-size (1x) photographs. The term *life size* means that the subject captured on the digital camera chip is the same size as the actual subject. We'll use a dime to illustrate this point. In **FIG. 6.6**, the dime is photographed at life size (1x). If you could remove the chip from the camera (think of it as a frame of 35 mm film), you could fit the actual dime exactly on top of the image of the dime on the chip. If you photograph the dime at half life-size, you could fit two of them on the life-size dime, as we did using Photoshop in **FIG. 6.7**.

Macro lenses come in a variety of fixed focal lengths. Some zoom lenses say *macro*, but they aren't true macro lenses, and usually can't get close enough to give you real close-up photographs. I use Nikon 60 mm, 105 mm, and 200 mm macro lenses. Canon and many other manufacturers make macro lenses in similar focal lengths. Canon even makes a special macro lens that focuses very close, from 1x to 5x—that's five times life size. This lens won't focus past a few inches, so it's only used for high-magnification close-up photography (**FIG. 6.8**).

Magnification has side effects: As you focus closer to your subject, you lose light. At 1x, you've lost two stops. More magnification also equals less depth of field. *Depth of field* indicates how much of your image is in focus. Using a DSLR with an APS-sized sensor and a 100 mm lens, shooting at f/16 with life-size (1x) magnification, your depth of field will be only 1/5 inch. To see this principle for yourself, place a ruler longways in front of your macro lens, focus on one of the lines on the ruler, and take a picture. Then check it out on the computer.

FIG. 6.8 I have no idea what kind of beetle this is; it fell out of a tree onto the paper. It's so tiny that I decided it would be a great subject for the super macro lens from Canon. The lens was less than an inch away from the beetle. When you're so close, it's hard to get a flash between the lens and the subject. This is a perfect situation for macro flash systems that attach to the front of the lens. Santa Barbara, California. (Canon EOS1DS, ISO 100, 65 mm 1x–5x macro lens at about 3x magnification, Canon ring flash, handheld, 1/200 sec. @ f/11.)

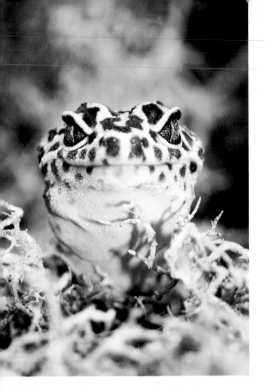

FIG. 6.9 A friend of mine, Dennis Sheridan, is an animal wrangler who works with reptiles, amphibians, and insects. Some of his animals are used in movies. This is one of his great reptiles, a leopard gecko from the Middle East. Many people have these animals as pets. Give you any ideas for where to find exotic subjects? (Nikon D300, ISO 200, 105 mm macro lens, 1/2x magnification, off-camera TTL flash with diffusion, tripod, 1/40 sec. @ f/16, captive.)

Extension tubes

If you don't have a true macro lens, you can use an *extension tube* to get greater magnification. These hollow metal rings come in different lengths and attach between the camera and lens. Using an extension tube allows any lens to focus closer.

When you add an extension tube, you shift the focus range of the lens closer. For example, if your regular 50 mm lens can normally focus from 1.5 feet to infinity, adding a 50 mm extension tube allows it to focus from about 3 inches to about 10 inches. You've turned your normal lens into a close-focus lens that can do life-size magnification. You can't focus at infinity anymore, but who cares? We're doing macro photography.

You can use extension tubes with normal lenses, telephoto lenses, and even zoom lenses. Before you buy extension tubes, however, make sure that they work with your lenses.

Diopters (close-up filters)

Another way to make a normal or zoom lens focus closer is to screw a close-up diopter onto the front of the lens. You can use diopters on any lens; the key is to buy a large-diameter diopter, such as a 72 mm, and then get a step-up ring so you can screw the 72 mm diopter onto the front of your lenses. Diopters come in different powers and quality. For the best quality, get a *two-element* diopter. They cost more, but produce better images by correcting more optical aberrations. For a great macro setup, put the Canon 500D close-up diopter on a 70–300 zoom lens. This will get you 3/4x. With just one lens and a close-up filter, you can get close enough to that butterfly or lizard to fill the frame (**FIG. 6.9**).

Lighting

Adding light to what's already there can enhance the color and mood of your photos. You can use a small flash as the main light or to add fill light. And it doesn't have to be a flash. If you're shooting in darkness, try using a flashlight, as I did with the red-eyed tree frog in **FIG. 6.10**.

In many macro situations, you're so close to the subject that you have to get your flash off camera and point it at the subject if you want anything lit. When working in the field, I typically use one off-camera TTL flash.

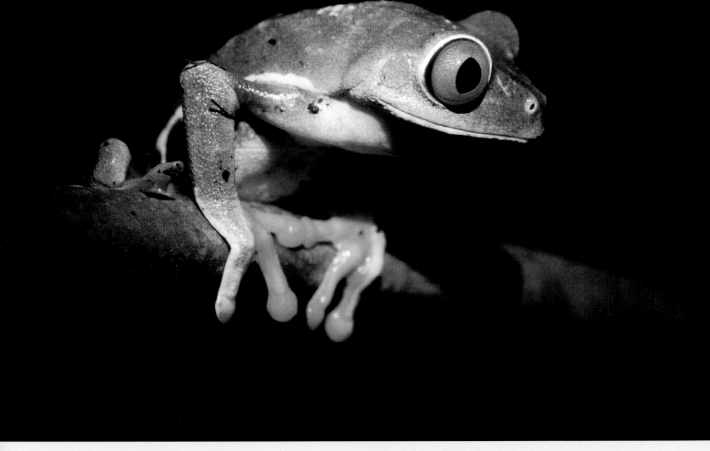

FIG. 6.10 This red-eyed tree frog is another creature we found at the herpetarium in Costa Rica's Monteverde cloud forest. These nocturnal frogs are active mainly at night; the herpetarium keeps the terrarium dark so you can see the frogs moving around, rather than sleeping. (Nikon D2X, ISO 400, 105 mm macro lens, 1/2x magnification, lit with flashlight, tripod, 1/10 sec. @ f/11, captive.)

▼ FIG. 6.11 I was photographing a butterfly in Costa Rica's mountain forests. When I knelt down to get a lower angle, I found this harvestman hiding under a leaf. By using a flash, I was able to freeze any motion caused by handholding the camera. Placing the flash off to the side helped to make the shot more dramatic. (Nikon D2X, ISO 200, 105 mm macro lens, 1/2x magnification, handheld, flash off-camera, 1/50 sec. @ f/8.)

Aiming the light in one hand while shooting with the other takes some practice, but it works well in many situations. If you don't want to hold the flash, buy flash brackets that hold the flash for you. Some camera and flash manufacturers offer special macro flash systems. Most are wireless and come with two flashes mounted around the lens. Using two flashes gives you more light; more importantly, it allows you to give shape to your subject by controlling the amount of light coming from each flash. These systems are essential for high-magnification shots (**FIG. 6.11**).

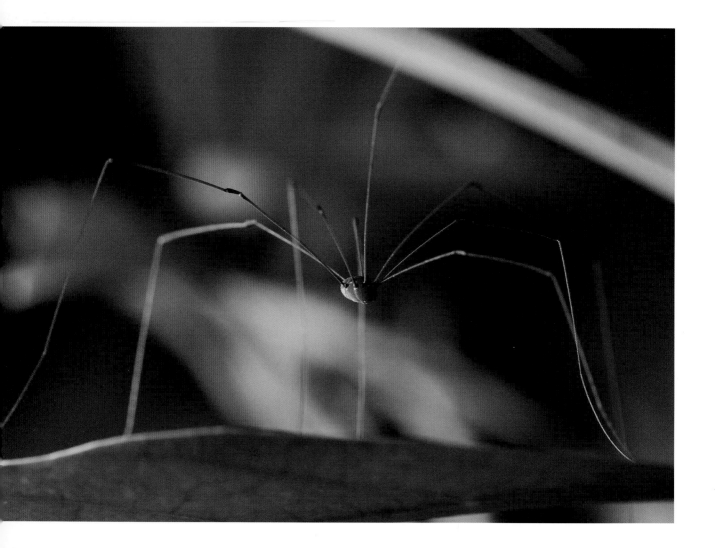

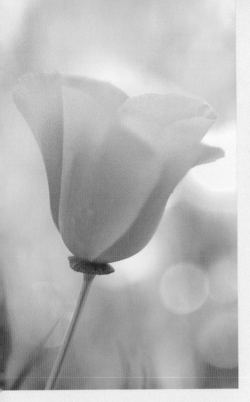

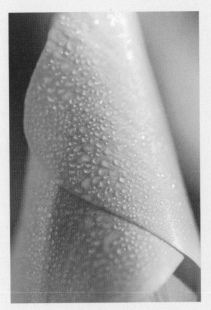

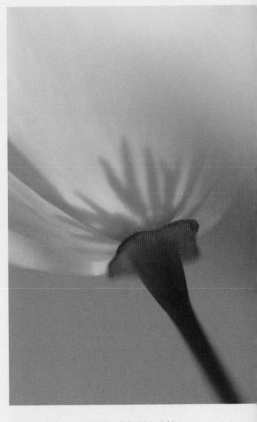

FIG. 6.12 Nikon D100, ISO 200, 1/3x magnification, 105 mm macro lens, diffusion over flower, handheld, 1/640 sec. @ f/3.5.

FIG. 6.13 Nikon D100, ISO 200, 3/4x magnification, 105 mm macro lens, reflector bouncing sunlight into flower, handheld, 1/500 sec. @ f/11.

FIG. 6.14 Nikon D100, ISO 200, 3/4x magnification, 105 mm macro lens, backlit by sun, handheld, 1/2000 sec. @ f/5.

Flash is essential for moving subjects such as insects, but I prefer natural light when photographing flowers. With natural light, I still need to control my lighting and contrast, so I use small reflectors and diffusers to bounce light into shadows and soften the quality of harsh sunlight. Leaves and flower petals are translucent; backlighting them can produce beautiful results. In the series of California poppies in **FIG. 6.12** to **6.14**, taken on a sunny morning, I used everything I had—reflectors, diffusers, and backlighting with the sun. They were all taken lying on my belly in the same spot. All I did was change lighting and compositions.

Questions & Answers

Q **How can I make my subjects stand out?**

A Because small subjects tend to blend into their surroundings, getting them to stand out is important. A lot of animals use camouflage to disappear into the background. One way to separate an animal from its environment is to use backlighting or sidelighting. For example, on closer inspection, the picture of feet on a rock in **FIG. 6.15** is the resting place of a frog. I composed so the shadows created by the sun would fall to the side and reveal the frog. It's still amazingly well hidden, though.

To make a subject really stand out, you need to be aware of the distance from the subject to the background, and the depth of field. If only the subject is in focus and the background is out of focus, the subject will separate from the background and stand out. The farther the subject is from the background, the more out-of-focus the background will be. You might have to move the subject to a new location; if so, be very careful not to injure the subject. Use a stick or a leaf instead of your hand (**FIG. 6.16**).

FIG. 6.15 It was spring in the Anza-Borrego Desert, and the stream in Palm Canyon was running strong. I was sitting on a boulder with my son, Gray; as we cooled our feet in the water, he pointed down by his toe. There, sitting perfectly still, was a totally camouflaged California tree frog. Sidelighting with the sun created shadows that helped separate the frog from the rock. Anza-Borrego Desert State Park, California. (Nikon F4, ISO 80, 105 mm macro lens, handheld, Kodak Ektachrome film, exposure unrecorded.)

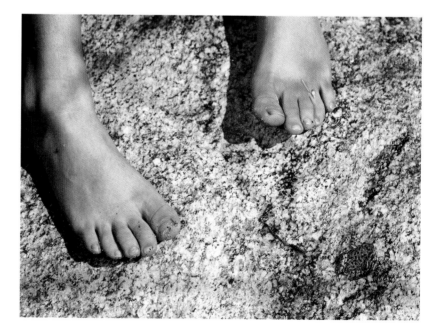

FIG. 6.16 At over eight inches long, banana slugs are the largest land slugs in North America—and probably the slimiest. I got low here, so the busy forest background would be far away. If I had shot downward toward the slug, a lot more of the log would have been in focus, and the slug wouldn't have stood out as well. Limekiln State Park, California. (Nikon D100, ISO 200, 105 mm macro lens, 1/3x magnification, one flash off-camera, tripod, 1/15 sec. @ f/11.)

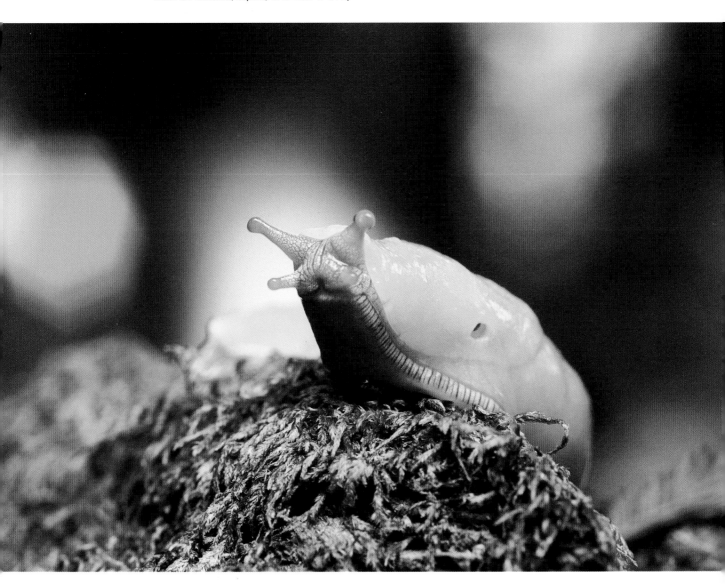

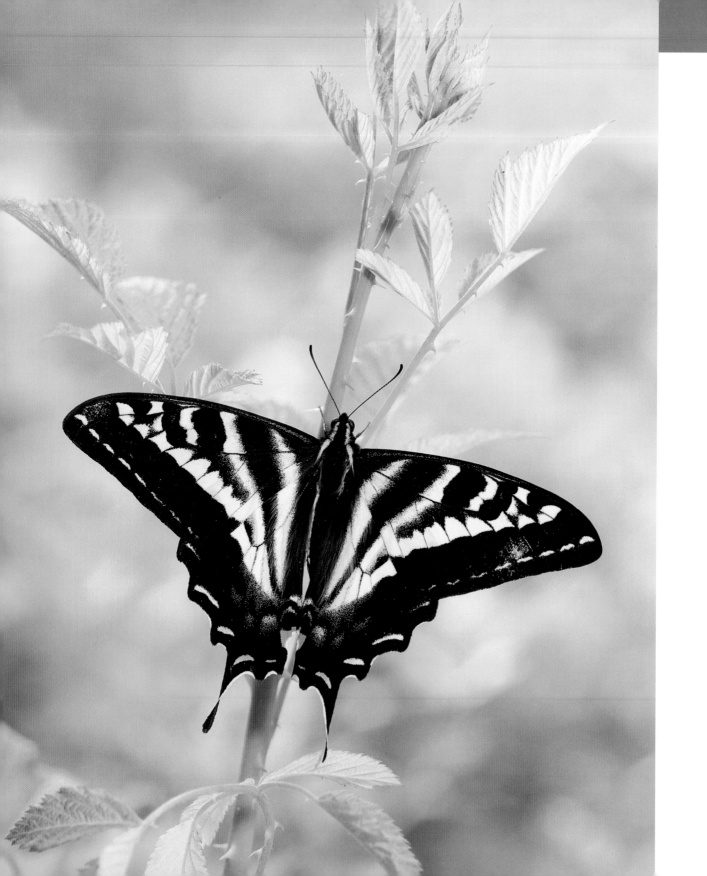

Q *How do you get your subjects entirely in focus?*

A I use two different techniques to get a subject in focus: plane of focus, and depth of field. Different subjects have different planes; many subjects, such as flowers and butterflies, have more than one plane. Think of the plane as a line through the part of the subject that you want in focus. The trick is to get your camera parallel to that line. This may sound easy, but it takes a lot of patience to tweak your camera position a tiny bit at a time to get everything sharp. When the subject is more mobile, like a butterfly, you really have to think about framing the shot before you approach. Most successful butterfly shots have the wings all in focus—if half of the wing is out of focus, the image doesn't work very well (**FIG. 6.17**).

Remember, depth of field is directly related to magnification—more magnification equals less depth of field. We're working so close to our subjects that we don't have much in focus, so think about your subject. What do you want in focus? Using a wide aperture, like f/2.8, will give you a shallow depth of field, blurring everything around the subject. Using an aperture like f/11 or f/16 will produce lots of depth of field. You could also back up and get less magnification, which gives you more depth of field, and then crop your image on the computer to get the subject larger in the frame (**FIG. 6.18** and **6.19**).

◀ **FIG. 6.17** If you're very lucky, butterflies like this large swallowtail in Kings Canyon National Park will stop long enough for you to set up your shot. This was early in the morning, which is a good time to find butterflies sunbathing. They're cold-blooded, so they can't fly well until they warm up. Shoot fast; once they're warm, they fly away. California. (Nikon D200, ISO 200, 105 mm macro lens, 1/3x magnification, flash on-camera, tripod, 1/100 sec. @ f/5.6.)

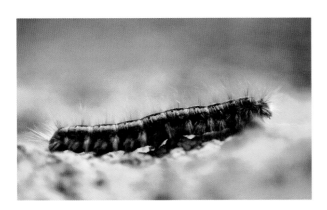

FIG. 6.18 A Western tent caterpillar crawling over a lichen-covered rock. Shooting with a wide aperture created the shallow depth of field I needed. Wide apertures give you less depth of field. Mojave National Preserve, California. (Nikon D2X, ISO 200, 1/2x magnification, 105 mm macro lens, handheld, 1/4000 sec. @ f/3.8.)

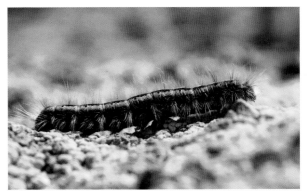

FIG. 6.19 A lot more is in focus in this shot of the caterpillar, because I stopped down to f/11, a smaller aperture. The smaller the aperture, the greater the depth of field. And yes, the caterpillar is alive, I just kept picking it up and putting it down in the same spot. (Nikon D2X, ISO 200, 1/2x magnification, 105 mm macro lens, handheld, 1/500 sec. @ f/11.)

FIG. 6.20 Look at those eyes! This jumping stick insect is from South America, another one of Dennis Sheridan's insects. Since I was handholding my camera at such a high magnification, I had to use a fast shutter speed and a flash to make sure that nothing moved. Santa Barbara, California. (Nikon D2X, ISO 200, 105 mm macro lens, 1x magnification, flash off-camera, handheld, 1/250 sec. @ f/16, captive.)

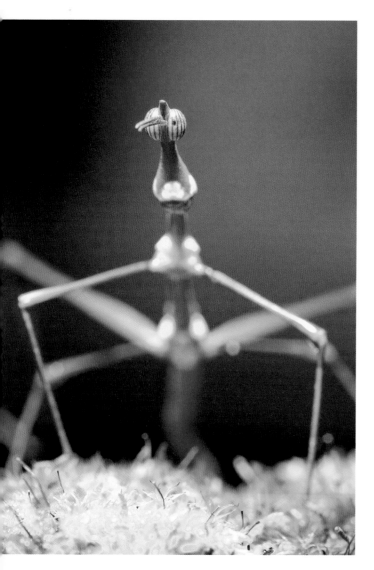

Q *My close-ups are fuzzy and dark. What should I do?*

A At the risk of stating the obvious, *fuzzy* means that things aren't sharp. Close-up photography uses higher magnifications, making your images more prone to camera shake and subject movement.

With higher magnification, your focus must be dead-on. If you're handholding the camera, you have to use higher shutter speeds to eliminate camera shake. And it's always a compromise—higher shutter speeds mean wider f/stops and less depth of field, but you have to get the image sharp. Try using a higher ISO to help get faster shutter speeds. You can work on the shallow-focus problem by paying attention to the plane of the subject and using f/stops like 11 and 16 to get more depth of field.

A tripod will prevent camera motion and allow you to use slower shutter speeds, and one of those Plamps that we talked about in Chapter 2, "You need more stuff?" can help to hold a flower steady in the wind. You can also add a flash or two, especially when shooting insects and other moving things. A flash can help to freeze motion, giving you more light to shoot at the smaller f/stops. Remember to get your flash off-camera, really close to the subject, and use the TTL flash mode (**FIG. 6.20**).

TIP Finding out what you've photographed and writing complete captions is important in close-up work. You need an answer for "What is it?" Researching your subjects also adds meaning to your photographs and completes the process. Don't rely on just the Internet for your research; if you're stumped, try showing your images to a local gardener or an insect specialist at a local museum.

Q **When shooting close-ups of tiny or fragile things, how do you avoid disturbing the subject?**

A When you're working with dandelion seed heads, butterflies, and other delicate subjects, move slowly. Pay attention to where your camera and tripod are. Where's that camera strap? Is it going to catch on a bush, scare away the butterfly, break a flower stem? Moving slowly and watching where I put my hands and equipment goes a long way toward not disturbing the things I photograph. And because I'm moving slowly or not at all, things come to me. A cricket might land on a leaf nearby, or I see a flower I hadn't seen before. With animals, I'll start shooting from farther away, and then scoot forward a bit and take some more pictures. If it doesn't seem bothered, I move a little closer and keep shooting. This staggered approach lets them get used to my presence, which usually results in some very close encounters (**FIG. 6.21**).

Assignments to try

- Practice some depth-of-field and focus techniques. Using a macro lens, shoot the same subject at f/4 and f/16. Try different subjects, and work with each subject's plane of focus.

- Here's a way to practice finding things. Lie down on the ground anywhere outdoors where there are natural plants, and stay still for half an hour. Breathe deeply, slow down, practice patience. Photograph all the cool things you start to see. Don't get up! It's okay to scoot around a bit. Try not to squish too many plants; working from the edge of a path can help. This is wet-belly photography, so remember to bring your trash compactor bag.

FIG. 6.21 I noticed this fork-tailed bush katydid nymph eating one of my wife's garden flowers. I got my camera all set up; starting a few feet away, I slowly moved closer and closer. I took photos as I moved, not knowing when it might jump away. This is as close as my lens would focus. Santa Barbara, California. (Nikon D300, ISO 400, 105 mm macro lens, 1.5x magnification, handheld, 1/1250 sec. @ f/5.6.)

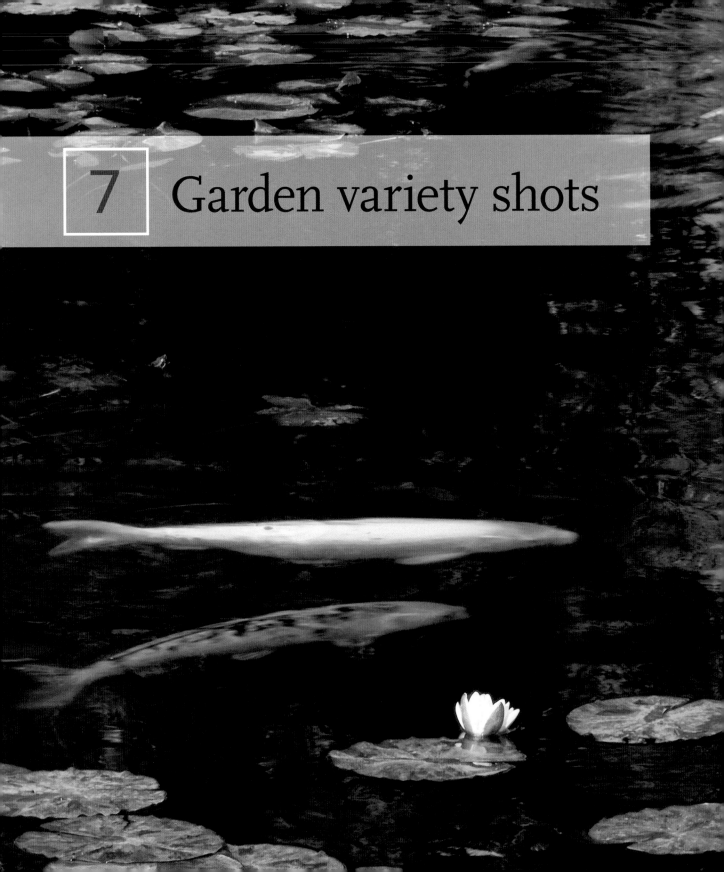

7 | Garden variety shots

Make beautiful images without packing a suitcase—
simply by walking out your back door.

Nature so close

I love gardens. They can have everything you'd ever want to photograph: trees, flowers, ponds, rabbits and squirrels, small birds, lizards, snakes, frogs, turtles, and all the insects you could want. Some of my friends' gardens are visited by deer, moose, coyotes, and bear. On our trips to Africa, warthogs have "mowed" the garden lawn in front of our lodge.

Most cities and small towns have public gardens. Alice Keck Park Memorial Garden in Santa Barbara is one of my favorites. Its large pond, shown in the opening photograph of this chapter, is home to a variety of aquatic species. Many regional botanical gardens feature native plants that attract local wildlife. Most hotels and wilderness lodges I've visited have beautiful gardens full of small wildlife and local plants. Gardens are oases for many animals; hanging out there not only can get you some great photos, but may improve your health and happiness as a bonus (**FIG. 7.1**).

Your own garden, no matter how small, is a miniature ecosystem. For many animals, your garden is just part of a whole neighborhood of gardens. My wife keeps a beautiful little garden full of plants and flowers that attract bees, hummingbirds, butterflies, and small birds. In winter, you can put out natural birdseed; in summer, a birdbath will draw lots of wildlife. The cool thing is that you can spend a day in the garden making beautiful images, then take a hot shower, eat a great meal, and sleep in your own bed.

FIG. 7.1 A lot of gardens attract migratory waterfowl to their ponds and lakes. This wild drake mallard was preening himself in a city park, oblivious to all the people around. The reflection of a blooming tree adds color to this garden scene. Santa Barbara, California. (Nikon D2X, ISO 100, 70–200 mm lens, handheld, 1/400 sec. @ f/4.)

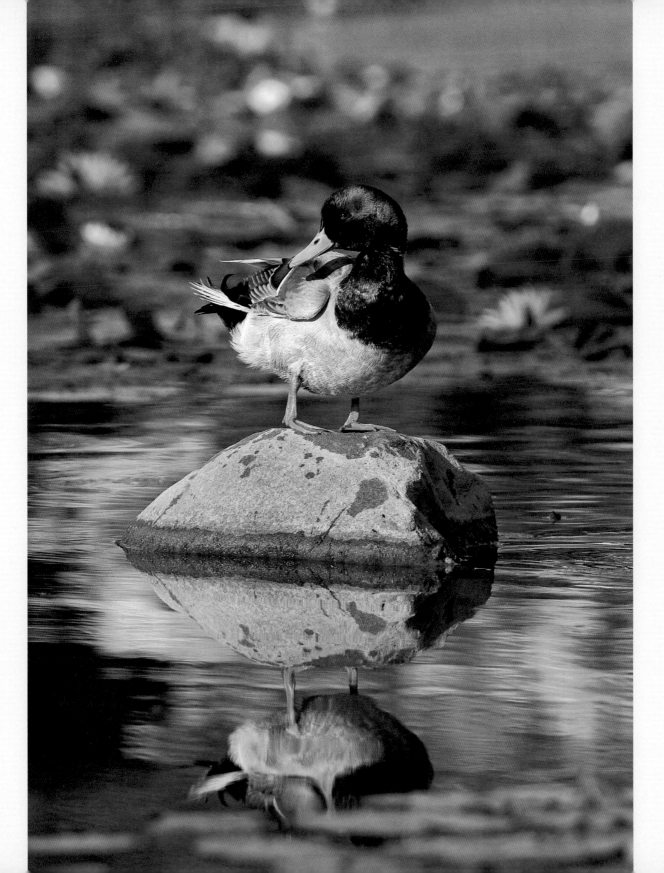

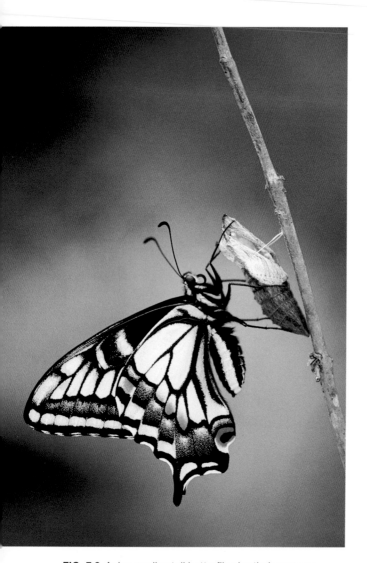

Why some subjects work and others don't

When you're looking for things to shoot, it's not enough just to find a subject; you need to look for the most interesting and beautiful example of that subject. A flower can't have any brown spots or chewed petal edges—it has to be perfect. That may seem obvious, but I'm always surprised when I see photos of a flower with a chewed petal, or half the leaf brown and shriveled. I guess people assume that they can fix the problem in Photoshop, but I'm not interested in more time on the computer. I'd rather spend my time in nature, looking for the perfect subject. But even the most "perfect" subjects show flaws at high resolutions. I retouch as needed, removing spots from petals or lint from an insect's head (**FIG. 7.2** and **FIG. 7.3**).

Most people are attracted to similar things: pristine water drops on a blade of grass, the perfect spiral of a rose, the brilliant colors of spring flowers being visited by bees. It's going to take time to find perfect examples, but what else do you have to do, why are you in such a hurry? Taking the time to look around before you get out your camera can make all the difference in whether your photo is one that will hang on a friend's wall or never escape from your computer.

FIG. 7.2 Anise swallowtail butterflies lay their eggs on anise or fennel plants, which grow like weeds in vacant lots and along roads in our area. I researched this butterfly's lifecycle online, found some plants with swallowtail caterpillars on them, and put those plants in pots in my backyard. A few weeks later I was rewarded with this gorgeous butterfly emerging from its chrysalis. I shot in my backyard on an overcast day in soft light and was careful about using the plane of focus technique to get the body and wings completely sharp. The nice green background is just a wall of English ivy. Santa Barbara, California. (Nikon F4, ISO 50, Fuji Velvia film, 200 mm macro lens, tripod, exposure unrecorded.)

▶ **FIG. 7.3** This rose is absolutely perfect. It took me nearly 30 minutes to find it among hundreds of roses in a public garden. Of the two hours I spent in the garden, I only photographed three roses. There was no wind, and the light was beautiful and soft—perfect for flowers. Santa Barbara, California. (Nikon D300, ISO 400, 105 mm macro lens, tripod, 1/250 sec. @ f/5.6.)

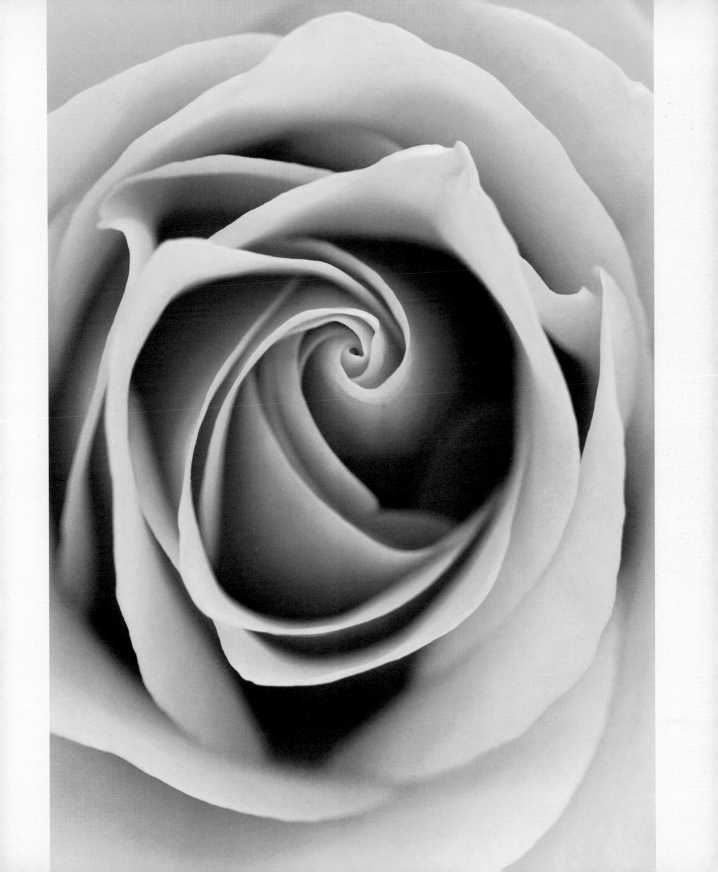

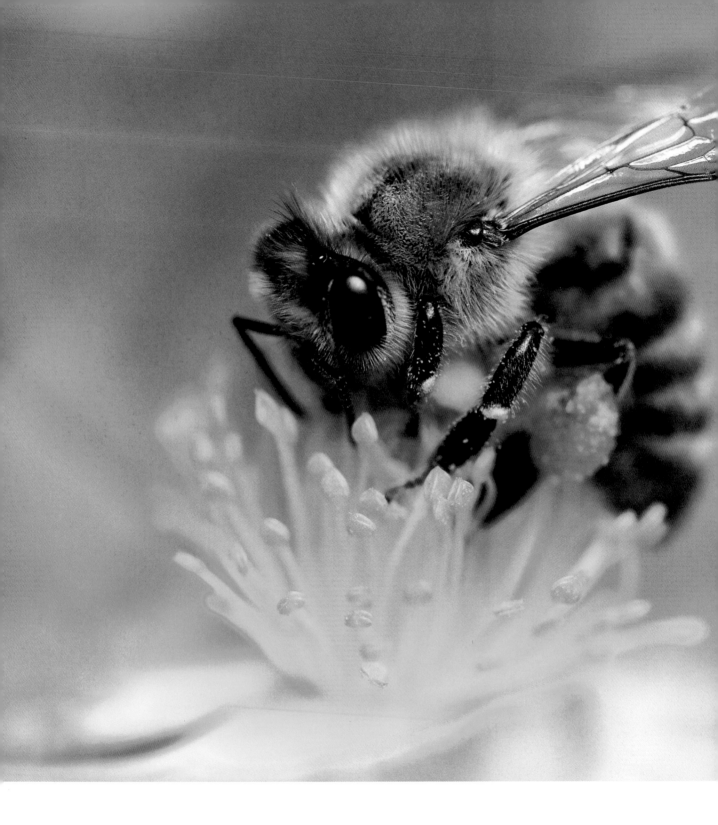

Equipment

Gardens are great places to use all your lenses, but a lot of people think "garden = flower," so they don't bring along their long telephoto or wide-angle lenses. Bring all your stuff, and don't forget the tripod.

A lot of close-up photography is done in gardens, so I'm going to cover some equipment that will help you with capturing the flowers, butterflies, and bugs you'll find.

Lenses

True macro lenses come in different focal lengths, but why would you choose a 105 mm or 180 mm macro lens versus a 60 mm macro lens? The longer lenses are a lot more expensive, larger, and heavier; what's the advantage? The longer macro lenses give you more *working distance*; that is, the distance between you and your subject. At 1x magnification (life size) on a small sensor, the 60 mm macro lens is focused four inches from the subject. The 200 mm macro, at the same magnification, is about 16 inches from the subject. The extra working distance gives you space to use a flash on your subject. And you may need that extra space with subjects such as butterflies, which tend to fly away when you get close, or with bees, which might sting (**FIG. 7.4**).

If you don't have a macro lens, try using a long zoom, 70–200 mm, with an extension tube or a close-up diopter to allow the lens to focus closer. With this type of lens combination, you can capture the longer shot, add the extension tube or diopter, and then move in for the close-up (**FIG. 7.5** and **7.6**).

◀ **FIG. 7.4** A honeybee sipping nectar and collecting pollen on a rock rose flower. This large bush in my dad's garden has flowers for months, and the bees love it. They totally ignore me—it's like they're drunk on nectar. Santa Barbara, California. (Nikon D300, ISO 200, 105 mm macro lens, handheld, 1/250 sec. @ f/11.)

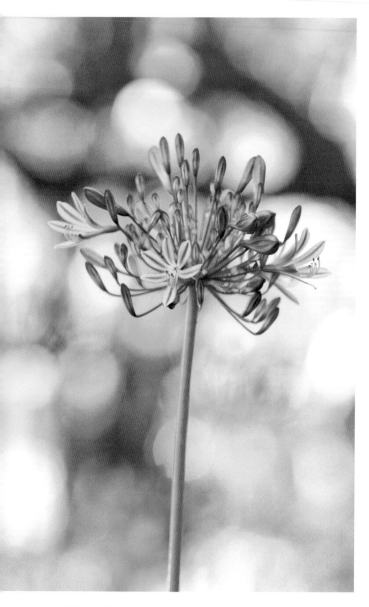

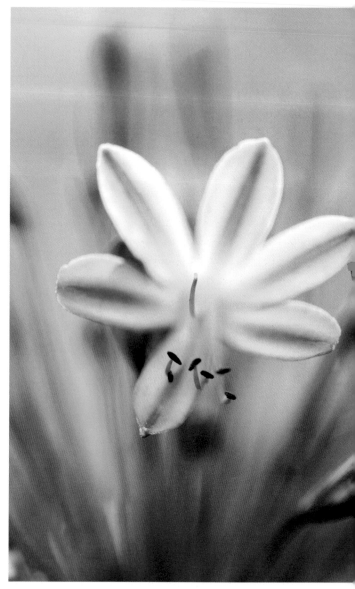

FIG. 7.5 Lily of the Nile (agapanthus) flowers in soft, shady light under a tree. The out-of-focus highlights in the background are just sunlight hitting leaves on another plant. This was about as close as I could focus with this zoom lens at 200 mm. Santa Barbara, California. (Nikon D2X, ISO 200, 80–200 mm lens, tripod, 1/125 sec. @ f/4.)

FIG. 7.6 The same flowers as in Fig. 7.5. By adding an extension tube between the lens and camera, I was able to focus much closer to the flower. Santa Barbara, California. (Nikon D2X, ISO 200, 80–200 mm lens, extension tube, tripod, 1/80 sec. @ f/4.)

The right tripod head for close-ups

When you're working so close to subjects, and at higher magnifications, it's really hard to focus. It's difficult making fine adjustments using a tripod alone, and most tripod heads don't move in the direction you need—forward or backward. You have a couple of choices. If you're using a ball-head with a mounting plate attached to the lens or camera body, you can just loosen the lock a bit and slide the whole camera carefully back and forth on the head. (Don't forget to retighten the lock!)

Another option is to use a *macro-focusing rail*. These little geared assemblies attach to the bottom of the camera and then to the tripod, allowing you to make tiny movements in nearly any direction. Macro-focusing rails don't work well with insects and other things that move, but if you have a stationary object and a lot of magnification, these rails are amazing.

Right-angle finders

I've spent a lot of time lying flat on the ground with my head cranked sideways, trying to see through the camera viewfinder to focus on a tiny subject. Believe me, that hurts after awhile. If you're going to do a lot of low-level photography, not just macro, check out a *right-angle finder*. The one I use attaches to any camera viewfinder and saves me from big chiropractic bills (**FIG. 7.7**).

Lighting

Gardens and other busy scenes usually look pretty bad in harsh midday light, so wait for more interesting light later in the day—or, even better, an overcast day. That's the beauty of working close to home; you can choose your lighting to fit your subject. It's really a bummer when you're on a trip with a bunch of non-photographers on a fixed itinerary, and they're ready to leave for shopping when the light gets perfect for shooting around the grounds. Tell everyone you'll catch up with them for dinner, and go shoot (**FIG. 7.8**).

FIG. 7.7 Right-angle finders really make wet-belly photography a lot more comfortable. They take some practice, since this isn't a natural way to look through a camera, but your neck will appreciate it. Mine has a lever that flips between a 1x and 2x magnified view, great for fine focusing.

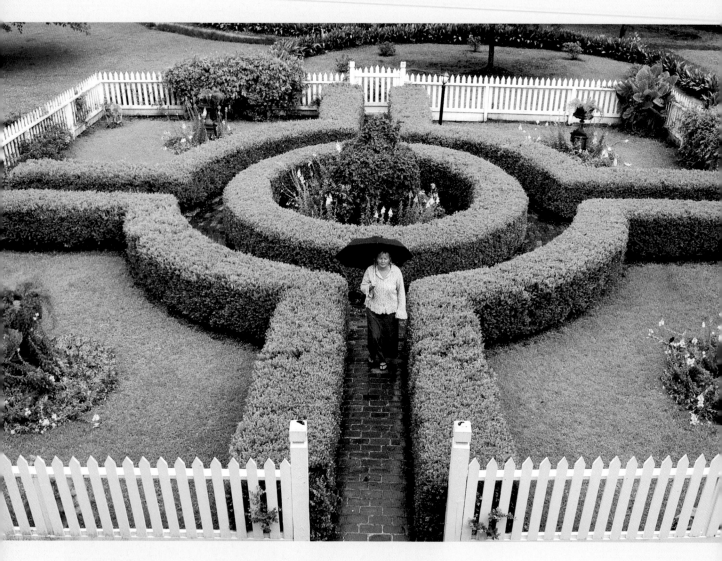

FIG. 7.8 That's my wife, walking in a formal garden at one of the plantations in Louisiana. It's rainy and the light is perfect for this scene. I shot from the balcony and composed so that no white sky was visible. I wish she had been wearing a pink top or holding a red umbrella; a bright color would really make her pop. (Nikon D100, ISO 200, 20–35 mm lens, tripod, 1/80 sec. @ f/4.)

When you photograph your gardens in overcast light, try to minimize any sky in the composition. Totally white sky is boring, and bright areas draw the eye away from the rest of the picture.

What if it's sunny and you still want to take pictures? Just put the sun behind your shoulder, and front-light the scene. Make sure that you have some color in the scene, and compose the photo with colorful subjects in the foreground. Bright, direct sunshine shows off color really well. Don't forget to get close to keep things from getting busy (**FIG. 7.9**).

As you get closer to your subject, you have more options with lighting direction and quality. Remember that leaves and petals are translucent, which lets you compose the scene so light comes through the flower, making it glow with color. You can add some fill light to lighten the shadow side of the flower, using a small flash or even a reflector.

Busy gardens, complex flowers, deep shadows; you've got to recognize that all these things conspire to make uninteresting photographs. Composition, lens, subject, and especially the lighting are the choices you use to make your photograph beautiful. For instance, I think of flowers as being soft, so I love to use soft light on them to open up the shadows and bring out their subtle colors. When I find a perfect flower in a busy garden, I use all my techniques: checking the background, isolating the flower, creating the soft light, controlling the shadows. It's all up to me (**FIG. 7.10**).

TIP Overcast and shaded light is soft and helps reduce distracting shadows when shooting more complex flowers and plants. But you have to remember to set your camera's white balance to overcast or open shade to warm up the blue cast created by these types of lighting situations.

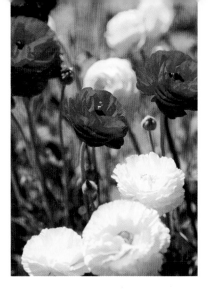

▲ **FIG. 7.9** These ranunculus flowers have lots of color, so I used sunshine to front-light them and pop the color. Plenty of gardens have flowers designed to add color to all the greenery. Look for splashes of color against plain green backgrounds or contrasting colors. Santa Barbara, California. (Nikon D2X, ISO 100, 105 mm lens, handheld, 1/1000 sec. @ f/4.)

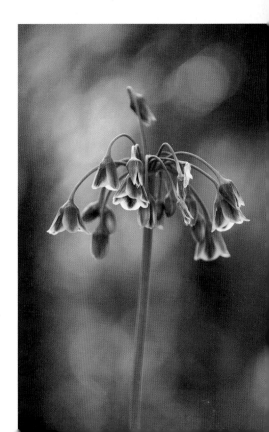

▶ **FIG. 7.10** This beautiful allium is shaded by a small tree. The sun is hitting the flowers and trees in the background, giving us those splotches of color. It's a complex flower, so I wanted to light it with soft, shady light. By shooting with a wide aperture, I kept the focus on the flower and blurred the background. Then I placed a silver reflector on the ground under the flower. I love that light and color. Santa Barbara, California. (Nikon D100, ISO 200, 70–200 mm lens, tripod, 1/200 sec. @ f/4.)

Questions & Answers

▼ **FIG. 7.11** The common name for these large flowers is "naked ladies." (Someone had a good imagination—pretty sure it was a guy.) I shot these in soft light after a rain shower, perfect for these large, complex garden flowers. But this shot looks pretty "messy" with that background and out-of-focus flower bunch on the right. Santa Barbara, California. (Nikon D2X, ISO 200, 105 mm macro lens, tripod, 1/200 sec. @ f/5.)

Q **My flower pictures look messy. What's your secret to getting uncluttered shots?**

A Get closer. No matter what lens you're using, just get closer. You could also try using a wider aperture, like f/4, which would give you less depth of field and put the background more out of focus. Or change your composition by getting higher or lower to eliminate the mess and isolate the flower. You can use a ladder to get a very unique perspective on the whole garden. Get up in that flowering tree and put the flowers in the foreground with a wide-angle lens. If you have the flower close to the lens and the background far away, it's much easier to blur that busy background. But really, just get closer (**FIG. 7.11** to **7.13**).

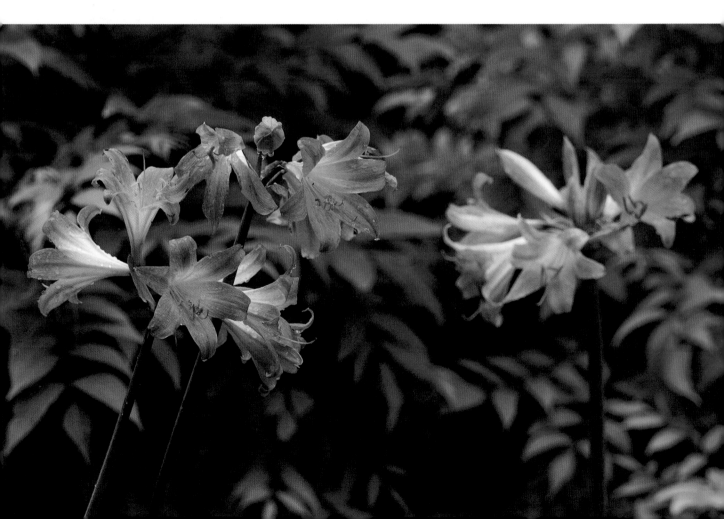

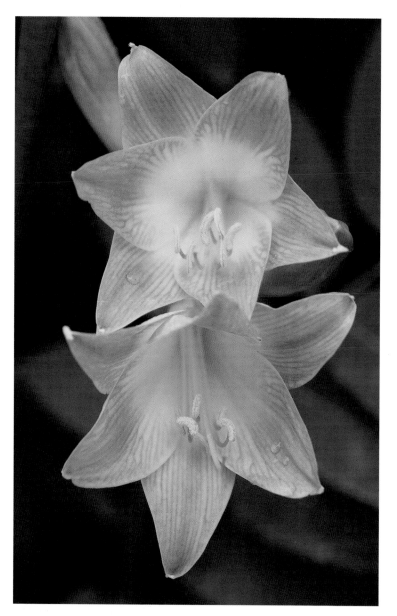

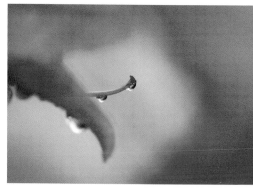

FIG. 7.13 Keep going, you've got a macro lens that can get life-size images. Work it, make a piece of art. There's no wind, but I used a pretty fast shutter speed just in case. I wanted everything but the stigma and raindrop out of focus, so I used a wide aperture; composing with a flower petal close to the lens, I was able to frame the raindrop in color. (Nikon D2X, ISO 200, 105 mm macro lens, tripod, 1/320 sec. @ f/4.)

FIG. 7.12 Using the same lens, I moved closer and composed vertically so I could get both flowers in focus. This looks much better, uncluttered and sharp. (Nikon D2X, ISO 200, 105 mm macro lens, tripod, 1/160 sec. @ f/5.6.)

Q When is the best time to photograph gardens?

A When to shoot depends a lot on what you shoot. If you're doing close-ups of flowers or insects, you can work in any kind of light, but if you're doing wider scenes, you need prettier light. For a book I photographed called *Alice's Garden*, I visited a popular local park nearly every week for a year. I'd always go early in the morning or late in the day. My favorite time was a couple of hours before sunset, close to that "magic hour" I've mentioned. At these times, the light is low and warm and the shadows long, creating a lot of depth. The light is less intense late in the day, lowering the contrast and showing details in the shadows. This is great light for those wider scenic photos (**FIG. 7.14**).

Another of my favorite times to photograph gardens is right after a rain shower, especially an early morning shower before the winds come up. In fact, I'm sitting here at my computer, it's early in the morning, and it rained last night. Snails are crawling around, raindrops are glistening, everything's so fresh—I need to take some photos. I'll come back and write more later (**FIG. 7.15**).

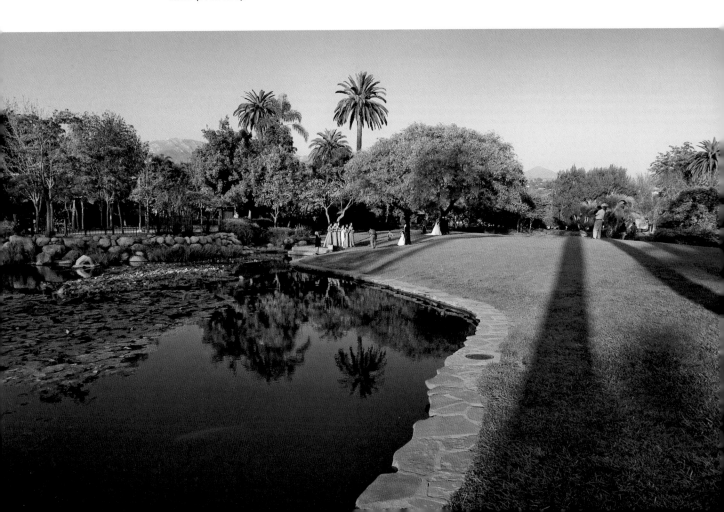

Q *How would using a flash change the look of my pictures?*

A There's a big difference in the look of an image when you use just ambient light versus using just flash. Contrast, depth of field, and color are all affected by your choice of which lighting to use. Seeing the difference, such as in the two spider images in **7.16** and **7.17** (on the next page), can help you to visualize what I mean.

With flash, you get more contrast. Any area that doesn't get lit by your flash goes dark, maybe even black. I call this the "cave" look. Sometimes a black background fits the subject; maybe a nocturnal animal or a night-blooming flower, but usually I want to see the natural colors of the area behind my subject. The easy fix is just to slow down your shutter and fill the shadows and background with the ambient light. Remember, the shutter speed only affects the natural ambient light, not the flash exposure.

You can get a lot more depth of field with a flash. It's very bright, and if you hold it close to your subject and set your aperture to f/16 nearly everything will be sharp. With available light, your shutter speed may need to be fast to eliminate camera or subject movement, so you're forced to open the aperture and get less depth of field.

The color of the flash is very consistent, about 5300° Kelvin. But ambient light is anything but consistent. Clouds, shade, light coming through leaves, the angle of the sun—all will give a different shade of color to the image.

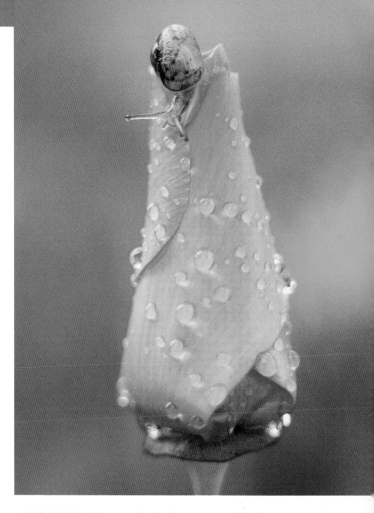

▲ **FIG. 7.15** Snails generally don't move around in the daytime; they tend to dry up in the sun. But when it rains they stay out longer, much to the displeasure of gardeners, since snails and slugs eat plants. The sun had ducked behind clouds left over from a late night storm, giving me nice soft light to photograph this baby snail crawling down a flower bud in our garden. Santa Barbara, California. (Nikon F4, ISO 80, 105 mm macro lens, Kodak Ektachrome film, handheld, exposure unrecorded.)

◀ **FIG. 7.14** Alice Keck Park Memorial Garden occupies one block of midtown Santa Barbara. It's a favorite place for weddings and monarch butterflies, Tai Chi classes and migrating songbirds, family picnics and turtles. I took this photo at 4:00 p.m. in November, close to magic hour. Santa Barbara, California. (Nikon D100, ISO 200, 14 mm lens, tripod, 1/125 sec. @ f/8.)

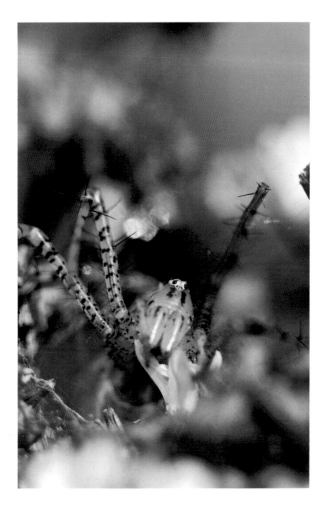 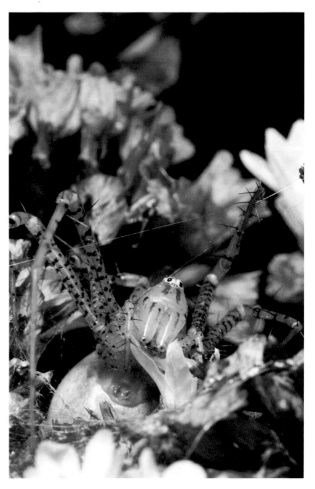

FIG. 7.16 These two shots of a green lynx spider guarding her nest in a garden flower show the difference between shooting without a flash and with a flash. The first is exposed with just ambient light. Note the shallow depth of field, lighter shadows and background, and the bluish color from shady light. Santa Barbara, California. (Nikon D1X, ISO 125, 105 mm macro lens, 1x magnification, tripod, 1/250 sec. @ f/4.)

FIG. 7.17 This image is lit with a single flash held above the spider. The background went dark because the ambient light is underexposed by three stops. The black area behind the spider didn't get any light from the flash. And check the color—it's very different from the ambient-only image. There's a big difference between these two just by adding a flash and underexposing the ambient light. (Nikon D1X, ISO 125, 105 mm macro lens, 1x magnification, tripod, 1/250 sec. @ f/16.)

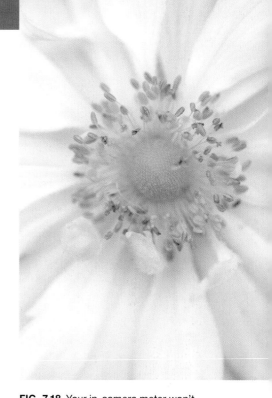

Q ***When I photograph white things, why do they look gray?***

A When technicians design light meters, they have to work off some known tone, and the one they use is medium gray. So if you photograph a snow-covered mountain, the meter makes your clean white snow a light gray rather than white. It's the same situation with fog, polar bears, and white flowers. But you're smarter than your camera—you know that the snow and the flower should be white, not medium gray. So you have to override the meter reading. You can do that by adjusting the +/- exposure compensation setting in your camera. I like to use manual exposure modes, changing the f/stop or shutter speed to overexpose or underexpose what the meter says. With white subjects, I fill the frame with whatever is white, and then open up 1–2 stops from what my meter says. With yellow subjects, I open up about one stop. By doing this, I get my "photographic" whites to look really white. On overcast days, you might have to open up even more (**FIG. 7.18**).

Your meter has the same problem with true black. If you photograph a gorilla, the meter will try to make it lighter than it really is, bringing the black closer to gray. So you have to underexpose what the meter says in order to keep the gorilla's fur black. Wait a minute—what's that gorilla doing in my garden?

Assignments to try

- Take pictures of a bouquet of flowers, so the types of flower you're shooting become unrecognizable. Try doing this inside at a table. Concentrate on the compositions.
- After a rainfall, go out and look under leaves. Lots of bugs escape the raindrops by waiting on the underside of leaves and will usually stay there while you take photos of them.

FIG. 7.18 Your in-camera meter won't give you a correct exposure setting for this white flower. All that white will fool the meter, and it will try to make the white a light gray. In this image of a Japanese anemone, I overexposed what my meter said by about 2 stops. That gave me a nice clean white and kept detail in the flower. Santa Barbara, California. (Nikon D2X, ISO 200, 105 mm macro lens, 1/2x magnification, handheld, 1/500 sec. @ f/5.)

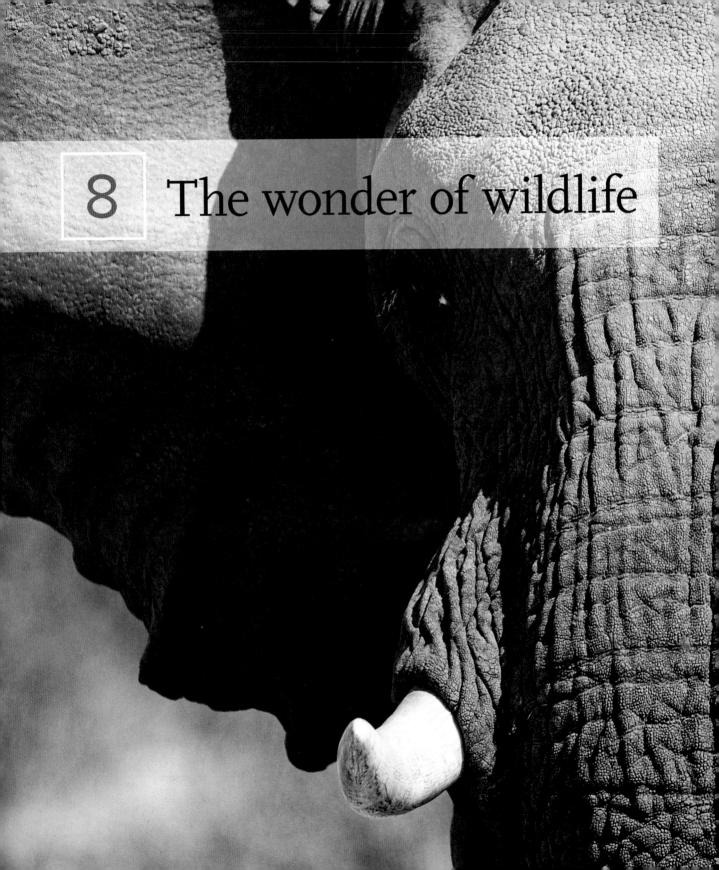

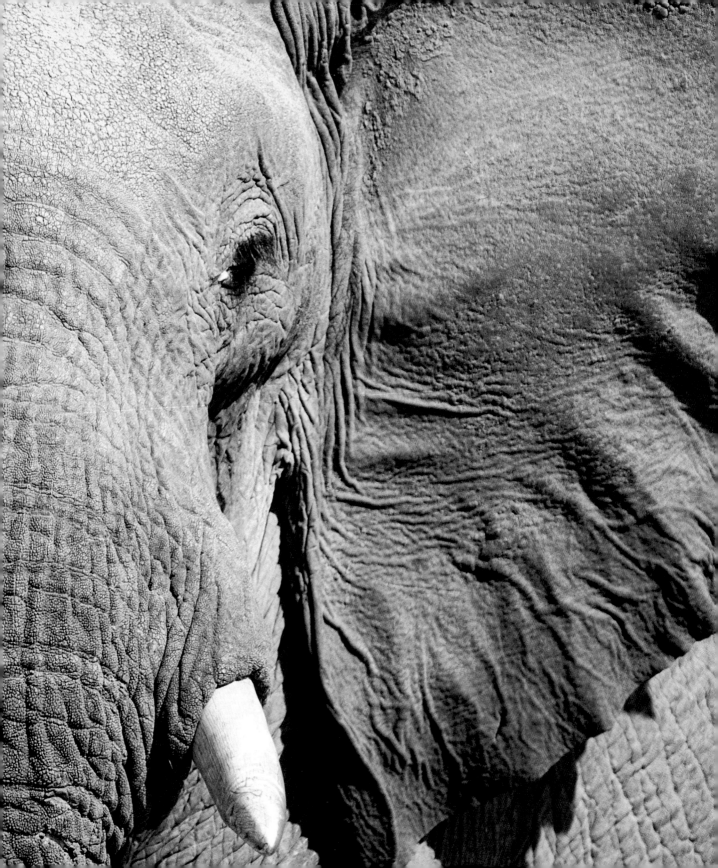

Use telephoto lenses to capture the beauty and excitement of birds and big animals.

Lions and tigers and bears, oh my!

For many people, the adrenaline rush of being close to large or dangerous animals is addictive. It touches our wild side, the primeval part of the brain. Photographs can help to remind us of these encounters, and great wildlife images can bring the rush to everyone. On safari in Africa it's the "big five": lion, elephant, leopard, buffalo, and rhino. In North America, it's the grizzly bear, bighorn sheep, moose, mountain lion, wolf, and bison. Other regions of the world have their own unique large animals.

Outside of parks and reserves, many of these animals are very difficult to see. They're right to fear us; in the wild, humans are their main predators. But when protected, large animals tolerate our presence, seeing us as part of the natural landscape and letting us sit and observe them. I can watch elephants for hours. Believe me, when a big elephant "bluff charges" with ears flapping, as in the opening photo for this chapter, it gets your adrenaline going. For our safety and the animals' comfort, maintaining a respectful distance is imperative. This is where telephoto lenses play their part. They allow us to capture intimate views of animals without intruding on their space.

Portraits of wildlife are not unlike portraits of people. We look first at the animal's eyes: Where are they focused? Are they looking at us? If they are, a connection is formed between the animal and the viewer. This connection is one of the strongest elements in wildlife photography. When you photograph an animal, especially if its face is looking toward the viewer, make sure that the eyes are sharp (**FIG. 8.1** and **8.2**).

TIP Try to get a highlight in the animal's eyes. Wait until it turns toward the sun, or add a flash to make the highlight. The highlight helps us to see the eyes and adds life to the face.

FIG. 8.1 It was raining on our last day in Kenya. As we headed to the airstrip for the flight to Nairobi, our guide spotted this young lion in the grass. My camera actually quit working after I took this photo, maybe because it was getting wet. Never give up, and never pack away all of your cameras. Maasai Mara National Reserve, Kenya. (Nikon 8008, ISO 200, 400 mm lens, handheld with steadybag, Kodak Kodachrome 200 film, exposure unrecorded.)

FIG. 8.2 It's fall in Denali National Park, and the grizzlies are eating lots of berries. The bears that wander near the only road in the park are used to vehicles and ignore them completely. Waiting for this bear to raise its head made this shot more dramatic. Alaska. (Nikon D2X, ISO 800, 200–400 mm lens, handheld with steadybag, 1/800 sec. @ f/4.)

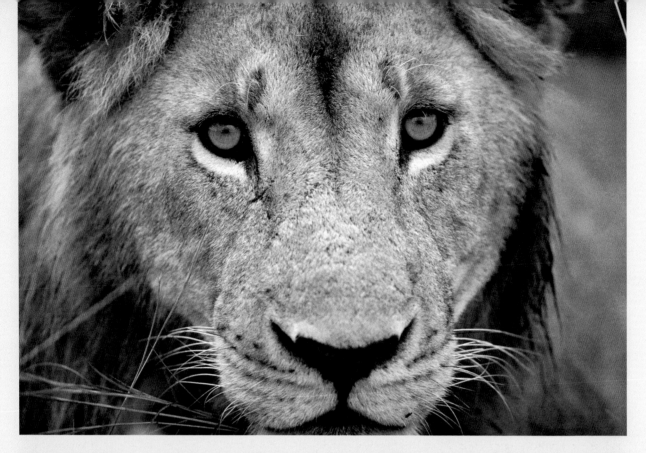

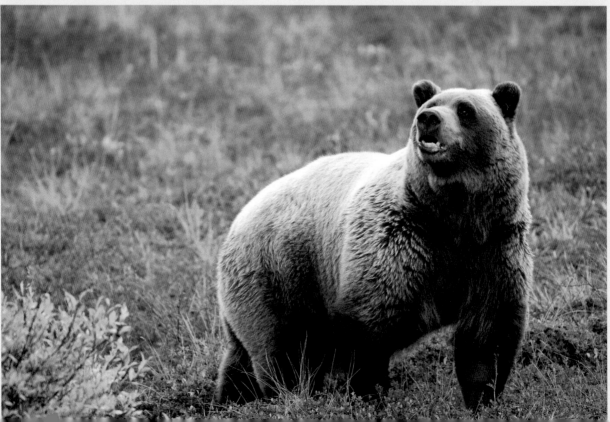

The wonder of flight

Birds are one of the most popular wildlife subjects in nature photography. But their diversity and behavior present unique challenges for photographers. Just the fact that they can fly makes them difficult to photograph. In gardens and backyards, where feeders and water are provided, birds are very tolerant of people. Using shorter telephoto lenses like 200 mm and 300 mm can produce some stunning images (**FIG. 8.3**).

In wilderness areas, birds are more difficult to approach, more wary of us. A longer lens is necessary to make the bird large in the frame. One bonus to using cameras with the smaller APC sensor is that crop factor. My 400 mm lens sees the same field of view as a 600 mm. But serious bird photographers regularly haul large telephoto lenses around and spend hours waiting for birds, light, and action to come together (**FIG. 8.4**).

FIG. 8.3 Building their nest in a park, this pair of Eurasian collared-doves was comfortable with people passing under the tree, and let me get close enough to frame them through the branches. Patience paid off when the male flew in with a branch and looked down at me. Santa Barbara, California. (Nikon D100, ISO 200, 70–200 lens, handheld, 1/500 sec. @ f/2.8.)

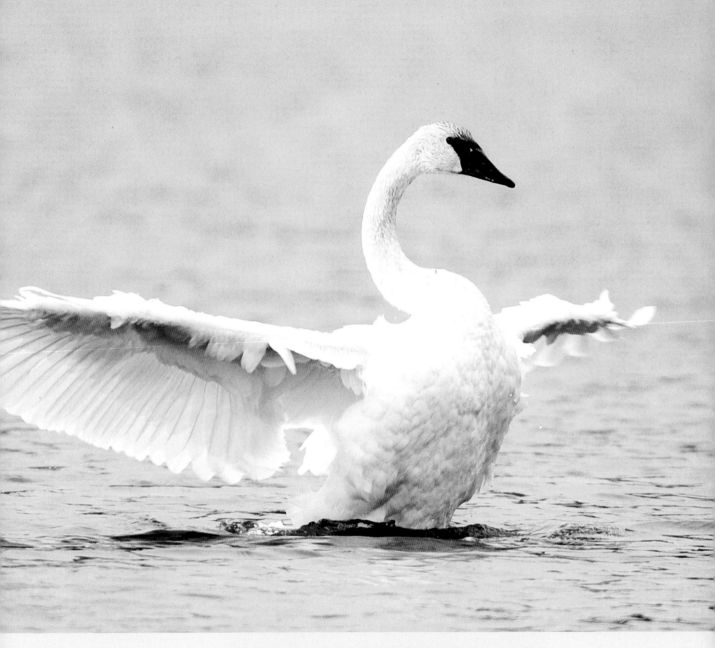

FIG. 8.4 I watched this trumpeter swan preening and knew that after it was finished it might stretch its wings. Watching animals will let you anticipate behavior like this. Denali National Park, Alaska (Nikon D2X, ISO 200, 200–400 mm lens, tripod, 1/800 sec. @ f/4.)

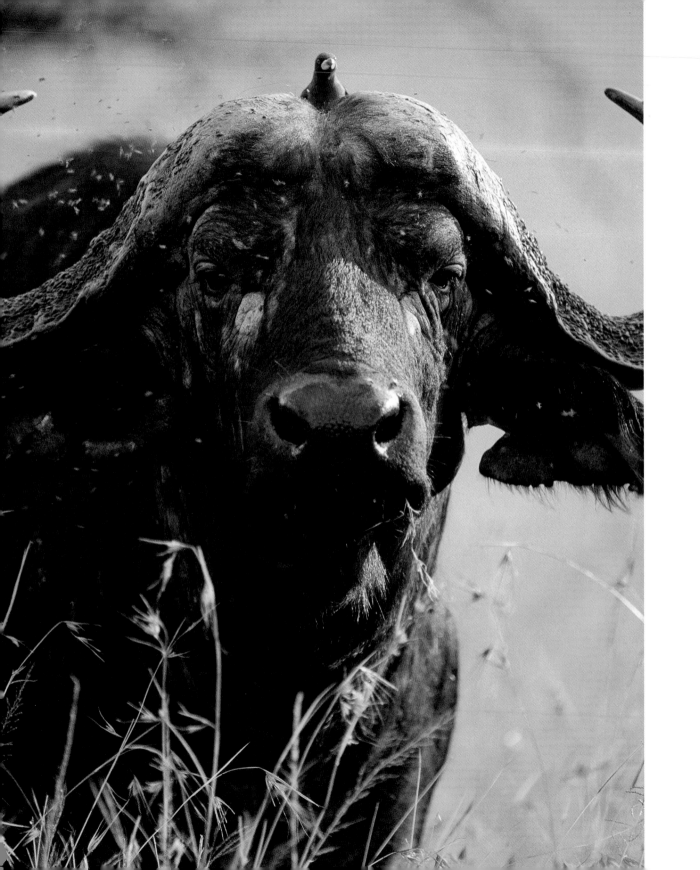

Equipment

Lenses

People say, "You must have used a zoom lens to get that Cape buffalo shot" (**FIG. 8.5**). Actually, I used a telephoto lens. A telephoto lens isn't necessarily a zoom lens. Zoom lenses can come in wide-angle and normal ranges, like 28–70 mm. That's not a telephoto lens. Telephoto lenses start at about 200 mm and go all the way to 800 mm and beyond. The longer ones are usually fixed focal lengths (called *prime* lenses) and don't "zoom" to other focal lengths. Telephoto zoom lenses give you different focal lengths in one lens, like 100–400 mm. I have a short telephoto zoom (70–200 mm) and a long telephoto zoom (200–400 mm). But I also use 500 mm and 600 mm prime telephoto lenses.

The speed of a lens refers to its widest aperture. An f/4 lens is "faster" than an f/5.6 lens. You need fast telephoto lenses for a couple of reasons. The faster the lens, the wider the aperture, and that means faster shutter speeds, which help to reduce camera and subject motion. A fast lens is easier to focus because it lets in more light and shows a very shallow depth of field. Subjects snap into focus, since everything around them is out of focus (**FIG. 8.6**).

The drawbacks to fast lenses are cost, weight, and length. The faster a telephoto lens is, the more glass in the lens. A 300 mm f/2.8 can weigh 5.6 pounds, whereas the 300 mm f/4 only weighs 2.6 pounds. That's a big difference when you walk several miles or travel by plane. Digital SLR cameras can produce good results with higher ISOs, so weigh the advantages and disadvantages carefully before choosing telephoto lenses.

◀ **FIG. 8.5** Late in the day, low sidelight accentuates shape and texture in this big male Cape buffalo. The oxpecker bird perched on the buffalo's head was a bonus. Waiting for the buffalo to look up from eating and make eye contact was worth the time. Serengeti National Park, Tanzania, Africa. (Nikon F5, ISO 100, 400 mm lens, handheld with steadybag, Kodak Ektachrome 100 film, exposure unrecorded.)

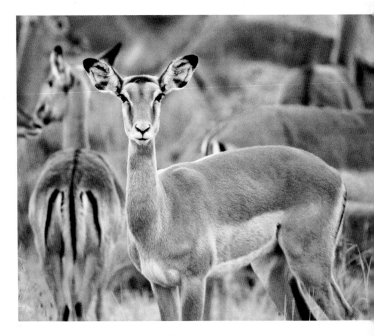

▲ **FIG. 8.6** Impala are among the most graceful antelopes in Africa. Overcast skies gave us soft light; shooting with my f/stop wide open helped to separate this female from the rest of the herd. Some sound behind us made her look up and perk her ears—perfect. Serengeti National Park, Tanzania. (Nikon F3, ISO 100, 400 mm lens, handheld with steadybag, Kodak Ektachrome 100 film, exposure unrecorded.)

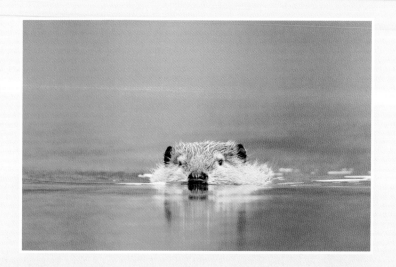

▶ **FIG. 8.7** I spent several hours watching a beaver family working a pond in Denali National Park. Because the pond level was higher than the ground, I could shoot right across the surface of the water, getting the reflections of fall colors. Using AF-C, dynamic area focus mode, and keeping the focus sensor on the face of the beaver, my lens was able to predict focus over several shots as the beaver swam toward me. Alaska. (Nikon D2X, ISO 400, 200–400 mm lens, tripod, 1/800 sec. @ f/4.5.)

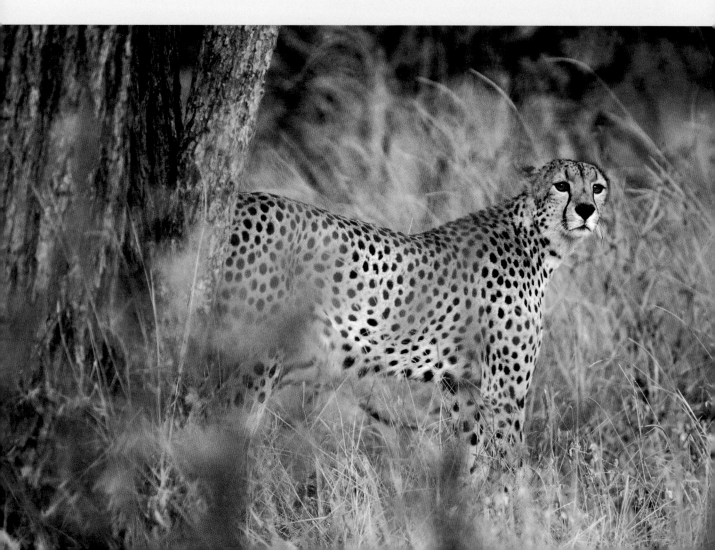

Auto-focus (AF)

Auto-focus settings on modern cameras are very complicated. It's difficult to talk about AF specifics here, since all the brands use different names for features, and even different models of the same brand have different choices. Very confusing. The Internet offers plenty of good model and brand-specific info; check out the appendix for some sites.

Most DSLRs have two settings for auto-focus: *one-shot* or *single-servo* AF works fine for stationary subjects, *continuous* or *AI servo* AF is better suited to moving subjects. I prefer the continuous setting for nearly all of my nature photography, whether or not the subject is moving. This setting allows the lens to "follow focus." It doesn't matter whether the subject moves or you move; the lens continues to stay focused on the subject (**FIG. 8.7**).

Auto-focus can be triggered in two ways: with the shutter button when you take the picture, or on the back of the camera with the AF button. Back-button auto-focus is used by many nature photographers, including me. It lets you activate AF by pressing a button on the rear of the camera with your right thumb. Most importantly, it separates focusing from picture-taking. The shutter release still wakes the camera and fires the shutter, but no longer activates focus. You have to go into the custom menus to change the default, setting the back-button AF for auto-focusing only. (For more details, see the Q&A section.)

In a few situations, auto-focus systems will fail. Auto-focus needs contrast to focus, so if the subject and the background are the same tone, or no shadows separate them, your AF will have a tough time. When there's lots of "stuff" between you and the subject, such as leaves or branches, the camera doesn't know what to focus on, and searches back and forth. This can be really frustrating. Usually the best solution is switching to manual focus in these cases (**FIG. 8.8**).

TIP Don't forget to adjust the diopter on the camera viewfinder to match your eyesight. If you use glasses, do this while wearing your glasses.

◀ **FIG. 8.8** I'm always trying to photograph animals differently, so instead of sitting in the back of the safari van I sat up front with the driver. It gave me a lower point of view of this cheetah coming out of the brush. The low-contrast light and bushes in the foreground would give auto-focus problems, so using manual focus is a good idea for this situation. Kenya. (Nikon F3, ISO 200, 400 mm lens, handheld with steadybag, Kodak Kodachrome 200 film, exposure unrecorded.)

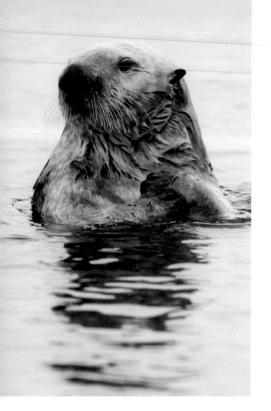

FIG. 8.9 Sea otters are wary of people and tend to stay offshore. For really intimate portraits like this, I added a teleconverter to my longest lens, plus I got an additional 1.5x crop by using my D300 with the smaller chip. The focal-length equivalent in 35 mm full-frame is a 1050 mm lens. Morro Bay, California. (Nikon D300, ISO 400, 500 mm lens with 1.4x teleconverter, tripod with gimbal head, 1/1000 sec. @ f/5.6.)

Teleconverters

Some photographers swear by teleconverters, but I've never been a big fan. Teleconverters increase the focal length of a lens by adding optics between the camera and the lens. They actually change the design of the lens and come in 1.4x to 2x powers. Throwing a 2x converter on a 200 mm lens is a relatively inexpensive way to get a 400 mm lens. But they have some serious drawbacks. You lose quality, images lose contrast and sharpness, and you lose light—up to two stops with a 2x teleconverter. Their advantages are size and weight. If you travel or have to carry your gear on foot for long distances, adding a teleconverter to your bag makes a lot more sense than carrying a heavy telephoto lens. And if you use teleconverters with high-quality prime lenses, such as a 300 mm f/2.8, you can get excellent results. Using them with zoom lenses won't give you as good an image (**FIG. 8.9**).

Support

Camera motion is one of the biggest problems with long-lens photography. Long focal lengths like 300 mm or 400 mm increase magnification, just like binoculars, and the tiniest amount of camera shake is transferred to the image. The longer the lens, the more movement is magnified.

The obvious choice to support these big lenses is a tripod. The bigger the lens, the bigger the tripod you'll need. But just as important is what you put on the tripod. A ballhead is a good choice for most lenses, but for the really big telephoto lenses, like the 300 mm f/2.8, 400 mm, 500 mm, and 600 mm, many wildlife and bird photographers prefer a *gimbal head*. Gimbal heads allow large, heavy lenses to hang, perfectly balanced; if properly set up, a 15-pound camera and lens system can be moved with one finger. These systems are great for following running animals or flying birds (**FIG. 8.10**).

When a tripod isn't an option, such as when shooting from a car, I use a *steady bag*. Basically just a sack filled with sand, crushed walnuts, rice, or plastic beads, steady bags can be draped over a window, laid on a rock or car hood, or just dropped on the ground. The bag cradles the long lens, lets you use slower shutter speeds, and provides a stable platform for telephoto lenses. You can make your own steady bag with a five-pound bag of rice, a Ziploc bag and some duct tape. Put the bag of rice in the Ziploc and cover it with the tape. Cheap and works great.

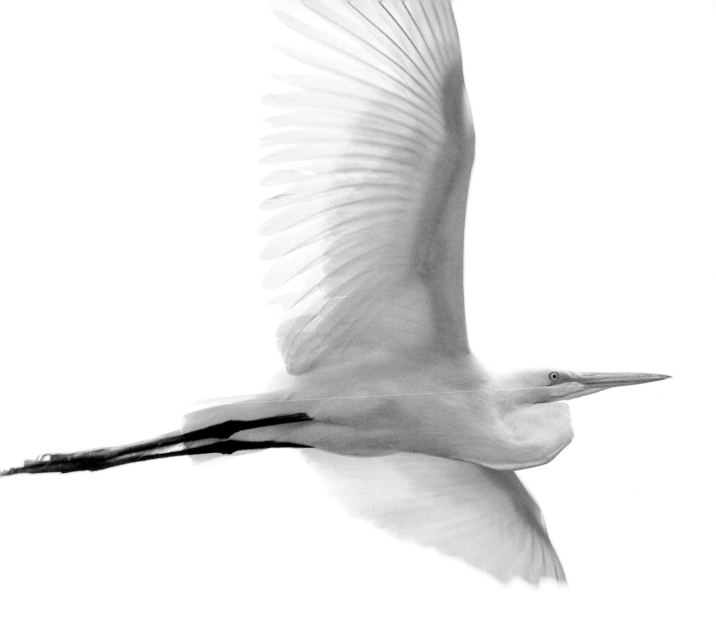

FIG. 8.10 I wanted to get some blur in the wings of this great egret as it flew past. With telephoto lenses, using a tripod and gimbal head helps reduce any up-and-down motion as I pan, and makes tracking fast-moving animals a lot easier. Avery Island, Louisiana. (Nikon D100, ISO 200, 300 mm lens, tripod, 1/100 sec. @ f/16.)

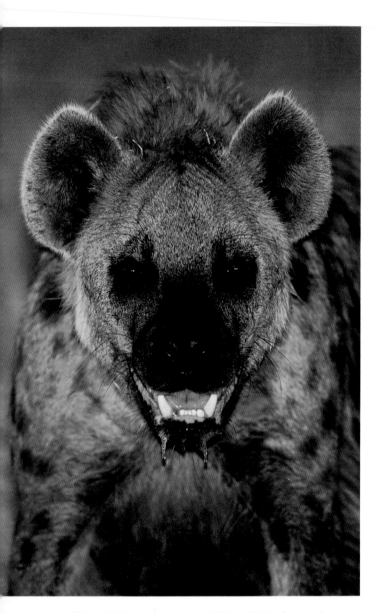

FIG. 8.11 Hyenas had made a kill the night before, and spent the day sleeping near it. As dusk fell, they went back to eating what was left. This female's belly was so full that it nearly dragged on the ground. Zambia, Africa. (Nikon D2X, ISO 800, 200–400 mm lens, flash, tripod mounted in vehicle, 1/250 sec. @ f/4.)

Lighting

During the hours near sunrise and sunset, you'll see more animals. I call it "animal time." It can also be the prettiest light of the day. These times of day are transitions from day to night, from diurnal activity to nocturnal activity for many animals. The diurnal species are preparing for sleep, looking for a safe place to spend the night; meanwhile, the nocturnal ones, such as hyenas, are getting ready for the hunt. It's a time when lots of animals move toward water for a drink. There is more action in the wilderness, like a city at rush hour (**FIG. 8.11**).

On safari in Africa, the morning game drives start at about 6 a.m., when the sun is rising. Then you're back in camp from around 10 a.m. to 2 p.m. It's hot during midday and most animals rest, conserve energy, and spend time with the kids. It's true everywhere, not just in Africa. It's also the worst light for photography—contrasty and hard, with no direction or warmth. About midafternoon, you're out again for the evening game drive. Your time in the field is regulated by animal time, and for photographers it's the time of dramatic light (**FIG. 8.12**).

In East Africa you can't drive in most parks before sunrise, and you have to be back in camp by sunset. Poaching is a big problem, and game wardens assume that anyone out in the park after dark is up to no good. But in southern Africa, especially in the private game reserves, you can be in the bush anytime. Many safari camps even offer night game drives, using spotlights to see nocturnal animals (**FIG. 8.13**).

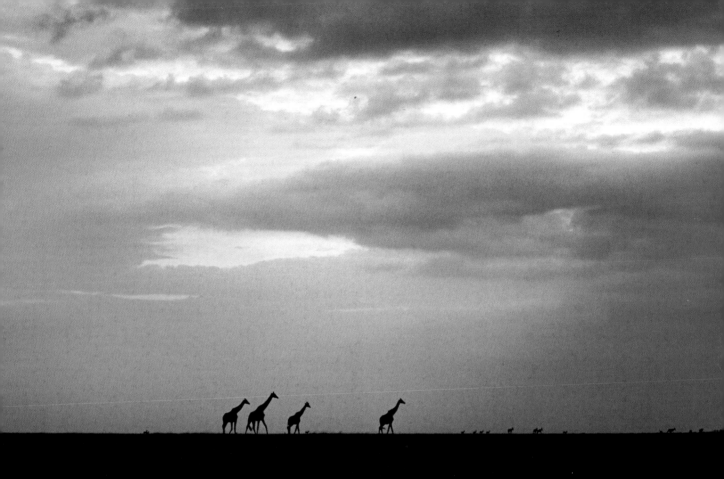

▲ **FIG. 8.12** We were headed back to camp and stopped to "check the tires" (polite speak for taking a pee). I looked up and saw the clearing storm clouds with these giraffe on the horizon. While others finished checking tires, I quickly got off a few shots. Maasai Mara, Kenya, Africa. (Nikon F3, ISO 100, 200 mm lens, steadybag, Kodak Ektachrome 100 film, exposure unrecorded.)

◄ **FIG. 8.13** Dusk at the watering hole. The last of the pride drinks before the night's hunt. Okavango Delta, Botswana. (Nikon F5, ISO 100, 200 mm lens, tripod mounted in vehicle, Kodak Ektachrome 100 film, exposure unrecorded.)

Questions & Answers

▶ **FIG. 8.14** Pikas are cousins to rabbits and inhabit rocky slopes where they hide among the rocks. We didn't see any when we arrived at this spot, but the habitat was perfect for them. I set up my long lens and waited. Sure enough, a few of them got curious and came out to investigate. Denali National Park, Alaska. (Nikon D200, ISO 400, 200–400 mm lens, tripod, 1/320 sec. @ f/5.)

Q *How do you steady yourself while handholding the camera with a long zoom lens?*

A Many long lenses have a tool for preventing out-of-focus images due to shaky hands. *Image stabilization* or *vibration-reduction systems* stabilize lens elements or the camera sensor itself to get a sharp image (**FIG. 8.14**). Lens stabilization systems can be turned off or on with a switch on the lens barrel. Some have a setting for tripod or handheld. Generally, if you have your lens on a tripod, you can just turn off the image-stabilizing feature. If you leave it on, some lenses will try to steady the lens even if it doesn't need it, causing blurry images.

To maximize your chances for getting sharp handheld telephoto images, turn on any image stabilizing available on the lens, and use a fast shutter speed. Then cradle the lens in your left hand; just your left arm should support all the weight. Point your left elbow to the ground and tuck it into your body. Your right hand should lightly hold the camera. Then pull the camera against your face and squeeze the shutter release. If you do this right for many years, you'll be rewarded with a bent nose—and lots of sharp images (**FIG. 8.15**).

When you kneel or lie on the ground, you can support the long lens with your elbows, forming a tripod with your arms. Leaning against things like trees, stumps, rocks, or even the hood of your car will help you to keep things steady. Be sure to have the stabilization turned on if you're handholding.

TIP A quick rule for getting sharper images when you handhold any lens is to set the shutter speed to twice the focal length. So with a 200 mm lens, I'll try not to use anything slower than 1/400 second when handholding.

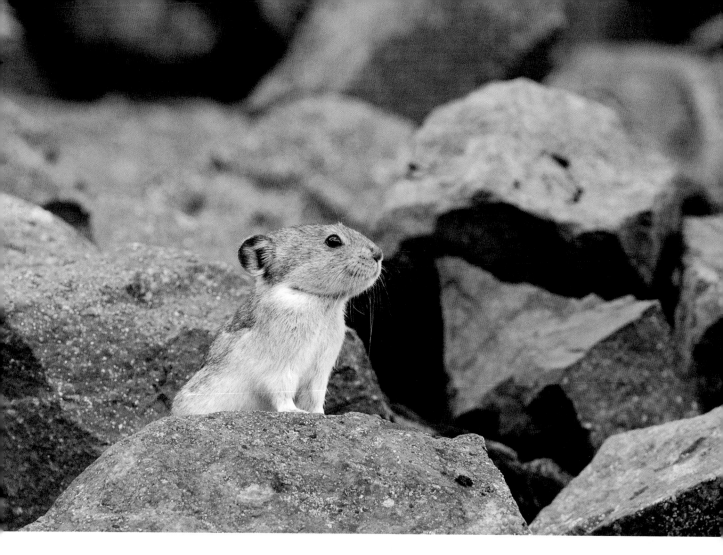

▶ **FIG. 8.15** Although I don't recommend handholding big lenses like this Nikon 200–400 mm, it's certainly possible with stabilization turned on and a fast shutter speed. My student is using good technique, supporting the weight of the lens with her left arm and tucking that elbow into her body.

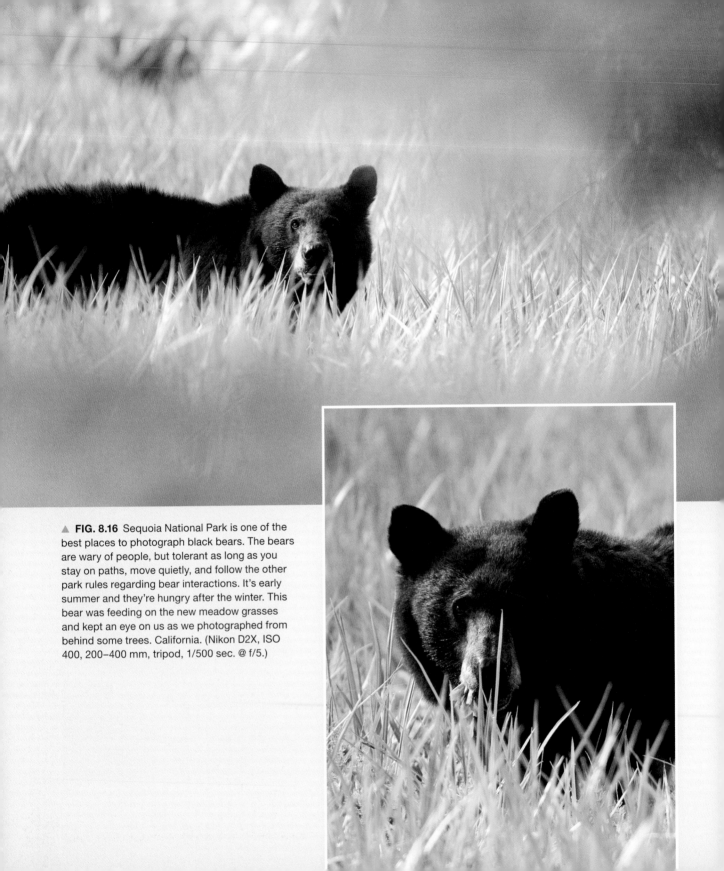

▲ **FIG. 8.16** Sequoia National Park is one of the best places to photograph black bears. The bears are wary of people, but tolerant as long as you stay on paths, move quietly, and follow the other park rules regarding bear interactions. It's early summer and they're hungry after the winter. This bear was feeding on the new meadow grasses and kept an eye on us as we photographed from behind some trees. California. (Nikon D2X, ISO 400, 200–400 mm, tripod, 1/500 sec. @ f/5.)

Q *Why do you use that back-button to focus?*

A While there are times when using the shutter button to trigger AF works fine, there are some important advantages to back-button auto-focus. Locking focus is much easier using the back-button. If you're shooting something that's not moving, and your camera isn't changing distance, just focus on the subject with the back-button, release it, and recompose with the subject off-center. With the focus now gone from your shutter button, your lens will stay focused on the subject no matter how you frame.

Let's say you're photographing a bear in a meadow. The bear isn't moving, but there are leaves between you and the bear (you're peeking around a tree). You want your focus to stay on the bear, even when the leaves blow around in front of the lens, so by using the back-button you can focus on the bear and remove your thumb from the button; the lens will stay locked on the bear no matter what. If you use the shutter button, when you take the picture the lens might try to refocus on those moving leaves, and the bear will be out of focus (**FIG. 8.16** and **8.17**).

In close-up photography, it's easier to pre-focus the lens at the magnification you want, and then move the camera back and forth until you see sharp focus. If you disable the shutter-button focus and use the back-button to set your focus, the camera won't try to refocus every time you take a picture.

You'll need to practice to get comfortable using the back-button AF rather than the shutter to focus. But this technique lets you focus faster and more accurately in many situations.

TIP I stick a small piece of fuzzy Velcro on the back AF button so I can feel it with my thumb, without having to take my eye from the viewfinder.

◄ **FIG. 8.17** The same bear, shot from from the same spot. The bear had moved a little closer, and I put a teleconverter on my long lens. Sequoia National Park, California. (Nikon D2X, ISO 400, 200–400 mm with 1.4x teleconverter, tripod, 1/400 sec. @ f/4.)

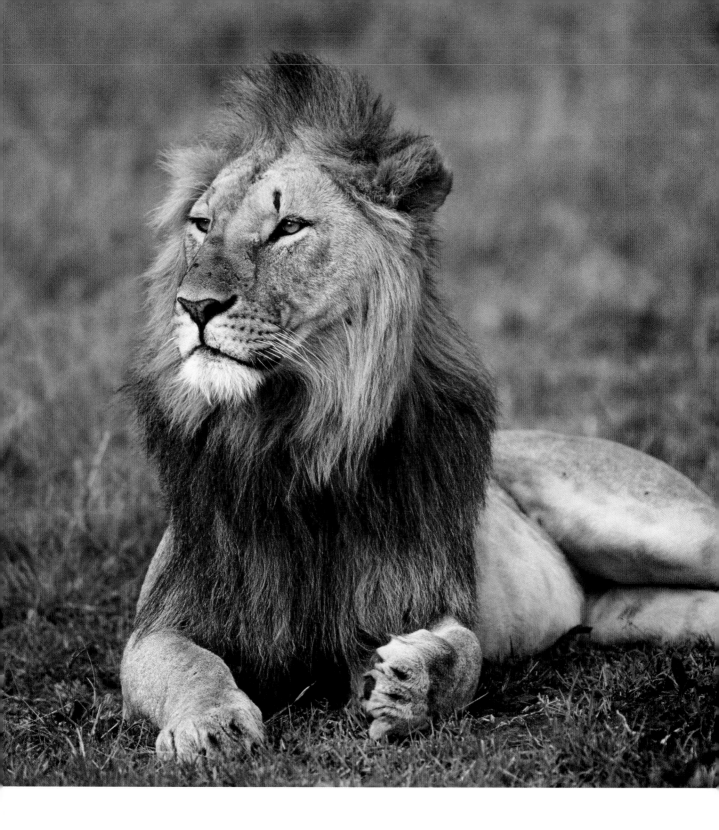

FIG. 8.18 Animal time again. Sunset clouds were lighting this regal lion as he began to stir from his day's rest. He spent several minutes yawning, stretching, and looking around. Too bad we had to leave to make it back to camp before sunset. Maasai Mara, Kenya, Africa. (Nikon F5, ISO 200, 400 mm lens, handheld with steadybag, Kodak Kodachrome 200 film, exposure unrecorded.)

Q *I get nervous* looking *at some of your pictures! Are you ever scared?*

A It's interesting how the act of taking photographs seems to insulate the photographer from the reality in front of the camera, as if you can hide behind the camera. You can't hide—that camera would be worthless if an animal wanted to attack you. But the goal is never to push an animal to the point of attack in the first place. Getting close is the job of these long lenses, so I use them a lot when photographing animals. Do I get scared? I'm certainly apprehensive when walking on trails in grizzly country, but the chance of getting a good close shot is practically nil in this situation. Most of my grizzly images are taken from a vehicle, just like most of the images of big animals in Africa (**FIG. 8.18**).

Keeping a safe distance, watching for signs of stress such as ears laid back or snorting, and using natural cover all help me to feel comfortable around my subjects. Even if they can eat me.

Assignments to try

- Since auto-focus is so complicated, practice with it, specifically the focus-tracking mode. Find a nice big open area, such as a park or field, and enlist your dog or kid to help. Standing a couple hundred feet away, use a 200 mm or longer lens, and focus on the subject. I'd use a tripod, but if your shutter speed is high enough you could get away with handholding. Make sure that your selected focus point in the viewfinder is on your subject. Set your shutter mode to fire consecutive images. Set your auto-focus to continuous or AI servo so it tracks the moving subject. Now, with your dog or kid running right toward you, keep the AF sensor on the subject and hold the shutter down. See how many images are in focus. Practice with the custom functions in the AF menu, learning how to get sharp images.

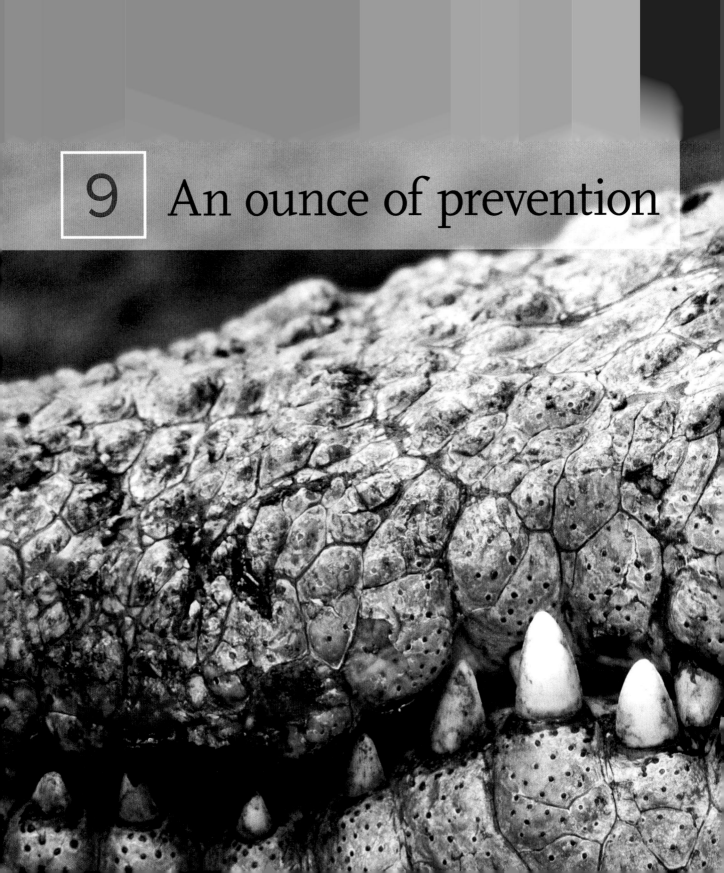

9 | An ounce of prevention

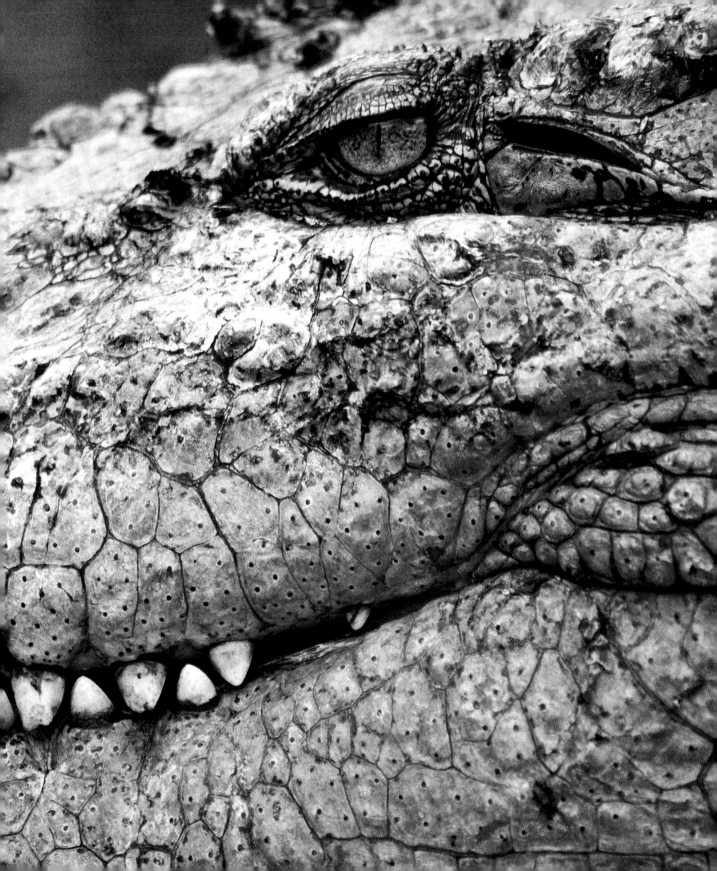

Get the shot and live to tell about it—ideas and techniques for capturing dramatic wildlife images without getting trampled, scratched, or bitten.

Zoos

As more of the world's natural habitats disappear, the role of zoological and botanical parks becomes increasingly important in preserving many animal and plant species. Zoos have become naturalized "homes" for animals, encouraging reproduction of endangered species and providing places of sanctuary for animals unable to live in the wild. Open moats and Plexiglas have replaced the traditional bars and cages; some zoos have even put humans in enclosures and let the animals roam "free." In some exhibits, humans and animals mingle, and visitors must search for a glimpse of creatures amidst the foliage (**FIG. 9.1**).

In the zoo, as in the wild, the more you know about an animal and its behavior, the better your photographs will be. Zoo animals live under artificial conditions, and their behavior often differs from that of animals in the wild. Be aware of the difference, and look for natural behavior. Watch the animal's daily routine, learn what to expect at different hours, talk to the keepers. Be patient; don't expect to photograph all the animals in the zoo in one day. Concentrate on specific animals during each trip.

FIG. 9.1 This bald eagle was struck by a car and lost a wing. A death sentence in the wild. Many zoos provide homes for animals that are no longer able to survive in the wild. Shooting through the wire mesh with a telephoto lens, I waited nearly an hour for the eagle to raise its head and call. Santa Barbara Zoo, California. (Nikon D200, ISO 400, 200–400 mm lens, tripod, 1/60 sec. @ f/4, captive.)

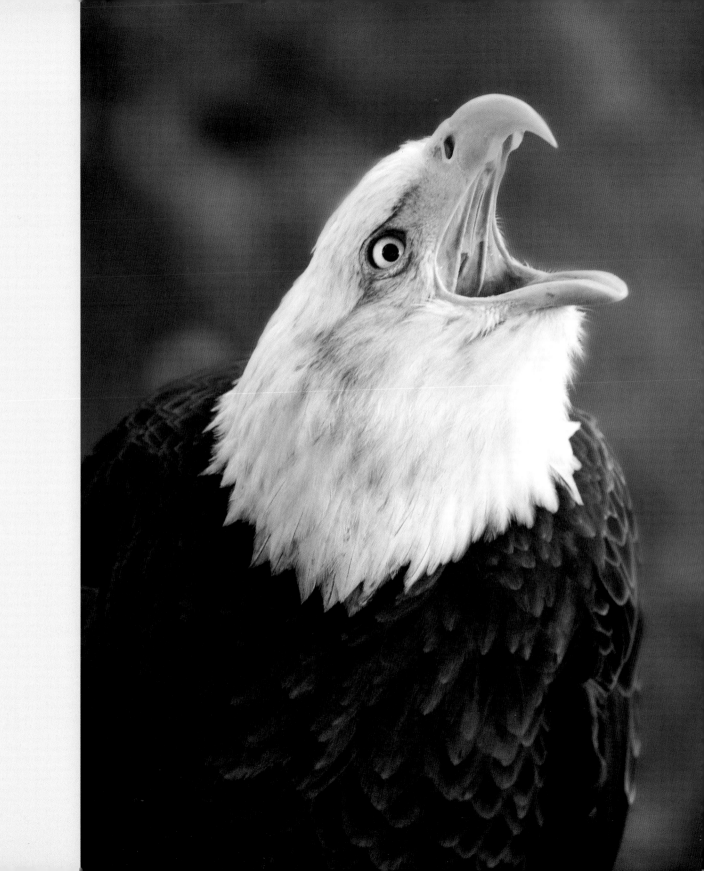

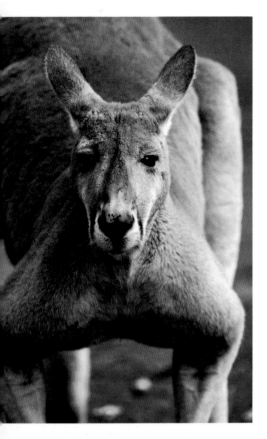

FIG. 9.2 The Cleland Wildlife Sanctuary has open grassland areas where you can walk among kangaroos and other native animals. This male red kangaroo stands over 5 feet tall and would lift its head to look around every few minutes. Getting the highlights in its eyes adds life to the face. Adelaide, Australia. (Nikon F4, ISO 80, 400 mm lens, tripod, Kodak Ektachrome 100VS film, exposure unrecorded, captive.)

It may be difficult to get some animals to appear interesting; with other animals, you don't have to do a thing. The captive salt-water crocodile in the opening photo in this chapter doesn't have to do anything to look fearsome. Getting this shot in the wild would have involved some risk, and a lot of luck just finding him. Using a telephoto lens and lying flat on a small bridge gave me the "in your face" view I needed. Living in a zoo must be boring for these animals, compared to being in the wild. By watching closely and having your camera ready, you may capture little things that make your photos look "alive." A yawn, a growl, perked ears, even a highlight in the eye can make a stronger image than just a shot of a sleeping animal (**FIG. 9.2**). Don't yell or tap on the glass to attract attention; this disturbs animals, and they'll quickly ignore your attempts as soon as they realize there's nothing in it for them.

TIP To help you learn about the animals and speed up your captioning process, photograph the informational signs in front of each enclosure.

To give zoo photographs a more natural look, try using plants in the foreground and background to hide walls, cement floors, feeders, and other signs of zoo life (**FIG. 9.3**). A telephoto lens and wide aperture will throw the plants nicely out of focus. A sturdy tripod is a must for these long lenses. Remember to choose one that you're willing to carry all day. Monopods are lighter, and useful if you're using a 200 mm or shorter lens. If you have a lot of gear, rent one of those cute strollers to haul everything around.

Remember that the animals and plants in zoological parks are ambassadors of their species; treat them with the respect that they deserve. Observe all rules and regulations and cooperate with the staff. Many zoos are happy to accommodate special requests, especially if you offer something in return. When captioning your images, be sure to identify the animal as "captive." Don't try to pass off zoo animals as wild.

Visits to the zoo can provide you with a training ground for photography in the wilderness. You can practice using your tools and learn more about animals. Most importantly, a full day at the zoo can teach patience. You're going to need it when no walls surround the animals you photograph (**FIG. 9.4**).

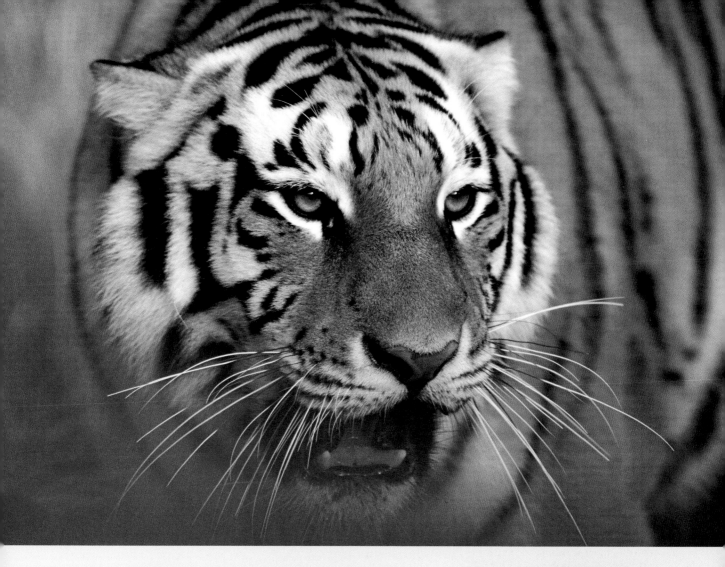

▲ **FIG. 9.3** This Siberian tiger lives in an exhibit that has lots of plants. Shooting from a low angle through some of the plants gives a feeling of watching this endangered cat from behind foliage. Getting this pose took nearly two hours. Los Angeles Zoo, California. (Nikon F5, ISO 80, 400 mm lens, tripod, Kodak Ektachrome 100VS film, exposure unrecorded, captive.)

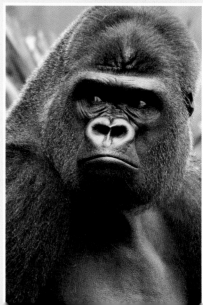

▶ **FIG. 9.4** The western lowland gorilla is endangered in Africa. The gorilla exhibit at the Santa Barbara Zoo provides privacy areas where the gorillas can hide from human visitors, but the gorillas often seem as interested in us as we are in them. California. (Nikon D2X, ISO 200, 200–400 mm lens, tripod, 1/200 sec. @ f/4.5, captive.)

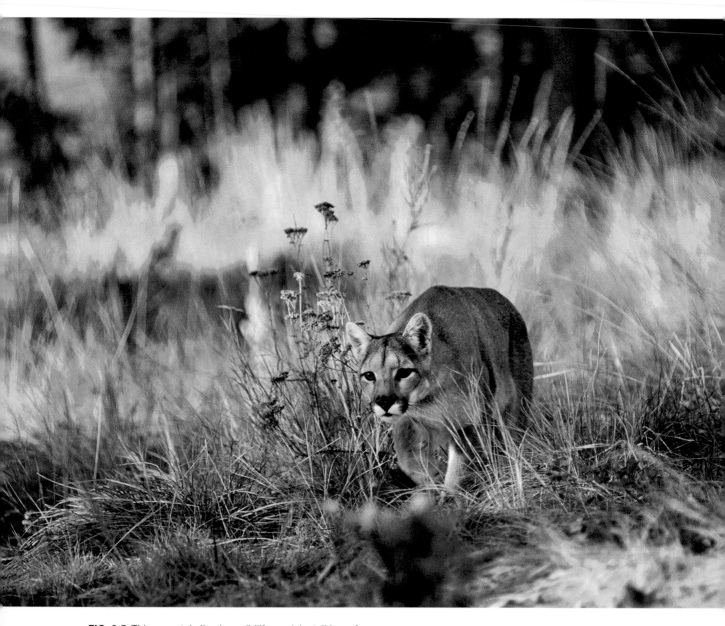

FIG. 9.5 This mountain lion is a wildlife model, stalking a fuzzy rubber duck being dragged on the ground by her handler. Since there are no fences, getting natural backgrounds was easy in this wilderness area near Columbia Falls, Montana. (Nikon F4, ISO 80, 200 mm lens, tripod, Kodak Ektachrome 100VS film, exposure unrecorded, captive.)

Wildlife models

We all know that the bear chasing the campers in a TV commercial isn't really a wild bear. It's trained, like the lions in a circus or elephants in an "Indiana Jones" movie. All of these animals and many of the other animals we see in the media are *wildlife models*. They live in controlled environments, sometimes called *game farms*, and interact constantly with humans. The people who work with these animals care deeply about their welfare, and numerous government agencies are tasked with ensuring the ethical treatment of wildlife models. But there's controversy among nature photographers about the use of these animals for photography and filmmaking (**FIG. 9.5**).

Like zoos, game farms provide a way for people to see and interact with animals that's impossible in the wild. Images of these animals help to provide a visual connection for people. I had a very positive experience with a game farm in Montana. A couple friends and I spent two days there, photographing several animals. I was impressed with the dedication of the people involved, the care given to the animals, and especially with the animals themselves. The animals were brought to wild areas—there were no fences—and their behavior was rewarded in the same way as we reward the behavior of our pets. There were time limits on photographing the animals, and restrictions on where we could stand and how many people could participate. The opportunity to interact so intimately with such amazing animals was an experience I'll never forget (**FIG. 9.6**).

The decision to photograph animals at game farms is a personal one. The decision to caption the images you take of these captive animals isn't. You must be truthful about the content of your photographs.

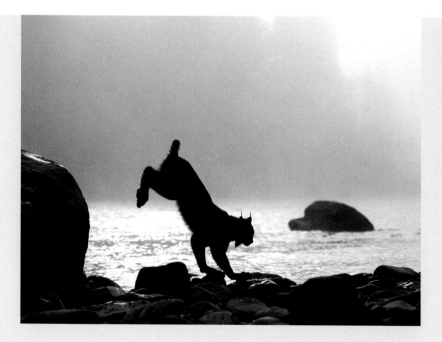

FIG. 9.6 Images like this one, shot on a foggy morning along the middle fork of the Flathead River, are nearly impossible to get in the wild. Just seeing a Canadian lynx in the wild is extremely rare. Knowing that this wildlife model would jump down off a rock and run over to its handler, I set the camera on continuous and fired a burst of 10–15 shots. Montana. (Nikon F4, ISO 80, 400 mm lens, tripod, Kodak Ektachrome 100 film, exposure unrecorded, captive.)

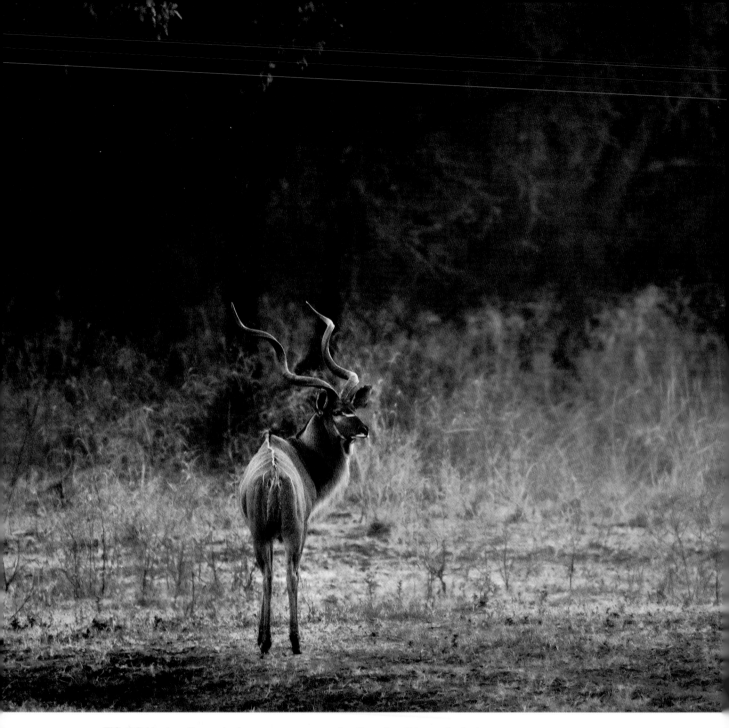

FIG. 9.7 I had pretty much given up on any more shooting when this greater kudu stepped out from the brush. I thought it would be impossible to get a sharp image in such low light, but he stopped and looked back, giving me a chance for several shots. Only one was sharp. South Luangwa National Park, Zambia. (Nikon D2X, ISO 800, 200–400 lens, ballhead mounted on vehicle, 1/80 sec. @ f/4.)

Equipment

As George Lepp says in his great series on Canon's Digital Learning Center, "New tools equals new rules." You can use many of these tools to lessen your impact on wildlife. Telephoto lenses allow us to get intimate views from safe distances. The greater the distance, the less stress on the subject, and the more natural the image will look.

ISO

The International Standards Organization (ISO) has defined standards for measurements in a variety of technical fields. Photography has taken the name of the standard to describe how sensitive a camera sensor is to light. The higher the ISO, the more sensitive the sensor, thus allowing you to photograph in less light. Being able to use ISO 400 or 800 or even higher settings and get nearly noise-free images has profoundly changed nature and wildlife photography.

In the days of film and early digital cameras, when the light got low, we would put away our cameras and just watch. Not anymore. Now we can capture that deer in the meadow at dusk, or the kudu in low light an hour after sunset. Using higher ISOs, combined with lens stabilization, you can use long lenses in much lower light, extending your shooting time and capturing high-quality images that were impossible in the past (**FIG. 9.7**).

There are tradeoffs with higher ISOs—increased noise and less dynamic range—but these can be mitigated by turning on in-camera noise reduction, exposing properly (don't underexpose!), and using noise-reduction tools when processing your images. I use an application called Neat Image to control noise when processing in Photoshop. Be careful—using noise reduction too aggressively makes your images less sharp.

Cars, boats, and blinds

It's interesting that many great wildlife images are taken from inside a "box." Whether the "box" is a car, boat, or blind, it doesn't seem to matter to animals. They see our vehicles as clumsy, noisy, and smelly, but for the most part harmless. In Africa and other places, if you stay in your vehicle you can get very close to animals. Many will even approach your vehicle if you sit quietly. On an evening game drive in Botswana, a group of lions

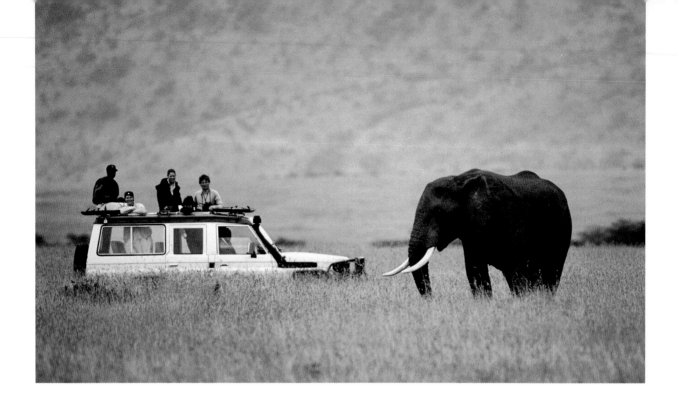

▲ **FIG. 9.8** Elephant watching again. If you move slowly and are quiet, sometimes animals may come very close to your vehicle. Maasai Mara Reserve, Kenya. (Nikon F3, ISO 80, 400 mm lens, handheld with steadybag on car window, Kodak Ektachrome 100 film, exposure unrecorded.)

hid behind our open vehicle as they stalked a herd of buffalo. One lioness was so close that we could nearly touch her. But as soon as a human opens a door and stands apart from the vehicle, every animal runs away— even elephants. It's the human shape they fear. So using your car or boat as a blind is a great way to get closer to wildlife (**FIG. 9.8**).

Once you've spotted your subject, roll down your window and slowly drive to the best vantage point; then turn off the engine to minimize noise and vibration. Use a steadybag or special window mount to stabilize your long lens on the window ledge. If you sit quietly for a few moments, the animal may decide that you're just another "box" and ignore you. I've photographed everything from leopards to jackrabbits this way (**FIG. 9.9**).

If you drive past your subject, go on, turn around, and come back to your spot. Stopping and driving backward tends to scare off wildlife. So do loud noises and sudden movements, so be patient and wait for your shot.

Use the same technique with a small boat. If the subject is moving, such as a pod of dolphins, try to anticipate where it will be and move ahead of the subject. Then kill the engine and wait, making sure that your camera is ready to go. If you've guessed right, the dolphins will surface close enough for some great shots. Remember, all marine mammals are protected from harassment, so let them come to you (**FIG. 9.10**).

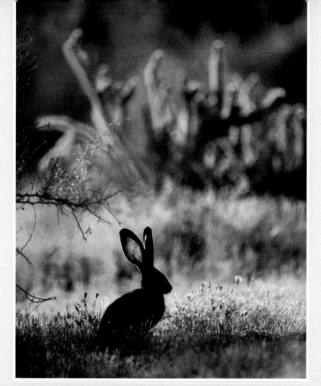

FIG. 9.9 I know from experience that black-tailed jackrabbits like to sit in the shade of desert plants. It's cooler, and the shade offers more concealment. Early in the morning you can find them silhouetted; I love the light coming through this one's big ears. Jackrabbits use those ears to dissipate heat. Anza-Borrego Desert State Park, California. (Nikon F4, ISO 100, 400 mm lens, handheld with steadybag on car window, Fujichrome 100 film, 81C filter, exposure unrecorded.)

FIG. 9.10 Common dolphin are numerous in the Santa Barbara Channel. They love to ride the bow waves of large boats, so you don't have to chase them—they come to you. Channel Islands National Park, California. (Nikon D2X, ISO 200, 70–200 mm lens, handheld, 1/1250 sec. @ f/2.8.)

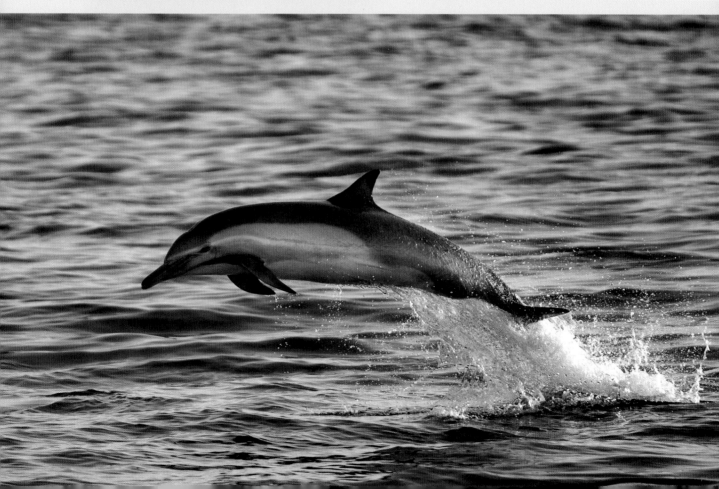

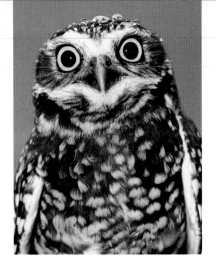

FIG. 9.11 The Ojai Raptor Center in California takes in injured birds and rehabilitates them for release back into the wild. It was raining there when I shot this burrowing owl against some green bushes, so I used my flash to bring out some color and get enough light to make an exposure. The owl didn't care about the rain. (Nikon F5, ISO 80, 200 mm lens, tripod, Kodak Ektachrome 100VS film, exposure unrecorded, captive.)

Lighting

To make beautiful images, you need beautiful light, whether you're at the zoo or in a national park. No matter where you are, shoot in early and late light, or when the light is lower in the sky. Unfortunately, most zoos don't open until 9:00 a.m., and they usually close at 5:00 p.m. There are some exceptions; it's so hot in Arizona in the summer that the Phoenix zoo opens at 7:00 a.m. Midday light doesn't make for good animal images—it's too hard and contrasty, and most animals rest during this time anyway. I remind my students that only humans and vultures are out in the middle of a hot day. At midday, I photograph in the nocturnal halls or aviaries, where the light is controlled, or work the insects and reptiles in the terrariums until the light outside gets better. A good thing about visiting zoos in winter is that the light gets beautiful a lot earlier, and you might get snow or rain. Most animals love inclement weather, there are fewer people, and the light is more interesting (**FIG. 9.11**).

Many photographers don't see the forest for the trees. Filling the frame with an animal by using a long lens or getting close is only one part of the picture. What about the scenic image, with the animal smaller in the frame? This type of image gives the viewer a sense of place, putting the animal in context with its environment. It's a landscape, but the animal is the subject. Don't get frustrated if you can't get close safely or don't have a giant telephoto lens. Wait for beautiful light, and compose a scene that creates a true feeling of the natural world (**FIG. 9.12**).

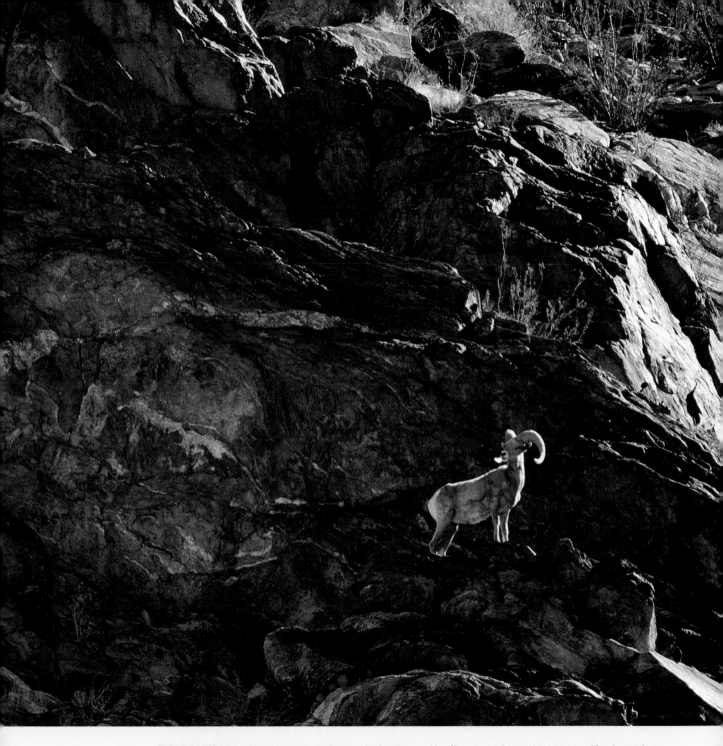

FIG. 9.12 Water is the most critical element in the desert. Hanging around permanent water, like the spring in Palm Canyon, is a good way to see wildlife. The desert bighorn sheep is an endangered species and rarely seen, but Anza-Borrego Desert State Park offers sanctuary and water for this magnificent animal. I had spent most of the morning hiking up the canyon, but on my return found a group of sheep working their way down the trail. This ram kept a close watch on his females and young. A very special moment for me. California. (Nikon F4, ISO 80, 400 mm lens, tripod, Fujichrome 100 film, exposure unrecorded.)

Questions & Answers

Q *How can I keep the wire mesh from showing up when I shoot in zoos?*

A Many enclosures, especially for birds and butterflies, are covered in wire mesh. Most of the time the mesh is coated with a dark plastic. When shooting through the mesh, make sure that no light from the sun or your flash is hitting the mesh in front of your lens, or you'll see the mesh pattern in your image. Move the lens as close to the mesh as possible and use a large aperture like f/4 to throw the mesh out of focus. The longer the lens, the more successful you'll be. Also, be aware that any mesh behind the subject may show up as an out-of-focus pattern if it's too close to the animal or lit by the sun. Another type of barrier is vertically strung metal wire. This is easier to shoot through, as it's more open than the mesh. Use the same technique as just described to minimize the effect of the wires on your image (**FIG. 9.13**).

Remember to pay close attention to the area behind your subject; eliminate posts, signs, people, and anything else that shows the captive environment of the animal.

Q *How do you avoid reflections when shooting through a glass aquarium or terrarium?*

A Just like mesh, glass enclosures can cause problems for photographers. Often the glass is dirty or scratched, and reflections make shooting very difficult. To solve the reflection problem, get your lens as close to the glass as possible—actually touching the glass is best. A rubber lens shade is a good way to protect the lens and glass. You can also reduce reflections by using a "mask"; cut a round hole in a piece of black mount board and fit your lens through the hole. The board has to be big enough to hide your hands and head when shooting. This mask will allow you to back away from the glass and not get reflections (**FIG. 9.14**).

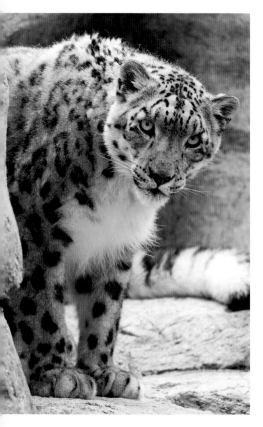

FIG. 9.13 This highly endangered snow leopard is part of a worldwide captive breeding program. Getting my long lens close to the wire mesh surrounding this enclosure and using a wide aperture ensures that the mesh doesn't show up in the photograph. California. (Nikon D2X, ISO 200, 400 mm lens, tripod, 1/80 sec. @ f/4, captive.)

FIG. 9.14 Piranha are great subjects; people like seeing scary things. This exhibit at the Santa Barbara Zoo shows how much effort is placed on designing realistic habitats. This is a big aquarium, so I used my wide-angle lens. To prevent reflections, I placed my lens right against the glass. California. (Nikon D2X, ISO 100, 12-24 mm lens, off-camera flash, handheld, 1/100 sec. @ f/11, captive.)

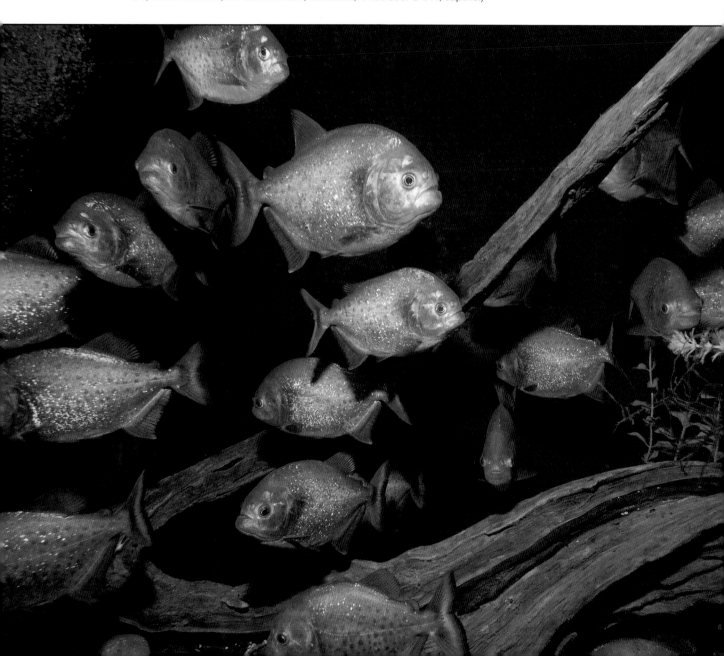

Wearing dark clothing and working in dimly lit viewing areas can reduce the chance of reflections. Shooting at an angle also reduces reflections, but because the glass is thick you probably won't be able to get a sharp image with this technique. Use wide apertures to prevent scratches and dirt on the glass from showing up, and to throw the background out of focus. I always try to clean the outside of the glass where I'll be photographing, especially if it's low, where excited kids put their hands. Remember, try to eliminate the zoo from your photos, making them as natural as possible. The lighting in most glass enclosures is weak and off-color, so I usually use an off-camera TTL flash to light my subjects. Place the flash close to the glass and above the animal (**FIG. 9.15** and **9.16**).

Be sure to check on any regulations regarding the use of flash in special zoo exhibits. Some nocturnal displays prohibit flash, but you might be able to use a small flashlight instead. Be sure to ask first.

FIG. 9.15 This terrarium is in the reptile house at the Living Desert Reserve in Palm Desert, California. It's a very natural-looking exhibit, with a great background. You can see my reflection and the way I hold my flash off-camera. You have to get much closer to the glass to eliminate these reflections.

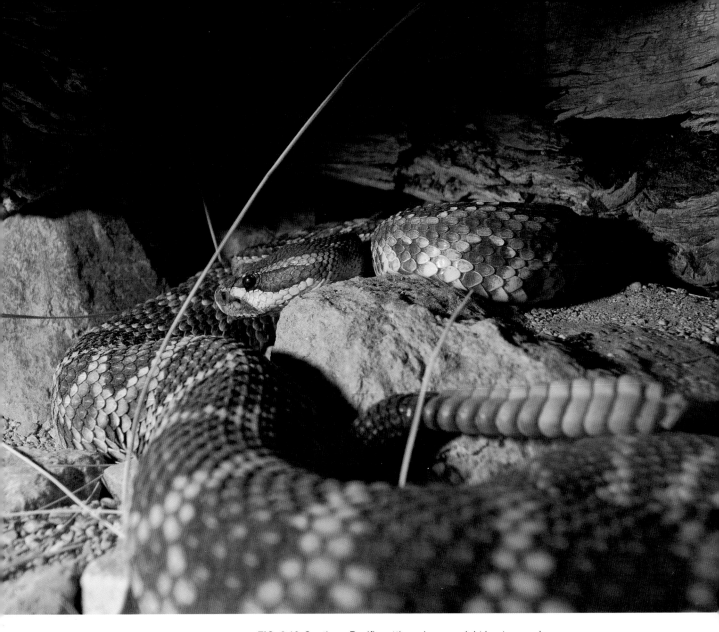

FIG. 9.16 Southern Pacific rattlesnakes are night hunters, so I wanted to light the scene as if the last rays of sun were slipping into its hiding place. Putting the flash way off-camera gave the light direction and showed off the texture in the snake and wood. The wide-angle lens is touching the glass, so there's no chance of reflections. (Nikon D2X, ISO 100, 12–24 mm lens, off-camera flash, handheld, 1/250 sec. @ f/8, captive.)

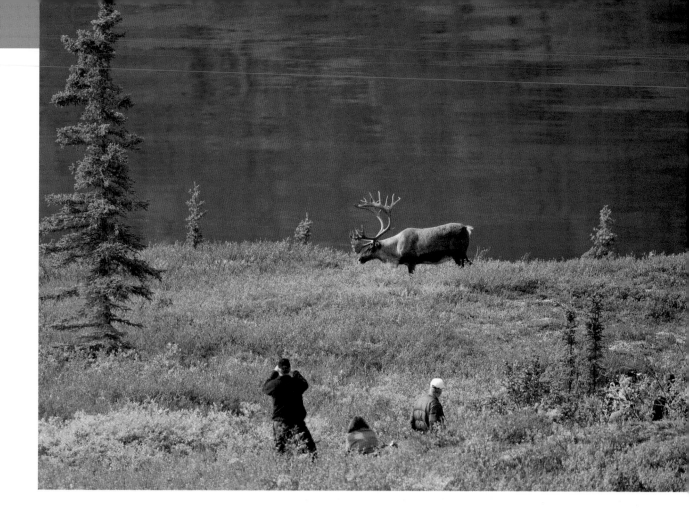

FIG. 9.17 and FIG. 9.18 National parks have guidelines for how close you can get to the animals, but if you sit quietly the wildlife may just come to you. This group of people were watching a male caribou in Denali National Park. I hiked over to the left and sat in the shade of a small tree. The caribou knew I was there, but since I was calm and quiet it sensed no danger. It walked right in front of me. Alaska. (Nikon D2X, ISO 400, 200–400 mm lens, tripod, 1/1250 sec. @ f/4.)

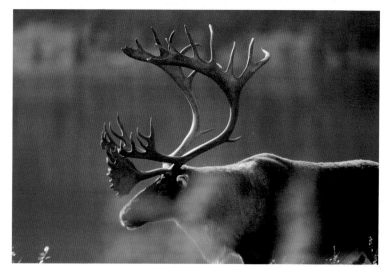

Q *How do you get close to skittish subjects?*

A Stalking animals is an art. Different animals require different stalking techniques, based on how they sense their environment. Birds, especially raptors, can see very well and react to quick movements. If you think you can sneak up on a bird without them seeing you, forget it. They saw you long before you saw them. Bears, elephants, and a lot of other large mammals rely on smell and hearing. Approach from downwind, so the wind carries your smell and noises away from the animal. Stay below ridgelines, stand in the shade of trees or bushes, wear natural-toned colors, and move slowly. All of these techniques will help animals to feel more comfortable around you (**FIG. 9.17** and **9.18**).

Prey animals such as small birds, deer, and squirrels are very sensitive to where your eyes are looking. Predators focus on their prey, so don't stare right at an animal. Try stopping as soon as you see the bird. Don't look straight at it; watch it out of the corner of your eye. Get your camera ready and point it away from the bird; pretend that you don't even see it. Stop if the bird looks alert. Wait until it continues feeding; then move slowly closer. See how close you can get. Remember, each individual animal has a safe zone based on its mood, experiences, and location.

The time of year has a lot to do with how animals will react to humans or other animals. They might be nesting or have young; it might be mating season. The stress of guarding food or drinking water, situations where an animal may be vulnerable, and even individual personalities—all have an effect on how animals react to humans and their environment.

Assignments to try

- Visit your local zoo and choose only two or three animals to photograph, or maybe just one exhibit, such as a walk-through aviary. Go early and stay until the zoo closes. Concentrate on trying to capture the essence of the animals you chose. What makes each animal unique? You need to know everything about an animal to succeed at this. For many animals, you'll need a fairly long lens, like 300 mm. Put your lens on a tripod and take your time.

10 Land, sea, and sky

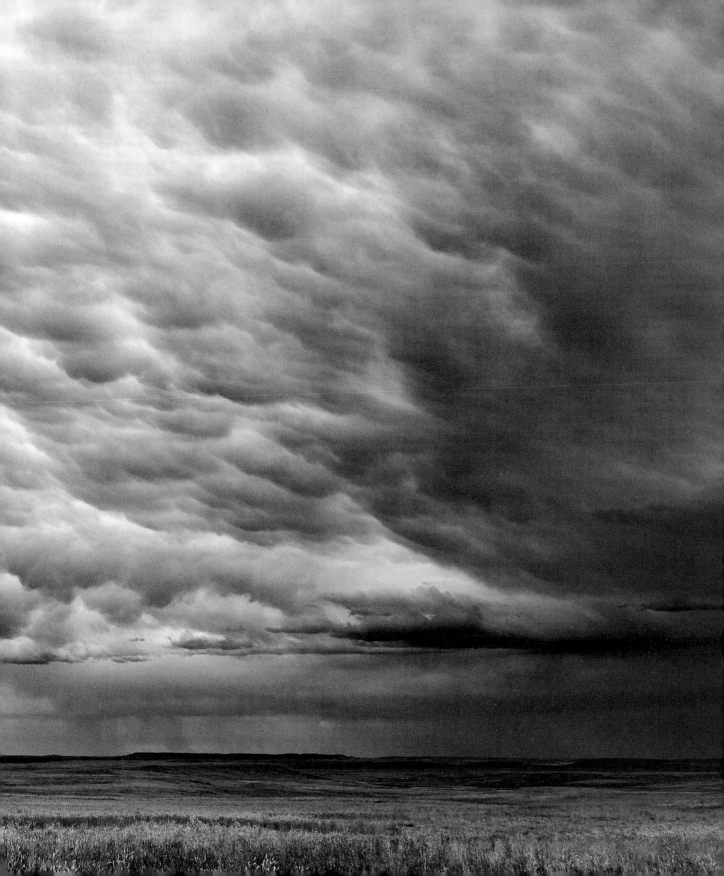

Throw on a wide-angle lens when looking at the natural world—you'll be surprised at what you find.

The wide view

Landscapes are one of the most difficult subjects to capture with camera and lenses. They're so vast and complex—filled with trees and grasses, mountains, clouds, cliffs, beaches, rivers, waves—that we're overwhelmed with subjects to photograph. The key to making beautiful images of all this complexity is to *slow down*.

Great landscape photographers have always moved slowly. Many use cumbersome large-format cameras. All use tripods. They take hours or even days to find the perfect spot to compose a scene, and then they wait. They wait for the light. Light is the most important element in capturing dramatic images of our natural world. Without the drama of light, our photographs of the land, sea, and sky can be flat and lifeless, regardless of the subject or composition (**FIG. 10.1**).

Consider the work of one of my former students, David H. Collier. David understands the importance of light; he's a master of landscapes and light. Looking at his images is a lesson in *planning*, *perseverance*, and *patience*. He *plans* his trips around weather, since the chance of storms means changing light. He *perseveres* in searching for the perfect vantage point; this gives him powerful compositions, bringing together all the elements within complex scenes. He is *patient*; his waiting pays off when the light finally breaks through the clouds and bathes his compositions in drama. If it doesn't happen on the first day, David goes back and waits again.

FIG. 10.1 I've been to Limekiln State Park in California many times, and only once has the right mix of sun and clearing fog created light this amazing. A wide lens let me capture the creek and redwoods in one view. (Nikon D2X, ISO 100, 12–24 mm lens, tripod, 4 sec. @ f/16.)

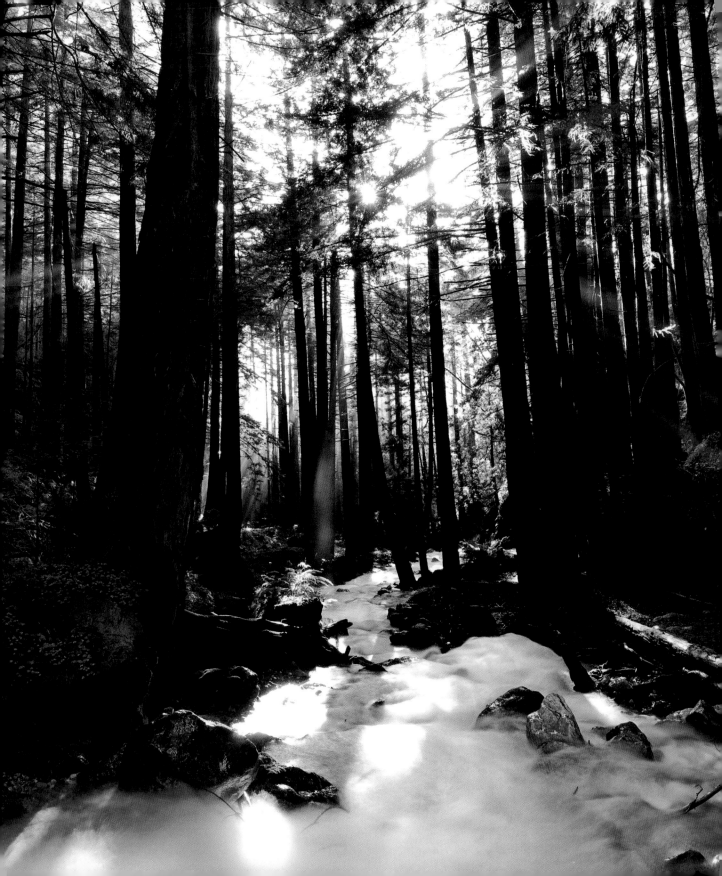

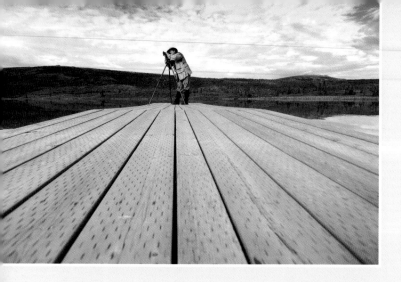

FIG. 10.2 Lying on the dock, I framed this photographer at the center of converging lines. Wide lenses are great for forcing perspective like this. Wonder Lake, Denali National Park, Alaska. (Nikon D200, ISO 200, 12–24 mm lens, handheld, 1/400 sec. @ f/5.6.)

FIG. 10.3 During the spring rains, California newts migrate by the hundreds to lay eggs in nearby streams. My wide lens shows the story—the newt isolated on the road, the forest where the newt lives, and the "Newt Crossing" sign. Wide lenses exaggerate perspective, making things up close in the foreground look very big and things far away look really small. Butano State Park, California. (Nikon D300, ISO 400, 12–24 mm lens, flash, handheld, 1/6 sec. @ f/10.)

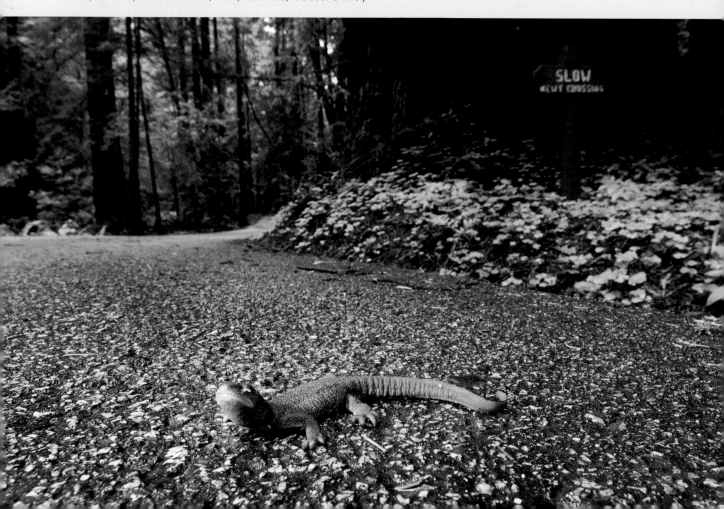

Telling the story

Wide-angle lenses have always been the first choice in landscape photography. In small-format digital photography, wide-angle lenses run from 10.5 mm to 28 mm in focal length. These lenses have a wider angle of view than normal or telephoto lenses—they *see* more (**FIG. 10.2**).

Nearly every landscape, every scene, has a story. Once you find a story you want to tell, wide-angle lenses give you the ability to tell that story in a photograph by relating the different elements within the scene. Only with wide lenses can we include enough in one shot to show the whole "place" as we saw it (**FIG. 10.3**).

The key to using wide lenses to tell a story is the *foreground*—what's up close, right in front of you, above you, or to one side. Find a foreground for your image; then compose the shot with your wide-angle lens to tell the story, by relating elements in the foreground to elements in the background (**FIG. 10.4**).

When I captured the image at the beginning of this chapter, I was in Montana, watching a massive storm front roll across the prairie. Montana, Big Sky country—there's my story. Using my widest lens and composing with a bit of prairie and lots of sky, I told the story of where I was and what I saw.

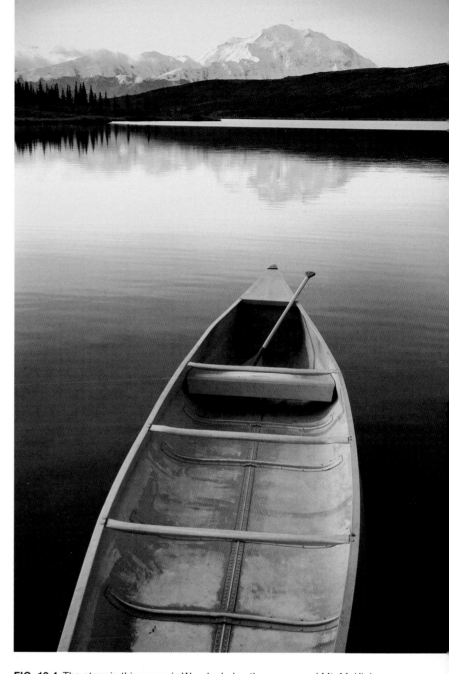

FIG. 10.4 The story in this scene is Wonder Lake, the canoe, and Mt. McKinley. A small aperture gave me the depth of field I needed to get everything in focus. Pointing down emphasized the canoe and showed less of a boring sky. I tied the canoe to the dock so I could use my tripod and take my time composing the scene. Denali National Park, Alaska. (Nikon D200, ISO 100, 12–24 mm lens, tripod, 1/60 sec. @ f/16.)

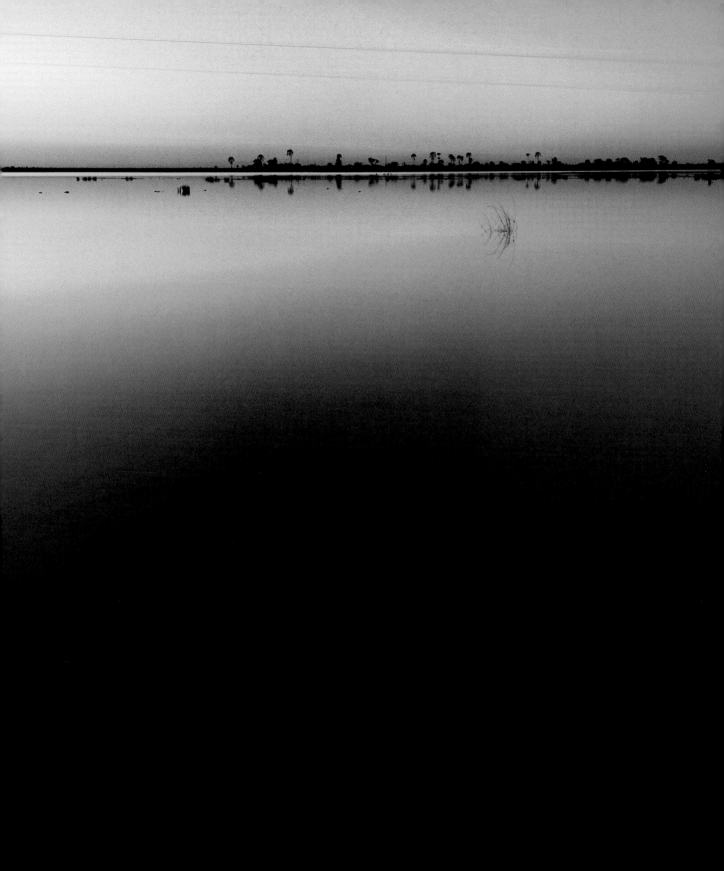

Equipment

Your light meter's modes

The light meter inside your DSLR camera is a *reflective* meter, measuring the light reflecting off a subject and entering the lens. Camera designers include a variety of metering modes and patterns for different shooting situations. One mode may be great for a running animal, another for landscapes or a sunset, and so on. Understanding metering modes and patterns will help you to get your exposures right and create the highest-quality image. The four metering *modes* are explained in detail in your camera manual; here, I'll talk about when to use them. (I cover metering *patterns* in the next chapter.) **(FIG. 10.5)**

In *manual mode*, you choose the shutter and aperture. This is the only mode I use, and I require my students to use it. Using manual mode puts you in control of exposure and the effects of shutter speed and aperture on motion and depth of field. If you hit a problem, you figure out how to fix it—that way, you *learn* and become a better photographer **(FIG. 10.6)**.

Program mode automatically selects aperture and shutter speed based on the metered exposure and ISO you've set. When you hand your camera to someone who knows nothing about photography, put it in this mode.

Shutter-priority mode lets you select the shutter speed, and the camera selects the aperture for a correct exposure. Use this mode to freeze or blur a subject moving through different lights, like sun and shade. Your exposures in both sunlight and shade should be okay, since the camera adjusted the f/stop automatically. Choose this mode if you have changing light while you're handholding a telephoto lens and you need a higher shutter speed to prevent camera motion.

▼ **FIG. 10.6** Some animals, like this meerkat, let you get close enough to use a wide-angle lens. After watching me lying quietly by the burrow for several minutes, they scurried around completely ignoring me. It was a bright day with no clouds, and even with lots of light bouncing off the sand I still needed to add a flash to fill in the shadows. Botswana. (Nikon D200, ISO 100, 12–24 mm lens, flash, handheld, 1/250 sec. @ f/11.)

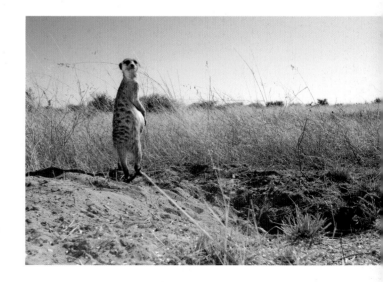

◀ **FIG. 10.5** There was not a breath of wind on this shallow lake in the Makgadikgadi Pan in Botswana, Africa. The sun had set and the western sky was glowing. Using manual metering, I pointed my lens up and took an exposure reading off the sky, and then reframed so you could see the pattern of dried mud under the water. (Nikon D200, ISO 100, 12–24 mm lens, tripod, 1/4 sec. @ f/16.)

FIG. 10.7 I wanted both the euphorbia plant in the foreground and the palm trees in the distance to be sharp. Using small apertures gets you more depth of field, but they also need slower shutter speeds, so a tripod is critical if you don't want a blurry photo. Santa Barbara, California. (Nikon D2X, ISO 100, 12–24 mm lens, tripod, 1/40 sec. @ f/16.)

Aperture-priority mode lets you choose the aperture, and the camera adjusts the shutter speed for the correct exposure. Aperture affects depth of field, so with this mode you're trying to control how much of a scene is in focus. This works with landscapes and wide lenses, since you're likely to be using a tripod and trying for maximum depth of field (**FIG. 10.7**).

Many cameras, especially point-and-shoots, have special auto-exposure scene modes that adjust exposure, white balance, contrast, and color settings based on specific subjects such as portraits, landscapes—even pets or food. For instance, in the sports setting, the mode chooses a fast shutter speed to freeze action, saturates the color so it's more

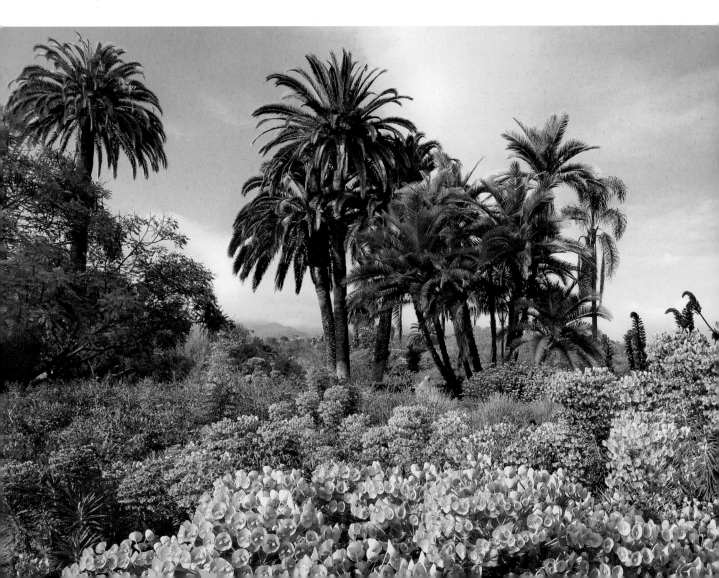

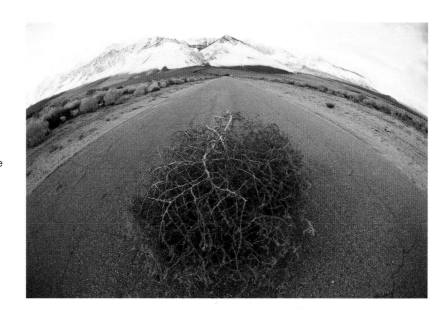

FIG. 10.8 This tumbleweed looks normal because it's in the center of the shot, but the fisheye lens curves the horizon line near the top of the frame. I'm pointing the lens down to exaggerate the tumbleweed in the foreground. Owens Valley, California. (Nikon D2X, ISO 200, 10–17 mm fisheye lens, handheld, 1/640 sec. @ f/8.)

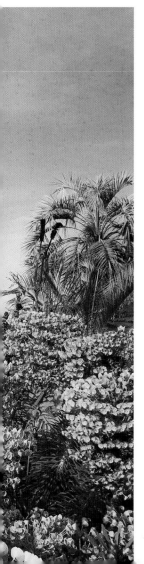

intense, and maybe adds contrast for a crisper appearance. But you can do these things using manual exposure and the camera's custom settings, so using these scene modes with DSLRs is just for convenience. I'd rather use my own settings.

Fisheye and perspective-control (PC) lenses

Fisheye lenses are extreme-wide-angles that distort any straight-edged object outside the center of the frame. Some of these lenses are so wide that they produce a circular image surrounded by black, but most fisheyes fill the sensor frame with an image. Cameras with small sensors use fisheyes in the 8 mm to 11 mm range, and cameras with full-frame sensors use fisheyes in the 14 mm to 16 mm focal lengths. I like to use these lenses in places that are really small, so I can show as much of the scene as possible. To prevent distortion, keep everything centered; as soon as you point up or down, or put the subject close to the edge, it'll bend like crazy. But maybe that's what you want. One of the biggest problems with these lenses is accidentally capturing your feet or your tripod legs in the shot, so check the edges of the frame carefully (**FIG. 10.8**).

Tilt-shift or *perspective-control* (PC) *lenses* do something that no other DSLR lens can do: Fix how things look. You know how, when you tilt a wide-angle lens up at a tree, the tree seems to tilt backward? The only way to straighten the tree is with one of these special lenses, which shift the position of elements within the lens to retain the correct perspective. Many landscape photographers use large-format view cameras to tilt and shift the film plane and the lens. Tilt-shift lenses can also alter the plane of focus, allowing you to get more or less depth of field, with less dependence on f/stops.

Lighting

Just watching light—I mean *really paying attention*—will help you to see how important light is to landscape photography. Late one afternoon as I drove, I noticed how the light kept changing. As the light got lower in the sky, the shape of the land changed. The valleys filled with shadows, hills were separated from each other, trees stood out against dark back-grounds. The land changed as the light changed. The time for viewing landscapes begins a couple of hours before sunset, and every 20 minutes everything changes again. It really is amazing to watch the light over a few hours. You'd think someone who has taken pictures for so long would

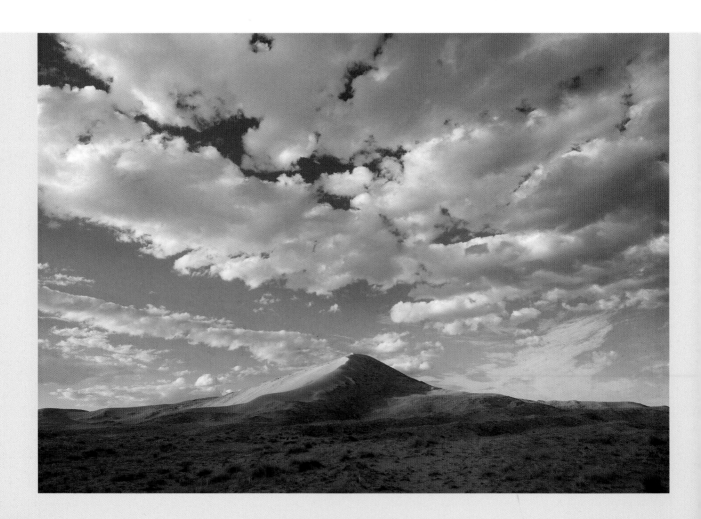

know this, but when I take the time to watch the light, I gain new insight into how to make my images better (**FIG. 10.9** and **10.10**).

Sometimes you can't wait for the beautiful light, but you have an interesting scene. What do you do? If you've got puffy white clouds and a colorful subject in the foreground, hard midday light can work. But without the clouds, you have to find something to cover up the boring sky, or compose with more of the interesting foreground and less of the sky. Think about your light direction: Are you trying to show color, texture, or shape? Each of these elements requires a different lighting direction (**FIG. 10.11** and **10.12**).

FIG. 10.9 and **FIG. 10.10** These shots were taken 11 minutes apart, about an hour before sunset. Every few minutes, the dropping sun and moving clouds changed the way the dunes looked. I liked the clouds, so I pointed the camera up to fill the top of the frame. Kelso Dunes, Mojave National Preserve, California. (Nikon D2X, ISO 100, 12–24 mm lens, tripod, 1/400 sec. @ f/6.3.)

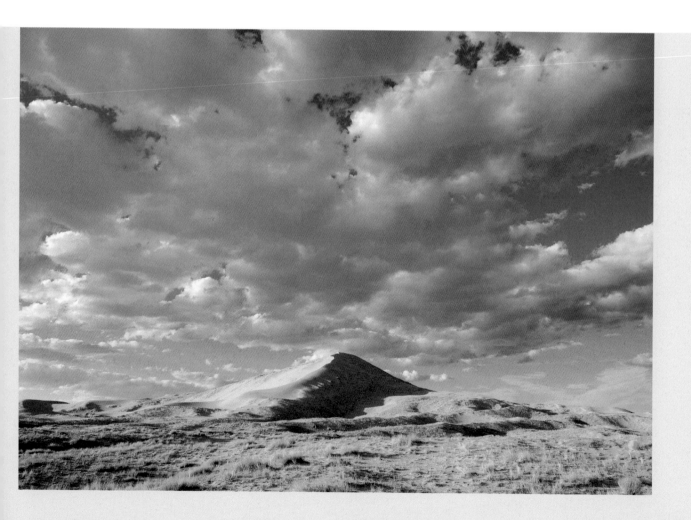

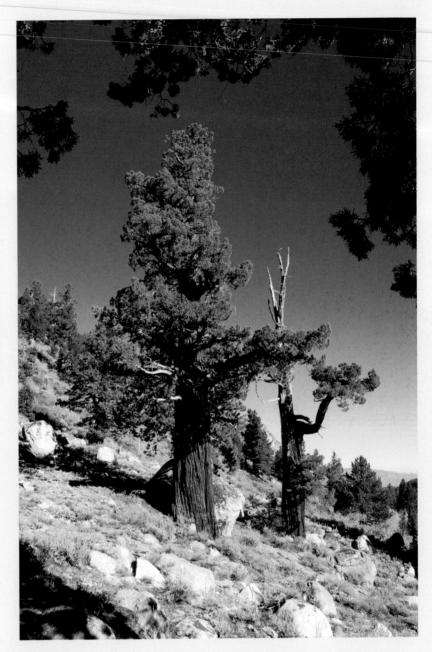

FIG. 10.11 It was nearly sunset, but the sun was dropping through thick haze and the sky was just a pale gray. I decided to concentrate on the seaside daisies and show how they grow on the ocean cliffs. Pointing the camera down eliminated the boring sky, and getting close to the daisies emphasized the flowers. Big Sur, California. (Nikon D3, ISO 200, 12–24 mm lens, handheld, 1/160 sec. @ f/5.)

FIG. 10.12 There were no puffy white clouds in the afternoon sky, so I used the branches of another tree to fill in the empty sky above this western juniper. My wide lens even got the little shadow in the lower-left corner that helps to frame the scene. Side lighting brings out the texture in the trunks of these ancient trees. Eastern Sierras, California. (Nikon D100, ISO 200, 20 mm lens, handheld, 1/250 sec. @ f/10.)

Questions & Answers

Q Could a polarizing filter make my landscape photos more colorful?

A Nearly every effect that an optical filter can provide can now be done in Photoshop. There's even a filter pull-down menu in Photoshop with common "filters" listed, like the 81A warming filter, which I used all the time when shooting film, to warm up skin tones. But there's one filter that you won't find listed in Photoshop: the polarizing filter. This unique filter is designed to eliminate reflections and has an interesting effect on color and contrast. First, the bad news about polarizers: They're expensive, they cut out nearly two stops of light, and they make skin look pasty. So don't use them when doing portraits of people. And definitely don't leave them on your lens all the time.

I use polarizers to eliminate reflections on water and other specular surfaces such as leaves. Leaves and flowers have a waxy coating to prevent evaporation and can be very shiny, especially when front-lit. A polarizer eliminates these reflections and makes leaves look greener, more "saturated." Polarizers also darken the sky by controlling the scattering of light in the air, but this only happens at about a 90-degree angle from the sun; even then, the effect falls off quickly, so only part of the sky gets darker. Be careful; this effect can look a little strange (**FIG. 10.13**).

TIP Before you put a polarizing filter on your lens, hold the filter up to your eye and look at the scene. Rotate the polarizer to see its effect on the light. If you like the result, put the filter on the lens. Always take one shot without the polarizer, though, just to be safe.

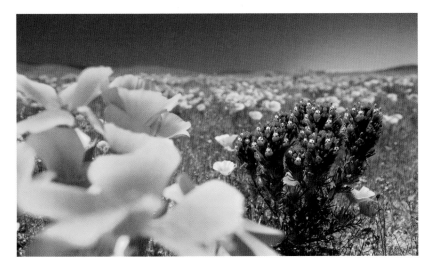

FIG. 10.13 The polarizer darkened the sky, but it didn't polarize equally across the frame. Wide-angle lenses see so much sky that this uneven result happens frequently with these filters. Owl's clover and California poppies, Antelope Valley, California. (Nikon D2X, ISO 200, 12–24 mm lens, polarizing filter, handheld, 1/400 sec. @ f/6.3.)

Q *Sometimes my scenic photos aren't tack-sharp, even if I used a tripod. Why not?*

A A lot of landscape photographers make big enlargements of their images for display on walls. The images have to be very sharp to blow up to these sizes. Using the best-quality lenses and a tripod is critical to image sharpness, but there are other techniques you can use to ensure sharp scenic images. First, use a cable release. A cable release allows you to trip the shutter without touching the camera, preventing any chance of camera movement. If you don't have a cable release, try using your self-timer. Second, use your camera's mirror delay or mirror lock-up feature when taking a photograph. The mirror in your camera can introduce motion, especially at slower shutter speeds. Mirror lock-up or delay raises the mirror, waits a second or two to let all motion stop, and then allows the shutter to fire, making the exposure. Of course, you can't see anything during this delay, but it doesn't matter because your landscape isn't going anywhere.

Q *How do you get water in streams to look so silky?*

A Easy—long exposures. But getting sharp pictures with long exposures isn't always easy. Your shutter speed controls how long the exposure will be. A slow shutter speed, say 1/15 second or longer, will cause most subjects—including streams—to blur if they're moving fast. But if the water is moving slowly, you may need two seconds, or even longer. Most DSLR cameras can go as long as 30 seconds. Use your lowest ISO, meter your scene using a slow shutter speed, and put your camera on a tripod. Study the water: How is it flowing? The places where you see whitewater will be the brightest and "silkiest." Think about your composition based on these parts of the stream (**FIG. 10.14**).

Sometimes it's too bright to use these long shutter speeds, even when you stop down to f/16 or f/22 and use your lowest ISO. Using neutral-density (ND) filters or even a polarizer to cut light can help in these situations. Neutral-density filters go on the front of the lens and cut the amount of light reaching the camera, but they don't change the color.

▶ **FIG. 10.14** You have to study the water for a while to see where the lightest areas are and how they fit into a composition. You need a slow shutter speed to get the silky look in the moving water. I usually bracket my exposure time a bit to get different effects in the water. Big Sur, California. (Nikon D300, ISO 200, 12–24 mm lens, tripod, 1.6 sec. @ f/16.)

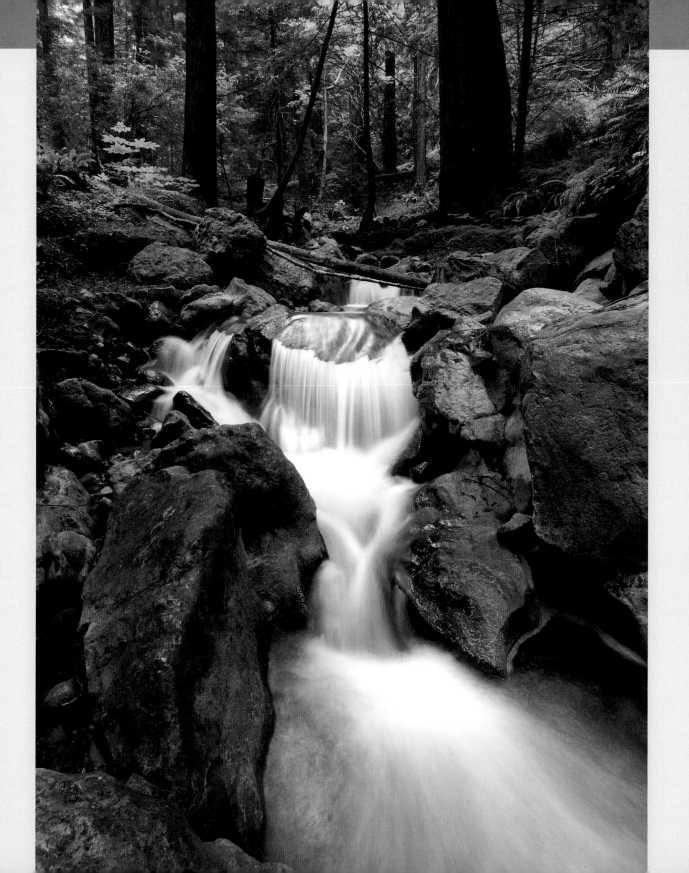

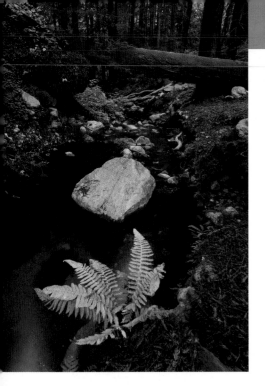

▲ **FIG. 10.15** The sun had gone down by the time I found this little fern by a creek. I made my exposure for the dark forest and just popped a little flash on the fern to get it to stand out. I used hyperfocal distance, focusing just past the fern, to make the whole scene sharp. Big Sur, California. (Nikon D300, ISO 200, 12–24 mm lens, flash, tripod, 10 sec. @ f/16.)

Q *How can I get my landscape photos to be in focus from the foreground all the way to infinity?*

A When you look at images by famous landscape photographers like Ansel Adams, Ray Atkinson, David Muench, and Jack Dykinga, you'll notice that everything in their photographs is in focus. Everything—the foreground, the background, all tack-sharp. Using view cameras and large-format film allowed them to make these amazing images. You can come close to duplicating their results with your DSLR, wide lenses, and a technique called *hyperfocal distance*. Essentially, the hyperfocal distance is the point of focus that produces the largest depth of field at a given aperture. Once you've focused a lens at the hyperfocal distance, everything in your scene—from the subject in the foreground all the way to infinity—will be sharp. It's all based on depth of field.

To get this technique to work, choose a scene with a strong foreground subject and an interesting background. Compose so the foreground subject is close to you. Wide-angle lenses in the 12 mm to 28 mm range work best, a tripod is critical for sharpness, and you need to use f/11 or f/16 for maximum depth of field (**FIG. 10.15** to **10.17**).

Some fixed wide-angle lenses have hyperfocal distance scales, but you won't find them on zoom lenses. Go to DOFMaster.com or Outsight.com and use their online hyperfocal distance calculators to find the distance to focus for the camera, lens, and f/stop you're using. (You can even download a depth-of-field hyperfocal calculator for your iPhone from DOFMaster.com.) I used this technique for each of my wide lenses, and now I carry that list in my camera bag.

▶ **FIG. 10.16** You need a foreground for wide-angle scenes, and these caribou antlers work perfectly. The pond is the middle-ground, and sunrise on Mt. McKinley fills in the background. I wanted everything sharp, so I used a tripod and cable release, focused on the hyperfocal distance, and selected a small aperture to gain the sharpest image and greatest depth of field. Camp Denali, Denali National Park, Alaska. (Nikon D2X, ISO 100, 12–24 mm lens, tripod, 1/5 sec. @ f/18.)

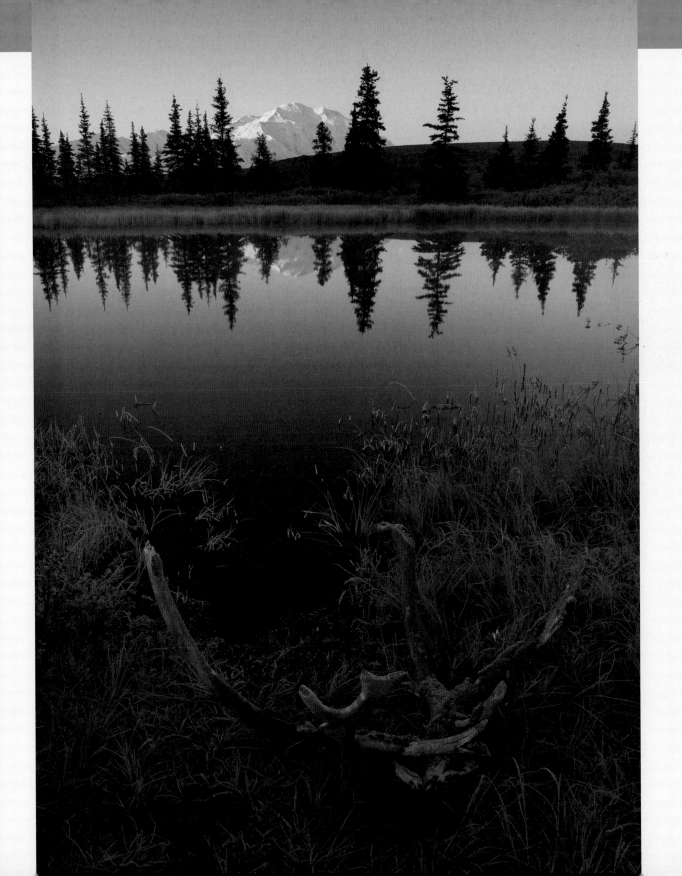

FIG. 10.17 Crescent Meadow is a magical place. This story is about the giant sequoia trees that surround the meadow. I framed the base of a fallen sequoia in the foreground, put my wife next to another sequoia to show scale in the middle-ground, and let the meadow fall away into the background. Getting really close to the foreground is the key to this wide-angle composition. Sequoia National Park, California. (Nikon D300, ISO 200, 10–17 mm fisheye lens, tripod, 1/50 sec. @ f/13.)

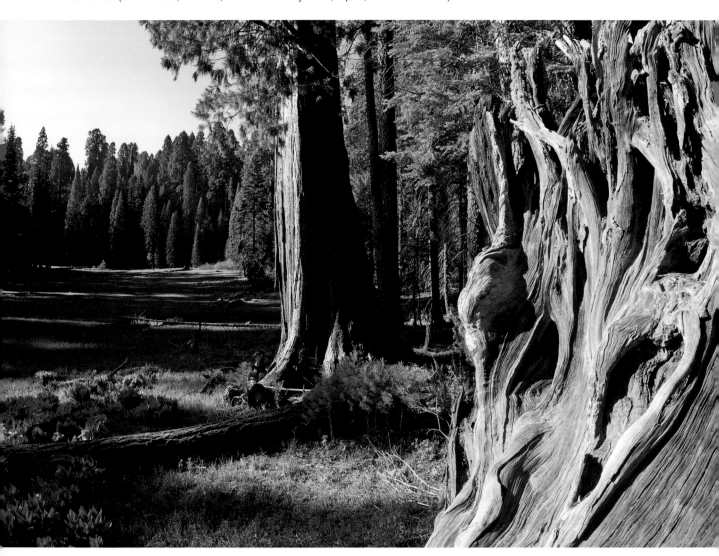

Assignments to try

To gain a better understanding of how the hyperfocal distance technique works, start by finding a scene with a nice foreground and an interesting background. Then follow these steps:

1. Set your camera on a tripod. Use a wide-angle lens and manual focus.

2. Set your f/stop at f/16 and meter the scene to get the proper shutter speed for a correct exposure. Use ISO 100 or 200.

3. Compose your scene so the subject in the foreground is about two feet away—it should look pretty large. Make sure that you can see the background in the top of the frame. (Vertical compositions help here.)

4. Using the info you got from the hyperfocal distance calculator, set the distance on the lens to match the hyperfocal distance, and take a picture. You'll probably notice that you're focused past the subject in the foreground; that's right where you want to be.

5. Refocus on the closest part of your foreground subject and take another picture.

6. Focus on the background and take a picture.

7. Check the photos on the computer and see which picture has everything from foreground to background in focus.

11 Looking through the frame

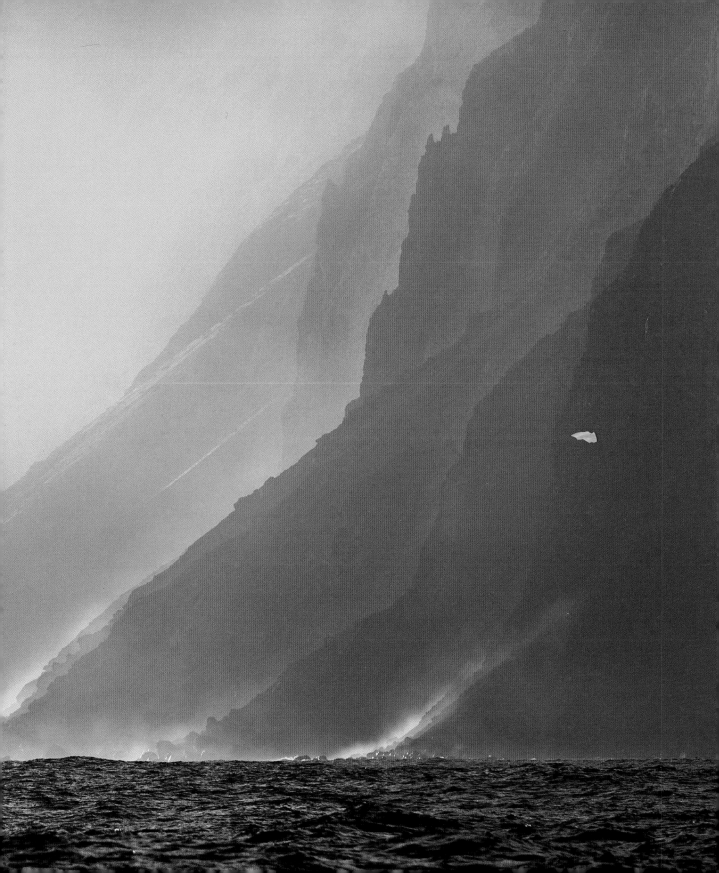

How to make your camera see
things the way you do.

The frame

The photographer's view of the world is limited, boxed within the frame of the camera and constrained to its single lens. We can rotate the frame, but we can't change its size unless we change the size of the camera. With only one "eye," the lens can't see depth, as humans can with our stereo-scopic vision. We're capturing images through a one-eyed box (**FIG. 11.1**).

This isn't the way we normally view our three-dimensional world. When we look at a scene, our eyes move around, focusing on an element that catches our attention, moving to the next element, looking up and down, close and far. By moving our heads we can take in a wider scene. Our impression of what we're viewing is based on movement.

The camera's view doesn't move. Whatever is within the camera's frame is what we capture, and it's two-dimensional only, not three-dimensional. Whether online or in print, an image has only height and width—no depth. To create the illusion of depth, the photographer must use composition within the camera's frame.

FIG. 11.1 At the end of a day of diving off Santa Cruz Island, we anchored the boat near a rock that brown pelicans used for roosting. Checking my compass, I knew that the sun would set behind the rock, so we got in our little inflatable skiff and waited as the sun dropped. Presetting my exposure for the sunset sky meant that I was ready when this pelican took flight. California. (Nikon F3, ISO 64, 200 mm lens, handheld, Kodachrome 64 film, exposure unrecorded.)

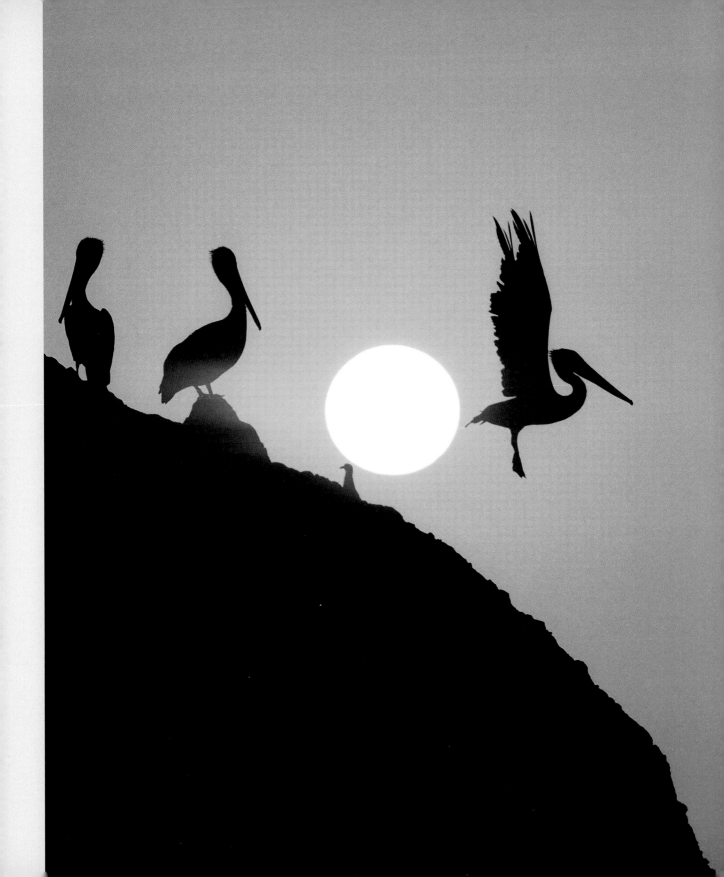

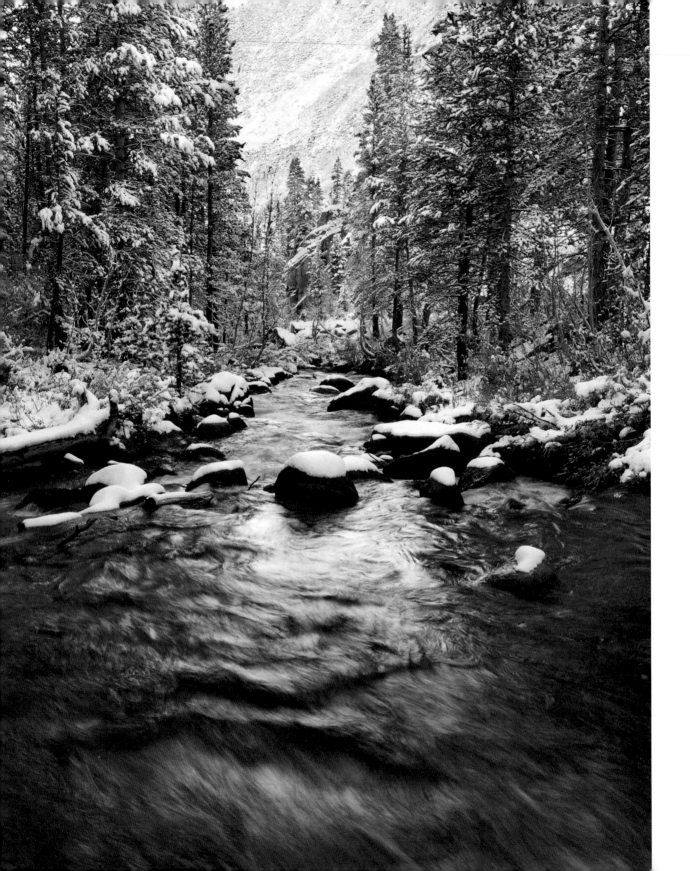

This description may sound a bit obvious, but few people are conscious of the difference between how we see and how the camera sees. The photograph at the beginning of this chapter shows dramatic cliffs on Mexico's Guadalupe Island. The camera frame has eliminated any reference of scale. You have no idea how large or small the cliffs are, because I didn't include the sky or a boat within the frame. As a photographer, you make a subjective decision about your composition by what you include, as well as exclude, from the frame (**FIG. 11.2**).

TIP Very few camera viewfinders see 100% of what's captured in the photograph. Want to see how much your viewfinder hides? Tack an open newspaper on a wall. While looking through the camera viewfinder, have someone mark the corners of the paper that you can see. Take a picture. Then compare the photograph with the marks you drew on the paper. Looking at the photograph, how much do you see outside the marks, stuff that you didn't see when you framed the picture through the viewfinder?

◀ **FIG. 11.2** A wide-angle lens exaggerates the distance between the foreground and the background. Pointing the camera down eliminated a distracting sky and placed the horizon line out of the middle. All of these decisions combined to create a sense of depth in this image of a mountain creek in California. (Nikon D2X, ISO 100, 12–24 mm lens, tripod, 1/40 sec. @ f/16.)

Composing the image

Many photographers think that composition is based on a set of rules, and by following these rules their images will miraculously appear perfectly composed. It doesn't really work that way. But composition is something you have to learn so you'll understand why some images work and others don't.

You need to understand how to create balance or imbalance within an image. How to use color and contrast, proportion and perspective. The use of lines and shapes within the frame. All these elements of composition will help you to create a sense of three-dimensionality in your images.

Entire books and websites are devoted just to composition and photographic design. Obviously I can't cover everything here, but I have some suggestions to share that will help you with composing your photographs. These are not "rules," just guidelines that help me.

My definition of composition is merely the arrangement of objects within the frame. Again, the frame is critical: What's in the frame? What's outside the frame? Is the frame vertical, horizontal, or somewhere in between?

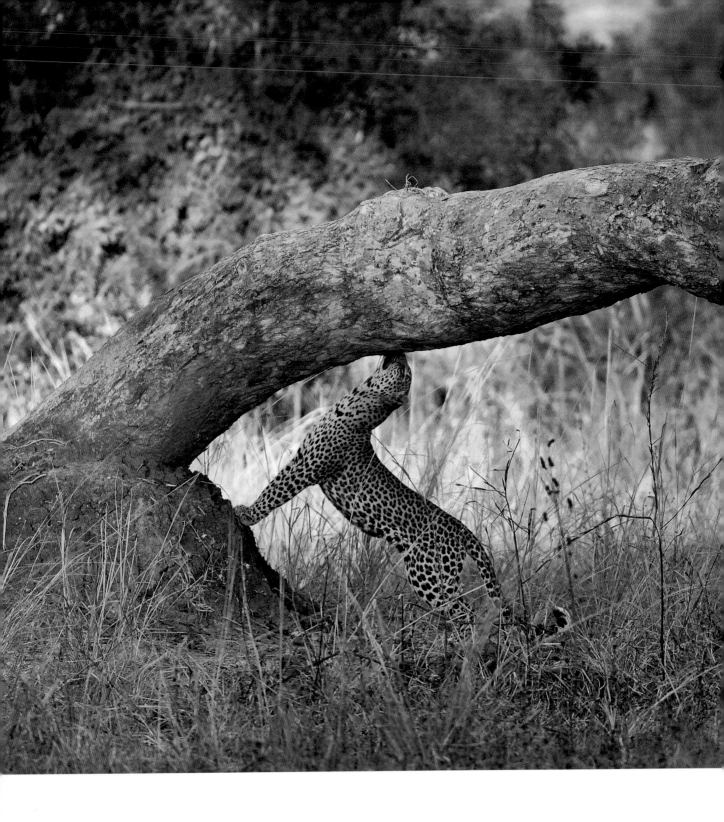

FIG. 11.3 One of my favorite photographs. Just after sunrise, we spotted this leopard walking through the tall grasses. Our guide said that it might go to this tree and mark it, so we drove ahead and waited. The guide was right. The light and dark elements, and the connecting shapes formed by the tree and leopard, created a strong sense of dimension. Zambia, Africa. (Nikon D2X, ISO 400, 200–400 mm lens, ballhead mounted on vehicle, 1/250 sec. @ f/4.)

Good composition keeps things simple. Reduce your composition to the essence of the subject. Only include elements that support the subject—eliminate or deemphasize everything else. The eye first goes to the lightest thing in the frame, and then looks for what's in focus. Using light and focus allows you to control how the viewer looks at your images. To put this principle into practice, look at your composition, think about what's in focus, think about the brightness of the various objects, and arrange things to make viewers look where you want them to look (**FIG. 11.3**).

The "rule of thirds" is a visual guideline to help balance objects within a frame. Placing your subject out of the center is one of the quickest ways to improve composition, but the rule of thirds only deals with two dimensions. I've expanded it to deal with three dimensions, making a "3D rule of thirds." This grid gives you a compositional tool that works with foregrounds, middle-grounds, and backgrounds. You need to be aware of all three of these areas in your scene, especially when shooting with wide lenses, to create that sense of depth we so desperately need in our photographs (**FIG. 11.4** to **11.7** on the next page).

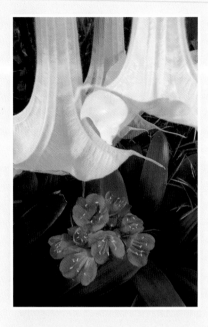

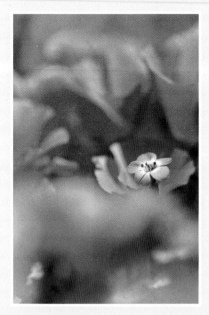

FIG. 11.4 and FIG. 11.5 Compose the photo within the frame to draw attention to the subject. *Far left:* Angel's trumpets at the top of the frame keep the viewer's eye within the picture. Placing the focus on the orange clivia shows you the subject. (Nikon D2X, ISO 200, 14 mm lens, handheld, 1/8 sec. @ f/5.6.)
Near left: The Davy gilia wildflower is the brightest and sharpest element amid a field of California poppies. The viewer's eye goes straight to it, wanders quickly around the frame to look for anything else of interest, and then snaps back to the gilia. It's the subject. (Nikon D100, ISO 200, 105 mm lens, handheld, 1/3200 sec. @ f.4.)

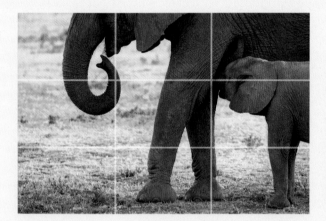

FIG. 11.6 Although it's actually natural to place things in these off-center points, the camera frame tends to make us center things. Keeping the rule of thirds in mind helped me frame this mother and young elephant in Tanzania, Africa. (Nikon D2X, ISO 200, 200–400 mm lens, ballhead mounted on vehicle, 1/160 sec. @ f/4.5.)

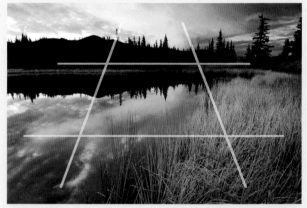

FIG. 11.7 Sunrise colored the grasses at the Camp Denali pond. Using the 3D rule of thirds, the foreground grass moves the viewer's eye into the middle-ground pond, and the trees and clouds fill in the background. Being aware of the foreground, middle-ground, and background helps in composing complex scenes. Denali National Park, Alaska. (Nikon D200, ISO 200, 12–24 mm lens, tripod, 1/25 sec. @ f/16.)

Equipment

There's a huge difference between what you see with a wide-angle lens and what you see with a telephoto lens. Each type of lens has a specific view of the scene within the frame (**FIG. 11.8** and **11.9**):

- Wide-angle lenses "de-magnify," making things look smaller, and exaggerating the distance between foreground and background.
- Telephoto lenses magnify the subject and bring the background closer. They compress distance and make objects appear stacked up in the frame.

The guideline I use for choosing a lens is whether my subject is in the foreground or the background of the frame. If the subject is in the foreground, I use a wide-angle lens; if it's in the background, I use a telephoto. The foreground doesn't have to be in the bottom of the frame; it can be on the top or even on the side of the frame (**FIG. 11.10**, next page).

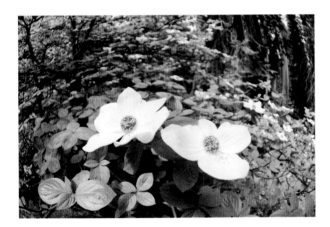

FIG. 11.8 I like telling stories. The story here is the Pacific dogwood growing among the giant sequoia trees. The wide lens emphasizes the large, showy flowers, yet still shows the forest. Choose a wide lens if you have a strong foreground. Sequoia National Park, California. (Nikon D2X, ISO 200, 10.5 mm fisheye lens, handheld, 1/400 sec. @ f/5.)

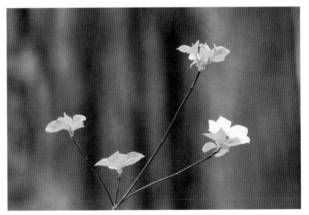

FIG. 11.9 A long lens let me compress the distance between the flower and the tree, telling the story of dogwoods growing among giant trees. If you have a strong background, choose a telephoto lens. Sequoia National Park, California. (Nikon D300, ISO 400, 200–400 mm, tripod, 1/15 sec. @ f/5.6.)

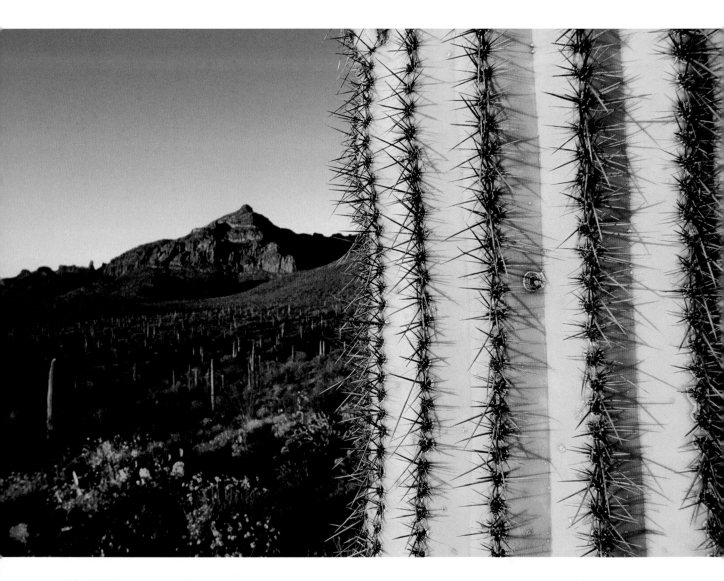

FIG. 11.10 Foregrounds, like this saguaro cactus, can be placed anywhere in the frame, including the bottom, top, or sides. And there's no rule about how far into the frame your foreground can be—put it where it works. Organ Pipe Cactus National Monument, Arizona. (Nikon F4, ISO 32, 20 mm lens, tripod, Fuji Velvia 50 film, exposure unrecorded.)

Light meter patterns

Metering patterns determine what part of a scene the camera uses to determine the exposure. There are three choices: *matrix* (also known as *evaluative*), *center-weighted*, and *spot* (**FIG. 11.11**, **11.12**, and **11.13**, respectively). Different manufacturers use different names, but no matter what they're called they work in basically the same way.

Matrix metering measures the light in several "zones" and averages the zones based on algorithms stored in the camera's computer to come up with an exposure. This pattern is actually "guessing" what's important in the scene. This is the default setting on many cameras, and works great most of the time. But it's based on things people typically photograph: indoor locations, scenes in good weather, and photos of people. The more sophisticated the camera, the more sophisticated the metering pattern. With contrasty scenes or backlit subjects, matrix metering can be fooled, so choosing one of the other patterns may work better.

The center-weighted pattern puts about 70% of its metering emphasis in the center of the viewfinder. To understand what's being measured, pay attention to where the center of the viewfinder is pointed. The center-weighted pattern is my choice nearly all the time. It doesn't rely on algorithms, and I find it very predictable. If you're photographing a sunset scene with a dark foreground and you want the sky to be exposed properly, point the camera up and meter just the sky; then lock the exposure and recompose for your shot (**FIG. 11.14**).

If you have a small subject against a darker background, how are you going to get that subject exposed properly? The matrix and center-weighted metering patterns will see too much dark background and overexpose the light subject. This is where the spot meter can help. This pattern measures light in a very small spot and bases nearly all the exposure on that spot. Most cameras tie the spot into which focus point is activated. Just put the spot on the subject, meter, and set your exposure. The light subject will have detail and the background will be darker, just like it looks to your eye (**FIG. 11.15**).

FIG. 11.11 Matrix or evaluative patterns measure light from each zone of the frame. Costa Rica. (Nikon D2X, ISO 100, 12–24 mm lens, tripod, 1/6 sec. @ f/16.)

FIG. 11.12 Center-weighted patterns measure light mainly from the center, with less emphasis on the rest of the frame.

FIG. 11.13 Spot patterns concentrate the measurement in a small circle in the center of the frame, and are sometimes tied into the focus point.

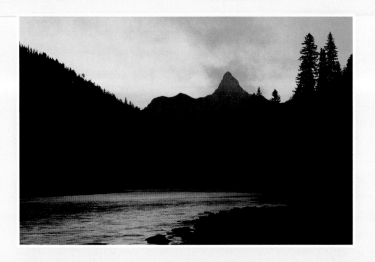

▶ **FIG. 11.14** We were actually lost when we came across this scene just before sunrise. We jumped out of the car and shot like mad for the few minutes before the color faded. Pointing my lens at the sky for my meter reading let me expose for the sunrise colors, placing trees and mountains in silhouette. Flathead River, Montana. (Nikon F4, ISO 80, 400 mm lens, tripod, Kodak Ektachrome 100 film, exposure unrecorded.)

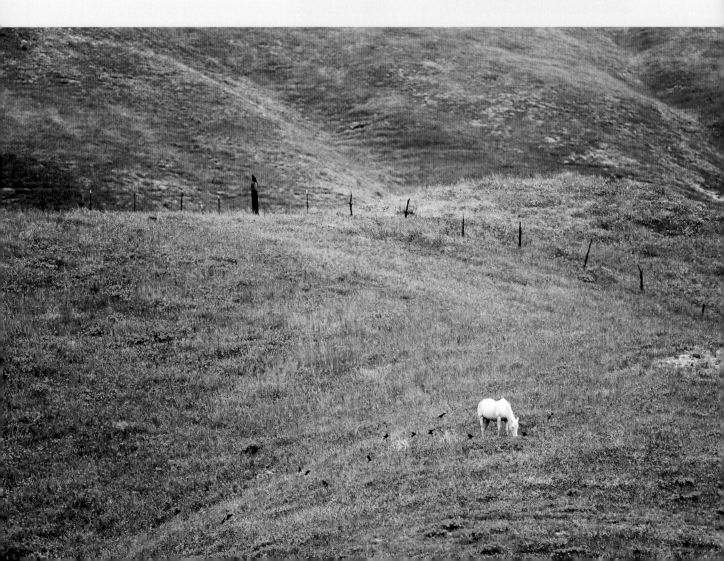

Filters

In digital photography, filters play a different role than they did with film. And there are definitely two camps here: one asks why we should stick a cheap filter onto an expensive lens when you can get the same effects in Photoshop. The other says to use filters just like we did with film cameras. You can use UV or skylight filters to protect your lenses, especially in inclement conditions such as blowing sand or salt spray from waves. Sand and salt water aren't good for lenses—better to damage a filter than damage your lens (**FIG. 11.16**, next page).

After a day spent photographing on the ocean, I carefully wipe down the outside of my camera and lens with a slightly damp cloth. Then I gently wipe the UV filter, using lens cleaning solution and a lens cloth. This technique removes salt spray, and the sooner you do it, the better. When water evaporates from salt spray, it leaves salt crystals that can scratch and corrode surfaces on your camera and lenses. Check out Ken Rockwell's website (listed in the appendix) for cleaning techniques.

When choosing filters, always buy the best you can afford, so the effect on image quality is minimized, and use multicoated filters to reduce flare and maintain contrast.

◄ **FIG. 11.15** Sometimes things just work out. A field of flowers, a white horse, and soft light gave me lots of elements to work with. Using a long lens and spot metering the horse ensured that I kept detail in the horse's white coat. Gorman, California. (Nikon F4, ISO 32, 400 mm lens, tripod, Fuji Velvia 50 film, exposure unrecorded.)

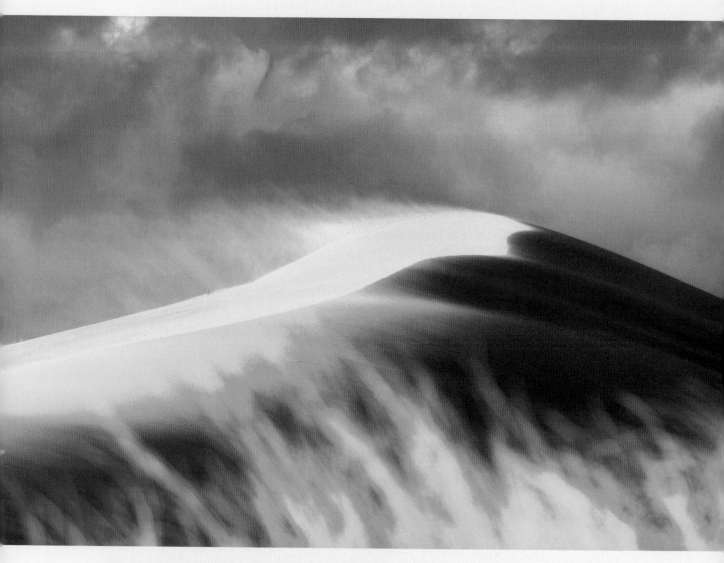

FIG. 11.16 Both salt spray from the ocean and blowing sand in the desert are tough on equipment. One of my mentors, Craig Aurness, had to replace his lenses after an assignment in the California desert for *National Geographic*. Sand storms had etched the front of his lenses. Better to lose a filter than the whole lens. Kelso Dunes, Mojave National Preserve, California. (Nikon D2X, ISO 100, 70–200 mm lens, tripod, 1/400 sec. @ f/4.5.)

Lighting

As we've talked about elsewhere in this book, great photographs usually have great light. Often we get so wrapped up with our subjects, composing our scenes and checking the technical stuff, that we forget to walk around the light. "Walking around the light" means literally that—if you're watching a beautiful sunset, turn around. What is that sunset lighting? Does that drop of water look better when lit from the front or the back? If you like the way some trees line up in a forest, walk around and look at them lit from the front, back, and side (**FIG. 11.17**).

Each lighting direction is a different picture. What are you trying to show—shape, color, texture? Choose the direction that shows what you want. Walk around the light.

▼ **FIG. 11.17** The uncluttered understory and strong lines of these trees had caught my eye every time I drove past them. But it wasn't until the light hit them that I stopped and took the photo. The sidelight brings out the textures in the bark and separates them from the background. Kings Canyon National Park, California. (Nikon D2X, ISO 100, 12–24 mm lens, tripod, 2 sec. @ f/16.)

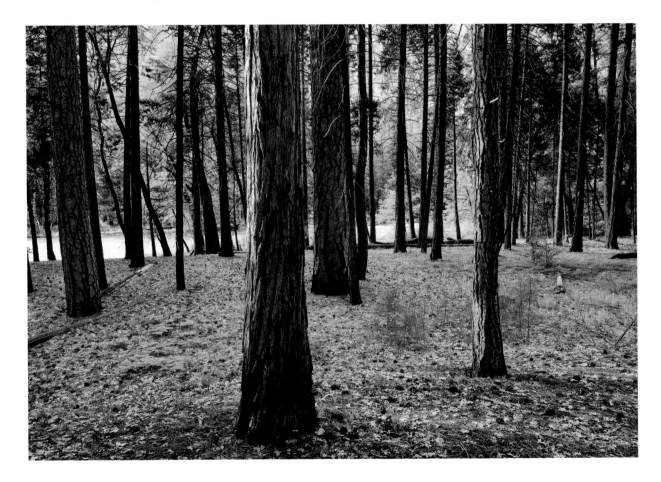

Questions & Answers

Q *How do you get your silhouette shots to look so colorful?*

A There are two issues here: exposure, and what I call *silhouette merger*. A silhouette is an easily recognized dark shape against a lighter background. A common background choice for silhouettes is a colorful sunset or sunrise sky, like the one I used in this shot of an oak tree (**FIG. 11.18**).

Metering this type of background can be a bit tricky, especially if the sun is in the frame (like in the pelican shot earlier in this chapter). The bright sun can fool your meter into underexposing the colorful sky and ruining the silhouette. Be sure to meter a bright area of the sky *without* the sun in the viewfinder to get your exposure. Now the sunset sky will look great, and your subject will stand out as a silhouette against a lighter background.

Now let's say you exposed the sky properly, but your subject still doesn't stand out like you wanted. This is probably because you don't have the subject's shape isolated against the lighter background. Some parts of the dark subject are merging with other dark areas, either behind the subject or within the subject itself. I call this a *silhouette merger*. All you have to do is recompose, moving so that you see the whole shape against the light background. A great thing about using water for silhouettes is that it reflects light, so you not only can use the sky but also the foreground.

TIP Remember, you don't see contrast the same way your camera does. Try that squinting trick I mentioned in Chapter 3, "It's all about the light," to see if you're getting any silhouette mergers.

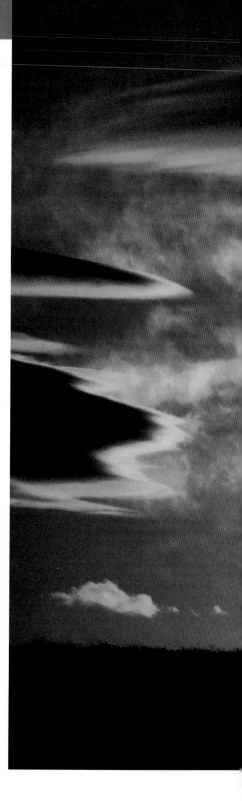

▶ **FIG. 11.18** Oak woodlands are a disappearing habitat in much of California. Since the sunset sky was more interesting than the hillside, I placed the horizon line low in the frame. I made sure that there was space between the lower branches and the hilltop, so the tree didn't merge with the hill. Santa Ynez Valley, California. (Nikon F3, ISO 64, 400 mm, tripod, Kodak Kodachrome 64, exposure unrecorded.)

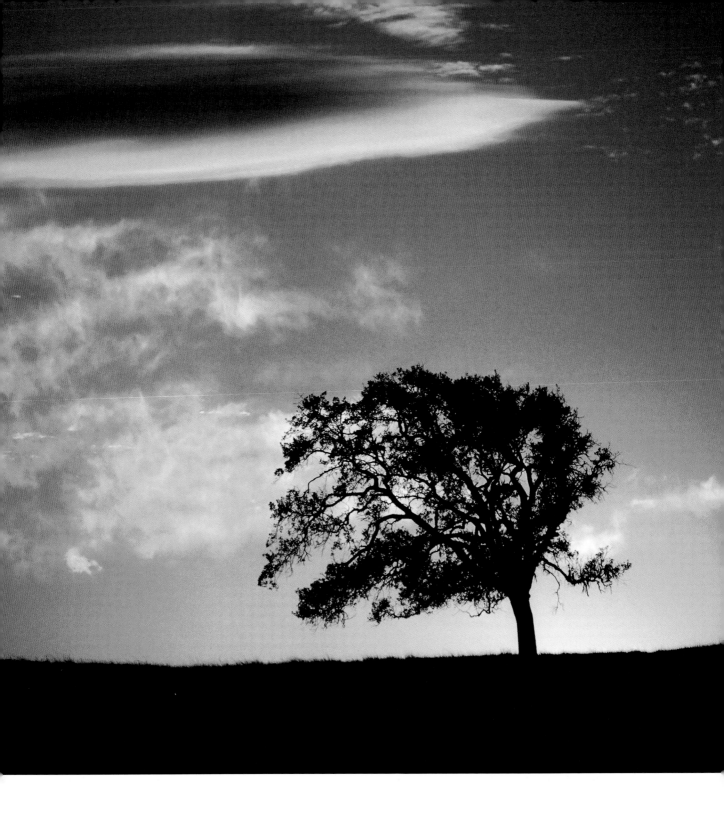

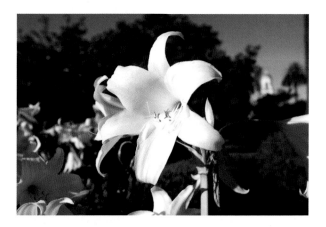

FIG. 11.19 These crinum lilies are large flowers, easy to get close to with a wide lens. Photographing them at eye level works okay, but the background is busy, with lots of distracting elements. Santa Barbara, California. (Nikon D2X, ISO 200, 12–24 mm lens, handheld, 1/1600 sec. @ f/6.3.)

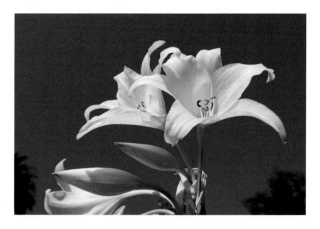

FIG. 11.20 Just by getting lower and isolating the crinum lily against the clear blue sky, I've solved the "busy background" problem. The trees in the bottom corners help to keep the eye moving toward the center of the frame as well. I created two very different photographs with just a simple change in point of view. Santa Barbara, California. (Nikon D2X, ISO 100, 12–24 mm lens, handheld, 1/500 sec. @ f/7.1.)

Q **What's your secret to creating uncluttered images?**

A Sometimes just moving your camera slightly in another direction can mean the difference between an image that looks busy and one that doesn't. Changing your *point of view* (POV) is one way to control your composition. Remember, less is usually best. Try shooting up or down to eliminate distracting backgrounds. Or just switch to a longer lens so you see less of the background (**FIG. 11.19** and **11.20**).

You can use objects in the scene to frame the subject and hide the clutter. Framing a subject can help you to control what the viewer will see and provide a lot of depth in images. Using frames such as leaves, arches, and shadows, especially with wide lenses, fits nicely into the 3D rule of thirds. The frame acts as the foreground to isolate your subject in the middle-ground or background (**FIG. 11.21**).

Q **Should I always follow the rule of thirds, or can I put things in the middle of a picture?**

A In many situations, putting a subject in the middle or placing lines in the center of the frame looks fine. Any subject or scene that has symmetry is a prime candidate for composing in the middle. Reflections in water, many types of plants, even some animals show symmetry. Think about sea urchins, starfish, a curled-up millipede, daisies and dahlias, even tufts of grass. All are symmetrical. Most reflections beg to be centered; after all, the symmetry makes the reflection interesting (**FIG. 11.22** and **11.23**).

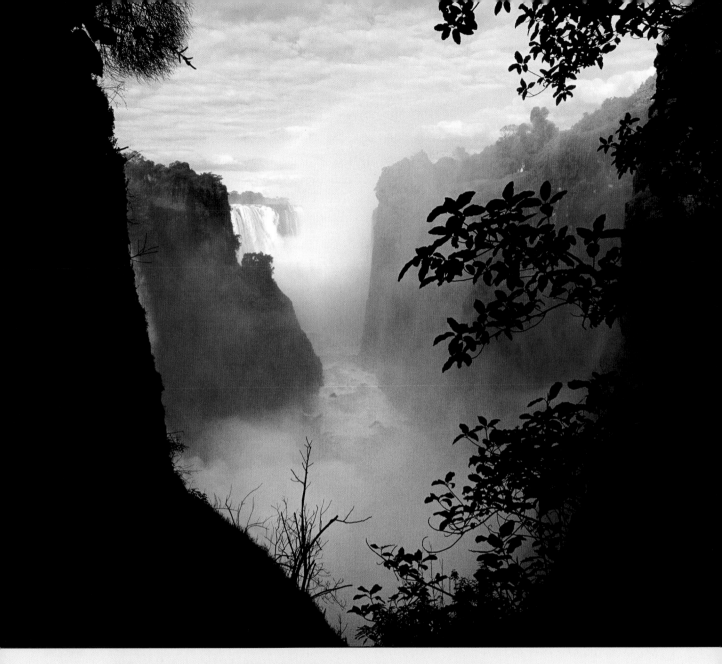

FIG. 11.21 Victoria Falls or Mosi-oa-Tunya (Smoke That Thunders) is a massive waterfall system. Often you can't even see the falls because there's so much mist. Framing the falls with cliffs gives the viewer a sense of being there, and adds depth to the scene by using the 3D rule of thirds. Zimbabwe, Africa. (Nikon F4, ISO 80, 20 mm lens, tripod, Fuji Velvia 100 film, exposure unrecorded.)

FIG. 11.22 Many flowers like this dahlia are designed in spirals and swirls. The symmetrical patterns are emphasized when you center the subject in the frame. Santa Barbara, California. (Nikon D2X, ISO 100, 60 mm macro lens, tripod, 1/30 sec. @ f/16.)

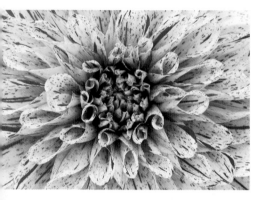

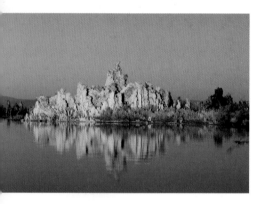

FIG. 11.23 Tufa towers reflected in Mono Lake. The symmetry of the tufa formation and its perfect reflection allowed me to center the horizon line in the frame. Working with George Lepp, we lit the tufa with large flash-lights as night fell. California. (Nikon D2X, ISO 100, 28–70 mm lens, tripod, 10 sec. @ f/8.)

Q *How do you keep your photos fresh? I'm bored with my compositions.*

A Sometimes we look at our pictures and nothing excites us. Nothing new, nobody going, "Ooh, nice photo!" It happens to everyone. Throughout this book I give you ideas on how to combat this malady of photography. If you can break out of a rut in the confines of a common place, like your own garden, just think what you can do when you travel to new and exciting places.

Try using radically different lenses to help change your preconceptions of what you're supposed to use, what this book says to use, or what your teacher says to use. Experiment with your tools, have fun, and don't be afraid to fail. Rent a lens you've never tried; make it a fisheye or a super macro, like the Canon 65 mm 1x–5x. While you're at it, change your camera's point of view. Get your belly wet, get a ladder, do something different (**FIG. 11.24**).

Assignments to try

- This assignment should force you to pay attention to composition. Pick a lens—a normal to wide one works best. If it's a zoom lens, set the focal length and don't change it. (Tape the lens so you can't change it, if that helps.) Use manual focus and select any focus point other than infinity. I like to use the closest focus point on the lens. Now go out in a field or garden, or along a creek, and take pictures. You can't change the focal length of the lens or the focus. By eliminating a lot of the choices you normally have when making images, you have to concentrate on just two things—the subject and the composition.
- One of the best ways to learn about photography is to look at photographs. Lots of the images in this book follow the compositional guidelines I've discussed in this chapter. Go back and look at the images again. See which ones use framing; which use the 3D rule of thirds with foregrounds, middle-grounds, and backgrounds; and which use focus and brightness to move your eye to the subject.

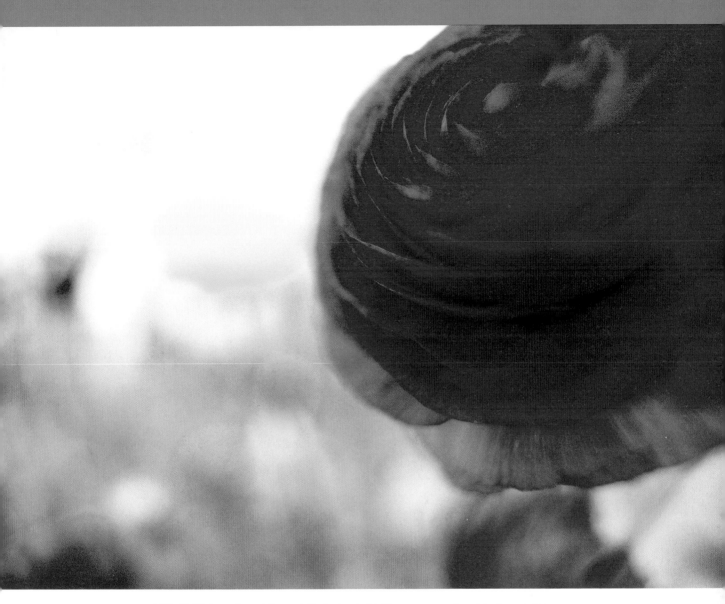

FIG. 11.24 I was bored, in a rut. So instead of taking my macro lens into the garden, I put a small extension tube on my wide-angle lens and focused it as close as possible. I didn't change the focus as I wandered around. When I found this perfect red ranunculus flower, I moved close. It was nearly touching the lens. Even with out-of-focus flowers in the back, I could still see it was in a garden, and that helps to tell the story. This is fun! I'm not bored anymore. Santa Barbara, California. (Nikon F4, ISO 32, 20–35 mm lens with a 9 mm extension tube, Fujichrome Velvia 50, handheld, exposure unrecorded.)

12 | What are you looking at?

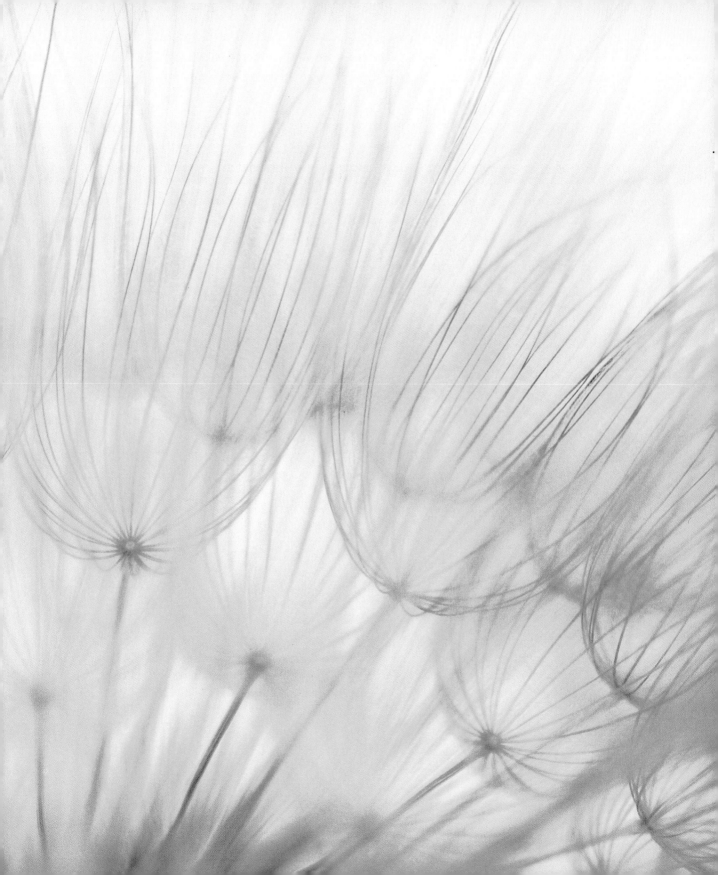

Learn to see things without preconceptions
and unlock your creativity.

Preconceptions

Great photographs are as much about choice of subject as about composition. You have to look for a subject, then you have to learn how to see the subject, and only then will you have something to compose. *Seeing* is very different from *looking*, and both are heavily influenced by our preconceptions (**FIG. 12.1** and **12.2**).

There are two types of preconceptions: photographic and creative. *Photographic preconceptions* are personal opinions about what to photograph, as well as where, when, and how to photograph it. We form our photographic preconceptions at an early age, based on what our family, friends, and culture teach us to appreciate. We can easily learn about and change these preconceptions. For instance, I've explained that the viewer's eye will go to the bright or colorful areas in a photograph first, and then look for what's in focus. Now that you know about this, your preconceptions of what makes a photograph "good" may change, allowing you to make better photographs.

Creative preconceptions aren't as easily changed; they require constant work. These preconceptions put up barriers to change, and control habitual behavior such as following compositional rules. Even though doing something over and over may make you very good at it, you need to break out of your routine and try something new if you're going to grow as a creative person.

FIG. 12.1 Few birds are as beautiful as the great egret in breeding plumage. I have many images of these birds and wanted something that was different from the standard portrait—but still recognizable as a great egret. Framing just the long feathers and black legs works. California. (Nikon F3, ISO 64, 300 mm lens, tripod, Kodak Kodachrome 64 film, exposure unrecorded.)

FIG. 12.2 After taking hundreds of pictures of impala in Africa, I finally saw what makes them so graceful—their legs. Tanzania, Africa. (Nikon F4, ISO 80, 400 mm lens, tripod, Kodak Ektachrome 100 film, exposure unrecorded.)

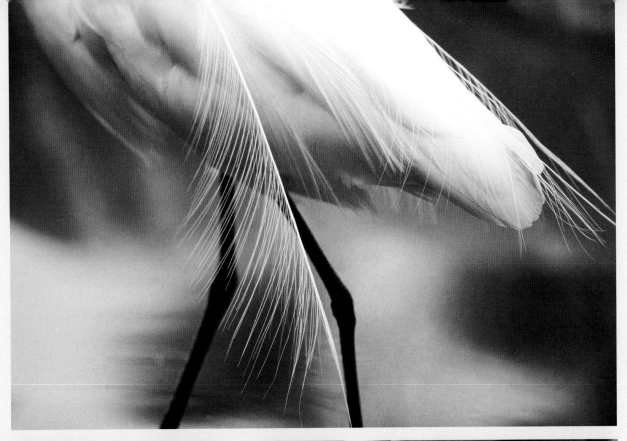

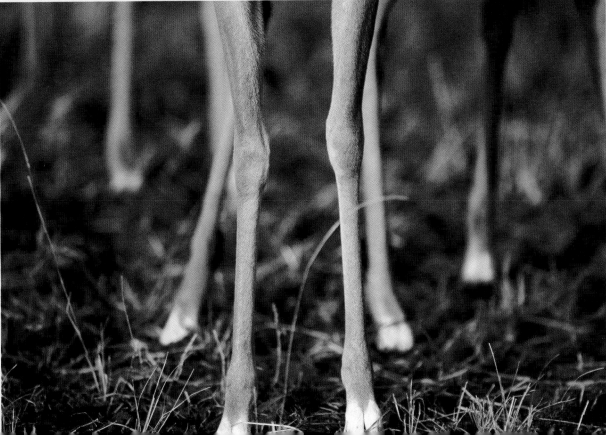

We're trained from childhood to follow rules, and for good reasons. But there aren't any *rules* in art—just guidelines. Break a few "rules." Shoot flowers with a fisheye lens. Don't be afraid to fail.

One of the hardest creative preconceptions is this: What defines a subject? You just have to find something interesting about whatever you want to photograph. Who said you couldn't photograph bug splats on a license plate (**FIG. 12.3**)?

Some people are serious about the boundaries they put on their photography. Once, at a workshop, I announced to students that we were going to work on macro subjects for the afternoon. One gentleman came up to me and said he only photographed wildlife and wasn't interested. I convinced him to give it a try, telling him that we might find some tiny wildlife. By the end of the afternoon, with his belly all wet, he came up and said that it was the most fun he'd had in a long time. And he got some beautiful macro images.

The first step in learning to see is recognizing that the preconceptions you bring to your photography might be the reason you aren't happy with your images.

FIG. 12.3 If you're open to seeing, anything can become a subject. Mojave National Preserve, California. (Nikon D100, ISO 200, 105 mm lens, handheld, 1/500 sec. @ f/11.)

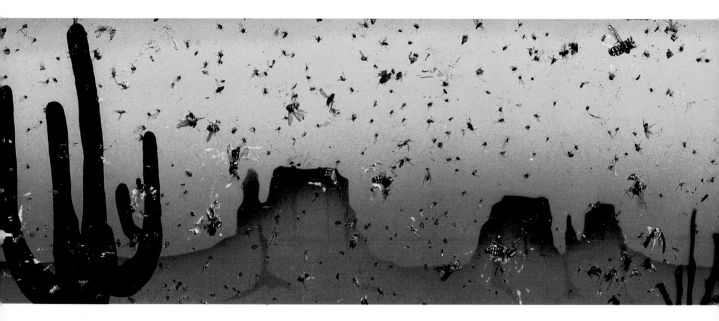

Learning to see

Many books on photography have chapters on learning how to see; Derek Doeffinger's *The Art of Seeing* is my favorite. It helped me to become more visually aware and defined the difference between looking and seeing.

Becoming visually aware will improve your photography. Looking at things isn't hard; we're born looking. The problem is that looking doesn't make good pictures. We have to get beyond looking and start *seeing*, and that's something you have to learn. Like creativity, seeing is not innate. You have to practice seeing all the time, even when you don't have a camera (**FIG. 12.4** and **12.5**).

As with most things done well, you have to do the work yourself. You have to *make* the photograph—not just take it. When you stop to take a picture, go ahead and just take it. Push the button, get it out of your system. Then take the time to figure out why you took that picture. What's interesting in the scene? Why did you stop there? You need to "see" the *photograph* in front of you, not just the scene or subject. This technique works with close-ups, landscapes, wildlife—everything (**FIG. 12.6** and **12.7**, on the next page).

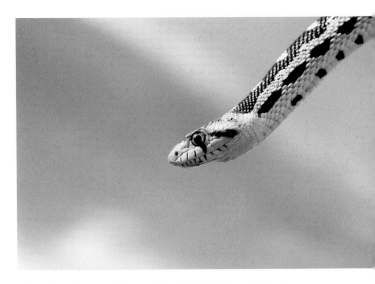

FIG. 12.4 Photographing a subject outside the context of what people expect is a great way to surprise them. Seeing this gopher snake against nothing but blue sky is certainly a different view. Anza-Borrego Desert State Park, California. (Nikon D100, ISO 200, 28–70 mm lens, handheld, 1/800 sec. @ f/7.1.)

FIG. 12.5 A pond before sunrise. It was full of grass, and I had to simplify my choices: What was it about the grass that I liked? How could I emphasize the calm stillness, the reflection, the water drops? I got rid of everything but what I *saw*. Denali National Park, Alaska. (Nikon D200, ISO 200, 70–200 mm lens, tripod, 1/60 sec. @ f/2.8.)

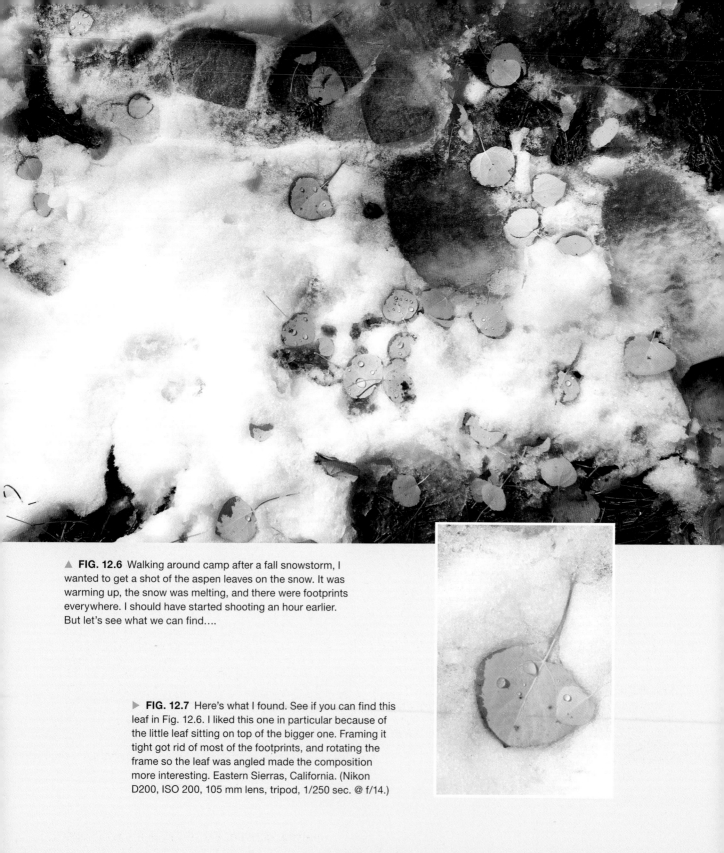

▲ **FIG. 12.6** Walking around camp after a fall snowstorm, I wanted to get a shot of the aspen leaves on the snow. It was warming up, the snow was melting, and there were footprints everywhere. I should have started shooting an hour earlier. But let's see what we can find….

▶ **FIG. 12.7** Here's what I found. See if you can find this leaf in Fig. 12.6. I liked this one in particular because of the little leaf sitting on top of the bigger one. Framing it tight got rid of most of the footprints, and rotating the frame so the leaf was angled made the composition more interesting. Eastern Sierras, California. (Nikon D200, ISO 200, 105 mm lens, tripod, 1/250 sec. @ f/14.)

Look again at the opening photo of this chapter. I was photographing cracks in dried mud on a road, and several common salsify plants were growing nearby. I liked the radial symmetry of the seed head, so I started photographing close-ups. After a few shots, I noticed the delicate ends of the seeds. These little "wings" carry the seeds on the wind. After about 15 minutes and 10 images, I had finally *seen* the subject. The next dozen shots were just fine-tuning my compositions of the little wings.

Creative image-makers think in terms of possibilities. They're not content with the first image; curiosity drives them to look for the next picture, experimenting with tools, composition, and choice of subject (**FIG. 12.8**).

▼ **FIG. 12.8** I'm always looking for new ways to photograph California poppies. Using my fisheye lens, I laid the camera on the ground in the center of a large cluster of flowers. The hard part was pushing the single flower into the middle. The only way to position it directly in front of the sun was to watch its shadow hit the lens. I pre-focused the lens and used the self-timer to take the picture. Highway One, California. (Nikon D300, ISO 200, 10.5 mm fisheye lens resting on the ground, 1/200 sec. @ f/16.)

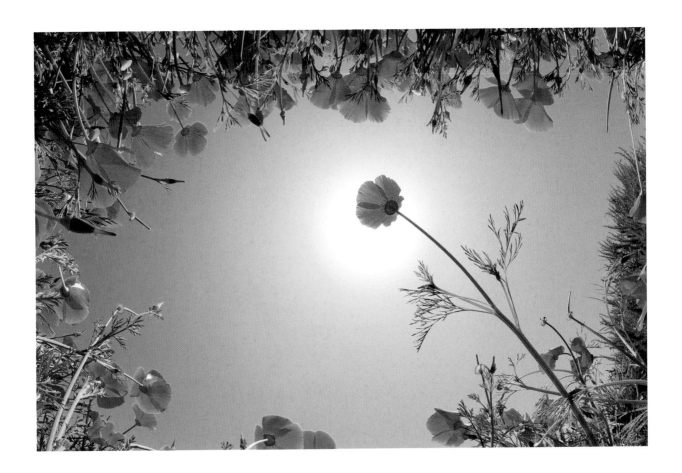

Equipment

You can handhold any camera and create panoramic images, but you'll quickly find that to get really good-quality panoramas, capable of large prints, you'll need a few more tools.

Using a tripod will ensure that the camera stays level and the images are sharp. The tripod head needs to rotate without tilting the camera. Most good tripod heads have this feature, and many have marks that help with overlapping your images as you rotate your camera (**FIG. 12.9**).

A bubble level, built into a lot of tripods, helps with leveling. There are also special bubble levels that will slide onto the hot shoe on top of the camera.

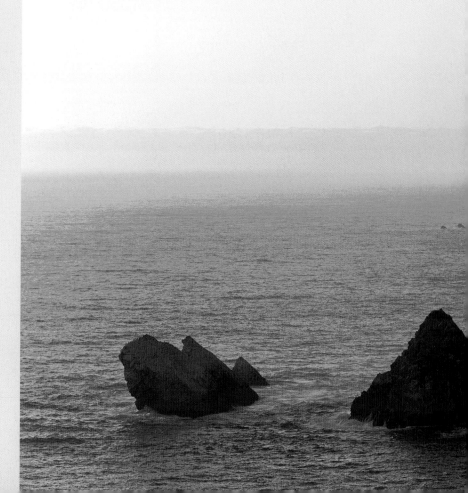

FIG. 12.9 Panoramic images provide a different way of seeing. They create images that are closer to the way we see when we are at the scene. They get us outside the viewfinder box. This two-shot panorama was stitched together using Photomerge in Photoshop. Keeping the tripod level helps when trying to align the ocean horizon. I tilted the camera down to get a better composition with the rocks and beach in the foreground. Julia Pfeiffer Burns State Park, California. (Nikon D100, ISO 200, 70–200 mm, tripod, 1/640 sec. @ f/4.)

Special panoramic heads can help you to set up your camera and lens to rotate around the optical center of the lens, sometimes incorrectly called the *nodal point*. Proper alignment helps prevent parallax problems, especially with wide-angle lenses, and makes the digital stitching process more effective. You can take it to the extreme with the GigaPan system. This unique robotic camera mount can be used with a variety of cameras and automatically moves the camera for each picture. It uses its own stitching program to composite hundreds of images into huge, highly detailed panoramas.

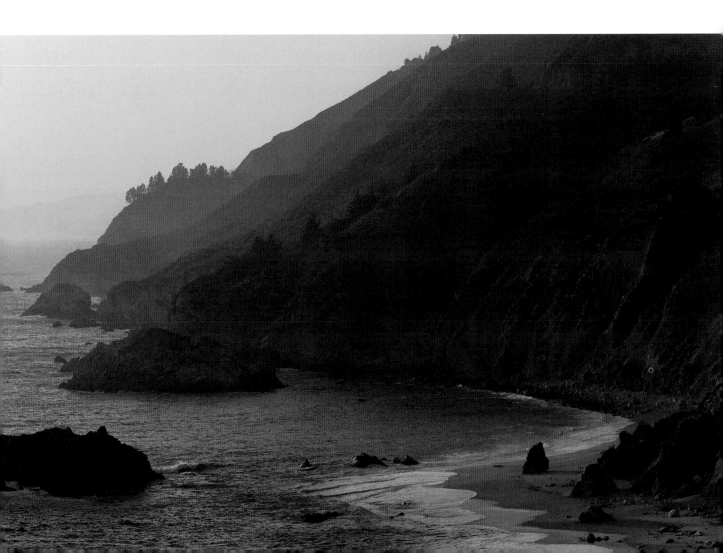

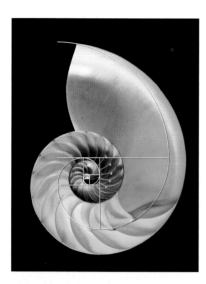

FIG. 12.10 The amazing shell of the nautilus exemplifies the relationship of function and design. Like many spirals, it fits neatly into the ratios of the golden mean. (Nikon D2X, ISO 100, 28–70 mm lens, tripod, 1/13 sec. @ f/11.)

The golden mean

Although it's not really a piece of equipment, the *golden mean* is a compositional tool, so I decided to talk about it here. The terms *golden mean*, *golden ratio*, *golden spiral* are all related to a mathematical sequence of numbers called the *Fibonacci series*.

Have you ever wondered about all these elements of composition—the rule of thirds, for instance—why do they work? Why do things look better in certain places in a photograph? It's actually nature. Scientific studies have shown that we're naturally attracted to things having proportions that fit the golden mean. A good explanation of the golden mean would take a whole chapter, maybe a whole book, but one way to visualize the golden mean is as a rectangle with sides at a ratio of about 1.618. Rectangles with this ratio seem to please the aesthetic side of our brains. Nature includes lots of completely unrelated things that have this ratio and work with the Fibonacci series of numbers: a nautilus shell, the swirl of a sunflower or a pinecone, the pattern of leaves on a stem, how trees and our blood capillaries branch, the spiral of a galaxy—the list goes on (**FIG. 12.10**).

Nature doesn't actually use the numbers or calculate the ratio; they just appear as a result of nature trying to do things in the most efficient manner. If nothing else, nature is very efficient. Understanding why is as important as understanding how in nature photography.

But how does knowing about these numbers and this ratio make for better pictures? When you go out into nature, it all seems so random—a field of grass, herd of animals, or even a range of mountains looks busy, complex, and without order. But now you know that it has order, a pattern. A pattern based on the golden mean will help you to choose your subject, focus on what's interesting, and make better photographs (**FIG. 12.11** and **12.12**).

TIP The number 1.618 is known as *Phi* and based on the Fibonacci series of numbers. If you're interested in learning more about composition, read up on this amazing element of nature's design.

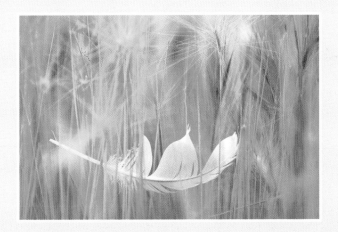

FIG. 12.11 The grasses were beautiful, their vertical patterns creating a perfect backdrop for the horizontal feather. I got three shots before the wind blew the feather away. Mono Lake, California. (Nikon D100, ISO 200, 70–200 mm lens, tripod, 1/400 sec. @ f/2.8.)

FIG. 12.12 A pair of Grant's zebra stand out among a herd of wildebeest. The animals rely on confusing patterns to thwart predators. There are so many animals and possible compositions that framing a scene that works is difficult. Sometimes seeing the subject is easy; sometimes it's not. (Nikon F4, ISO 80, 400 mm lens, tripod, Kodak Ektachrome 100 film, exposure unrecorded.)

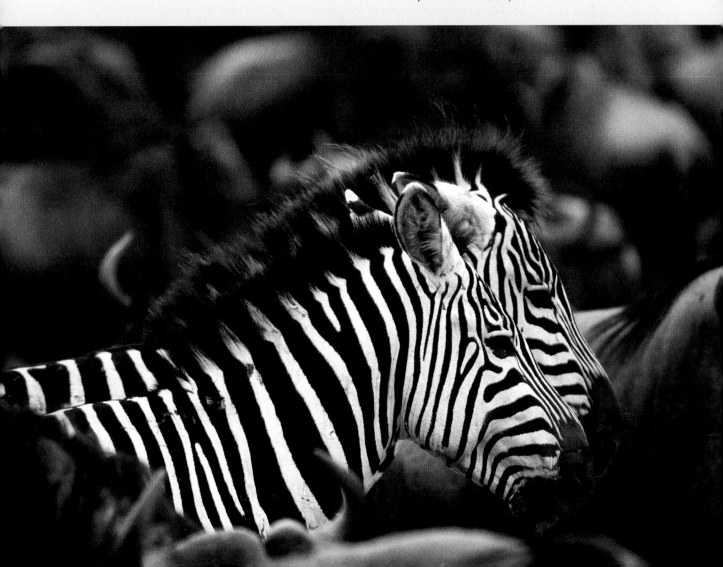

Lighting

Preconceptions and creativity can be affected by techniques and equipment. New technology lets us try things that we just couldn't do previously. Wireless TTL flash is one of the most liberating technologies in digital photography. The capability to adjust the power and position of multiple small flashes without any wires has opened up all kinds of new lighting possibilities.

Spending time to get the best picture, combined with creative technology, can create a totally unique image. This next series will show you what I mean.

Most of the trillium flowers I had seen in the forest had big holes chewed in them from banana slugs, but right next to my campsite was a beautiful, perfect flower. I composed the flower, taking advantage of its natural balance. See all those 3's? You can't ignore them; three is a Fibonacci number. But the little green sorrel plants behind the green trillium made the scene busy. So I underexposed my ambient light and added a snooted flash to light just the trillium. A snoot narrows the beam of light from the flash (**FIG. 12.13** to **12.15**).

I liked this shot, but what else could I do to make it more interesting? Then I thought, "Leaves are translucent." I took a second wireless flash, laid it on the ground under the trillium leaves, and fired both flashes. From my camera I could control the output of each flash, balancing how bright the backlighting was in relation to the front-lighting (**FIG. 12.16**).

This process of searching for the next image and experimenting with new tools and techniques is the way to feed your passion about photography. Don't worry if the shot doesn't turn out; just try something else. You're being creative.

TIP One of the things I hear a lot is "I'm not very creative." Studies have shown that drive and motivation are more important to growth in creativity than any predisposition to being creative. To become more creative, a photographer has to look at pictures and take photographs all the time.

▶ **FIG. 12.16** Firing a second, wireless TTL flash through the leaves makes a totally different image. Just changing the lighting can alter the look of a subject. When you find a good subject, like this trillium, you need to keep playing around. After all, it's raining, and you don't have anything else to do, right? Butano State Park, California. (Nikon D300, ISO 200, 12–24 mm lens, two TTL flashes, tripod, 1/80 sec. @ f/5.6.)

FIG. 12.13 Sometimes you don't have to go far to find the perfect subject. The trillium I photographed is in the upper left of the frame.

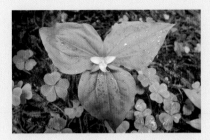

FIG. 12.14 I chose a wide-angle lens for this trillium because it's rather large, and I wanted to show the pattern of the three leaves and three petals. The background plants are the same color, so it's hard to keep the eye focused on just the flower, without wandering around the frame. (Nikon D300, ISO 200, 12–24 mm lens, tripod, 1/40 sec. @ f/4.)

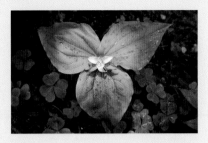

FIG. 12.15 I underexposed the ambient light by two stops and used a wireless TTL flash with a snoot to light the trillium. This helps focus the eye on the subject and keep it there. The forest is dark here, and this choice of lighting and exposure helps convey that feeling. (Nikon D300, ISO 200, 12–24 mm lens, TTL flash with snoot, tripod, 1/80 sec. @ f/5.6.)

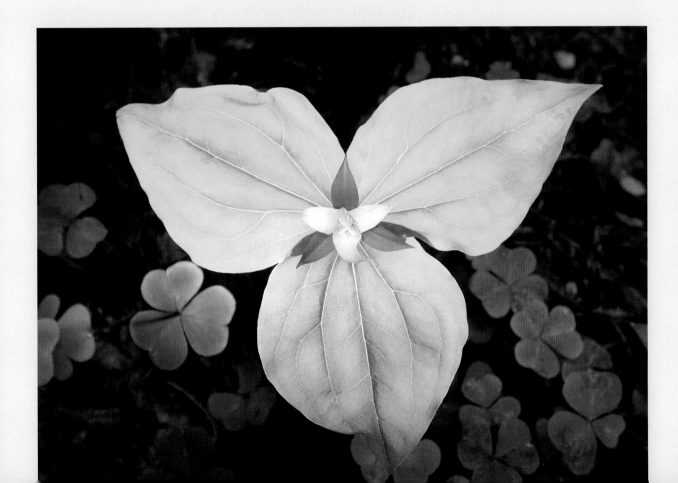

Questions & Answers

Q **What's your technique for creating panoramic images?**

A Multi-image panoramas have become incredibly easy to create, thanks to some great software. Doing the stitching by hand is too hard, so I recommend using the automated methods provided by Photoshop, Canon PhotoStitch, and dozens of other stitching applications (**FIG. 12.17**).

Of course, before you can stitch your panorama together, you have to take the pictures.

Here's how I shoot a panorama. I always use a tripod, which I level before mounting the camera. I compose the scene, making sure that the camera is level horizontally. I use a longer lens, such as my 28–70 mm zoom at 70 mm. I take a meter reading for the brightest frame of the panorama, and set exposure, focus, and white balance on manual. That's one of the "rules": Don't change the exposure! I usually orient the camera vertically and shoot the series of pictures, overlapping each shot by 30–50%. (**FIG. 12.18**).

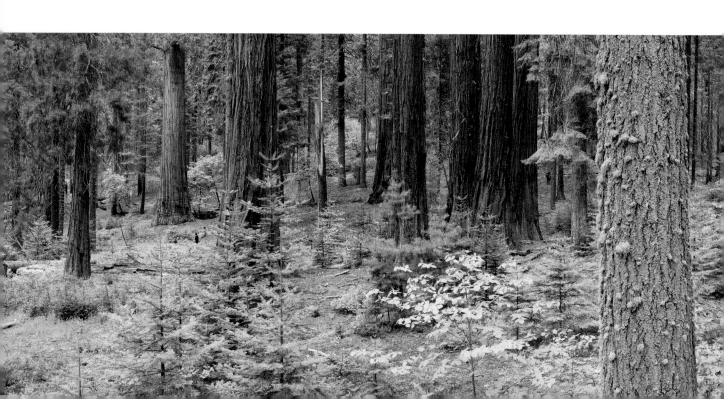

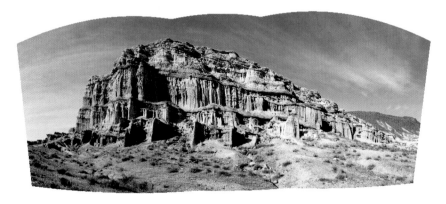

FIG. 12.17 A three-shot panorama of eroded cliffs in the Mojave Desert. Depending on the stitching application and the method of stitching, this is one way your finished panorama may look. These applications can even correct for some distortion, such as verticals falling backward. Cropping the top and bottom will give you a more normal-looking image. Red Rock Canyon State Park, California. (Nikon D300, ISO 200, 12–24 mm lens, tripod, 1/320 sec. @ f/9.)

Don't forget about vertical panoramas. Shooting a pano of a vertical subject, such as a tree, is basically the same as shooting a horizontal scene, except that orienting the camera horizontally is better. Level the tripod and just tilt the camera up, overlapping each shot. Keep the camera level horizontally. Most stitching programs can handle vertical panoramas, no problem. Trees, cliffs, even a giraffe can make a great vertical panorama.

▼ **FIG. 12.18** Nine vertical images make up this panorama taken on the Hazelwood Nature Trail. The size of these trees is difficult to grasp until you see the tiny person on the left side of the frame. Having a tree in the foreground gives the image more depth. Composition with panoramas is important, so look for those foregrounds and backgrounds. Sequoia National Park, California. (Nikon D100, ISO 200, 28–70 mm lens, tripod, 1/20 sec. @ f/11.)

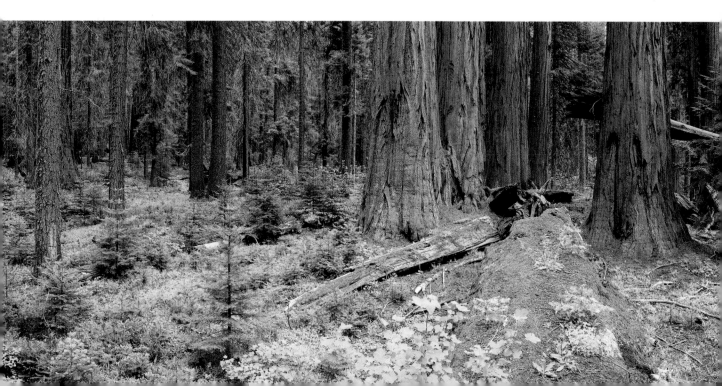

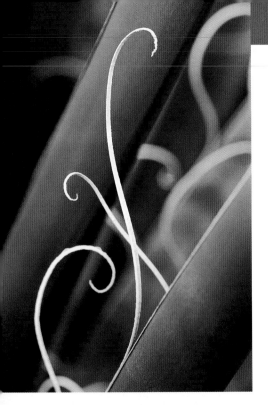

FIG. 12.19 I had just read how native people in the desert would use the fibers from the yucca plant to weave baskets. That bit of information gave me something to focus on when I found some large yuccas. This one reminded me of a musical note. Anza-Borrego Desert State Park, California. (Nikon F4, ISO 32, 105 mm macro lens, tripod, Fuji Velvia 50 film, exposure unrecorded.)

Q *What do you look for when you're trying to find subjects to photograph?*

A Nature is full of patterns: spirals, circles, ripples, branches, cracks, lines, shapes, curves—they're everywhere. Patterns are part of being human; our music, our math, our gardens are all based on patterns. We seek them out and find comfort in knowing that things have consistency.

When I'm out looking for subjects, I look for curves, especially S-curves. Having this planted in the back of my mind is a good way to focus my "looking." Curved lines create a sense of movement within a photograph. They lead the eye to places of interest. Once you know to look for them, they're everywhere. Since nearly everything has curves, it can get a little overwhelming for me, so I concentrate on just S-curves (**FIG. 12.19** and **12.20**).

Early in my career, I was fortunate to spend some time assisting one of the 20th century's greatest photographers, Ernst Hass. At one of his workshops, a student asked what he looked for when searching for subjects. "Figure-8's," he responded. Ever since, I've kept an eye out for figure-8's. Because they're just two flipped S-curves, when I'm focused on S-curves it's not hard to see the figure-8's. Turn an 8 on its side, and it's the symbol for infinity. All these shapes, curves, and lines are part of the patterns that dominate everything in nature (**FIG. 12.21**).

Q *How do you give your photos a sense of motion?*

A One technique is called *panning*; you see it used with moving animals. You have to use a telephoto lens to get the best effect of motion panning. The concept is to focus on the subject, following it with your eye on the viewfinder while trying to keep the camera moving at the same relative speed as the subject. Choose a slow shutter speed; something between 1/15 to about 1/2 second usually works. If you match the subject's speed perfectly, the subject is sharp, and everything around the subject is blurred. Doing it perfectly doesn't happen very often (**FIG. 12.22**).

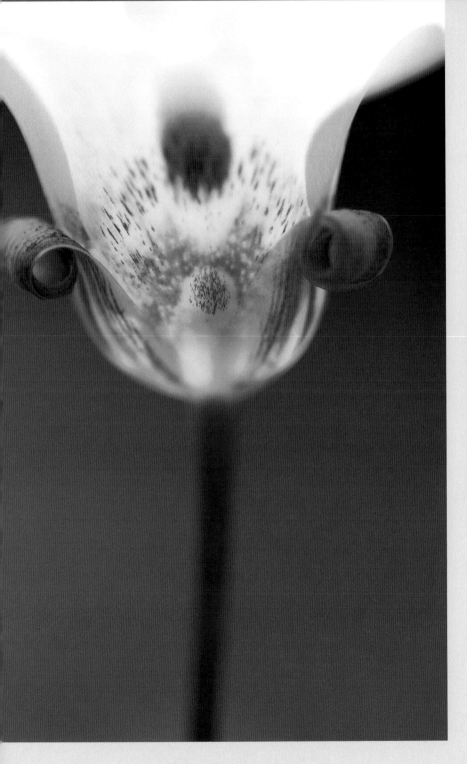

◀ **FIG. 12.20** This Mariposa lily was growing in some gravel on the side of a highway. I just loved the perfect curves and the way the petals curled down, forming little spirals. Kings Canyon National Park, California. (Nikon D100, ISO 200, 105 mm macro lens, handheld, 1/2500 sec. @ f/3.8.)

▲ **FIG. 12.21** The low sun revealed the shapes of these two anthills. They form a near-perfect figure-8. I would have easily missed seeing this if I weren't always looking for the pattern. Looking is easy; seeing takes focus and practice. Mojave Desert, California. (Nikon F4, ISO 32, 20 mm lens, tripod, Fuji Velvia 50 film, exposure unrecorded.)

FIG. 12.22 This wolf is an animal model. As soon as she and the rest of the pack were released, they took off running through the woods for several minutes. It was amazing watching them jump over logs and dart around trees. Looking for plain areas in shaded light helps to keep the backgrounds from getting too busy when you pan. Montana. (Nikon F4, ISO 200, 400 mm lens, Kodak Kodachrome 200 film, handheld, exposure unrecorded, captive.)

Any up-and-down motion of the subject or camera will be blurred because you're only stopping the horizontal motion. Some telephoto lenses have a switch to tell the image-stabilization system not to try to correct for the panning motion and only stabilize vertically. Be sure to switch to this mode, or just turn off image stabilization.

The other way I like to use motion is to create a painterly look. Any lens will work with this technique. Choose a slow shutter speed and just move the camera. Move it a lot. The direction of the motion depends on your subject's shape, but try different movements. Even rotating the camera can produce some interesting effects, especially with symmetrical subjects (**FIG. 12.23**).

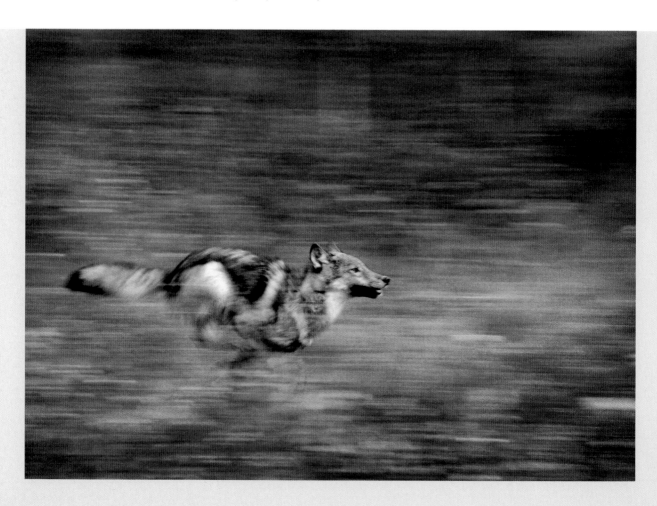

Assignments to try

- Find a scene you like—a small garden, some reeds beside a creek, a meadow, a stretch of beach, a patch of forest, and so on. Take a wide-angle picture. Now look around until your eye catches on something interesting. Move to get a better composition, maybe closer or just a different POV. Change lenses, if necessary. Keep moving and taking pictures. You should be able to make 15–20 images of what caught your eye. Don't give up. Hopefully, by the end you'll have created an image that surprises you.

FIG. 12.23 Just shooting a stand of aspens isn't very creative. The wind was blowing hard that day, and instead of fighting all the movement I decided to try to capture the feel of the blowing trees and leaves. Using a slow shutter speed, I swung the camera up during the exposure. Since trees are vertical, I thought the vertical motion would work best. Trying new things keeps the creative juices flowing. Eastern Sierras, California. (Nikon D300, ISO 200, 12–24 mm lens, handheld, 1/8 sec. @ f/16.)

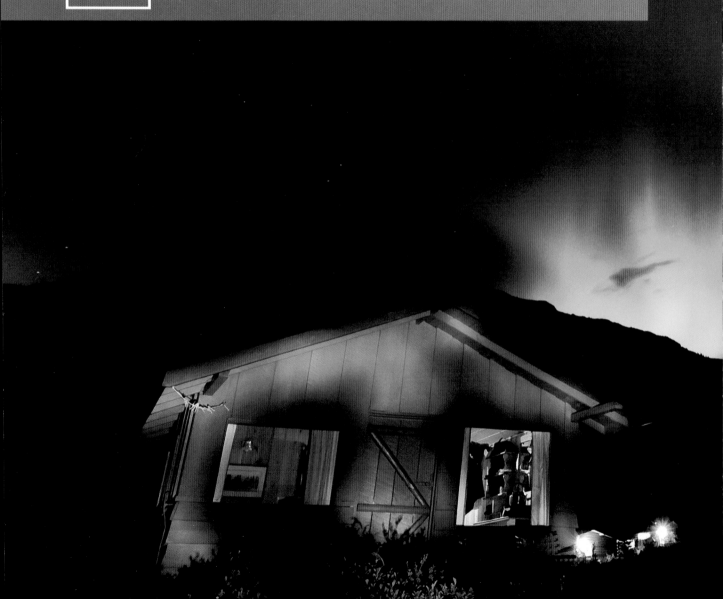

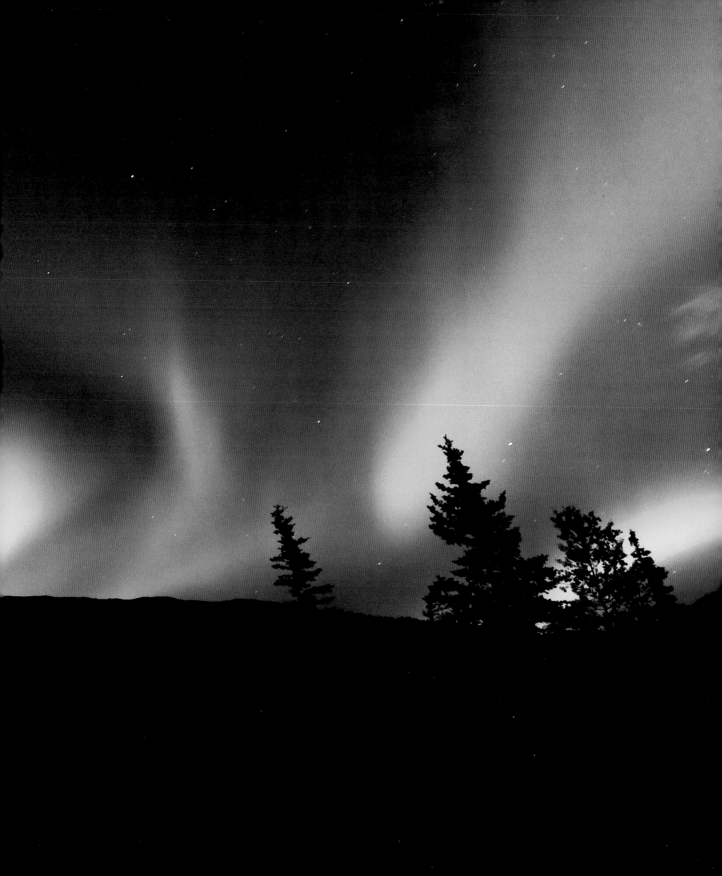

Travel with a plan, and remember to capture all the things that make your trip a true journey.

Road trip

Part of the excitement of travel is the newness of everything. But *new* also means *different*, which includes challenges beyond just your photography. How you handle these challenges has a big effect on your photos. As they say in Swahili, "Hakuna matata"—no problem, just go with the flow, enjoy yourself, laugh at the problems—and take pictures.

When we travel to parks and wilderness areas, we usually go with other like-minded people. They're not always photographers, but they enjoy spending time outdoors, and they make our experiences more enjoyable. We're all part of nature, and including your fellow travelers in your photos helps to connect your experiences to people who aren't there. Photographing them around a campfire or on a hike is appealing to those within the picture, but it also gives scale and dimension to your photographs. This doesn't mean that every picture needs a person in it. Try taking one without a person; then back up and include your companions in the scene. A lot of nature photographers don't *see* the experience of traveling. And because they don't see it, they don't photograph it. I make an effort to photograph the whole experience—animals, plants, trails and roads, what we eat, where we sleep, the landscapes, the people, and the camps and cabins where we stay (**FIG. 13.1** and **13.2**).

FIG. 13.1 Jack's Camp is one of our favorites in Botswana. On the edge of one of the world's largest salt pans, it offers a unique experience in camping and wildlife viewing. Africa. (Nikon D200, ISO 100, 12–24 mm lens, tripod, 6 sec. @ f/11.)

FIG. 13.2 Africa offers nature photographers every type of camping experience you could want, from rustic to luxurious. This is our tent at Kwando Lebala Camp in Botswana, Africa. (Nikon D200, ISO 200, 12–24 mm lens, tripod, two off-camera wireless TTL flash, 1/10 sec. @ f/16.)

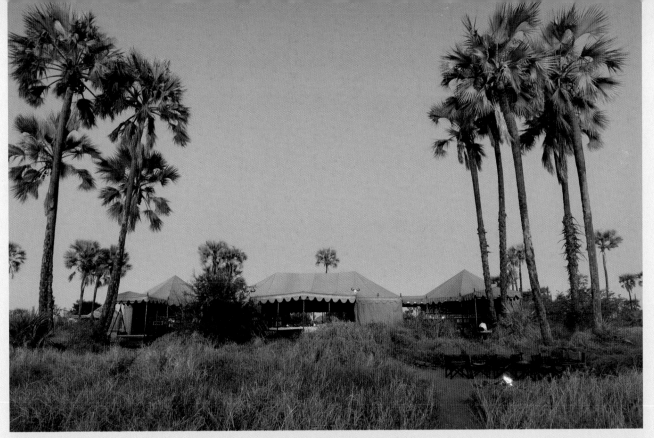

▶ **FIG. 13.3** If I don't have someone to model for me, I'll put the camera on self-timer and myself in the picture. I always try to put people in shots of trails or roads—places where we expect to see people. Limekiln State Park, California. (Nikon D300, ISO 200, 12–24 mm lens, tripod, off-camera wireless TTL flash, 1/8 sec. @ f/8.)

The opening photo of this chapter was taken at Camp Denali in Alaska. It was early September, and I knew there were chances of seeing the aurora borealis. The camp baker, who works at night, offered to wake me up if he saw any northern lights. During the day, I checked out where to put my camera and which lens to use (12–24 mm). The baker woke us up at about 2 a.m., and we ran outside to witness this amazing scene. For the 30-second exposure at ISO 200, I left our cabin lights on and painted the outside with a big flashlight.

When you photograph the places, food, and people that are part of your experience, don't just document them. Add interesting lighting or use a unique POV. Include a human element: clothing, a guidebook and binoculars, or even just a hand. (**FIG. 13.3** and **13.4**).

FIG. 13.4 One of the most enjoyable things about traveling is the food. Whether you're camping and have to do it all yourself, or you never have to touch a dish, the taste of food outdoors is something special. This is our bush breakfast after a long morning wildlife drive. Zambia, Africa. (Nikon D200, ISO 100, 12–24 mm lens, handheld, 1/160 sec. @ f/4.)

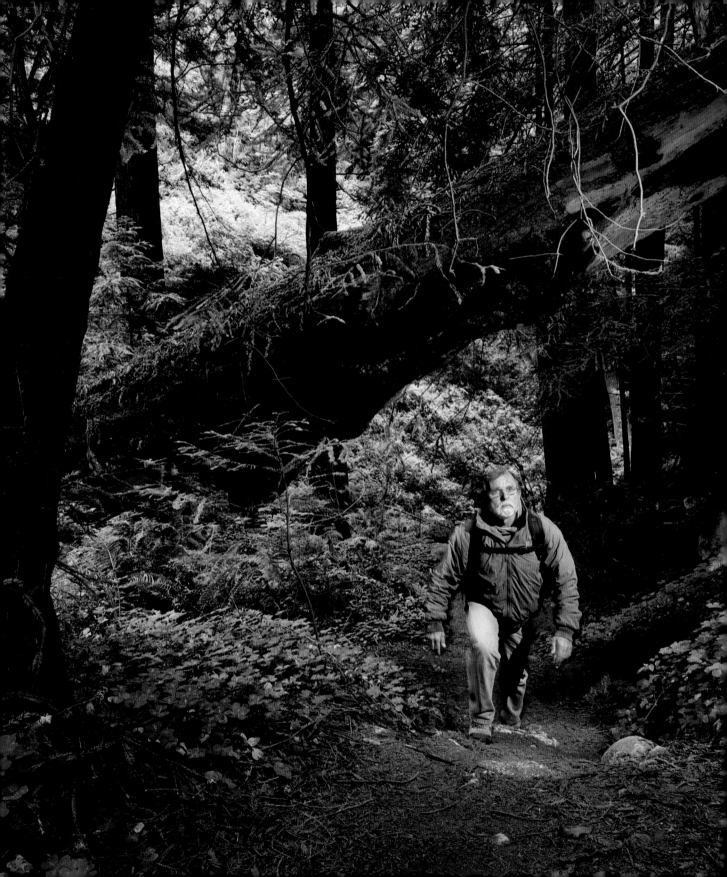

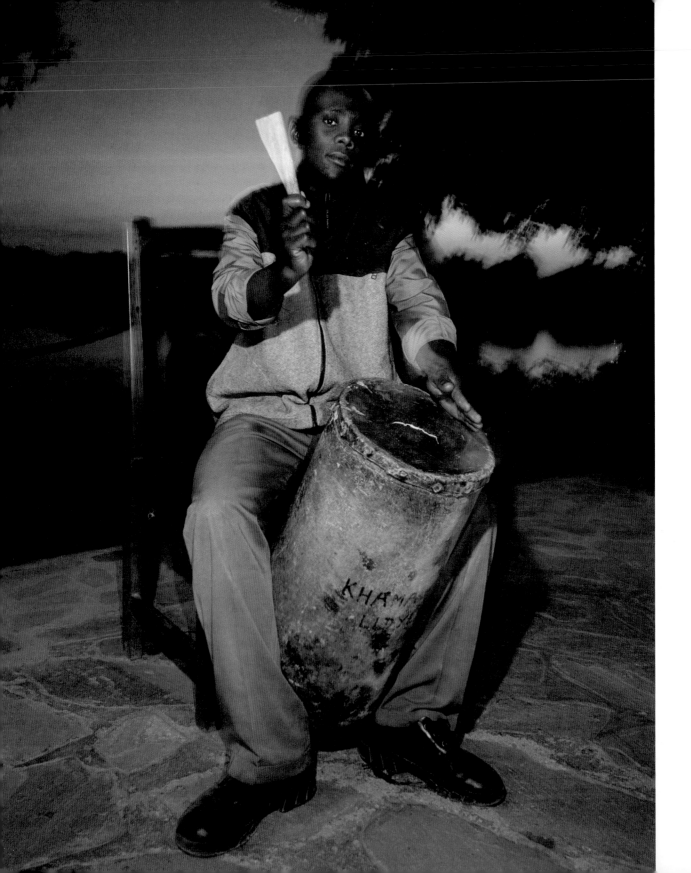

A 'typical day' of shooting

There is no typical day in nature photography. Whether you're photographing waterfowl, fall colors, wildflowers, or an African safari, each has its own timetable. Sometimes your routine is affected by other people or local laws: having to be back at camp by sunset in Kenya, limited vehicle access during the winter in Yellowstone, driving restrictions in Denali National Park. But most places we visit as nature photographers are accessible all the time.

I research my destination first, checking maps, reading up on the location, and talking to other people about what to expect. That way, I have a focus when I arrive. I think that having this focus is crucial to a successful shoot. It doesn't mean that's all you photograph, but it gives you a place to start.

A lot of my motivation for traveling to a place is a specific event or animal behavior, rather than just the location. For instance, the wildflower displays in South Africa's Namaqualand, the caimans of Brazil's Patanal wetlands, the migrating waterfowl at Bosque del Apache in New Mexico, and the nesting puffins in Newfoundland are all on my list of things and places to photograph.

On a photographic trip, my typical day may be something like this: Up at least an hour before sunrise, pull batteries out of chargers, coffee and smoothie in the car while driving, opportunistic shooting along the way as I head to a scenic location for sunrise. Let's say sunrise is about 7 a.m., so I shoot from 6:00 to 7:15, and then drive around looking for wildlife in the early light. Finish morning drive between 9:30 and 10:00. Stop at a visitor's center and talk to rangers about anything they think might be interesting to photograph. Hike one of the nature trails, doing macro photography of insects, small animals, and plants (**FIG. 13.5** and **13.6**).

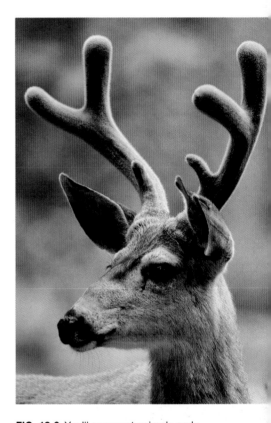

FIG. 13.6 You'll see most animals early in the morning or late in the afternoon. Driving to our sunset location, I had my big lens on my lap and a steadybag draped over the car window, ready for anything we might see. We found this mule deer grazing along the road; coasting to a stop, I was able to get three shots before he bounded away. Sequoia National Park, California. (Nikon D2X, ISO 400, 200–400 mm lens, steady bag, 1/100 sec. @ f/4.)

◀ **FIG. 13.5** Every morning, about an hour before sunrise, we would awaken to the sound of drums. This young man was our alarm clock at this camp. Zambia, Africa. (Nikon D200, ISO 200, 12–24 mm lens, tripod, flash on camera, 1/8 sec. @ f/5,6.)

FIG. 13.7 Always have your camera ready. I had returned to our open-air room after lunch and was taking a nap when I heard shuffling. This elephant was outside. I moved as quietly as possible, but she didn't expect anyone to be in the room, and reacted when I took the picture. Zambia, Africa. (Nikon D200, ISO 100, 12–24 mm lens, handheld, flash on camera, 1/250 sec. @ f/4.5.)

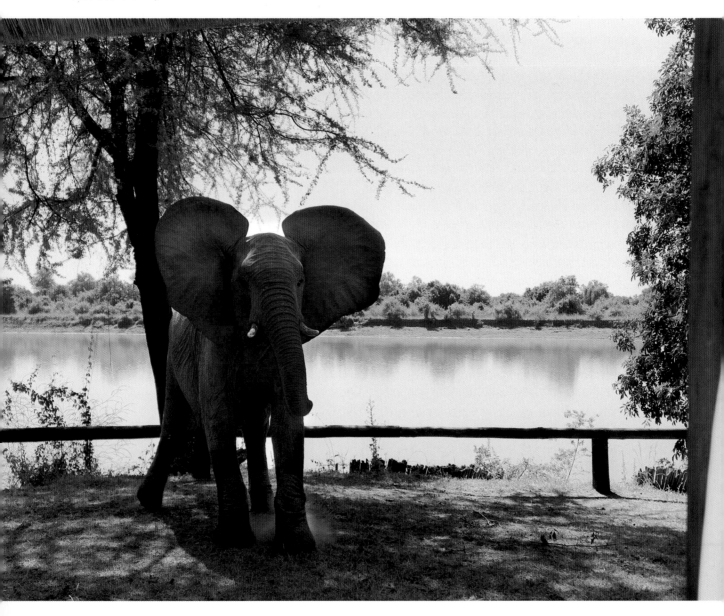

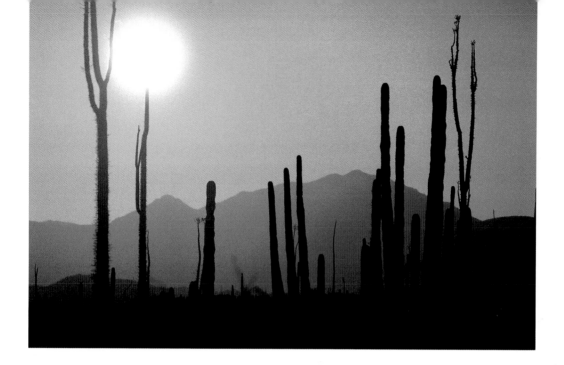

Everything looks pretty harsh in midday light, so I spend those hours talking to locals about where to find things, scouting locations for sunset and sunrise, going back to the camp or cabin and taking a nap, or eating a big lunch. (I know I'll miss the normal dinner hour because the light at that time is amazing, and lots of animal activity is going on.) Sometimes wildlife will come to you when you're back in camp, so don't put away that camera (**FIG. 13.7**)!

Sunset is at about 6:15 p.m., so I'm back on the road at about 3:30. Drive the same route as in the morning, or pick a different destination based on my midday scouting. Everything may be different from the morning drive—animal activity, light, how things look, what I see. Arrive at my chosen sunset location about 5:30, shoot the sunset, and then about 7 p.m. take a slow drive back to camp or the lodge (**FIG. 13.8**).

Pick up a light dinner on the way. Back at whatever I call home, clean all my gear, recharge the batteries, download and back up all of my images, and take some night shots of where I'm staying.

Whether I'm camping or staying at a lodge or motel, this is a pretty typical day. When my wife is with me, she brings along some good books to fill in the time between watching wildlife and hiking. She loves flowers and birds, and it's great to have a second pair of eyes to look for things to photograph.

FIG. 13.8 Cardon cactus and Boojum trees dominate this remote desert on the Baja peninsula. There are few roads here and only one paved highway; just drive off the road and camp anywhere that looks good. You have to be totally self-sufficient to travel in deserts like this, prepared for anything. Mexico. (Nikon F3, ISO 64, 400 mm lens, tripod, Kodak Kodachrome 64 film, exposure unrecorded.)

TIP When working out of a photo bag or case, always close it after removing what you need. If you don't, and you have to move fast, you're liable to pick up the bag, forgetting that it was unzipped, and fling it over your shoulder. I've banged up a few lenses that way.

FIG. 13.9 In many places, such as the "Alabama Hills" in the Eastern Sierra mountains, you can camp close to your shooting location. From here, we just walk to areas that offer the views we want. For this shot, I used a gelled flash and painted my van with light under a moonlit night. California. (Nikon D2X, ISO 400, 12–24 mm lens, tripod, wireless flash off-camera, 30 sec. @ f/5.)

Equipment

What type of camera bag you need depends on the type of photography you do. Some nature photographers hike long distances and may spend days in the backcountry. Others never walk more than a mile or so from the car. Your choice of bag should be made based on comfort, how much gear you take with you, and security. There's a huge choice of bags and cases, and I recommend visiting a good camera store and looking at different bags before buying.

TIP I usually take my old bag with all my gear into the store, sit down on the floor with a couple of new choices, and make sure that everything fits before I buy a new bag or case.

Most of my photography is done within a few miles of my vehicle, but I may spend an entire day walking on a trail, so a comfortable backpack that can carry a basic set of gear is important. My small backpack weighs about 20 pounds fully loaded and includes wide-angle, macro, and short telephoto lenses. If I need a longer lens, I carry it mounted on my tripod, with a second camera attached. Hard cases with additional gear stay secured in my vehicle or some other location (**FIG. 13.9**).

When I have to fly, a few things change: I usually take less gear than when I drive, I have to be careful about weight, and I have to be aware of security issues.

My destination also affects the type of bags I take. If I'll be working out of my own rental vehicle, I take my small backpack and a rolling hard case. I can carry both of these items on the plane. The hard case I use is a Pelican 1510 with wheels. This case can be locked and offers a lot of protection for equipment (**FIG. 13.10**).

If I can't travel with two bags, I take a larger backpack that can handle all my gear, including my big telephoto lens, a second camera, extra flashes, and backup digital storage. This bag is the maximum size allowed on international flights. Fully loaded, it's heavy, so my next one will be a backpack with wheels.

My one check-in bag holds clothing, my tripod, and any other photography gear I may need. I use soft wraps made by Tenba and Domke, and just

FIG. 13.10 My airline carry-on hard case holds a camera body, one or two strobes (flash), 200–400 telephoto lens, chargers for camera and batteries, cables and cords for camera and computer, model releases, flashlight, spare camera battery, waterproof card case with Lexar compact flash cards, laptop computer, and Epson multimedia hard drive.

▶ **FIG. 13.11** Binoculars can help you
to spot wildlife long before you scare
it off. These people were canoeing on
Wonder Lake, where swans, moose,
and caribou are frequently seen. Denali
National Park, Alaska. (Nikon D2X, ISO
400, 200–400 mm lens, tripod, 1/1250
sec. @ f/4.)

wrap things up with the clothes. Be sure to check with your airline regarding baggage allowances, as regulations tend to change frequently.

I also have a small shoulder bag that fits flat in my checked bag for "city" shooting, and when doing underwater photography I use large hard cases for my underwater photo gear. These cases are heavy and usually incur excess weight charges.

Indispensable travel items

I always carry certain items when I travel: flashlight, headlamp, first-aid kit, Swiss Army knife, and Leatherman tool. The lights are invaluable out in the field or when camping—especially the headlamp, since it leaves my hands free. Never assume that someone else has a first-aid kit; always carry your own. I have three, in different sizes and outfitted for different situations. I take my saltwater kit on dive trips; it includes things like eardrops, waterproof adhesive bandages, and even saltwater soap. My first-aid kit for air travel includes drugs for malaria, "traveler's stomach," and dehydration. The last kit is a large one that I carry in the van. My Swiss Army knife includes tweezers, handy for pulling out splinters and cactus spines. It also has a corkscrew for that occasional bottle of fine wine.

Why do I always carry a Leatherman tool? While we were traveling in Zimbabwe, the small bus we were in blew a radiator hose. The driver pulled over, and a couple of us offered to help with repairs. But the driver said that he didn't have any tools, so he would flag down a car, go back to town, and get a mechanic to come out and fix the hose. That plan would have taken at least four hours. Instead, one member of our group took out his Leatherman tool, unscrewed the hose clamps, cut off the busted part of the hose, clamped the hose back on the radiator, and it was fixed!

Unfortunately, we didn't have enough water to refill the radiator. By amazing luck, though, the first car we flagged down was carrying several gallons of water in the trunk. We filled the radiator, thanked our rescuers, and were back on the road less than an hour after we stopped. As soon as we got home, I bought a Leatherman tool. (Don't forget that the Swiss Army knife and Leatherman tool have to be packed in your checked luggage when you fly.)

If you travel outside of North America, be sure to check on the types of plugs and electrical voltage available in the countries you'll visit. All of my battery chargers can handle 120 and 220 volts, so I don't have to

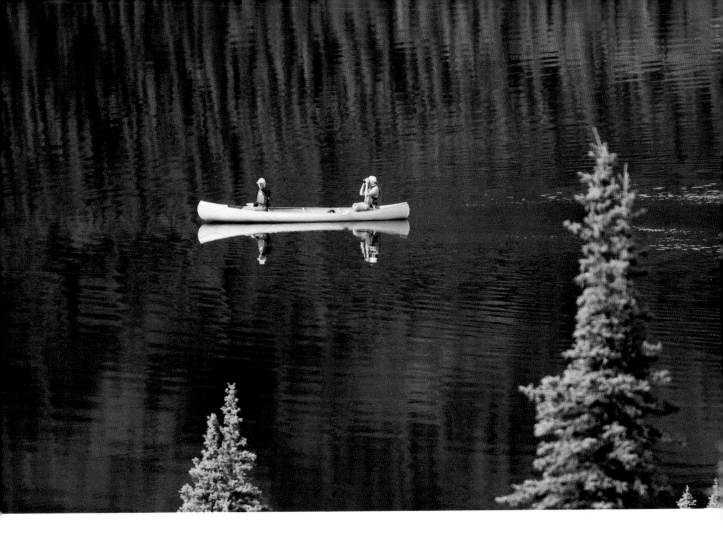

worry about that, but I do need to pack the right plug adapter. (Magellan's is a great travel store for these types of items.)

Other gear

When you travel by car, you can plug your battery chargers into an inverter to charge the batteries while driving. The inverter plugs into the 12V DC "cigarette lighter" jack, and supplies power for electronic devices that have regular AC plugs. Most inverters have at least two AC receptacles, so you can run more than one piece of equipment. For backpacking, you can also get small, flexible solar panels that will charge a camera battery or cell phone.

I always carry binoculars in my car or my camera bag. I use them to watch wildlife, of course, but also to help decide whether to get out my big telephoto lens. Looking through 8x binoculars gives you about the same view as a 400 mm lens. When I travel with my wife, she uses the binoculars, many times spotting things before anyone else does (**FIG. 13.11**).

An alarm clock is helpful for getting up at 4 a.m. to photograph the sunrise. A GPS can tell you when sunrise and sunset will be, and what phase the moon is in.

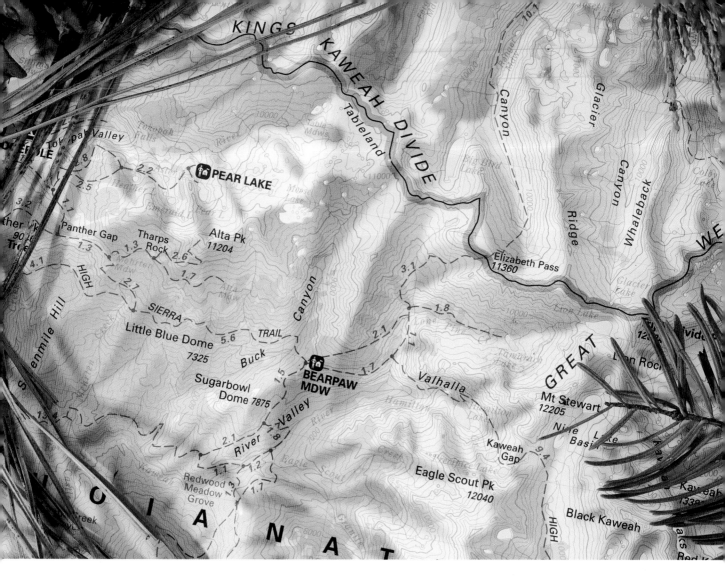

FIG. 13.12 I love maps. They tell you so much—how steep cliffs are, which way valleys point (so you can line up the sunset), and just how far the top of that hill *really* is if you're out walking. In combination with GPS devices and a compass, maps are important tools for nature photographers. A lot of places have very detailed local maps that show trails and points of interest, good things to know when you're looking for subjects. This is a map of Kings Canyon National Park in California.

A compass and map are helpful so you know where you are and in what direction the sun will rise. You can actually get all these features on an iPhone now, but you'll still need a wireless signal for that, so don't throw away that map and compass yet (**FIG. 13.12**).

Whenever I travel in national and state parks, I always stop at the visitor's center to buy local maps, check the weather, and talk to the rangers about what they've seen, where the wildflowers are, what to avoid, and any other tips that only the experts would know. This is true for parks in other countries as well as the U.S.

Lighting

Plan your trips around the potential for dramatic weather and lighting—summer thunderstorms and lightning in the southern U.S., winter storms on the west coast, snow in the north and the mountains. These are the conditions that the average traveler may try to avoid, but photographers need the dramatic light that weather provides.

You use the same techniques for lighting animals or people. For scenics, the lower the angle of the sun, the more dramatic the lighting will be. For portraits, soft light, such as open shade, usually looks best, especially if you can get some backlight to separate the subject from the background. The most important thing to remember is to control the contrast. An easy way to do that on a sunny day is to put the sun behind your subject and use a diffused flash to light the subject's face (**FIG. 13.13** and **13.14**).

FIG. 13.13 It's not typically considered nature photography, but when you travel with other people and share experiences, someone has to take the group shots. Put their backs to the sun so they don't squint, and add some fill flash to help separate the group from the background and make everyone look good. For this shot of the Camp Denali staff, I stood on a small ladder and shot downward to lose that boring sky. Alaska. (Nikon D2X, ISO 200, 28–70 mm lens, handheld, 1/200 sec. @ f/4.)

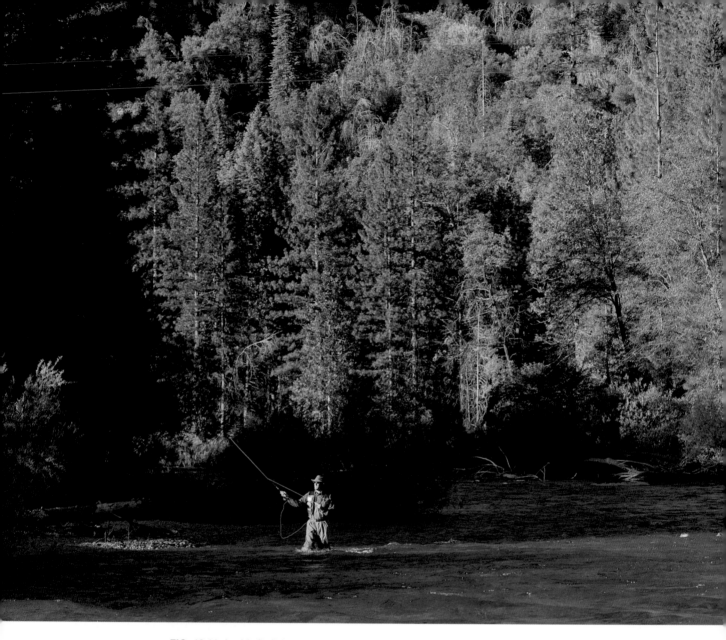

FIG. 13.14 As this fly fisherman worked his way up the river, he stepped into a shaft of light. The dark background and color of his clothes help to focus the viewer's eye on him; keeping him small provides scale to the landscape. The image is about where the fisherman is fishing, not just the fisherman. Kings Canyon National Park, California. (Nikon D100, ISO 200, 70–200 mm lens, tripod, 1/500 sec. @ f/5.)

Questions & Answers

Q *How can you make sure that nothing gets stolen when you travel?*

A When I travel by air, I carry all my critical photographic gear with me, and I use TSA locks on all my bags, whether checked or carry-on. At lodges and hotels, if I leave any photo gear in my room, I lock it in a suitcase and cable-lock the suitcase to something solid. I lock all my cases when I leave them in my van or a rental car, and then cable-lock them to something in the vehicle so a thief will have to steal the vehicle to get the stuff. I never leave cameras or camera bags visible in my vehicle when I'm away. I cover the gear in my van with blankets or towels, and my back windows are tinted and covered with curtains. I secure my backpack and soft-sided cases with a wire PacSafe net, and lock that net to something immovable. I always pay attention to my surroundings and practice the same caution when I travel as I do at home relative to security (**FIG. 13.15**).

FIG. 13.15 Some camera bags now come with wire mesh or a cable built into the bag itself. PacSafe makes this wire net; put your soft bags into it and then lock them inside your car or cabin.

Q *How do you back up your pictures when you travel?*

A When I'm driving, taking along a computer isn't a big deal. When I fly, especially to foreign countries, I don't take a computer unless I have to give a presentation. When I have a computer, I download my cards to a folder on the computer and then back them up a second time to DVD or CD. You could use a small external hard drive rather than the CD. Packing a computer when you travel isn't difficult. Lots of bags have special pockets for computers, and so many people have computers that many locations have made arrangements for charging and Internet access (**FIG. 13.16**).

When I don't have a computer with me, I copy images to two Epson multimedia hard drives. Once I've copied my pictures to each drive, I can reformat my cards and continue shooting. You should have at least two copies of all your pictures before you erase a card. Even if you carry enough cards for the whole trip, back up those cards.

FIG. 13.16 Back in camp for lunch, two of my students download and review the morning's shots. Charging their computers while they drive to locations lets them back up images twice a day. Remember to pack extra card readers and cables.

Q *Why do you put people into your landscapes? Doesn't that make the photograph less natural?*

A One reason I put people into my landscape images is because they give scale to the photographs. When we stand and look at a scene, we have ourselves as a reference to the size of things, but people who look at our photographs don't have anything, unless we include

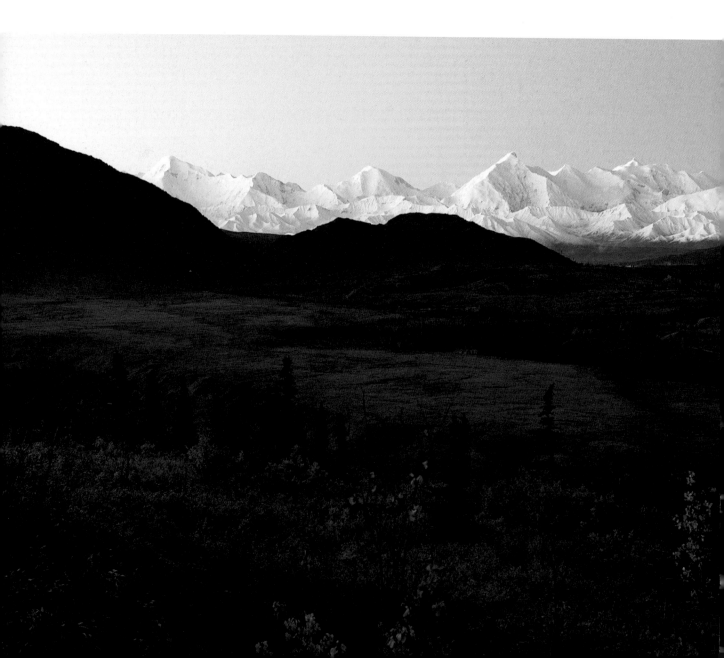

something that they can recognize. You don't have to use people; you can use a car, boat, or cabin, because we all know the approximate sizes of those things (**FIG. 13.17**).

Another reason for including people in your nature photos is that people generally like seeing other people in pictures. It gives them a connection to the place and allows them to visualize themselves in the picture (**FIG. 13.18**).

FIG. 13.17 The North Face Lodge and Mt. McKinley, dawn on a frosty morning in early fall. Where we stay is a big part of our nature photography experience. I captured this two-shot panorama from the porch of my cabin at Camp Denali. Denali National Park, Alaska. (Nikon D2X, ISO 200, 28–70 mm lens, tripod, 1 sec. @ f/5.6.)

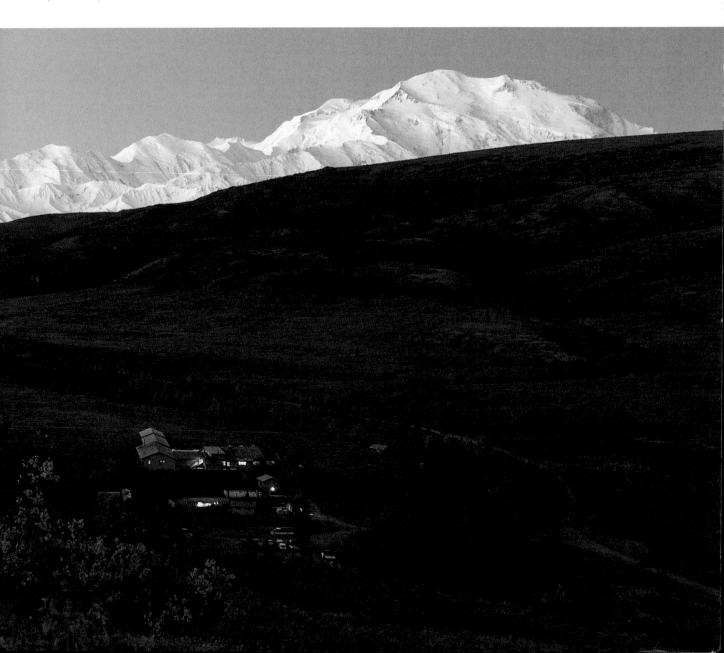

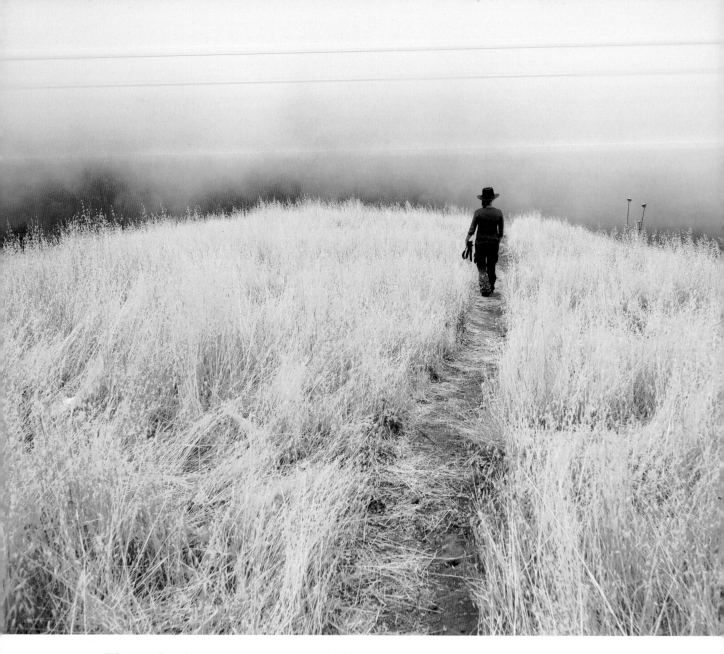

FIG. 13.18 One of my students, dressed in a red shirt, was walking down this trail to photograph the redwoods across the canyon. Every once in a while, it all comes together. I shot about 20 pictures of her with different lenses as she worked on her own shots. The red shirt made it all happen. Santa Lucia Mountains, Big Sur, California. (Kodak DCSPro 14N, ISO 80, 20–35 mm lens, handheld, 1/250 sec. @ f/5.6.)

When you photograph people in nature, keep in mind how different focal-length lenses will render the scene. Each focal length corresponds to a specific angle of view. You can use this fact to make a better picture, by understanding that a wide lens will show more of the background, and a long lens will show less of the background—even though the subject is exactly the same size. You keep the subject the same size by moving close with the wide lens, backing up with the long lens (**FIG. 13.19** and **13.20**).

FIG. 13.19 At 15 mm, a wide-angle lens shows a lot of background, but your subject can be any size you want. In this shot, I'm about five feet from my friend Tracy Trotter. Notice that his head is the same size here as it is in the next shot. Big Sur, California. (Nikon D300, ISO 200, 12–25 mm lens, tripod, 1/1000 sec. @ f/5.6.)

FIG. 13.20 In this shot I used a 200 mm focal length. Tracy didn't move, and the camera was kept at the same height as in Fig. 13.19. I moved back to keep Tracy's head the same size as in the wide-angle shot. Telephoto lenses show a lot less background. Notice the rock in both shots. The distance from your subject and the choice of lens will have a big effect on showing scale in your images. Big Sur, California. (Nikon D300, ISO 200, 70–200 mm lens, tripod, 1/1000 sec. @ f/4.)

Q *I've heard people talk about 'painting with light.' How can I do that?*

A In Chapter 3, "It's all about the light," I mentioned that the word *photography* literally means *light writing*. Painting with light in photography is simple, in theory. While your camera shutter is open, you point the light at different places in the scene and literally "paint" things with the light. Obviously, you have to do this when the scene is pretty dark. Your "paint" can be any light source: flashes, flashlights, even camping lanterns. In my class, students light a tent at night to learn about painting with light. The technique's the same whether you're lighting an RV, a tent, or a cabin (**FIG. 13.21**).

I like starting about one-half hour after sunset, when there's still a glow on the horizon. That way, the sky renders dark blue, rather than black.

First, I get my exterior, ambient exposure. I use a low ISO, such as 100, and set my shutter at 10–30 seconds to give me time to fire all my flashes. Everything has to stay dark, so I choose an f/stop that will underexpose the ambient by at least three stops. (If you meter that twilight glow in the western sky, you should be good.)

Next, use a battery-powered lantern or a flash to light the inside of the tent. My flashes are usually at quarter-power on manual mode. Have someone in the tent fire the flash after you open the shutter. They'll have to point it at different places to light all the corners of the tent. At the same time, you can fire another flash or use a big flashlight to light trees or things outside the tent. It'll take a few tries to get everything balanced, but it can look very dramatic.

▶ **FIG. 13.21** Shooting before the sky is totally black gives you a deep blue color. One student was in the tent popping a flash; another was behind the tent flashing up into the trees, while I fired my gelled flash a couple of times to light around the tent. Lodgepole Campground, Sequoia National Park, California. (Nikon D2X, ISO 200, 12–24 mm lens, tripod, flash off camera, 6 sec. @ f/4.)

Assignments to try

Your assignment is to light your tent, RV, or cabin the next time you go camping. I've just talked about how to do this in the Q&A section, but here are a few more tips:

- If you want people in the shot, they have to stay very still, and you should pose them doing something. Flash works better at lighting people, since it will freeze any motion.
- Put a warming gel over the flash—or any light you use—to make your lighting look more natural.
- If there's a fire in your scene, the longer the exposure, the bigger the fire. Make sure that the smoke is going away from the camera—you'll see why if it's blowing into your lens.
- If you're lighting an RV, turn on all the lights inside. Since you can't control their intensity, you need to set up your exposure based on those lights.

14 | Back in the lab

Managing pixels and making art
in the digital darkroom.

Becoming the lab

Digital photographers can finally do what painters and other artists have always been able to do—create images that show how we interpret a scene, rather than just what's *there*, in front of the camera.

In many ways, the days of shooting with film were simpler. If you shot slides, as most nature photographers did, you'd capture the image, send the film to the lab for processing, and pick out the pictures you liked. Then you'd send them off to clients or back to the lab for prints, or put them into a slide tray to share with friends.

The penguin in the opening photograph of this chapter was shot on Ektachrome Lumiere 100 film. I spent several days testing different films and exposures before leaving on a long assignment to Chile and Antarctica. When I returned, I ran my film through the lab on multiple days to reduce the risk of processing errors. I relied completely on my photo lab to process my film perfectly.

With digital photography, the photographer has to do it all: Create the images, edit them, process them, and in many cases print them. We've become the lab as well as the photographer (**FIG. 14.1**).

FIG. 14.1 To make this image more dramatic, I darkened the paddle and saturated the warm colors. Then I lightened the reflection area, working on the paddle reflection and water ripples separately. Finally I added contrast and selective sharpening to produce what I saw, not what the camera captured. Alaska. (Nikon D200, ISO 200, 12–24 mm lens, handheld, 1/640 sec. @ f/5.)

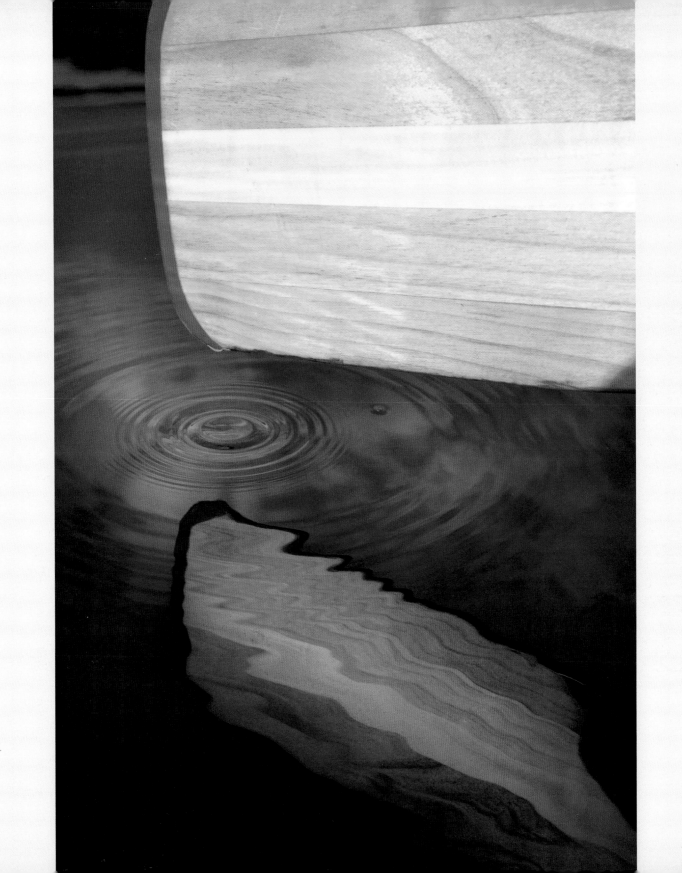

Cameras and computers can't be separated. We have to understand and stay current on far more information now than ever before. Serious nature photographers have to learn how to use photographic applications and keep up with changes in those applications. Photoshop is probably the most common software, but others, including the processing applications that come with Canon and Nikon cameras, can do much of the work. You don't have to be a Photoshop expert to produce beautiful nature images.

Manipulation

Controversy abounds when nature photographers get together and talk about the "manipulation" of photographs. The way I see it, the instant a photograph is taken, it becomes a subjective interpretation of the actual scene. Objectivity is gone. Color balance, lens choice, composition, timing—all are personal choices reflected in the final image. So forget about photographs "telling the truth." The only way to get the truth is to be there yourself.

Digital RAW files are like negatives; they have to be processed and printed before final viewing. By *printed*, I don't necessarily mean on paper. Most photographs are viewed on a computer, so preparing an image for electronic viewing is analogous to preparing it for publication or display. Each step of the way, you make subjective choices about how you want a photograph to look. It's your picture, and you can do anything you want with it. The ethical issue is how you present an image to the public. The caption and metadata associated with the image must be truthful and accurate.

For instance, when captioning your images of zoo animals or wildlife models, you need to say that they're captive—don't try to pass them off as wild, either intentionally or through an omission of information. If you're creating a digital composite of multiple images, say so in the caption. I call these types of images *digital illustrations*, rather than *photographs*; they're a big part of my commercial stock-photography business. (**FIG. 14.2**).

I see digital "manipulation" as a series of stages. First is basic processing for contrast, color-correcting, spotting dust, and capture sharpening. These activities are necessary just to fix things in the original image.

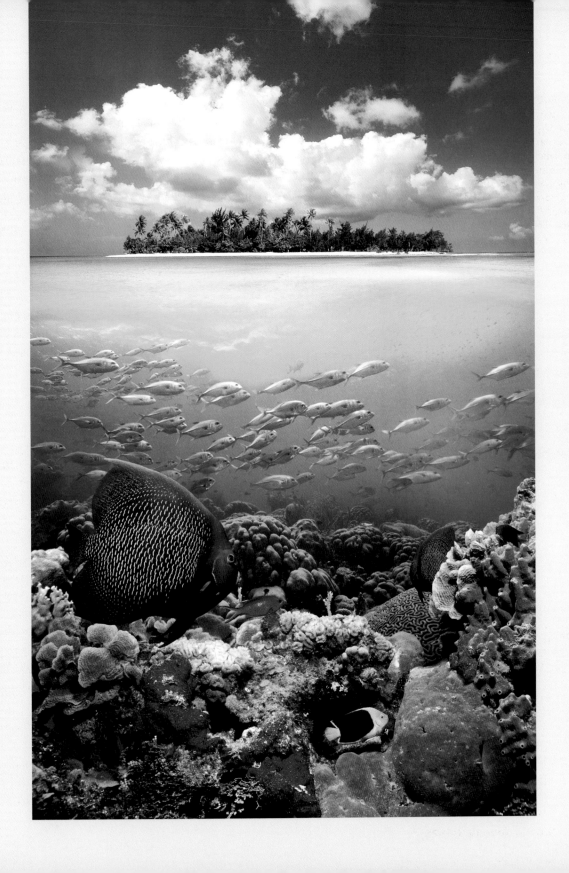

No need to tell anyone about them. In fact, if you don't do these things, the photograph probably will look pretty bad.

Second is creative retouching. In nature images, this usually means adding some color saturation, creative color-balance such as warming up a desert scene, maybe a little local sharpening, some dodging and burning, and removing distracting elements—bits of lint, a cigarette butt, fencing. I don't usually note these changes in my captions, but it's important to be honest if asked.

The third stage is adding elements from other images, or removing the entire background and showing the subject out of context—essentially creating conceptual illustrations. I always divulge this type of manipulation in my captions (**FIG. 14.3** and **14.4**).

Equipment

With regard to Photoshop and other digital-processing applications, there really aren't any special tools or applications that apply specifically to nature photography. But there are some techniques that most nature photographers will find very helpful, if not absolutely necessary, to create great images of our natural world.

TIP Remember to straighten your images. It's easy to spot a crooked horizon, but check the verticals too. Images that are photographed crooked look out of balance. Straightening is easy in Photoshop, Adobe Camera Raw, and other processing applications.

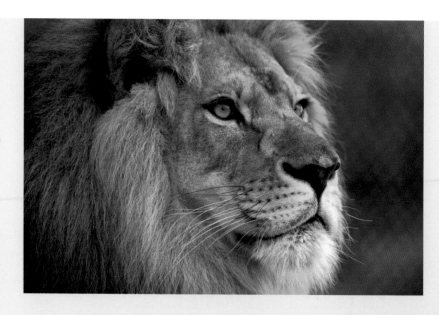

FIG. 14.3 This is the original RAW file of a magnificent lion at our local zoo. The image looks flat, and a fence is noticeable in the background. But it's a good exposure and all the data is there. Santa Barbara, California. (Nikon D100, ISO 200, 80–200 mm lens, tripod, 1/100 sec. @ f/2.8, captive.)

Applications to help you create images

Software can help with dynamic range, lens correction, sharpening, color effects, enlarging, and depth of field.

High Dynamic Range (HDR)

The high dynamic range (HDR) technique works best with landscapes and subjects that don't move. Because you can't get detail in both the highlights and shadows in a single shot, you'll have to take two to three images to cover the full tonal range.

First, place your camera on a tripod. Don't move it or change anything on the lens. Once everything is composed and focused, bracket your exposures: Take one shot exposed for details in the highlights, and take a second shot exposed for details in the shadows. If the scene is very contrasty, get a third shot for details in the midtones. Usually these shots are about one to two stops apart. Use manual exposure and your shutter speed to do the brackets, so you don't change the depth of field.

Next, use special software to blend the images, or do it yourself in Photoshop with layer masks (my preferred method). If you don't want to do the blending yourself, try Photomatix, one of the best HDR programs. Photoshop also has an automated HDR feature in its File menu (**FIG. 14.5** to **14.7**).

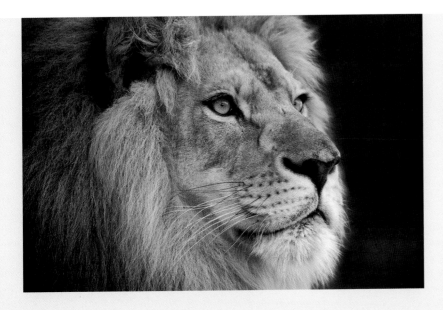

FIG. 14.4 I processed the image in Adobe Camera Raw, adjusted the contrast and color, and added a little capture sharpening. In Photoshop, I desaturated the color and gave the lion an old, sepia-toned look. Darkening the background and removing the fence finished the image.

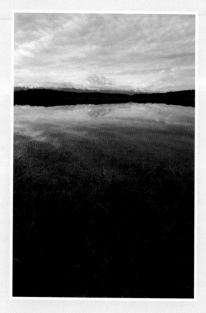

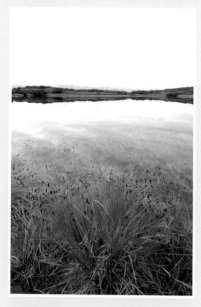

FIG. 14.5 and **FIG. 14.6** The contrast range of this scene is too large to be captured in a single exposure, so I made one exposure for the sky (Fig. 14.5) at 1/100 second, and the next exposure for the grass in the foreground (Fig. 14.6) at 1/40 second. (Nikon D2X, ISO 200, 12–24 mm lens, tripod, f/16.)

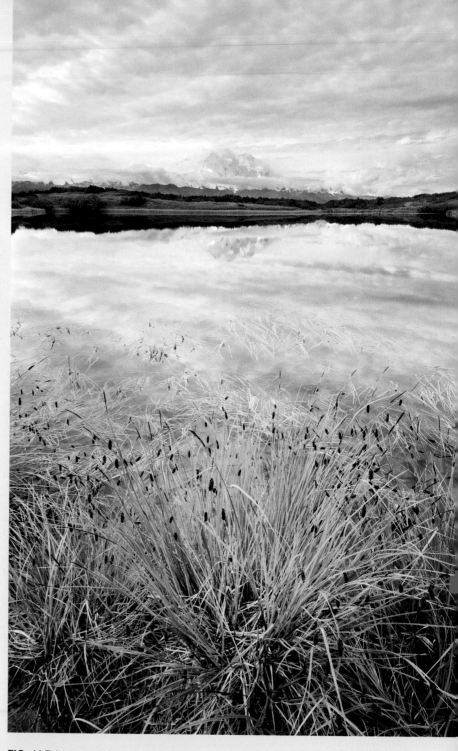

FIG. 14.7 I processed the two previous images in Lightroom. Then I used Photoshop to blend the two images with layer masks, creating a high dynamic range photograph that looks more like what I saw at the scene. I did some tweaking with color balance and saturation to perfect the final image. Denali National Park, Alaska.

Lens Distortion

When you use really-wide-angle lenses, especially fisheyes, you get a lot of distortion. The most common types are *pincushion* and *barrel* distortion. Photoshop has some correcting tools in the Filters > Distort menu, which work fine. But if you really want some automation, try PhotoFixLens, DxO Optics, or the one that I use—Image Trends Fisheye-Hemi. It's a plug-in for Photoshop designed just for fisheye lenses, and is really easy to use (**FIG. 14.8** and **14.9**).

Sharpening

All digital images start out looking unfocused. I don't know why, they just do. You have to sharpen them to make them look focused. Sharpening should occur in two steps: *capture sharpening* and *output sharpening*. Most cameras can apply sharpening when you take the picture; if you're shooting JPEGs, turn on this feature. If you're shooting RAW, it's your choice, since you can do your sharpening later in the processing software. But you still want to apply a bit of sharpening when you process the image. This is done automatically in many programs.

Output sharpening is the last step, and is based on whether you're posting your image on the web or making a print. But be careful: Over-sharpening can ruin an image.

Canon and Nikon software, Adobe Camera Raw, Photoshop, Aperture, and Lightroom all offer good sharpening tools. Several other sharpening programs are available, including Genuine Fractals, and the one I use, PixelGenius PK Sharpener (**FIG. 14.10**, on the next page).

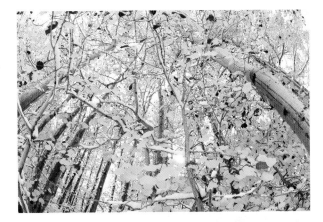

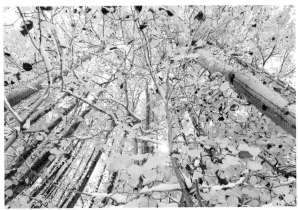

FIG. 14.8 and **FIG. 14.9** Fisheye lenses distort things that are not centered in the frame. This distortion is especially noticeable with subjects that we think of as being straight. Using special software, you can correct some of the distortion and get a more natural-looking scene. I used Image Trends Fisheye-Hemi software to correct this image of aspen trees after a fall snowstorm. Eastern Sierras, California. (Nikon D2X, ISO 200, 10.5 mm fisheye lens, handheld, 1/250 sec. @ f/5.6.)

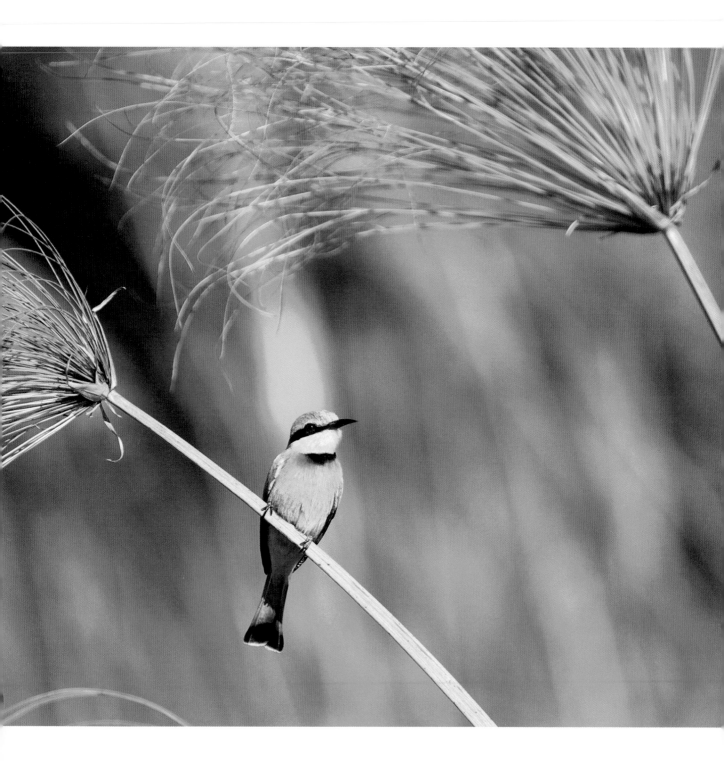

FIG. 14.10 This little bee-eater, perched on some papyrus at sunset, had to be sharp. I focused on its head and used a shallow depth of field to help separate it from the busy background. I used capture sharpening when I processed the image in Lightroom, and output sharpening when I converted it for printing in this book. Botswana, Africa. (Nikon D2X, ISO 200, 70–200 mm lens, handheld, 1/2000 sec. @ f/2.8.)

Color Effects

There are lots of ways to control color and saturation in your images. Some camera settings give you more vivid color and greater contrast; if you're shooting JPEGs, turn on these features in your camera and try them. JPEGs don't hold up well to processing, so do as much in-camera as possible. On the other hand, RAW images need a lot of processing, so using software to add color and special effects works great. I use Adobe Camera Raw, Lightroom, and Photoshop to do all my color and effects work, but you should also check out Nik Software, DxO, PixelGenius, and AutoFX for some great automated programs. Some of these applications can match the look of different films (**FIG. 14.11** and **14.12**, on the next page).

Enlargements

A lot of my students ask how I make such large prints. As long as your original image is sharp, well exposed, and processed correctly, you can make beautiful enlargements from your digital files. The largest print I've made from a single image was about six feet long. You can use Photoshop to interpolate (enlarge) the file, but do it in increments. Under Image Size, change pixels to percent and enlarge the file in 10% steps until you get the size you want. I use a Photoshop plug-in called Blow Up, by Alien Skin, to do my interpolation.

Extended Depth of Field

Due to the high magnification in close-up images, the depth of field is shallow. Some techniques and software can overcome that problem. The technique is a lot like HDR, where you shoot several images of a subject, refocusing on a different part each time. Of course, for this technique to work, the camera has to be on a tripod, and the subject can't move.

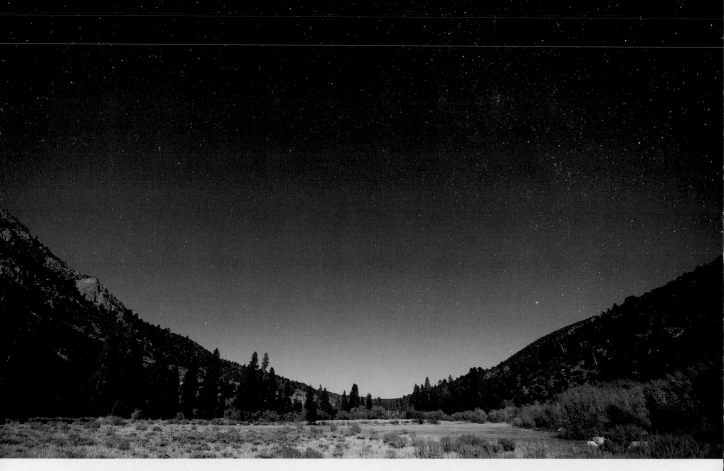

▲ **FIG. 14.11** Several applications and plug-ins provide automated conversions to give digital images the look of different types of film. I used Lightroom's Aged Photo and then tweaked things in Photoshop to give this image its toned black-and-white look. Eastern Sierras, California. (Nikon D3, ISO 800, 14–24 mm lens, tripod, 30 sec. @ f/3.2.)

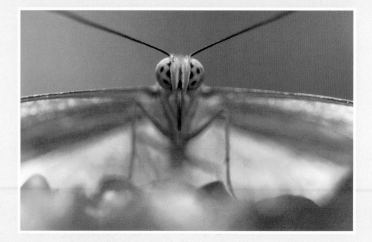

▶ **FIG. 14.12** If you shoot JPEGs, look at some of the color, saturation, and sharpening settings in your camera. This image of a Julia Heliconian butterfly was taken in RAW and then enhanced in Lightroom and Photoshop to bring out the brilliant colors. Backlighting also helps show off the colors. Santa Barbara, California. (Nikon D300, ISO 400, 105 mm macro lens, handheld, 1/640 sec. @ f/4.2, captive.)

After shooting your images, bring them into Photoshop. In the File menu, choose the Auto-align function to make sure that the images are aligned. Apply the Auto-blend Layers function to stitch the images together automatically, giving you a photograph with the entire subject in focus (**FIG. 14.13** and **14.14**). For more automated features for extended depth-of-field, try the Helicon Focus software. These techniques work on both close-up and landscape images.

Firmware

All of your cameras and storage devices, such as Epson multimedia drives, need to have the latest firmware to access new cameras and fix bugs. You can check which firmware you have (read the manual) and download the latest version directly to your camera or drive from the computer. Don't forget to update your computer software as well, especially programs that deal with reading images from cameras.

Lighting

Dodging and burning is an art practiced by master photographic printers. *Dodging* is holding back light from an area; *burning* is adding light. It's a way of controlling the visual contrast in a scene very selectively. Tools in Photoshop and other photo applications allow you to duplicate what the master printers did in the darkroom.

FIG. 14.13 After aligning all three images, I used the Auto-blend Layers function in Photoshop to put all the images together. It's amazing how Photoshop can figure out all the masking to make this technique work.

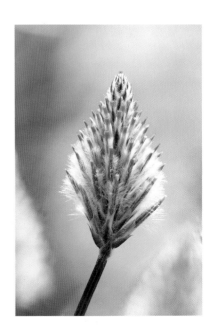

▶ **FIG. 14.14** Here's the final image. Notice how the whole flower head is sharp from front to back, top to bottom. You may have been able to get this much focus with a smaller aperture, such as f/16, but the background would be sharper and busier. This technique of extended depth of field gave me a sharp flower and nice out-of-focus background. Santa Barbara, California. (Nikon D300, ISO 200, 105 mm macro lens, tripod, 1/400 sec. @ f/6.3.)

One of the best things about Adobe Camera Raw and programs like Lightroom is the retouching tools they provide for selective contrast control (burning and dodging). I do most of my processing and retouching in Lightroom, and many of my images are never opened in Photoshop, but if you want to work with layers then you have to use Photoshop. Here's one way to create an image with selective contrast: Shoot multiple exposures, one dark and one light of the same scene. Combine these as layers in Photoshop and use masks to "reveal" the dark and light parts of your image. It's a lot like doing HDR (**FIG. 14.15** and **14.16**).

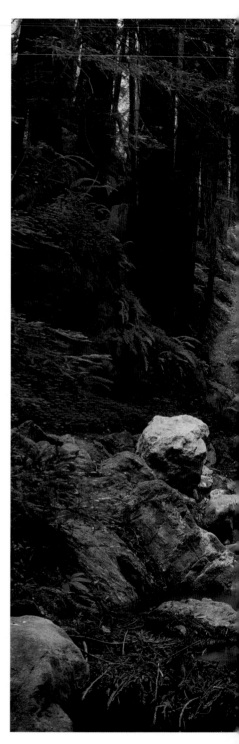

FIG. 14.15 and **FIG. 14.16** Here's another technique: I made a single exposure of this image of Hare Creek, being sure to capture all the detail in the shadows (Fig. 14.15). In Photoshop, I created a second, darker layer and used layer masks to dodge and burn the original image. This technique created a much more realistic and dramatic-looking photograph of the forest (Fig. 14.16). Big Sur, California. (Nikon D300, ISO 200, 12–24 mm lens, tripod, 1.6 sec. @ f/16.)

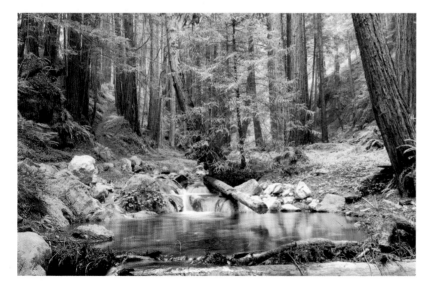

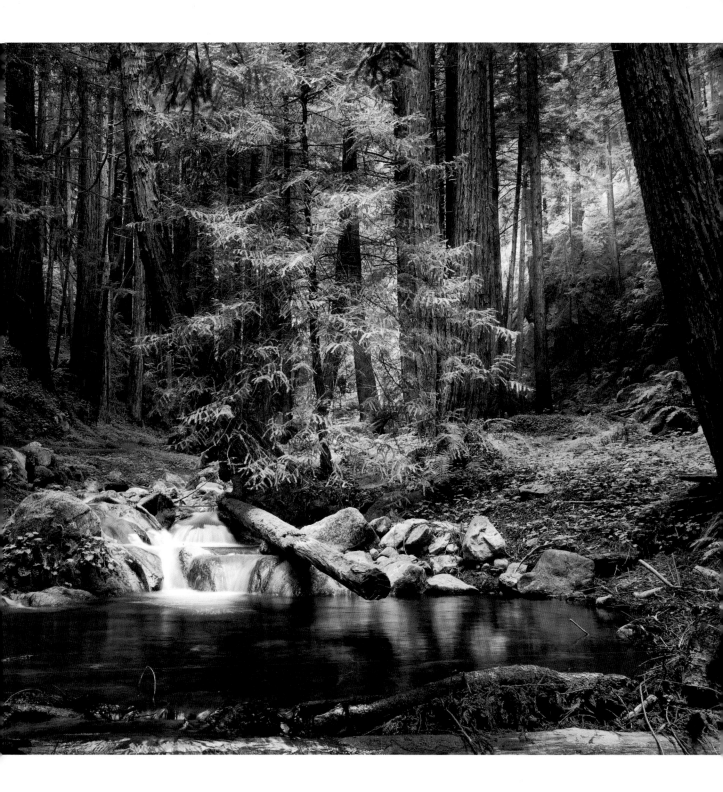

Questions & Answers

Q **Why does my wide-angle lens show weird colors in the corners, especially around branches?**

A Lenses are designed to focus all the wavelengths of light onto the sensor plane. The wider the lens, the harder it is to get all these rays to focus on the same spot, due to the bending of light as it goes through all that glass. The wavelengths that don't get focused on the sensor are seen as *chromatic aberrations*—little colored edges along lines of contrast, especially in the corners of your image. You don't see many aberrations with normal and telephoto lenses; but wide lenses, especially cheap ones, can have lots of problems (**FIG. 14.17**).

Fortunately, there's a quick fix. In Photoshop, Adobe Camera Raw, Lightroom, and other image-processing applications, look for a "lens correction" tab containing sliders and switches for fixing chromatic aberrations. I usually set Defringe to "all edges" and slide the other color sliders until the aberrations are minimized (**FIG. 14.18**).

Q **I see that iceberg image of yours everywhere. How did you make it?**

A This question always comes up eventually. The iceberg is one of my most successful conceptual images. It's been published hundreds of times and has generated hundreds of thousands of dollars. It's been used in ads, posters, brochures, and editorial stories all around the world. Because it has such a strong conceptual interpretation, people find it easy to use as visual support for their words.

▶ **FIG. 14.17** and **FIG. 14.18** I used a wide-angle lens to photograph this jungle scene. Wide lenses can have some pretty disturbing chromatic aberrations, especially near the edges and in contrasty areas. One of the most common is *fringing*, that bluish line on the edge of the plants. (You can see it clearly when the image is enlarged, as in Fig. 14.18.) The wider the focal length and the cheaper the lens, the more aberrations you'll have. Photoshop and most processing applications have tools to minimize these chromatic aberrations. Monteverde Cloud Forest, Costa Rica. (Nikon D2X, ISO 400, 12–24 mm lens, tripod, 1/100 sec. @ f/5.6.)

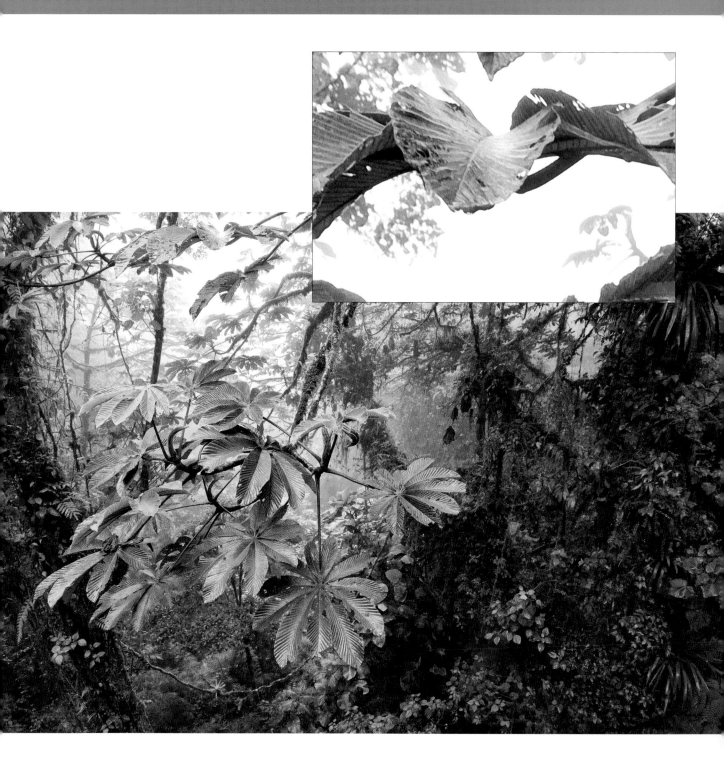

FIG. 14.19 It's impossible to see—let alone photograph—an iceberg this large in the ocean. The density of water limits visibility to a few hundred feet at the very best, and usually much less. To create a realistic-looking iceberg illustration, I composited four images. This is my most successful stock image.

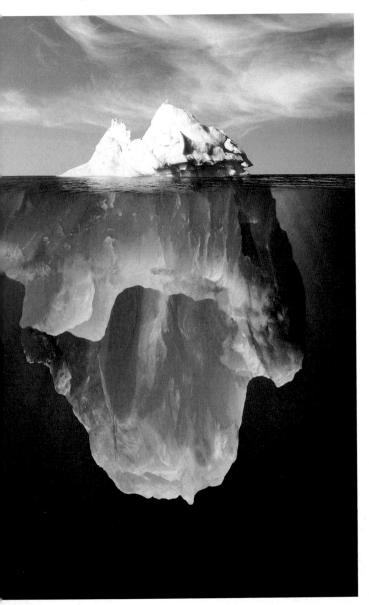

There are actually three versions of the iceberg in different compositions. One of my mentors, Craig Aurness, a highly successful photographer and cofounder of the Westlight Stock Agency, came up with the idea to do the iceberg. I had shot all the components already, and did some research on how a large iceberg might look if you could actually photograph it underwater. Working with Craig and his team of digital artists, we created the iceberg from four original images, all shot on film. The sky and underwater components were shot off the California coast, the top iceberg was taken in Antarctica, and the bottom iceberg was shot above water in Alaska and then flipped. The iceberg images are licensed exclusively through my stock agency, Corbis (**FIG. 14.19**).

Assignments to try

Nearly everything I've talked about in this chapter can be an assignment. It just depends on what software you have and what you haven't tried.

- Two things I think everyone should try are the high dynamic range and extended depth-of-field techniques. Both can be done in Photoshop, so you don't have to use any special software, but you may have to upgrade your software if you're working with an older version. I've given brief explanations on both of these techniques, and the web has plenty of tutorials. So get out there, shoot photos, and put some time into creating new images. Remember, it's supposed to be fun!

"In every walk with nature one receives
far more than he seeks."
—*John Muir*

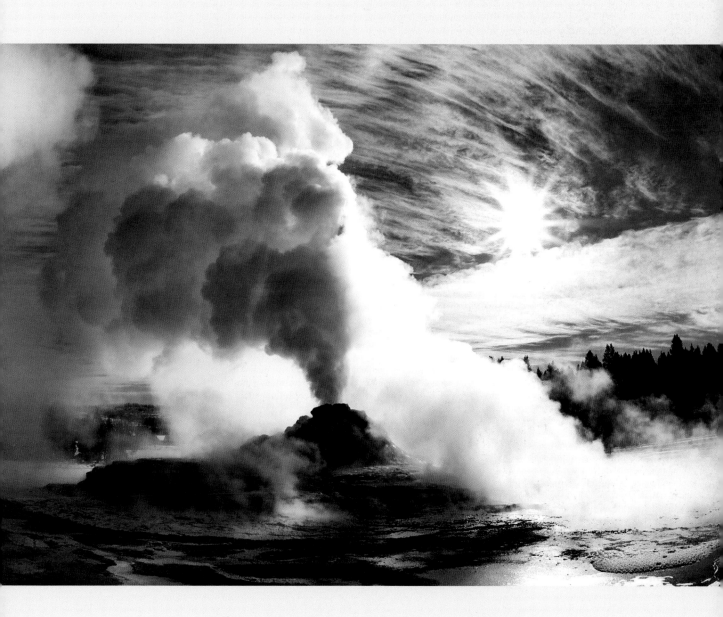

Appendix: Resources

Mentioned in *Photographing Nature*

All websites were current at the time of printing; however, we all know how things can change on the Net.

Books

Ansel Adams, *Yosemite and the Range of Light*. New York Graphic Society, Little Brown TIME/LIFE books, 1996.

William Neill and Pat Murphy, *By Nature's Design*. Chronicle Books, 1993.

Derek Doeffinger, *The Art of Seeing: A Creative Approach to Photography*. The Kodak Workshop Series by Eastman Kodak Company, 1984.

Peter Krogh. *The DAM Book: Digital Asset Management for Photographers*. O'Reilly Media Inc., 2006.

Photographers' personal sites

David H. Collier Photography
dcollierphoto.com

Eloquent Images: Gary Hart Photography
garyhartphotography.com

Dewitt Jones Productions Inc.
dewittjones.com

George Lepp Imaging
georgelepp.com

Muench Photography (David Muench and Marc Muench)
muenchphotography.com

Ethan G. Salwen
ethansalwen.com

Dennis Sheridan
dennissheridan.com

TIP Be one of this book's resources by sharing your work at our Flickr page (www.flickr.com/groups/photographingnature).

Additional Web Resources

This list is meant as a starting point, not a comprehensive guide. Where applicable, I've included brief notes to indicate what type of information you can glean from that site.

Photography community, tips and techniques

lexar.com/dp/index.html

photo.net

photographytips.com

Neil van Niekerk's Tangents.
planetneil.com/tangents/about

Nature Photographers Online Magazine is a great all-around resource.
naturephotographers.net

North American Nature Photography Association (NANPA).
nanpa.org

The Nikonians. You have to join the user community site to get all the benefits, but it's worthwhile if you shoot with Nikon.
nikonians.org

Canon Digital Learning Center. Tips and techniques from the designers.
usa.canon.com

Techniques and equipment

Vortex Media provides lots of cool stuff for photography and video.
vortexmedia.com

NatureScapes.net is one of the most comprehensive sites on nature photography.
naturescapes.net

The Digital Photography School is a source for good basic info on all things digital photo.
digital-photography-school.com

The Luminous Landscape is a great site with info on both Canon and Nikon.

luminous-landscape.com

Cambridge in Colour. Digital photography tutorials on everything about digital photography.

cambridgeincolour.com/tutorials.htm

DigitalReview.ca supplies custom functions and menus for cameras.

digitalreview.ca/cams/NikonD70vsRebelXT_pg3.shtml

KenRockwell.com provides a tutorial on Canon 30D custom functions.

kenrockwell.com/canon/30d/custom-functions.htm

Digital SLR Guide is a useful source for details about digital SLRs.

digital-slr-guide.com/digital-slr-articles.html

Digital Camera Product Reviews is a source for detailed reviews and information on all types of cameras and lenses.

dpreview.com/reviews

Dynamic range, tonal range

forums.dpreview.com/forums

forums.steves-digicams.com/forums

Noise in images

photoxels.com/tutorial_noise.html

outbackphoto.com

Rain, dust, weather protection

studiomirage.si/en

kata-bags.com

cameraessentials.com/new.htm

camrade.alphatron.com

xtratufboots.com

lenscoat.com

Tripods, ballheads, gimbal heads, flash brackets

tripodhead.com

manfrotto.com/Jahia/site/manfrotto

reallyrightstuff.com/ballheads/index.html

luminous-landscape.com/reviews/accessories/
wimberley.shtml

Camera bags and steadybags

kgear.com

vertexphoto.com/PhotoTools.aspx

thinktankphoto.com

tamrac.com/welcome.htm

pelican.com

Blinds and gear for outdoor photography

rue.com

kirkphoto.com

Sensor sizes

cambridgeincolour.com/tutorials/
digital-camera-sensor-size.htm

Batteries and chargers

mahaenergy.com

metaefficient.com

call2recycle.org

White balance, color

Great article by Moose Petersen, no matter what camera you use.

nikondigital.org/articles/white_balance.htm

Good information on Kelvin temperatures and color correction.

aeimages.com/learn/color-correction.html

Color Matters. Questions and answers, debates and discussions. Everything you need to know about color.

colormatters.com

White balancing cards and plug-ins

rawworkflow.com/whibal

vortexmedia.com/WC_PHOTO.html

Monitor calibration

beesbuzz.biz/art/tutorials/gamma.php

photoshopsupport.com/resources/color.html

xrite.com/home.aspx

Cleaning your equipment

How to clean lenses, monitors, filters, and CCDs.

kenrockwell.com/tech/cleaning.htm

How to clean your DSLR camera lens. Some great tips here; be sure to read down the page in the discussion forums.

lifehacker.com/software/cleaning/how-to-clean-your-dslr-camera-lens-241856.php

Auto-focus

nikonians.org/nikon/multi-cam2000/review.html

kenrockwell.com/nikon/af-settings.htm

usa.canon.com/dlc/controller?act=GetArticleAct&articleID=2286

Light and creativity

Magic hour

golden-hour.com

ronbigelow.com/articles/magic/magic.htm

Sunrise/sunset, moon phases, weather

srrb.noaa.gov/highlights/sunrise/sunrise.html

sunrisesunset.com

calculatorcat.com/moon_phases/phasenow.php

www.desertusa.com/wildflo/wildupdates.html

Articles on creativity, golden mean, and the Fibonacci series

photoinf.com/Golden_Mean/Stuart_Low/The_Golden_Mean.htm

library.thinkquest.org/27890/mainIndex.html

mcs.surrey.ac.uk/Personal/R.Knott/Fibonacci/fibnat.html

Flash

Flash techniques and gear

strobist.blogspot.com

pixsylated.com

canon.co.jp/imaging/flashwork/ettl2/technology/index.html

nikonmall.com/detail/NIK+11484

stickyfilters.com

Macro photography

photo.net/learn/macro

layersmagazine.com/adventures-in-close-up-photography.html

shutterbug.com/equipmentreviews/lighting_equipment/1101sb_novoflex

earthboundlight.com/phototips/closeup-macro-flash-brackets.html

Depth-of-field calculators

dofmaster.com/dofjs.html

outsight.com/hyperfocal.html

Film scanning and processing

agximaging.com

Panorama tool and techniques

panoguide.com

kaidan.com

gigapansystems.com

reallyrightstuff.com/pano

ptgui.com

Travel

moosepeterson.com/gear/carryon.html

hoothollow.com

luggagepoint.com/baggageguide.asp

cameraontheroad.com

magellans.com

Portable solar panels for charging batteries

siliconsolar.com/portable-solar-power-systems.html

solartechnology.co.uk/shop/freeloader-pro.htm

Traveling green

greenhotels.com/index.php

gogreentravelgreen.com/

travelingthegreenway.com/

nomadik.com/camping-hiking/green-camping-hiking

Identifying insects and plants

bugguide.net

whatsthatbug.com

insectidentification.org

Game farms and zoos

Kroschel Films Wildlife Center

www.kroschelfilms.com

Minnesota Wildlife Connection

minnesotawildlifeconnection.com

Triple "D" Game Farm

tripledgamefarm.com

Lakota Wolf Preserve

lakotawolf.com

Alberta Bird of Prey Center

burrowingowl.com

Image manipulation and processing

Software that does it all

niksoftware.com

ononesoftware.com

alienskin.com

pixelgenius.com

dxo.com/us/photo/dxo_optics_pro

Filters and color effects

downloads.digitaltrends.com

autofx.com

High dynamic range (HDR) software

hdrsoft.com

Lens-distortion software

humansoftware.com

dxo.com/us

imagetrendsinc.com/products/prodpage_hemi.asp

Sharpening software

pixelgenius.com/sharpener/index.html

focusmagic.com/index.htm

niksoftware.com/sharpenerpro/usa/entry.php

Enlarging software

ononesoftware.com/products/genuine_fractals.php

alienskin.com/blowup/index.aspx

Noise-reduction software

neatimage.com

picturecode.com

niksoftware.com/dfine/usa/entry.php

Extended depth of field

heliconsoft.com/heliconfocus.html

NANPA

PRINCIPLES OF ETHICAL FIELD PRACTICES

NANPA believes that following these practices promotes the well being of the location, subject and photographer. Every place, plant, and animal, whether above or below water, is unique, and cumulative impacts occur over time. Therefore, one must always exercise good individual judgement. It is NANPA's belief that these principles will encourage all who participate in the enjoyment of nature to do so in a way that best promotes good stewardship of the resource.

ENVIRONMENTAL: KNOWLEDGE OF SUBJECT AND PLACE
Learn patterns of animal behavior
So as not to interfere with animal life cycles.
Do not distress wildlife or their habitat.
Respect the routine needs of animals.
Use appropriate lenses to photograph wild animals.
If an animal shows stress, move back and use a longer lens.
Acquaint yourself with the fragility of the ecosystem.
Stay on trails that are intended to lessen impact.

SOCIAL: KNOWLEDGE OF RULES AND LAWS
When appropriate, inform managers or authorities of your presence and purpose.
Help minimize cumulative impacts and maintain safety.
Learn the rules and laws of the location.
If minimum distances exist for approaching wildlife, follow them.
In the absence of management authority, use good judgement.
Treat the wildlife, plants and places as if you were their guest.
Prepare yourself and your equipment for unexpected events.
Avoid exposing yourself and others to preventable mishaps.

INDIVIDUAL: EXPERTISE AND RESPONSIBILITIES
Treat others courteously.
Ask before joining others already shooting in an area.
Tactfully inform others if you observe them engaging in inappropriate/harmful behavior.
Many people unknowingly endanger themselves and animals.
Report inappropriate behavior to proper authorities.
Don't argue with those who don't care; report them.
Be a good role model, both as a photographer and a citizen.
Educate others by your actions; enhance their understanding

Approved by the Board of Directors July 2003

Committed to Photography of Our Environment
10200 WEST 44TH AVENUE, #304 · WHEAT RIDGE, COLORADO 80033–2840
303/422–8527 · FAX 303/422–8894 · E–MAIL: info@nanpa.org · WEB: www.nanpa.org

Index

C

cable release, 200
cable-management bags, 35
cactus, 81, 216, 257
calibrating your monitor, 91
California condor, 21
California newts, 105, 190
California poppies, 47, 115, 121, 235
California tree frog, 122
cameras
 cleaning, 219
 DSLR, 31
 dynamic range of, 59, 61
 firmware for, 285
 flash synchronized with, 100
 histograms, 40–41
 point-and-shoot, 31
 sensors, 39–40
 stabilizing, 126, 156, 160, 161
 white-balance settings, 83–84
 See also equipment
camping
 documenting experience of, 250–252
 near shooting locations, 258
 See also travel
Canadian lynx, 173
Canon PhotoStitch, 242
Cape buffalo, 153
captive animals, 170
capture sharpening, 281
car travel. See road trips
carbon filter tripods, 45
caribou, 184
caterpillars, 125
CD/DVD backups, 265
center-weighted metering, 217
charging batteries, 261
cheetahs, 155
children, 6
chinstrap penguins, 7
chromatic aberrations, 288
cleaning your camera, 219
Clear Vision DVD (Dewitt), 26
Cleland Wildlife Sanctuary, 170
Clevenger, Ralph, v

close-up photography, 112–127
 assignments on, 127
 diopters for, 118
 emphasizing subjects in, 122
 experimenting with, 227
 extension tubes for, 118
 focusing for, 125, 126
 lighting for, 114, 118–121, 126
 macro lenses for, 116, 117, 135
 moving slowly in, 127
 tripods used for, 47, 126
clouds, 197
Collier, David H., 188, 292
color
 of flash, 143
 of light, 56, 76–79, 85, 90
 of subjects, 80–81, 269
color effects, 283, 284
color noise, 72
color wheel, 80–81
colored gels, 103
compasses, 262
complementary colors, 81
composition, 208–227
 assignments on, 226
 experimenting with, 226
 filters and, 219
 golden mean and, 238
 guidelines for, 211–213
 lens choice and, 215
 light meter patterns and, 217
 lighting and, 221
 panoramas and, 242–243
 point of view and, 224
 rule of thirds and, 213, 214, 224
 silhouettes and, 222
 uncluttered, 224
computers
 backing up photos to, 265
 darkroom techniques on, 285–286
 image adjustments made on, 279–285
 manipulating images on, 276–278
 updating software on, 285
continuous AF, 155
contrast, 55, 143, 222, 263, 286
Costa Rica, 68, 88, 114, 288